Remembrance, Faith, and Fancy
Outdoor Public Sculpture in Indiana

Indianapolis, beware! An adult alamosaurus and two juveniles appear to be breaking out of the Children's Museum Dinosphere.

Remembrance, Faith, and Fancy
Outdoor Public Sculpture in Indiana

Glory-June Greiff

INDIANA HISTORICAL SOCIETY PRESS
INDIANAPOLIS 2005

Printed in Canada

This book is a publication of the
Indiana Historical Society Press
450 West Ohio Street
Indianapolis, Indiana 46202-3269 USA
www.indianahistory.org
Telephone orders 1-800-447-1830
Fax orders 317-234-0562
Order online shop@indianahistory.org

The paper in this publication meets the minimum requirements of
American National Standard for Information Sciences—Permanence of Paper for Printed Library Materials,
ANSI Z39.48-1984. ∞

Library of Congress Cataloging-in-Publication Data

Remembrance, faith, and fancy : outdoor public sculpture in Indiana / Glory-June Greiff.
 p. cm.
 Includes bibliographical references and index.
 ISBN 0-87195-180-0 (case : alk. paper)
 1. Outdoor sculpture—Indiana—Guidebooks. 2. Public sculpture—Indiana—Guidebooks.
I. Greiff, Glory-June.

NB230.I6R46 2005
7309.9772—dc22

 2004065769

Photos are courtesy of author unless otherwise indicated.

To Eric Grayson and to my mother, June F. Greiff,
stalwart companions in this search.

Contents

■

ALTAR OF ST. FRANCIS OF ASSISI AND THE SHRINE OF SEVEN DOLORS, AT ST. FRANCIS, VALPARAISO, IND.

Demolished in the 1990s, the Shrine of the Seven Dolors near Valparaiso was filled with a variety of interesting statues and grottoes.

Raiders of the Lost Art
A Quest for Outdoor Sculpture in Indiana

■

"WHEN IT COMES TO CONTEMPORARY SCULPTURE—THAT art of triangles, planes, circles, and open spaces—the city is something of a cultural backwater." So wrote art critic Marion Garmel about public sculpture in Indianapolis in 1983, and she might well have expanded the extent of her dismay to the entire state, with a few exceptional pockets. But things have changed. For all the lamentation one still hears regarding the state of art in Indiana, there has never been such an outpouring of public sculpture as there has been in the past decade. Creating what I hoped would be as close as possible to a compendium of information on outdoor sculpture throughout the state has been more difficult than I ever imagined, owing to the fact that more outdoor sculpture than anyone could have predicted has been erected since the completion of the Save Outdoor Sculpture! survey sponsored by Historic Landmarks Foundation of Indiana in the early 1990s. As director of

the statewide survey from 1992 to 1994, I oversaw the locating and cataloging of twelve hundred sculptures and personally documented more than 80 percent of them. But artists kept on merrily churning out art, and unless the people or communities involved responded to my many queries, both broad and individual, I could not hope to discover them all! Who is responsible for this rush to culture? Although corporations still commission a large share, more local governments and community organizations are becoming involved. While there has been a plethora of abstract works, traditional sculpture still comprises much of what is new today. Both commemorative statuary and aesthetically pleasing representational pieces continue to appear. (Harold R. "Tuck" Langland [b. 1939] of Granger and Kenneth G. Ryden [b. 1945] of Anderson have each completed a number of them in recent years.) And unlike some artwork of the past, a lot of new contemporary sculpture is "audience-friendly."

Another unexpected factor complicating my task is the fact that a disturbing number of documented sculptures have disappeared. Several pieces have been stolen (including a rare Harriet W. Frishmuth piece in Elkhart) or destroyed, while others have been inexplicably moved into storage with indeterminate plans to bring them out again. Some must be stamped "whereabouts unknown," as new owners or administrators of a site may have no knowledge whatsoever of the fate of a missing sculpture. Worse, some do not seem to care.

Finally, it is surprisingly difficult to find even the most basic biographical information about a large number of the artists, past and present. There are several biographical compilations, traditional and electronic, but all are woefully incomplete. Many Indiana sculptors work beneath the national radar screen and are often unaware of what their fellow artists are doing in another part of the state, even when their work shares similarities.

Over and above the problems of gathering information was the more basic matter of establishing the boundaries of this discussion.

What is outdoor sculpture? The *Save Outdoor Sculpture! Handbook* issued to directors and volun-teers of the nationwide project undertaken in the early 1990s to document all extant outdoor sculpture defines it this way:

> A three-dimensional artwork that is cast, carved, modeled, fabricated, fired or assembled in materials such as stone, wood, metal, ceramic, or plastic, located in an outdoor setting, and is accessible to the public.

What followed in the SOS! guidelines was a half page of exclusions and the admission that many pieces rest on a borderline of some sort. For this more inclusive study I have embraced some works that might not have been noted by SOS! Some monuments are architectural, not sculptural, but several blur the line and require a judgment call. I included some while excluding others. For the most part, mass-produced commercial figures are not included, but some that have become local landmarks are. Always, where artistic significance may have been lacking, I took into account historic significance.

This is a book about *sculpture*, not memorials, and not monuments. The latter two terms are almost interchangeable, but not quite. Most monuments are, in fact, memorials. But memorials may be any number of other things, natural or man-made: a plaza, a highway, an oak grove. A memorial may be a monument, and the monument *may* be a sculpture—and if it is, it is included in this book. Tablets, obelisks, and textual plaques on stones are not. Cemetery art in general is not discussed at length; however, notable individual monuments and sculptural grave markers are included. Anyone wanting more detailed studies of gravestones in Indiana would do well to consult Susanne S. Ridlen's *Tree-Stump Tombstones: A Field Guide to Rustic Funerary Art in Indiana* (1999) or the classic *Viewpoints on Folklife* (1988) by the late Warren F. Roberts.

I had a number of different outlines and plans of action when I began this project. Most of them were scrapped or greatly altered during the course of collecting information and trying to process and interpret the material in such a way that it made sense to

me and to the reader. What I have ended up writing is, essentially, two books in one. The first examines the outdoor sculpture of Indiana in the context of type and theme and in broad categories of commemorative, religious, aesthetic, whimsical, and abstract/contemporary. The second looks at Indiana's outdoor pieces by location, county by county. Each, theoretically, could stand alone, but neither by itself gives a complete picture of outdoor sculpture in the state.

I began with a file cabinet of twelve hundred individual folders on the sculptures documented by SOS! and the idea to weave their stories into a cohesive, contextual narrative. While I certainly expected there might be several dozen, I was hardly prepared to discover that there are more than three hundred new sculptures throughout the state (and a lot more if you consider each of the ninety-two pieces on the outside walls of the new Indiana State Museum separately). I also did not realize how difficult it would be to find information on the individual artists, be they dead or alive. I discovered I would have to relinquish my plan of visiting every new sculpture—although I have actually documented a great many new pieces and have seen images of most. Time spent traveling, however, is not time spent writing, and I had to weigh the necessities if I was ever to complete the project.

This study was never intended to be merely a guidebook, although Part Two serves that function reasonably well. My opinions as to the artistic merit of any of the sculptures are not a part of the book's purpose. I do, however, take the responsibility of commenting upon the placement, maintenance, and destruction of these artworks when necessary because the chief mission of this book is to create public awareness on several levels. My purpose is to open the public's eyes to the amazing and growing collection of public sculpture in Indiana—for I firmly believe that simply *seeing* more art helps to educate the viewer as well as the reader to understand at least some of the many reasons why sculpture is erected and to encourage observers to become more discriminating. Also, I hope to call

attention to the fact that too many outdoor works are neglected or poorly maintained (sometimes with good intentions), or are simply in the wrong place, either for conservation or aesthetic reasons, or both. As Stacy Paleologos Harris noted in a 1988 commentary, "the most successful works achieve a genuine marriage between art and its environmental context, whether natural or manmade."[1]

If I have missed any sculptures of significance, I apologize, but unless I was informed of a sculpture's existence or stumbled on it by accident—as I did with a frighteningly large number—I could not include it. I had learned, for example, of an abstract piece that was supposed to be located in Shadyside Park in Anderson. While I could not find that particular sculpture (I found it two years later on another expedition), I did find another one that no one had mentioned. I have been known to screech to a halt upon spying a previously undocumented sculpture on the street (*Iris*, on the sidewalk along North Delaware Street in Indianapolis) or off a highway (Ryden's *Illumination* at the Daleville Community Library east of Anderson). The likeliest institutions did not always have the knowledge I sought; some librarians informed me that there were no new sculptures (or even any at all) in their communities, when in fact there were dozens. A number of arts organizations expressed how excited they were that someone had undertaken this project so that *they* could use it as a resource. I fear the grant budget did not allow for procuring a psychic, although that might have helped! The information is as complete and accurate as I could make it at least through fall 2004.

The lack of information out there informs me that just such a compendium is needed, even as I realize it will be instantly outdated as the outpouring of public art continues. Art lives! But it is incumbent upon *us* to keep it alive and well.

This casting of C. E. Dallin's famous *Appeal to the Great Spirit* was erected in Muncie in 1929 as a memorial to Edmund B. Ball.

ACKNOWLEDGMENTS

◼

WHAT COULD ONE DO WITHOUT GOOD LIBRARIANS?
My gratitude goes to all the friendly staff at the library at
the Indianapolis Museum of Art; Suzanne Stanis,
Resource Center at Historic Landmarks Foundation of
Indiana; David Lewis and the always helpful staff in the
Indiana Room of the Indiana State Library. Thanks also
to Janice Blanchard, Kokomo-Howard County Public
Library; Linda Chapman, Allen County Public Library;
the late Suzanne Long, Calumet Room, Hammond Public
Library; Sue Medland of the Mitchell Public Library; Dan
Naylor, Elkhart Public Library; Lynn Rueff and her col-
leagues at the New Albany Public Library; Mary Clare
Speckner, Bartholomew County Public Library; and E. G.
Yarnetsky, Madison-Jefferson County Public Library.

I am grateful to several sculptors for providing infor-
mation about themselves and their work to me: Alison
Adams, William Arnold, Arlon Bayliss, Matthew Berg, Todd
Bracik, Amy Brier, David Caudill, Brian Cooley, Phil Dees,

Robert Donnoe, Michael Dunbar, Dale Enochs, Ryan Feeney, James F. Flanigan, C.S.C., Hector Garcia, C. A. (Carol) Grende, Guy Robert Grey, Lars Jonker, Chaz Kaiser, Jason Knapp, David Kocka, Tuck Langland, the late Anthony J. Lauck, C.S.C., David Layman, Joe LaMantia, Jan Martin, Hank Mascotte, Mark Mennin, Nathan Montgomery, John David Mooney, Eric Nordgulen, Roy Patrick, Beverly Stucker Precious, Fr. Earl Rohleder, Kenneth G. Ryden, Tom Scarff, C. R. Schiefer, Connie Scott, David Scott, Phil Simpson, Georgia Strange, Guy Tedesco, Tom Tischler, Rudy Torrini, Linda Vanderkolk, Tony Vestuto, Donald Weisflog, and David Jemerson Young.

Thanks to the many observant and cooperative people who helped me find information, sources, or the sculptures themselves: Rex Allman, Winamac; Michael Atwell, Purdue University Art Galleries; Sheri S. Beaty, Minnetrista Cultural Center; John Becker, formerly of Terre Haute; Robert Borns; Carol Carithers, Evansville arts patron; Julie York Coppens, former arts writer for the *South Bend Tribune*; Mark Dollase, formerly of HLFI Western Regional Office; Kathleen Glynn, Richmond Art Museum; Polly Harrold, Indiana Arts Commission; David Heighway, historian, Hamilton County; Judy Jacobi, Michigan City; Tommy Kleckner, HLFI Western Regional Office; Paul Knapp, 2nd Globe; Steve Knowles, Falls of the Ohio State Park; Martha Libby; Charles R. Loving, the Snite Museum of Art; Matthew J. McNichols, Art Curator, Rose-Hulman Institute; Julia Moore, Indianapolis Art Center; Leah Orr, Riley Area Development Corporation; Kathleen Pucalik, Purdue University Calumet; Geoff Paddock, Headwaters Park Alliance, Fort Wayne; Angie Quinn, ARCH; Marianne Randjelovic, Crown Hill Cemetery; Ed Riley, Howard County Historian; Jolene Rockwood, Batesville; Brooks Rowlett; Julie Schaefer, Herron School of Art; Gayle Siebert, Fayette County Schools; Charlene Stout, Town of Munster; David Thomas, Indianapolis Art Center; David Vollmer, Swope Art Museum; and Peter Youngman, Lincoln Highway Association. My apologies to anyone whose name I inadvertently left out. I simply could not have done it without you all.

Thanks to those who helped in the original Save Outdoor Sculpture! (SOS!) survey that provided the foundation on which to build this book: stalwart assistants William F. Gulde and Sue Ann Wilgus; my mother June Greiff, who never lost her sterling secretarial skills; and volunteers John B. Allen, Merri Andivan-Anderson, Roseann Auchstetter, Marcia Blomeke, Cynthia Brubaker, the late Gene Combs, Glenn Curtis, Kim Dadlow, Barbara Davidson, Richard Davis, Dale Drake, John Dugger, John Fierst, Camille Fife, Harold Furr, Lisa Gehlhausen, Jim Gibson, Edith Ham, Fred Holycross, Helen Horstman, Mary Johnson, Michael Kelly, Frank Kish, Patricia Lewis, Phyllis Mattheis, Sam Mercantini, Ron Morris, Julia Moore, George E. Neeley, Patricia Powell, Pat Reed, Jennifer Reiter, Eric Rogers, Tom Salmon, Carolyn and Robert Schmidt, Charles A. Schreiber Sr., Martha Shea, Hugh Smith, Joann Spragg, John Stratman, Lisa Teeple, Alvetta S. Wallace, Phyllis Walters, Nancy Weirich, Wanda Willis, Barbara Wolfe, Roger Woodcock, Todd Zeiger, and Scott and Nola Zimmerman. The project, undertaken 1992–94, was supported by Historic Landmarks Foundation of Indiana, through a grant from the National Gallery of American Art, Smithsonian Institution, and the National Institute for the Conservation of Cultural Property.

Thanks again to Bill Gulde, Chair of the Social Studies Department of North Central High School, Indianapolis, for reading most of the manuscript and his very helpful observations and suggestions; to naval historian Brooks Rowlett, for reading much of the manuscript and providing useful, albeit occasionally arcane knowledge that aided in improving the accuracy of the material presented, and to Dr. Ralph D. Gray, Professor Emeritus of History, IUPUI, for reading portions of the manuscript and offering helpful editorial suggestions.

Of course, my gratitude to the Indiana Historical Society for awarding me the Clio Grant that helped to fund the research for this study, to Stephen Cox for his patience in awaiting the completed manuscript, to editors Paula Corpuz, Ray Boomhower, Kathy Breen, and Rachel Popma, and

to the late Robert M. Taylor Jr. for his belief in the project.

Thanks to J. Scott Keller, whose donation to this project was made in memory of Charlene Buchanan Keller.

Finally, thanks to Eric Grayson for driving around the state with me in the never-ending search for sculptures old and new and gone missing; for searching the Internet, months on end, seeking elusive resources on obscure artists; for taking my SOS! Files index and turning it into an invaluable database (kicking and screaming into the twenty-first century) that helped me in countless ways to interpret the material; and for unfailing support.

Elmer Harland (E. H.) Daniels created this tribute to Richard Lieber, Indiana's first Director of Conservation, in Turkey Run State Park.

Yesterday and Today
An Overview of Outdoor Sculpture in Indiana

WHAT IS THE SIGNIFICANCE OF OUTDOOR SCULPTURE? AFTER a few years most pieces become virtually invisible, blending into the landscape unnoticed. And yet most outdoor sculpture has much to tell about the place, the time, the values, the artist, the medium, and what or whom they might represent, as well as why, where, and by whom they were erected. Outdoor sculptures are three-dimensional historic and cultural documents.

Apart from the occasional ornately carved gravestone and possibly a few examples of religious statuary, there was little in the way of public outdoor sculpture in Indiana before the mid-nineteenth century. Henry Cross (1821–1864), a stone carver, fashioned three road-marker heads in Brown County in the early 1850s. One survives at a crossroads known on today's state maps as Stone Head, in honor of our oldest homegrown sculpture.

The surge in outdoor sculpture in public spaces began in the post–Civil War period. Monuments and memorials began to appear on courthouse squares and in prominent locations in cemeteries, many with at least one sculptured figure, if not several. The largest in the state is the Soldiers and Sailors Monument in Indianapolis, covered with large sculpture groups in stone and surrounded with oversize bronze figures. Statues honoring individuals appeared as well, where there were funds to support them. Commemorative images of town founders or people for whom a settlement was named, local heroes, and national heroes of the moment or of the ages began to appear with increasing frequency into the twentieth century. The practice continues to this day in remembrance of the past and in celebration of the present.

As settlements grew into towns and towns into cities, especially in the latter third of the nineteenth century, elegant churches ordered or commissioned religious figures for exterior display. Some of these were demolished, but one example that survives is Saint John Catholic Church in downtown Indianapolis. Above the entrance in high relief is *Saint John Pondering the Scriptures* by Joseph Quarmby. The limestone work dates to 1871. As the state began to experience increased waves of immigration, new populations erected familiar images of saints at their churches and cemeteries. Such images are found today among both rural and urban German Catholic parishes in southern Indiana and other pockets of the state, as well as among the later various ethnic groups from eastern Europe who poured into the urban areas and industrial centers of the north. These ethnic populations supported not only churches but also convents, monasteries, shrines, schools, and hospitals, all of which displayed figures of the Holy Family and any number of saints. More or less standardized religious statuary has continued to be erected into the present, with only the medium changing—the oldest pieces are most likely to be stone and later ones a metal alloy. Today's pieces are usually concrete or even fiberglass.

Artists continue to interpret traditional sacred themes or explore the concept of faith in new ways. David Kocka (b. 1950) of Harrison County, for example, has done numerous unusual statues of Saint Francis of Assisi that focus on his mysticism. Religious statuary is not, of course, limited to the Roman Catholic Church, although the vast majority of pieces in Indiana are associated with a Catholic institution. Cemeteries of almost any stripe very often are filled with angels and other religious figures, and some Protestant churches display the image of Christ and, occasionally, other religious personages. Indiana has many followers of other faiths, but none that display outdoor sculpture, although some synagogues of Reform Judaism do

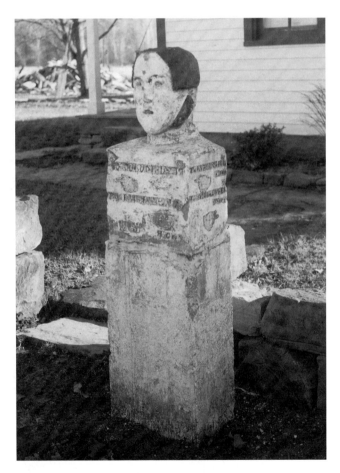

Indiana's earliest outdoor sculpture functioned as a road marker in the hills of Brown County.

A marble statue of the Virgin Mary (opposite page), astonishing for its eighteen-foot height, stands behind Ancilla Domini, the motherhouse of the Poor Handmaids of Christ near Plymouth.

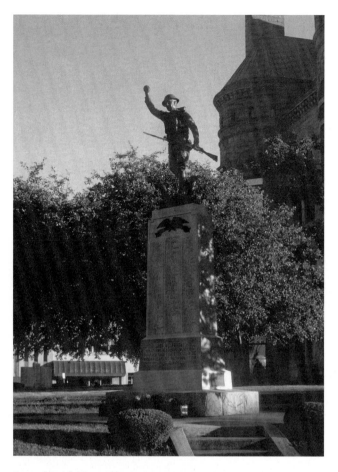

One of E. M. Viquesney's doughboys stands before the court-house in Hartford City.

Public buildings, reflecting community pride, tended toward elegant and ornate embellishments. This was especially true of opera houses and hotels of the late nineteenth century. Sadly, few of these survive, and often all that is left is the statuary that graced the facade, ranging from the so-called Lady of the Grand, a large terra cotta bust from the Grand Opera House in Evansville, to the many lime-stone portrait medallions of governors that once ornamented the English Hotel and Opera House in Indianapolis. The Lady is on permanent display at the Evansville Museum of Arts, History and Sci-ence, but the Indiana governors are scattered to the four winds, with many lost and several known to have been destroyed. Fancy opera houses evolved into the exotic movie palaces of the 1920s, such as

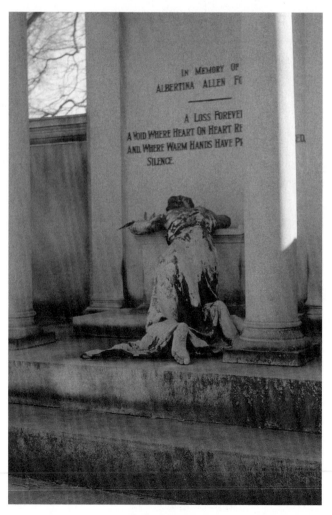

The Forrest monument in Crown Hill Cemetery in Indianapolis includes this poignant bronze figure by Rudolf Schwarz.

exhibit contemporary outdoor pieces. There is the occasional isolated abstract work with a spiritual theme, some more obviously so than others.

As architectural styles grew more elaborate in the decades after the Civil War, more buildings featured sculptural ornamentation. Courthouses in particular became extremely grand, and many were festooned with sculptures. Among the earliest was the Knox County Courthouse of 1874 with two limestone relief panels and marble statuary, but for jaw-dropping excess, it is difficult to choose between the former Vanderburgh County Court-house in Evansville and the Allen County Court-house in Fort Wayne. Each features continuous themes carried out around all four sides of the build-ing through related groupings of sculpture and friezes at the same level.

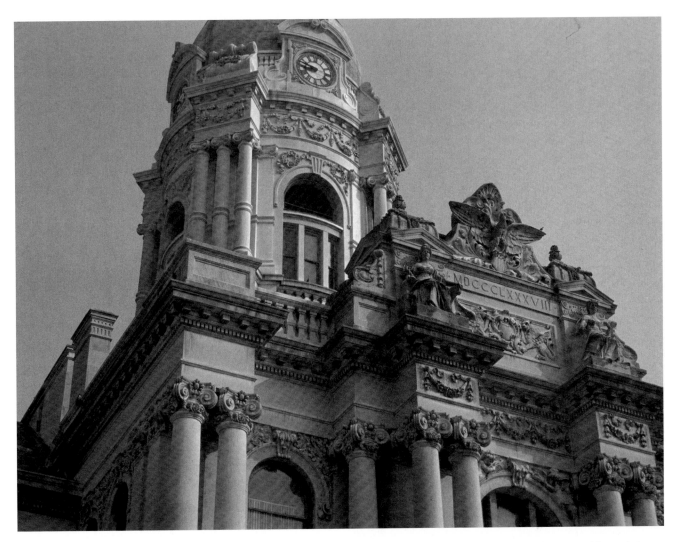

The former Vanderburgh County Courthouse, now home to various community and arts organizations, is covered in sculpture.

the terra cotta-clad Indiana Theater in Indianapolis, covered with sculptural ornament by Alexander Sangernebo (1856–1930).

As cities and towns established identities, besides fine civic structures and lovely parks, there came an increase in what might be called street furniture—attractive streetlights, for example, or resplendent fountains, such as the Depew Fountain in University Park in Indianapolis or the Poseidon Fountain in front of the Elkhart County Courthouse in Goshen. Elegant public gardens often included allegorical or purely decorative sculpture. The turn of the twentieth century saw a rise of women working in sculpture, and the fashion for decorative and beautiful pieces gave many of them

opportunities for work, since few women were awarded commissions for large commemorative pieces. (Some, such as Terre Haute native Janet Scudder [1869–1940], refused even to do that sort of work, believing that there were already too many big bronze men standing about.)

The rise of public art in the 1930s, aided by a number of New Deal programs, was one of the earliest responses to the clamor that art was for the people, not simply for well-informed aesthetes. In Indiana this resulted in many murals in post offices and the like, but as there were a number of unemployed stone carvers in the southern part of the state, some small but lovely pieces of sculpture, primarily done in relief, were also created.

The movement faded in the 1940s as Hoosiers, along with the nation, were fighting World War II and afterward reestablishing a normal life. New ideas were afoot in the art centers of the East, but it took a while for them to reach Indiana. No abstract public sculpture appeared in the state until about 1960, in isolated hothouses such as New Harmony and on college campuses. The seeds took root, though, and many large abstract works livened the landscape by the 1970s. Art museums, such as the Indianapolis Museum of Art (IMA) and the Evansville Museum of Arts, History and Science (Evansville Museum of Arts and Sciences), began to assemble permanent collections of outdoor pieces. Robert Indiana's (b. 1928) *LOVE* became the IMA's signature piece—although it has been moved around a number of times. Several corporations began to sprout sculpture outside their headquar-

ters, and some even began corporate collections, most notably Lincoln National in Fort Wayne. Corporate funds also helped the cause of public sculpture in civic spaces. The shining example is Columbus, world famous for its modern architecture, which is accompanied by equally modern sculpture. The city's most renowned piece is probably Henry Moore's (1898–1986) *Large Arch*.

New movements for public art began to surface in the 1960s, and by the next decade many Hoosier sculptors found work through the Comprehensive Employment and Training Act (CETA) and grants from the Indiana Arts Commission, funded by the National Endowment for the Arts. These programs often had sculptors teaching classes and creating permanent public art, such as the large Cor-Ten steel piece *Skopos* in Mill Race Park in Columbus. Although government funding for art has dwindled the past few decades, in many cases corporate funding has taken its place. A more recent trend is community and collaborative art, which relies upon a preponderance of private resources—cash as well as donated materials and labor. This concept has worked especially well when schools are involved. An artist works with the children, the parents, and community organizations, creating a piece of permanent contemporary art that has a sense of place.

There have always been Hoosier sculptors, dating back at least to the stone carver Henry Cross, and many stayed in Indiana without starving—with the exception of Rudolf Schwarz (1866–1912), the master of bronze memorials, who did. A great many sculptors are working in Indiana today, many of them more or less making some sort of living with their art. The range and variety of styles pursued by these creative souls is beyond description. Some choose traditional methods and produce exquisite pieces that are not so far removed from the best of a hundred years ago. Others experiment constantly with new styles, new forms, and new media. Fiber optics, for example, are now a component of some recent pieces around the state.

There is a lot of enthusiasm for art in public places today, and it may be the result of several sym-

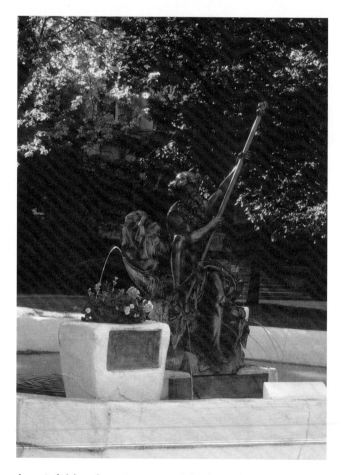

A grateful immigrant presented Goshen with this Poseidon Fountain in 1912.

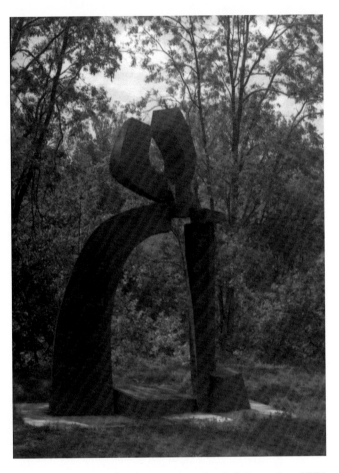

Skopos by Richard (Ric) Bauer was funded through a CETA program in Columbus.

biotic trends. There is the idea of community art, often in celebration of an event. A number of public sculptures resulted from a desire to celebrate the passing of the Millennium, for example. Community art is also a means of expressing the identity of a place, as does the new fountain-sculpture-timeline in downtown Batesville. There is no limit today where contemporary sculpture might be found, from a park in Connersville to the exterior walls of the new Indiana State Museum. People are likely to see outdoor sculpture on display as they go to meet a plane (South Bend Regional Airport at South Bend) or as they take an evening stroll (old Washington Street bridge in Indianapolis). Sculpture on demand is available through design companies rather than from an individual artist. Is such work good, and is it art? If it is art for the masses as opposed to art for art's sake, is it less valid? The

debate has gone on for centuries, and it will not end here in Indiana. And as more art of whatever merit comes before the public eye, it may gain a place in the consciousness of the average Hoosier.

Julie York Coppens, former arts writer for the *South Bend Tribune*, agrees:

As hard as our museums work at outreach, and as creative as our independent gallery owners have become at making their spaces accessible to the casual viewer, and as brilliant as I find the work of so many of our own local artists, I'm afraid that actually getting people, regular people, into art spaces—and getting them thinking and talking about what they see—will always be an uphill battle. Too many just haven't made a habit out of it. And that, to me, is the genius of public art. An outdoor sculpture can capture that gallery experience—the joy of the unexpected, a moment of quiet contemplation, an opening for conversation—and take it to the streets, where we live and work and play. It's like a little (sometimes not so little) museum without walls, just waiting to be discovered. Each new one is a cause for celebration. Taken together, these artworks send a message that we as a community believe there's room in our urban landscape for something other than commerce. The more our cities and towns get mallified and homogenized, the more we'll need these one-of-a-kind landmarks to remind us who and where we are.

From Billy Yank to GI Joe
Sculptural Memorials to War and Peace

■

A STATUE OF A MILITARY FIGURE IN A PARK OR A CEMETERY MOST LIKELY SPRINGS TO mind when imagining a "public sculpture." With a few exceptions, carved or cast monuments commemorating the role of Indiana troops in the Civil War were the earliest outdoor sculptures erected in the state. Indeed, Hoosiers promptly raised one of the first Civil War monuments in the country, honoring the Fifty-eighth Indiana Regiment in

July 1865, less than three months after the surrender at Appomattox. A soaring shaft topped with a fierce eagle, the simple but impressive monument stands on the courthouse square in Princeton. In 1869 a similarly uncomplicated monument was erected in Noblesville's Crownland Cemetery, and twenty years later the Grand Army of the Republic (GAR) placed a gilded eagle on a pedestal at the military section in Crown Hill Cemetery in Indianapolis. Of the same period, an equally simple sculptured monument, featuring a plain cannon carved of limestone, is in the town cemetery at Gosport.[1]

A seated soldier rendered in stone atop a hill outside Greencastle was the first Civil War memorial in Indiana that featured a human figure. Dedicated July 2, 1870, in Forest Hill Cemetery, it is unique

in the state. The sculptor was Thomas D. Jones (1811–1882) of Ohio. In the 1880s more figurative memorials began to appear. Carroll County erected a bronze flag bearer on a tall pedestal flanked by relief panels in its courthouse square in Delphi in 1882.[2]

Erected by the local GAR post in 1883, Indiana's earliest sentry figure stands in Rose Hill Cemetery in Bloomington. The single sentry on a pedestal is the most common form for sculptural Civil War monuments, and Indiana boasts more than twenty-five around the state of various materials: bronze, limestone, marble, and a few of cast iron. An interesting phenomenon is the handful of granite sentries, all essentially alike, that are found only in northern Indiana, mostly in the top tier of counties. There is one in the town cemetery of New Carlisle, another in Middlebury, and still another placed on a substantial pedestal in the town of Saint Joe in De Kalb County. The southernmost site is in Wells County in the cemetery at Ossian. With one exception, the sentries

Erected in 1923, the War Mothers' Monument stands in Bloomington's Rose Hill Cemetery.

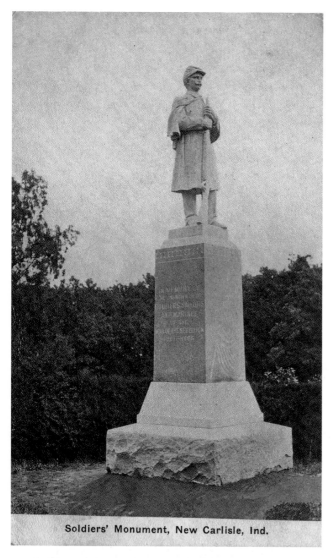
Soldiers' Monument, New Carlisle, Ind.

Dedicated in 1909, the Soldiers Monument in the New Carlisle Cemetery is one of several granite statues of Union sentries found only in northern Indiana.

were erected between 1909 and 1911. The two in South Bend's City Cemetery are within close proximity of each other and were erected by the same organization three years apart. The Norman Eddy Post of the GAR dedicated the first one in 1911 to "our unknown soldier and sailor dead." Vandals long ago rendered it headless, causing some viewers to assume it was intended to be so, to represent the "unknown." The second monument was dedicated in 1914 to the "memory of all who served the union."

Urged on by veterans, some highly impressive monuments were erected in the 1880s. In 1886 Howard County dedicated its Soldiers and Sailors

Monument in Kokomo's Crown Point Cemetery, featuring a flag bearer atop a high pedestal flanked by two life-size soldiers, all in granite. A year later Cass County installed the most magnificent Soldiers and Sailors Memorial up to that date in Logansport's Mount Hope Cemetery. Constructed entirely of limestone, it features a soaring shaft topped with a flag bearer and four life-size figures on the lower tier, representing Infantry, Cavalry, Artillery, and Navy. While this is Indiana's only such monument rendered in limestone, the format of the central figure on a high pedestal surrounded by the four military figures began to appear frequently, sometimes with interesting variations. Schuyler Powell sculpted this magnificent work, unfortunately damaged by vandals over the years.

A stunning work by Illinois sculptor Lorado Taft (1860–1936) was dedicated in Randolph County in 1892. The Soldiers and Sailors Monument stands on the northeast corner of the courthouse square in Winchester. Another Civil War-related work by Taft is in the National Cemetery adjacent to the Soldiers Home on the south side of Marion. Dedicated in 1915, the bronze piece is a smaller copy of his commemorative sculpture erected at Chickamauga Battlefield.[3]

The installation of Civil War monuments around the state increased dramatically in the 1890s, as veterans grew older and hoped their contributions would be remembered after them. Although many of these memorials were the ubiquitous sentries, their pedestals were growing ever higher and more ornate. Jasper's courthouse square features a white bronze (a zinc alloy) figure atop a mausoleum-like structure intended for relics pertaining to the companies formed in Dubois County. The monument includes a poignant relief commemorating two soldiers from the nearby village of Celestine. German immigrant Nicholas Kremer and his American-born son John both died the same day in May 1863 in the Battle of Champion Hill in Mississippi, an important part of General Ulysses S. Grant's Vicksburg campaign. Local stonemason and architect Michael F. Durlauf created the monument, which was dedicated with great ceremony in 1894.[4]

In 1893 Michigan City erected a particularly grand monument, rising sixty-two feet in the newly created Washington Park on the shore of Lake Michigan. It depicts Peace (often interpreted as Liberty) standing high on a soaring column, with beautiful bronze reliefs around the base, showing scenes of departure, battle, and homecoming. The Muldoon Monument Company of Louisville, Kentucky, constructed the stately monument. The bronze works are the joint design of New York sculptors William R. O'Donovan (1844–1920) and J. Scott Hartley (1845–1912). The Soldiers and Sailors Monument was a gift to the city from John H. Winterbotham (1813–1895), a prominent local businessman and sometime state senator. Erected that same year in Fort Wayne is a bronze monument featuring a standing Liberty in the act of placing a laurel wreath upon the head of a kneeling soldier. It was cast in Philadelphia, but the origins of the statue are obscure. The local chapter of the GAR placed the allegorical monument north of downtown in what later became Lawton Park, where today it is scarcely noticed. High-speed automobile traffic makes it difficult even to pull into the park for a look.[5]

The GAR veterans group, begun in 1866, grew more active toward the end of the nineteenth century. The organization often instigated movements to create permanent memorials, and its signature medal is cast or engraved on the base of many Civil War statues. The GAR spurred the building of not only sculptural monuments but also large memorial halls. In Wabash the entrance to the GAR Hall (now the county historical museum), built in 1899, is flanked by painted cast-iron figures representing a soldier and a sailor of the Civil War era. Two iron soldier figures of the same vintage but clearly a different casting guard the Commandant's Home at what is today called the Indiana Veterans Home north of West Lafayette.

The most imposing soldiers and sailors monument in the state—by far the largest in Indiana and believed to be the largest of its type in the nation—is in the center of Indianapolis. Directly because of it, Indiana is blessed with several other magnificent sculptural memorials. In 1897 Austrian-born sculptor Rudolf Schwarz (1866–1912) arrived in Indianapolis from Berlin to work on the monument that was to be erected on the Circle. Architect Bruno Schmitz (1858–1916), for whom Schwarz had worked in Germany, hired the sculptor to carve the huge limestone groupings on either side, representing *War* and *Peace*. Schmitz had designed the groupings: a furious battle scene complete with a martial goddess surrounded by the fray to depict war; Liberty, holding the flag amidst returning soldiers and a slave brandishing his broken chains, to symbolize peace. Schwarz made adaptations to the designs and

The Soldiers and Sailors Monument in Indianapolis is the largest in the state.

augmented each with a related smaller (though still massive), more intimate scene below the large group, just above the fountain pools. His graphic *The Dying Soldier* underlines the horror of war; the heartwarming *The Return Home* shows a father throwing down his plow at the sight of his son arriving safely, while the mother is overcome with joy. He also carved the four heroic military figures at the entrances (Artillery and Navy on the north; Infantry and Cavalry on the south). The versatile Schwarz undertook much of the bronze work as well, designing all the bronze entrance doors.[6]

The bronze astragals were the work of other sculptors. Nicolaus Geiger (1849–1897), for whom Schwarz had worked in Berlin, created the army astragal that writhes with wounded and dying men and horses as well as weaponry. Geiger never came to Indianapolis, shipping his finished casting from Berlin. He died before the monument was completed. Twelve feet higher on the shaft is the navy astragal, with its bows of gunships pointing from each corner, the work of American sculptor George Brewster (1862–1943). He also designed the astragal displaying the dates 1861 and 1865 near the top, as well as the huge figure of Victory (sometimes identified as an allegorical figure of Indiana) that crowns the monument.[7]

The Circle was designed originally to provide a site for a governor's residence. The dwelling that had been built—and never used by any governor—had deteriorated and eventually gave way to a park. A bronze statue of Civil War governor Oliver P. Morton by Franklin Simmons (1839–1913) was erected in 1884. In 1895, with the monument under way, Welsh-born John H. Mahoney (1855–1919) was commissioned to create three more figures of the same size to commemorate Indiana's participation in the wars prior to the Civil War. Along with that of Morton, these statues were placed around the outer perimeter of the monument. Bronze and of heroic proportions, the figures of George Rogers Clark, William Henry Harrison, and James Whitcomb represent Indiana's role in earlier conflicts: the Revolutionary War, the War of 1812 and related Indian wars, and the Mexican War.

After Schwarz's work on the Soldiers and Sailors Monument was completed, he stayed on in Indianapolis, working in a shack behind a local brewery until friends and patrons contributed the funds to build him a modest new studio nearer to his home. Schwarz became enamored of the "lost wax" process of bronze casting, which he did himself. Since oftentimes the first casting did not succeed, and Schwarz did not allow for that factor in pricing out his work, he not only failed to realize any profit but also was usually deeply in debt. In 1902 he was awarded the commission for a massive statue of Michigan governor Hazen S. Pingree to be erected in Detroit. The resulting sculpture was the first bronze work cast in Indianapolis by the lost-wax method.[8]

Schwarz's next commission, awarded in 1902, was in South Bend. The city's Soldiers and Sailors Monument features Schwarz's flag bearer at the top, plus the four military figures around the base. Montgomery County hired him the following year. For the monument in Crawfordsville Schwarz created two flanking figures with Liberty perched on the pedestal. Next Schwarz completed the bronze work on the Vawter Memorial (named for its donor, John T. Vawter) in Franklin, dedicated in 1905. The Franklin monument is topped by a slouch-hatted soldier carrying a rifle and shading his eyes, very similar to his cavalry figure for Indianapolis's Soldiers and Sailors Monument. The monument is also a fountain, with water-spewing lions similar to the bison that surround the monument in Indianapolis. The only commission on which Schwarz actually made money was a heroic figure of Morton, guarded by two Union soldiers and flanked by two small but exquisite relief panels. One shows Morton exhorting the troops; the other shows a battlefield hospital in painful detail. This monument, prominently placed before the east entrance of the state capitol, was dedicated in 1907.[9]

Schwarz received commissions for four more soldiers and sailors monuments in Indiana, each with Liberty or a flag bearer at the top of a tall shaft flanked by the four military figures. Posey County's monument in Mount Vernon (1908) is topped with Liberty; Terre Haute's (1910) with a flag bearer.

Schwarz died in poverty in April 1912, having just started to work on the figures for Knox and Gibson counties. On November 12, 1912, nearly fifty years after the first Civil War monument was erected in Princeton's courthouse square, the GAR installed a larger, more ornate memorial with bronze figures by Schwarz. Two years later the Soldiers and Sailors Monument in Vincennes was dedicated. It is unclear who did the actual casting, since only the designs were completed at the time of Schwarz's death. The monument includes a substantial vault in the base to house artifacts. Unfortunately, the space sealed off neither water nor vermin, and most of what was placed inside ultimately deteriorated beyond repair.[10]

While Schwarz was responsible for the majority of the larger Civil War sculptural monuments in the state, there are others worth noting. In 1908 Norwegian-born Sigvald Asbjorsen (1867–1954) sculpted a wonderful bronze grouping for Jefferson County's Soldiers and Sailors Monument in Madison. Here the four representative military figures are clustered together with the sailor holding the flag. The Soldiers Monument in Angola, dedicated in 1917, is a slender soaring shaft rising eighty-five feet, topped with a figure of Columbia and with the four military figures, including the sailor, surrounding the base. Steuben County did not contribute any sailors to the Union cause, however—hence the name of the memorial. The figures, which are sheet bronze, came from the W. H. Mullins Company in Salem, Ohio.[11]

George Honig (1874–1962) was a Rockport native who sculpted numerous small bronze reliefs with historical scenes and personages around southwest Indiana and also created the Lincoln Pioneer Village, the state's first living history museum, in his hometown. Honig did his most monumental work in 1916: two heroic groupings flanking the entrance to the Soldiers and Sailors Coliseum in downtown Evansville. The *Spirit of 1865* and the *Spirit of 1916* represent, respectively, victory for the Union and the reflective elderly veterans of that conflict. Only a few years before, in 1909, the GAR had erected a

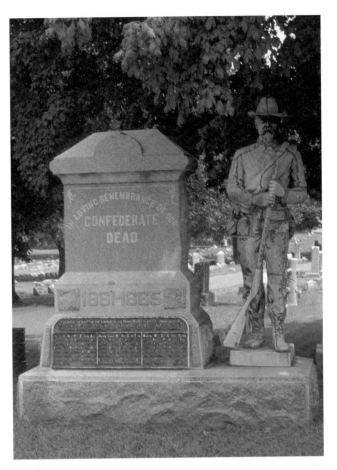

In Evansville a statue of a Confederate soldier marks the burial place of prisoners of war who died while interned.

memorial featuring a sentry, a sheet-bronze figure from the Mullins company, in Oak Hill Cemetery on the city's north side. Perhaps they felt compelled to do so by the installation five years earlier of what may be one of Indiana's most surprising Civil War memorials—erected by the Evansville chapter of the Daughters of the Confederacy—the Confederate soldier commemorating the prisoners of war buried in Oak Hill. The statue may also have been procured from the Mullins company, as it offered commemorative figures for both sides.[12]

The popularity of the sentry figures continued, peaking in the 1910s, with flag bearers also being popular. Then came World War I, the war to end all wars, and although it introduced a new round of war memorials that featured the doughboy, Civil War monuments continued to appear throughout the next decade or so. Lawrence County elected to

add pioneers into the mix of soldiers and sailors for its monument erected in 1923 on the courthouse square in Bedford. Funded with a legacy left by prominent judge Moses Fell Dunn, the monument, the work of Charles Dodd, commemorates both the Civil War and World War I in carved relief panels on the west and east, respectively. Pioneers are remembered on the north panel, and the south panel is dedicated to peace through labor. The heroic figure atop the pedestal is that of an allegorical "Miss Indiana," which stands more than fourteen feet high. The dedication of the Pioneers, Soldiers, and Sailors Monument took place on January 13, 1924. Nevertheless, winter did not prevent the typical celebration with speeches and music, in this case from several combined choirs.[13]

In the courthouse square in Bloomington, the Alexander Memorial, erected in 1928, commemorates soldiers from Monroe County who fought in the Mexican War, Civil War, Spanish-American War, and World War I. The impressive limestone monument is named for its chief donor, Captain W. M. Alexander. Designed by renowned architect George W. Bunting, the memorial features reliefs around the sides, each specific to one of the wars, which were executed by master carvers Albert V. McIlveen and Joseph Graf. Some of them have succumbed to decades of weathering and are barely discernable. The monument is topped with an eight-foot Union sentry.[14]

The sentries soldiered on through the 1920s. The last sculptural Civil War monument in Indiana—erected by the GAR in 1931—is a marble sentry in Shelbyville. Towns that lacked the money or the inclination to erect statues commemorating Civil War veterans found other ways to honor them. There are countless plaques and tablets throughout the state. Discontinued Civil War-era artillery began to appear on courthouse lawns and as adjuncts to memorial sites and statues. Some of these pieces can still be seen today, although unfortunately much rusty nineteenth-century ordnance was donated to World War II scrap drives. Lest the citizens of Kosciusko County forget, though, a replica of their

sacrificed Civil War cannon was fashioned in limestone and placed on the carved stone base that once held the real thing. The original base with its pseudo-cannon stands on the edge of the courthouse square in Warsaw, where it appears to be largely ignored.

Indiana has a handful of individualized variations of the Civil War monument that consist of commemorative sculptures of heroes or the occasional common soldier. Erected in 1910, a heroic bronze figure of Major General Robert H. Milroy (1816–1890), who commanded the Ninth Indiana Regiment, stands on the south side of Rensselaer, where the general lived for several years. The work was that of Mary Washburn (1867–1965), one of several women sculptors working around Indiana in the early twentieth century. Seldom were women awarded such large commissions, but Washburn, a Rensselaer native, had the hometown advantage. She also donated her labor. Chicago sculptors Lorado Taft and Charles J. Mulligan (1866–1916) both praised her work.[15]

About 1877 John Mahoney sculpted a large marble figure of Major General Solomon Meredith (1810–1875) that stands above his grave in Riverside Cemetery at Cambridge City. General Lew Wallace (1827–1905), probably better known today as the author of Ben-Hur and other novels, was rendered in bronze in 1910 by Andrew O'Connor (1874–1941). It stands at the General Lew Wallace Study in Crawfordsville. Wallace, hatless and with his uniform coat open, appears as if he has just stepped out of his tent into the wind. Another casting of the same statue stands in the National Statuary Hall Collection in the Capitol in Washington, D.C.

On the other end of the scale are statues marking the individual graves of Civil War soldiers, such as the Bryan monument outside Arcadia. A stalwart marble sentry commemorates Jacob A. Bryan's status as a Civil War veteran, although he died in 1916, more than fifty years after the war. A similar rendition in limestone marks veteran John D. Laughlin's grave in rural Martin County. When he died in 1900, his grave site surely qualified as a public place, but it has long since been encompassed by the

Crane Naval Surface Warfare Center.[16] Veteran Levi Price died in 1910; nevertheless, his grave in Linton's Fairview Cemetery is guarded by a life-size granite statue of a bearded Union soldier. The most poignant of these, surely, is the grave marker of Captain Samuel Edge in Waterloo. A rude stone carving by an unknown artisan, the stumpy little statue has been vandalized and is badly weathered.

The Spanish-American War, over almost before it began, inspired a few memorials, most in the form of bronze plaques that today few people know exist. The plaques, generally bolted to large granite rocks that the glaciers left behind, often feature reliefs, nearly always including the storied battleship USS *Maine*. A person can stumble on these quite by accident. One is mounted on a rock in front of Michigan City's Lighthouse Museum; another is in the middle of Columbian Park in Lafayette. Still another is largely forgotten in Beech Grove Cemetery in Muncie. Likely there are others, but Indiana appears to have no major sculptural memorials of this war.

There are, however, two statues of one of its martyrs, Major General Henry W. Lawton (1843–1899), who spent part of his youth in Fort Wayne and was a student at Fort Wayne Methodist Episcopal College. Lawton left school to fight in the Civil War and was awarded the Congressional Medal of Honor for his actions during the Battle of Atlanta in 1864. His decades-long military career was ended by a sniper's bullet in the Philippines in 1899 in the turmoil following the Spanish-American War. The first statue, erected in Indianapolis only eight years after Lawton's death, was dedicated by President Theodore Roosevelt. Placed at the southwest corner of the courthouse square not far from the curb, the bronze figure had been created by Andrew O'Connor in 1906 and exhibited at the Paris Salon that year. A somewhat stern Lawton, heroically sized at over eight feet, wears a pith helmet and gazes into the distance. Less than a decade later, the statue was moved to Garfield Park on the south side of the city. With the rise of the automobile, it had become a traffic hazard. The second statue of Lawton, a

heroic bronze figure by Frederick C. Hibbard (1881–1950), stands in Lakeside Park in Fort Wayne. Dedicated in 1921, this statue depicts Lawton holding a slouch hat at his right side.[17]

There is only one grave in Indiana that features a portrait statue of an ordinary soldier in the Spanish-American War. John W. Shaw, who was killed in action in the Philippines in 1900 at the age of twenty-three, is buried in a small rural cemetery near the village of Westport in Decatur County. Sadly, the limestone statue, vandalized decades ago, is in pieces.

World War I brought a new wave of commemorative statuary to Indiana, even as more Civil War monuments continued to be dedicated throughout

This unobtrusive memorial to the Spanish-American War stands in the middle of Columbian Park in Lafayette.

the 1920s. Once again, Indiana leaped to the forefront, boasting one of the country's first World War monuments, dedicated on Armistice Day 1919 in Carlisle. An impressive if not particularly artistic monument, it consisted of two concrete figures representing a soldier and a sailor standing on a large pedestal. Only the pedestal remains today. The sailor has disappeared, and the soldier was last seen chained to a tree several blocks from the pedestal, presumably for safekeeping.

Several stalwart doughboys in a variety of media stand stiffly throughout the state. The Gold Star Mothers of Michigan City raised funds to erect a bronze doughboy in Washington Park, dedicated in 1926. The World War Memorial on the courthouse square in Rockville has a limestone doughboy by Theodore F. Gaebler, dedicated in 1930. Another limestone doughboy stood for many years in Wilson Park in Bedford, a gift to the city from the local post of the Veterans of Foreign Wars. Vandals repeatedly damaged the monument, resulting in its removal in the late 1970s. There is even one at the Indiana Boys School outside Plainfield, carved in limestone by some talented but now forgotten inmates about 1922 as a World War Memorial to those boys from the reformatory "who rendered valiant service in the World War."[18]

Stone doughboys mark a handful of graves of World War I soldiers and are intended as portraits. In an isolated cemetery near Patricksburg a stalwart

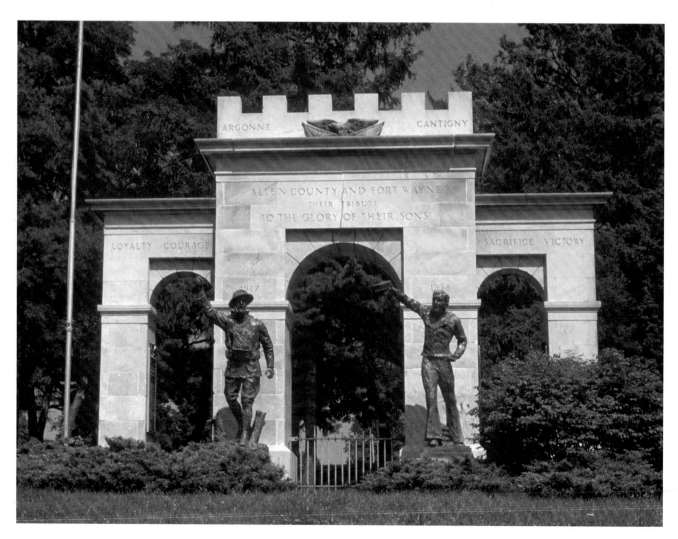

The impressive World War Memorial in Fort Wayne includes E. M. Viquesney's *The Spirit of the American Navy* as well as his better known *The Spirit of the American Doughboy.*

soldier stands atop the grave of Carl H. Kaiser, who died in France at the age of twenty-seven. Kaiser was among the many casualties of the war who died of pneumonia. In Pleasant View Cemetery northeast of Bloomington, another limestone doughboy marks the grave of the Riddle brothers. Thomas F. Riddle (1895–1919) returned home from the war only to succumb to influenza. While his funeral was in progress, word reached his family that his brother Raymond (1897–1919) also had died of influenza. Perhaps most poignant of all is the grave of Michael Wallner in Bedford, who was wounded by shell fire in the Battle of Soissons in July 1918 and was hospitalized until his death in 1940. Famed local artisan Frank Arena designed the statue, which Fred Edler carved in 1942.[19]

The War Mothers Monument in Bloomington's Rosehill Cemetery, erected in 1923, shows a bronze doughboy on the move, leaning forward and running, rifle in hand. The fourteen-foot pedestal of the monument is a tribute to the stone carver's art and resembles a Greek temple. But by far the most artistic—and most prolific—rendition of a World War I soldier was the work of Owen County native Ernest Moore Viquesney (1876–1946). A wonderfully life-like figure, *The Spirit of the American Doughboy* depicts a soldier running across the barbed wire of no-man's-land, yelling with bayoneted rifle in his left hand and a grenade ready to be thrown from his right hand. The detail is complete down to the hobnails on his combat boots. Eleven of these figures dot Indiana town squares and cemeteries, including Viquesney's hometown of Spencer, where the statue graces the courthouse lawn. Viquesney apparently had no intention of living the life of a starving artist, and he vigorously marketed his works, offering scaled-down versions for home or office. He even put together fund-raising plans geared to organizations that wanted to erect a memorial and included plans for various types of pedestals. The pedestals run the gamut in Indiana from an earthen mound to the impressive triple-arched limestone monument in Memorial Park in Fort Wayne, which also includes Viquesney's *The Spirit of the American Navy*, a com-

panion piece to the doughboy.[20]

The most magnificent tribute to the veterans of World War I is in Indianapolis, where Henry Hering (1874–1949) designed the sculptures for the World War Memorial, based on one of the Seven Wonders of the Ancient World, the tomb of King Mausolus at Halicarnassus, Turkey. The huge limestone building is surrounded by allegorical sculpture, culminating in *Pro Patria,* a twenty-three-foot-high male figure strategically draped in a flag. Restored, along with the rest of the memorial in the late 1990s, the bronze statue stands majestically on the south steps leading up to the building.

As with earlier wars, there are many nonsculptural tributes to veterans of the Great War. Tablets and plaques too numerous to count honor the veterans. An especially popular commemoration of this particular conflict was the memorial grove, most often planted in oak trees.

While there are many memorials to the veterans and casualties of World War II, few of them are sculptural. Viquesney lived long enough to create *The Spirit of the Fighting Yank* celebrating the American GI, but these were never as popular as his World War I figure. Indiana has one, dedicated in 1944 while the war still raged, in the courthouse square in Bloomington. Oddly, the life-size soldier is rendered not in bronze but in limestone—the more suitable for its location in quarry-laden Monroe County. Two years later Viquesney, despondent after the death of his second wife, committed suicide.[21]

Much discarded World War II armament has found its way to the grounds of VFW and American Legion posts. But the American Legion post in Montpelier chose to honor its veterans with a statue rendered in concrete by W. A. Hoover. The rarity of sculptured GIs adds to this figure's significance. Both in style and material, the statue bears some similarity to its World War I counterparts erected in Carlisle in 1919, and like those, was dedicated very soon after the war's end in 1945.

A very unusual World War II memorial is almost all that remains at the former Seven Dolors Shrine northwest of Valparaiso. There, Hungarian sculptor

Eugene Kormendi (1889–1959), in residence at the University of Notre Dame, created a Pietà figure, substituting a GI for the figure of the dead Christ in his mother's arms. The dramatic work was erected in 1946.

The fiftieth anniversary of Camp Atterbury, established in 1942 as a military post to support World War II, was celebrated in part with the installation of a permanent memorial that included a heroic bronze statue of a GI, titled *On Point*. The soldier holds a rifle while he points forward into the distance. The work of sculptor Alexa K. Laver, the statue stands in front of a wall lined with the insignia of all the divisions and other groups that were deployed from Camp Atterbury. The memorial is part of a larger park filled with military vehicles.

For decades the soldiers who gave their lives to the Korean War were remembered only with tablets and plaques, usually as adjuncts to existing war memorials. In more recent years some sculptural monuments have appeared. Indeed, fifty years from the day of the event, a Korean War Medal of Honor winner from Vigo County was honored with a life-size bronze statue, the work of local artist Bill Wolfe, on the courthouse lawn in Terre Haute. The local chapter of the Marine Corps League raised the funds in 2001 to erect the statue of Corporal Charles G. Abrell, depicted in full battle gear. Abrell died in combat, sacrificing himself so his unit could advance. For a setting near the Ohio River in downtown Evansville, Kentucky sculptor Steve Shields (1947–1998) created a heroic work in 1992 of two GIs helping their wounded comrade to safety. The hell of war, not the glory implied by the bold sentries or the charging doughboys of the past, is all the more apparent in a work such as this. Similarly, Indianapolis-born sculptor William Arnold, widely known for his amazingly lifelike animals fashioned

The World War II Memorial at Camp Atterbury in Johnson County includes a bronze statue of a GI.

Its figures formed entirely of twisted wire, this memorial honoring Korean War veterans stands in Oaklandon's Veterans Park.

from bundles of wire, was commissioned in 1995 by the Indiana Chapter of the Chosin Few, an organization of veterans who fought in the Battle of Chosin Reservoir in November 1950, to create a memorial. From a distance the sculpture not only appears to be solid, but it also almost seems to breathe. Only as the viewer continues to approach the piece does it become obvious that it is sculpted entirely of wire. The three figures depict a wounded soldier receiving treatment from a medic on the battlefield as another soldier stands guard. It is located in Lawrence Veterans Park outside the town of Oaklandon in Marion County, which had been farmland only a few years before the sculpture memorial was dedicated.[22]

The divisive Vietnam conflict inspired few memorials of any kind for a time, and those that

finally began to appear generally did not include sculpture. Indeed, most war and veterans memorials erected in the latter half of the twentieth century—if they went beyond the tablet or obelisk—were more architectural than sculptural in nature. Eventually time healed some of the wounds, and communities began to make an effort to honor Vietnam veterans, perhaps motivated by the installation in 1982 of the controversial Vietnam Veterans Memorial in Washington, D.C. The Saint Joseph County Vietnam Veterans Memorial in South Bend, dedicated in 1989, is an abstract work, but it seems to suggest an exploding shell. The work of Jed Eide, it is entirely of granite and eleven feet high, placed across the river from downtown in Howard Park. Two years later the Monroe County Vietnam Veterans Memorial was

dedicated in Bloomington on the courthouse square, already crowded with several other sculptures, including a peace monument. The Vietnam Memorial, designed by Tony Grub, was clearly influenced by the wall in Washington, although there are additional elements, including a wind chime. The work seems to straddle the line between architecture and sculpture.

Less difficult to label is the Vietnam Veterans Memorial erected in 1988 in Terre Haute, the first *representational* monument of this conflict in the state. The memorial, on the courthouse grounds, includes a figure of a soldier carved in limestone by Robert Crotty of Rosedale, Indiana. Unfortunately, the memorial is located along busy US 40 where

there are few pedestrian passersby; the traffic makes it difficult to view it from a vehicle, and parking is prohibited along the highway. Thus, while the location is prominent, it discourages proper appreciation of the memorial.

The isolated site in Darrough Chapel Park on the eastern edge of Kokomo, far from downtown, also might have seemed to be a poor choice of location for a memorial. The citizens of Kokomo, nevertheless, seek it out, and it is seldom that the site lacks visitors. Indeed, the memorial immediately became a focal point for expressions of solidarity and patriotism. When the USS *Cole* was bombed by suicide terrorists in October 2000, the new monument, dedicated only the month before, became a

The Vietnam Veterans Memorial in Terre Haute was the first in Indiana to include the figure of a soldier.

place for people to come to demonstrate their grief and support. The memorial centers on a life-size bronze statue by Marine artist John Chalk. *The Clasping Hand* depicts a Vietnam-era soldier in fatigues and all his battlefield gear kneeling forward and reaching out as if to shake someone's hand. Unlike most sculptures, which are intended to be hands-off, this one encourages the viewer to grasp the outreached hand.[23]

It may come as a surprise to learn that Indiana boasts a sculpture honoring the veterans of Operation Desert Shield and Desert Storm, located near the Civic Center in downtown Evansville and dedicated in 1993. The work of Steve Shields, who had created the city's Korean War Memorial on the riverfront the previous year, it bears the distinction of featuring both a male and a female combat soldier, larger than life, each equipped with a gas mask and the other paraphernalia necessary in that conflict.

An ambitious project commemorating those who fought in wars of the twentieth century has come to fruition in Lake County in Munster. The Community Veterans Memorial, completed in 2003, is set in an eight-acre park. Five separate sections display sculptured tableaux and reliefs in bronze for each of the century's five conflicts in which Americans fought: World War I, World War II, the Korean War, the Vietnam Conflict, and Operation Desert Storm. The figures are the work

Evansville boasts the first war memorial in the state to include the figure of a female soldier, honoring veterans of Operation Desert Shield/Desert Storm.

of husband-and-wife sculptors Omri (b. 1954) and Julie (b. 1958) Rotblatt-Amrany of suburban Chicago.[24]

As the Civil War was the impetus for many of Indiana's first public sculptures, it was an appropriate place to begin an examination of commemorative military sculpture. However, America participated in a number of wars before that, and Indiana was involved even before it became a state. A statue commemorating a veteran of the Revolutionary War stands in a tiny cemetery in Sullivan County outside Hymera. On the grave of Nathan Hinkle, who died in 1848 at the age of ninety-nine, is a Revolutionary War soldier carved in limestone. It was erected about 1904 in honor of Hinkle's service. Certainly Hinkle

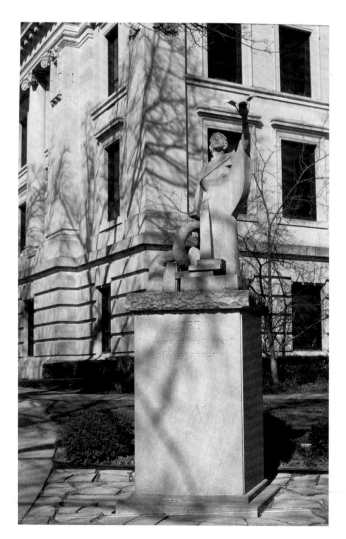

In a courthouse square filled with war monuments, William T. Dahman's *Congregations for Peace* stands out.

is not the only veteran of the Revolutionary War buried in Indiana, but his grave is the only one marked with a statue. The hero who captured British-held Fort Sackville at Vincennes in 1778, George Rogers Clark, represents Indiana's participation (even before there was an Indiana) in the Revolutionary War. Depicted urging his bedraggled band of soldiers onward, the figure of Clark, sword upraised, stands among the bronze statues that rim the Indiana Soldiers and Sailors Monument. As earlier noted, it was created by John Mahoney.

Of course, the George Rogers Clark Memorial in Vincennes should be noted, although the wonderful heroic statue of Clark by Hermon A. MacNeil (1866–1947) is inside the memorial.

Anthony Wayne (1745–1796), the celebrated general of several wars with the Native Americans—not to mention the person for whom Fort Wayne is named—is commemorated in Indiana's only heroic equestrian statue. The huge bronze work—twenty feet high—was created by Chicago-born George Etienne Ganiere (1865–1935) and dedicated in 1918. Originally it stood on a ten-foot base in a different location. When it was moved to its present site downtown in Freimann Square, the statue was inappropriately placed at ground level, where too often a child will climb onto the upraised foreleg of the horse. Not only is the sculpture jeopardized by its easy accessibility, but its impact is reduced, since the artist intended the piece to be seen from below.

William Henry Harrison was Indiana's first territorial governor, and his house, Grouseland, still stands in Vincennes. He remains best known, however, for his victory in the Battle of Tippecanoe, which, even though it took place in 1811, led into and is essentially considered part of the War of 1812. A heroic statue of Harrison is part of the Battle of Tippecanoe Monument at Battle Ground. Mahoney's bronze statue of Harrison in military attire also represents Indiana's role in the War of 1812 at the Soldiers and Sailors Monument in Indianapolis.

Veterans' memorials today reflect the new face of war. When Carmel dedicates its Veterans Memo-

rial in 2005, it will display two bronze figures—a male and a female—only the second such sculpture in the state. The artist is Bill Wolfe of Terre Haute.

Decatur, the seat of Adams County, makes claim to having erected the world's first Peace Monument in 1913, ironically only a year before the beginning of World War I. The sculptor was Irish-born Charles J. Mulligan, head of the sculpture department of the Art Institute of Chicago. Succeeding decades brought us no closer to lasting peace, but the divisive conflict in Vietnam inspired another attempt at a monument to the concept. *Congregations for Peace,* a work by William T. Dahman dedicated in 1979, took its place on the grounds of the Monroe County Courthouse, where it is outnumbered by three other memorials to various wars.

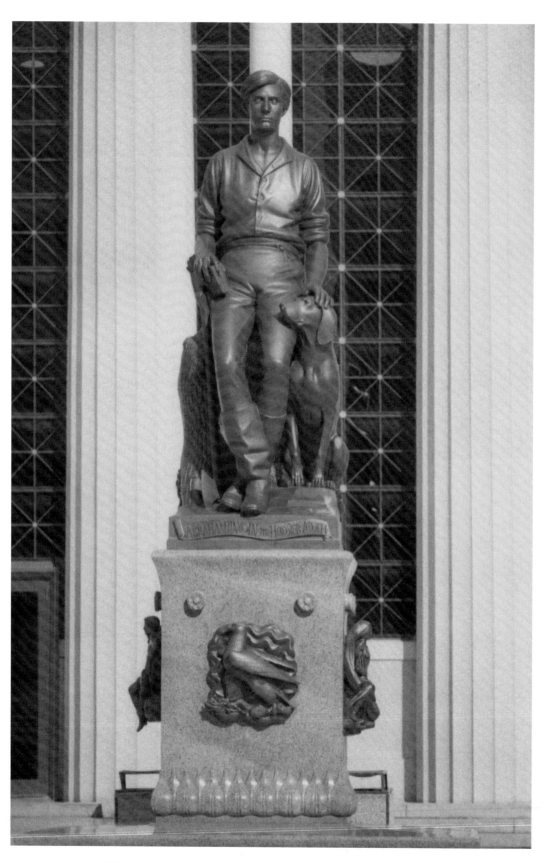

In downtown Fort Wayne, Paul Manship's *Abraham Lincoln, the Hoosier Youth* portrays the future president resting dreamily beside his hound.

Movers and Shakers and Monument Makers
Effigies of Heroes and Archetypes

T OWARD THE END OF THE NINETEENTH CENTURY, ALONG WITH ALL THE WAR MEMO-rials, Indiana communities began to honor other sorts of notables with various graven images. These include national heroes, especially those with an Indiana connection—Abraham Lincoln being the most obvious—and Hoosier leaders who made an impact on the national scene. Local men, and occasionally, women, are well represented, along

with regional heroes and town namesakes. There are also statues honoring anonymous groups. Some have become three-dimensional historic documents of forgotten people or forgotten times. Portrait gravestones are yet another form of commemorative sculpture.

Along with Kentucky and Illinois, Indiana claims Lincoln as its own, touting the fact that Lincoln spent his "formative years" (ages seven to twenty-one) in Indiana. It is no surprise to find numerous sculptural images of the sixteenth president, including some depicting him as an adolescent. Minnesota-born sculptor Paul Manship (1885–1966), most famous for his work at Rockefeller Center in New York, created *Abraham Lincoln, the Hoosier Youth* in 1932. The huge bronze image, over twelve feet in height, was commissioned by and stands in front of the Lincoln National Life Insurance headquarters in Fort Wayne. Another quite different image of the young Lincoln is a nine-

foot bronze that stands west of the statehouse on the north side of the Government Center South in Indianapolis. *Young Abe Lincoln* was originally dedicated in 1969 southeast of the older State Office Building and moved to its present location when the new building opened to the south. Indiana sculptor David K. Rubins (1902–1985) pointedly made the hands and feet proportionately larger than normal, and the figure is rough-hewn, suggesting something of the rawness of the frontier state that molded him.

Indiana has two seated Lincolns, both erected in the 1930s. Wabash-born lawyer and philanthropist Alexander New provided funds to erect a sculpture of Lincoln on the courthouse lawn in his hometown. New, a lifelong admirer of Lincoln, offered the monument in memory of his parents. He commissioned New York sculptor Charles Keck (1875–1951), who created the masterful bronze work after studying all the available photographs and visiting all the other statues existing at that

time. The eight-foot-high seated figure conveys a sense of all the responsibility and pain that weighed upon our Civil War president. The sculpture, placed upon a substantial granite base, was accepted by the city and dedicated in May 1932. Two years later Henry Hering (1874–1949), who had recently completed the World War Memorial in Indianapolis, finished his seated figure of Lincoln for University Park just to the south of the memorial. This wonderfully detailed work shows a contemplative Lincoln in a heavy fringed chair, a shawl draped around his shoulders and his pince-nez dangling from a cord around his neck. His stovepipe hat and gloves lie behind the chair.[1]

Rockport native George H. Honig (1874–1962), a Lincoln scholar who urged his hometown to seek New Deal funding to create Lincoln Pioneer Village, Indiana's first living history museum, in 1935, sculpted numerous small bronze reliefs with historical themes in southwestern Indiana. A number of these were of and about Lincoln, including a silhouette on a boulder on the riverbank below Rockport, where Lincoln and his friend Allen Gentry set off on their fabled trip to New Orleans on a flatboat. Another bronze relief of Lincoln is outside the Warrick County Courthouse in Boonville, where Honig also created several commemorative bronze plaques with relief portraits of local notables.

A lesser-known and much-moved image of Lincoln was the result of a competition for high school art students, sponsored by the Commercial Club in Indianapolis in 1906. Marie Stewart of Shortridge High School won the contest with her design, and Rudolf Schwarz (1866–1912) executed it in bronze relief. The plaque was originally placed on the Claypool Hotel, built on the site of the Bates House, where Lincoln had once spent the night and addressed a crowd from the hotel's balcony. Following the razing of the Claypool in 1969, the salvaged plaque was relocated onto a new limestone pedestal in the 300 block of West Washington Street. It was removed when the new Government Building South was erected but reinstalled close to the same site after the expansion of the government complex was completed.[2]

Elmer Harland (E. H.) Daniels (1905–1986), a native of Michigan who studied at the John Herron Art School, was commissioned in 1941 by the Indiana Lincoln Union and the Indiana Department of Conservation to create five huge panels in relief showing Lincoln at various stages of his life for what was then called the Nancy Hanks Lincoln Memorial. Now part of the Lincoln Boyhood National Memorial, at the time the new monument was part of Lincoln State Park in Spencer County. Four of the panels depict scenes in each of the four states or locations where Lincoln lived: Kentucky, Indiana, Illinois, and Washington, D.C. The center panel speaks to the influence of Lincoln on the nation and on the generations that followed. The limestone panels, each eight feet by thirteen and a half feet, were completed by July 1943. Because there was a war on, the building was never formally dedicated.[3]

The state has some other presidential images: Indiana's own Benjamin Harrison (although he was born in North Bend, Ohio), the twenty-third president, was captured in bronze by Cincinnati-born Charles Niehaus (1855–1935). Completed in 1908, the statue is more than ten feet high and depicts a well-fed bearded gentleman, all the more grand set within a stone exhedra on the south side of University Park in downtown Indianapolis. As noted in the previous chapter, his grandfather William Henry Harrison, the ninth president, is depicted in military attire as the hero of the Battle of Tippecanoe on one of the outer statues surrounding the Indiana Soldiers and Sailors Monument. The heroic bronze figure is the work of John H. Mahoney (1855–1919). Harrison is also featured on the Battle of Tippecanoe monument at Battle Ground near Lafayette. Until recently, however, there was no statue of Harrison in the vicinity of his home, Grouseland, in Vincennes. The substantial brick dwelling, built in 1804, is a national historic landmark. In spring 2002 Vincennes University erected a limestone figure of Harrison. The statue had actually been carved thirty years before by Harold "Dugan" Elgar and placed on campus, but after about ten years of student abuse it was removed and placed in storage.

This image of Harrison shows him in civilian dress with a full-length cape, perhaps more befitting his role as the founder of the university in 1801.[4]

George Washington, the nation's first president, is displayed in his Masonic regalia on the south side of the statehouse in Indianapolis. Erected in 1987, the masterful bronze work is one of several around the country designed in 1959 by Boston-born figurative sculptor Donald DeLue (1897–1988). The statue, more than nine feet tall, was a gift to the state from the Grand Lodge of Free and Accepted Masons. This seems to be the only public sculpture in Indiana of Washington, apart from a different bronze figure at Washington Park Cemetery on the east side of Indianapolis, which also dates to the 1950s and displays his Masonic regalia. The life-size statue was crafted by an Italian artist and cast in Milan.[5]

Jeffersonville was named for Thomas Jefferson, and a heroic statue erected in 2003 makes the connection clear. A ten-foot bronze figure portrays America's third president as if stepping off a dock, suggesting the boundless energy of the man. The work of local artist Guy Tedesco (b. 1962), the piece is in a landscaped setting in Warder Park.[6]

Erected in 2002—and a seemingly unlikely candidate for a statue in Indianapolis—is an oversize image of James A. Garfield, installed in the city's oldest park. Originally called Southern, the park was renamed in 1881 for the assassinated president. Lawrence sculptor Chie Kramer created the twelve-foot-high statue from a storm-felled sycamore that had long stood in Garfield Park and had been a thriving sapling at the time of the president's death.[7] Wood is not the best choice for an outdoor piece, especially in Indiana's climate, and the statue is already showing signs of deterioration.

Favorite Sons

Indiana has become known as the home of vice presidents, although only two of them have been commemorated in bronze. The statue in University Park, Indianapolis, of Schuyler Colfax (1823–1885), vice president in the tainted administration of Ulysses S. Grant, is probably more significant for its being the first major commission of Illinois sculptor Lorado Taft (1860–1936). Born in New York, Colfax came to the newly platted town of New Carlisle on the Michigan Road at the age of thirteen, ultimately becoming a journalist and local politician in nearby South Bend. Colfax entered national politics and rose to speaker of the house, which led to his being chosen as Grant's running mate. A popular fellow, Colfax was known as "Smiler," and although he had been tinged with the corruption of owning stock in a fraudulent railroad company, he pursued a successful career on the lecture circuit after leaving office. The statue, erected in 1887, was commissioned by the International Order of Oddfellows, whose symbols and allegorical figures are in relief on the base.[8]

Thomas A. Hendricks (1819–1885), briefly vice president (he died after eight months in office) under Grover Cleveland, is honored with a huge bronze statue on the southeast corner of the statehouse grounds. Flanked by allegorical female figures, it stands on a massive granite base. Hendricks had been a United States senator in the 1860s and served a term as Indiana's governor in the 1870s. Richard Henry Park (1832–1902) of New York created the massive work in 1890.[9]

Scattered around the state are sculpted images of also-rans. There are two identical bronze images of William H. English (1822–1896) by John Mahoney, both cast about 1898. One, dedicated in 1907, graces the courthouse square in Scottsburg in Scott County. The other statue still stands in what was once the city park of the town of English, the seat of Crawford County. Ironically, the town, which was named for English, no longer stands around him. Having frequently suffered from the destructive flooding of the Blue River over the years, the town moved to higher ground and demolished most of the buildings left behind. William English was born in Lexington, Scott County, and after several terms in Congress returned to Indiana to make his fortune in banking in Indianapolis. Reckoned to be the wealthiest man in Indiana, English was picked in 1880 to be the running mate of former Civil War general Winfield Scott Hancock. After los-

ing to the Republican team of James A. Garfield (who was assassinated his first year in office) and Chester Arthur, English returned to Indianapolis where, among other activities, he built the elaborate English Hotel and Opera House on the Circle.[10]

Wendell L. Willkie (1892–1944), who ran for president against Franklin D. Roosevelt, is commemorated in Elwood and Rushville, the two towns most closely associated with him. In Elwood, where Willkie grew up, is a portrait bust in relief, erected in 1966 in Wendell L. Willkie Memorial Park. Although Willkie accepted the 1940 Republican presidential nomination in Elwood, he set up his campaign headquarters in Rushville, where he owned farms. After losing the election, he embarked on a world tour that provided the impetus for his great work *One World* (1943). In 1944 Willkie suffered a series of heart attacks that ultimately killed him. Willkie is buried in East Hill Cemetery in Rushville, and the memorial at his grave site, erected in 1946, features a crusader's cross and a huge open book inscribed with excerpts from *One World*. All elements are of pink granite, the work of New York sculptor Malvina Hoffman (1887–1966), a friend of Willkie's widow Edith.[11]

National Heroes

Robert F. Kennedy hoped to be president, but the event he is most remembered for in Indianapolis occurred on the evening of April 4, 1968, while he was campaigning for the Indiana primary. Kennedy, speaking to a crowd of supporters in an African American neighborhood on the city's north side, had the unenviable task of announcing that Dr. Martin Luther King Jr. had just been assassinated. The fact that Indianapolis, unlike many other large cities, did not suffer violence in the aftermath of King's assassination has been attributed to Kennedy's extemporaneous words to the crowd that night. (Kennedy himself was assassinated two months later in California.) *Landmark for Peace*, an unusual sculpture commemorating the event, was unveiled at the site in 1995. Indianapolis sculptor Dan Edwards executed the design by Greg Perry.

The symbolic work, which incorporates metal from melted-down handguns, depicts the figures of Kennedy and King each emerging from a wall and reaching across a chasm toward each other.[12]

Anderson sculptor Kenneth G. Ryden (b. 1945) created a full-size statue of King, which in 1988 was erected in a landscaped traffic island on that city's south side. In 2000 a full relief bust of King by Ryden was placed at the south edge and another at the north edge of Marion, marking the route between as Dr. Martin Luther King Jr. Memorial Way.[13]

Virgil I. "Gus" Grissom (1926–1967), one of the seven original Project Mercury astronauts and the second American in space, is a national hero

This relief sculpture on the south side of Marion and another identical to it on the north mark the Dr. Martin Luther King Jr. Memorial Way.

The simple monument in the shape of a Redstone rocket pays tribute to Mitchell-native Virgil I. "Gus" Grissom, one of the original Mercury Seven astronauts.

with a strong Hoosier connection. In his hometown of Mitchell stands an impressive yet simple limestone memorial. More than thirty feet high, it depicts a space capsule atop a rocket. The town had begun tentative plans for a monument before Grissom's tragic death in 1967 while running tests for the Project Apollo moon program. Erected more than a decade later in 1981, it became a poignant memorial.[14]

Franklin College boasts a fine marble statue of Benjamin Franklin, the namesake of both the town and college. However, regular acts of vandalism by students have coated the lovely stone with several layers of paint, masking its detail.

Although the college seems to be an obvious place for a statue of Franklin, the campus is the figure's third location. It began as a fancy advertising icon for the Franklin Building constructed on the Circle in Indianapolis in 1875. The statue was John Mahoney's first commission. He was working as a marble cutter at the time, and his employer noticed the young man's talent and recommended the aspiring sculptor for the job. When the building was torn down in 1929 to make way for the city's art deco gem, the Circle Tower, the Franklin statue was saved and rededicated in front of the Typographical Workers Union headquarters on North Meridian Street. Franklin was, after all, a printer by profession. When the union vacated Indianapolis (and the recycled mansion in which the headquarters had been housed) in 1962, Indiana AFL-CIO president Dallas Sells provided the funds to move the statue to Franklin College, where he had two children enrolled.[15]

In progress once again is the Lewis and Clark Plaza, slated to be completed by the end of 2006 along the Ohio River in Clarksville at the original town site. Through bronze sculpture and carvings in the plaza's stone walls, the memorial will display the series of events leading to the departure in 1803 of the Corps of Discovery. Local sculptor Guy Tedesco is creating the bronze figures.[16]

Several other towns display statues of the persons for whom they were named. An image of the Marquis de Lafayette (1757–1834), the young French nobleman who helped the cause of the American Revolution, stands in a fountain outside the Tippecanoe County Courthouse in Lafayette. The life-size figure, another very early work by Lorado Taft, was dedicated in 1887. Lafayette's visage is also among those carved in the pediments of the courthouse itself, and he is on the facade of the 1918 Merchants Bank Building that faces the courthouse.

William Tell, for whom Tell City was named by its Swiss founders, stands with his son Walter (Walther) at the top of a fountain in City Hall Park. Dedicated during the town's Schweizer Fest in

1974, the work was modeled by Donald B. Ingle of Evansville and cast in bronze at the Modern Art Foundry in New York. The life-size piece is based on a small sculpture purchased in Altdorf, Switzerland. Created by Swiss artist Richard Kissling (1848–1919) in 1895, the statuette is displayed on a pedestal outside the Tell City National Bank on Main Street. The bank funded the construction of the fountain in City Hall Park.[17]

There are two public sculptures honoring Christopher Columbus, although neither is in the Bartholomew County seat of that name. One, a bronze bust created by Indianapolis sculptor Enrico Vittori, was donated by Italian immigrants in 1920. It stands on an ornately carved limestone pedestal southwest of the statehouse. The second, crafted in 1992 by local sculptor David M. Layman (b. 1959) for the five hundredth anniversary celebration of Columbus reaching the Americas, is a heroic bronze statue in Mishawaka's Central Park.

The suburb of Irvington, now a neighborhood on the east side of Indianapolis, was named for Washington Irving (1783–1859), the popular author of tales about such characters as Rip Van Winkle and Ichabod Crane. German-born William Kriner, who had been employed as a stone carver on the Soldiers and Sailors Monument, was commissioned in 1936 to create a bust of the author to grace the little park in Irving Circle. The piece suffered vandalism over the years and eventually was placed in the yard of Indianapolis Public School No. 57 on Washington Street in the heart of Irvington. International Harvester (now Navistar), whose plant was located on the south edge of Irvington, donated the funds to create a metal casting of the stone bust. The copper-clad iron version of the same head was placed in Irving Circle in 1971.

In Greenfield, on the north side of the courthouse square facing US 40, is a life-size bronze statue of Hoosier poet James Whitcomb Riley (1849–1916), whose birthplace stands several blocks to the west. The sculpture, dedicated in 1918, two years after the poet's death, is the largest work in Indiana of Myra Reynolds Richards

(1882–1934). She also completed a bust of Riley from life, shortly before he died in 1916, which is mounted on a pedestal outside the poet's home in Indianapolis. It was originally displayed inside.

James Dean (1931–1955), unquestionably a gifted and attractive actor, died young and thus became a legend. He was raised in Grant County outside of Fairmount, where he was buried following his death in an automobile crash. California artist Ken Kendall (b. 1921) created a bronze head of Dean, which was stolen less than two years after it was dedicated in Fairmount. (Few things relating to Dean are safe from rabid fans and thieves; his grave marker has been stolen a number of times.) In the 1990s the head was recast and placed on a tall pedestal downtown, where, so far, it remains.

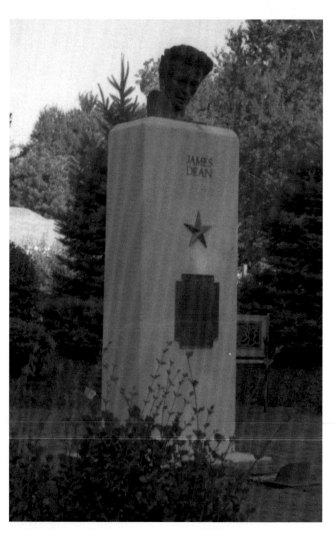

The James Dean Memorial in downtown Fairmount.

Local and Regional Movers and Shakers

When William English built his opulent hotel and opera house on the northwest quadrant of what is present-day Monument Circle in Indianapolis, the facade decorations included large portrait medallions of several Indiana governors and members of the English family. The medallions were executed in limestone by English-born Henry Saunders, who completed several projects in Indianapolis in the 1890s. When the building was demolished in 1948, most of the medallions were salvaged and offered for sale, scattering them about the state. About half apparently are lost and some are misidentified, but several of the governors currently can be found in their home counties. A recently refurbished Ratliff Boon (1781–1844), for example, has a place of honor on the courthouse square in Boonville, while David Wallace (1799–1859), father of Lew Wallace, is properly mounted on the grounds of the Lew Wallace study in Crawfordsville. Interestingly, Saunders worked for Lew Wallace, carving the faces of characters from his popular novels, such as *Ben-Hur* and *The Prince of India,* in a frieze below the cornice of the novelist's study. Lew Wallace also owned an apartment building in Indianapolis on Meridian Street, the Blacherne, and the entrance and limestone sills of the building are similarly carved.

E. H. Daniels sculpted three early Catholic priests significant to the history of Jasper and the surrounding area. Completed in 1944, they stand in a little garden adjacent to Saint Joseph Catholic Church, where the priests served. In 1932 Daniels fashioned a bronze bust of Richard Lieber (1869–1944), the "Father of Indiana State Parks," for a memorial erected to the first director of the state's Department of Conservation, which had been established in 1916. When the conservationist died, he was buried at the memorial in Turkey Run State Park, and the sculpture became Lieber's grave marker.

Town platters and forgotten early entrepreneurs are typical subjects of commemorative statues. Amy Musia's *The Bend in the River,* a monument of stone and steel depicting the founders of Evansville, Hugh McGary and Robert M. Evans, in negative silhouette, was erected downtown near the Ohio River in 1993. At this writing, it languishes in storage. The Havilah Beardsley Monument, dedicated in 1913, honors the founder of Elkhart with a life-size bronze statue commissioned in Italy and placed in a fountain setting designed by E. Hill Turnock, the renowned architect of many of the city's finest buildings.

Judge Elbert H. Gary (1846–1927) stands downtown in the city that bears his name. Gary was one of the chief organizers and the chairman of the board of the United States Steel Corporation, which in 1906 built a huge new plant in the duneland of Lake County. Around it was platted a company town named for the judge. In 1957 the city dedicated a heroic bronze statue created by English-born Bryant Baker (1881–1970) that stands adjacent to the city hall downtown.[18]

Many early movers and shakers of Fort Wayne are scattered around the city's parks, several the work of Frederick C. Hibbard (1881–1950) of Chicago. The earliest is the bronze bust of civic leader Perry Randall (1847–1916), erected in Swinney Park the year of his death. Six years later, at the same park, Hibbard's bronze statue of David N. Foster (1841–1934), a developer, businessman, and president of the city's board of park commissioners, was dedicated in gratitude for his service to the community. In 1930 Hibbard created a lovely aesthetic statue of cast stone as a memorial to the veterans of World War I and former Fort Wayne resident Olen J. Pond. Erected in Memorial Park, *Memory* is a provocatively draped figure of a woman that was originally flanked by two drinking fountains and backed by a semicircle of trees. The fountains are gone; the trees have overtaken the statue; and the statue's head was knocked off the figure in 1990. The same park contains *The Spirit of Flight,* a memorial to Art Smith (1890–1926), a pioneer aviator from Fort Wayne, created by sculptor James S. J. Novelli (1885–1940) in 1928. The city's practice of honoring lives and accomplishments with bronze effigies continues unabated. The Hamilton sisters, Edith and Alice, and their cousin Agnes,

Classical scholar Edith Hamilton, one of the three Hamilton women honored in a memorial near downtown Fort Wayne.

granddaughters of one of the early town fathers, Allen Hamilton, and his wife Emerine Holman Hamilton, grew up in Fort Wayne in the late nineteenth century. Each went on to achieve considerable fame in her respective field. Edith Hamilton (1867–1963) was a renowned scholar of classical mythology; Alice (1869–1970) was a doctor noted for her work in industrial medicine and safety. Their cousin Agnes was an artist and social reformer. In 2001 life-size bronze statues of each of the three women, created by Michigan sculptor Anthony Frudakis (b. 1953), were erected in a landscaped setting in Headwaters Park. Each figure is posed naturally, in a manner appropriate to her life's work. The Hamilton Women Memorial was a product of Fort Wayne's Celebrate 2000 Committee.[19]

Elsewhere, traditional commemorative sculpture also thrives. Today's statues are often far less formal than in decades past. In Wabash, Mark C. Honeywell (1874–1964), who cofounded Honeywell Inc.

and later established the foundation that bears his name, is immortalized in bronze. Arizona sculptor John Soderberg (b. 1951) was commissioned in 1994 to create the piece for a new garden area added when the Honeywell Center's building was expanded. Although Honeywell had no children of his own, he is depicted with two in poses that suggest some of the community activities that take place at the center.[20]

On the Bloomington campus of Indiana University, a full-size statue of Herman B Wells (1902–2000), the university's legendary chancellor, by Harold R. "Tuck" Langland (b. 1939) recently joined the formal bronze bust that stands outside Kirkwood Hall, done in 1965 by French-born sculptor Robert Laurent (1890–1970). Langland's naturalistic statue shows Wells seated on a park bench as if waiting for students to come along to stop and chat.

The University of Notre Dame has commemorated its heroes and campus legends with several outdoor sculptures. Two of the most recent are a large bronze statue of football coach Frank Leahy (1908–1973), erected in 1997 outside the expanded stadium, and a seated bronze figure of Edward "Moose" Krause, installed two years later just across the street. Both were the work of Jerry McKenna (b. 1937) of San Antonio, Texas. The myth-laden Knute Rockne (1888–1931) is remembered with an interior sculpture in a building that bears his name, but he is also captured in stone in a niche on Alumni Hall. The other niches on the building are occupied by saints, which says something about the status of Coach Rockne. Two early presidents of the university also maintain a bronze presence on the campus. The founder of Notre Dame du Lac (its original name), Father Edward F. Sorin (1814–1893) has stood in the main quadrangle since 1906, rendered in bronze by Italian sculptor Ernesto Biondi (1855–1917). Father William E. Corby (1833–1897) served in the Civil War as chaplain of the Irish Brigade that fought in the Battle of Gettysburg. The statue on campus by Samuel A. Murray (1869–1941) of Philadelphia is a replica

of one placed at Gettysburg. After the war Corby became president of Notre Dame. Both men also have buildings named for them. More recently, a tribute to the storied missionary Doctor Tom Dooley (1927–1961), who attended Notre Dame, was dedicated in 1985. The bronze statue by Rudolph E. Torrini (b. 1923) portrays the doctor with two Laotian children. It is a smaller version of a nine-foot work that stands in Saint Louis.

Earlham College in Richmond, befitting its Quaker roots, has no sculpture on campus at all, save for a three-quarter figure (from the knees upward) in bronze of martyr Mary Dyer, who was hanged in Boston in 1660 for her religious beliefs. The piece, dedicated in 1962, is one of three castings by Sylvia Shaw Judson (1897–1978); the other two are in Boston and Philadelphia.

Ball State University in Muncie commemorates the five Ball brothers who gave the campus its name and the land that it occupies. Rather than big bronze men, however, the memorial is a beautiful allegorical figure christened *Beneficence*, dedicated in 1930. It was the last major work of renowned sculptor Daniel Chester French (1850–1931).

Pioneers

Indiana, like many states west of the Alleghenies, cherishes its pioneers. Memorials honoring rugged ancestors began to appear frequently in the twentieth century, once Hoosiers were safely distanced from them in time. In Glen Miller Park on the east side of Richmond is one of twelve identical statues that the Daughters of the American Revolution placed across the country in the late 1920s, one in each state along US 40. German-born August Leimbach (1882–1965) of St. Louis designed *The Madonna of the Trail*, which is made of Algonite, a type of cast stone.

A *Pioneer Family* observes the passing decades from a fountain at the intersection of three streets in the Fountain Square neighborhood of Indianapolis. Myra Reynolds Richards, head of the sculpture department at the Herron School of Art, created the piece, which was dedicated in 1924. It was removed from the intersection (the fate of many early pieces so placed) and stood for many years in the Garfield Park Conservatory about a mile to the south. A clamor to restore the fountain that gave the neighborhood its name resulted in the little bronze family returning to the square in 1989, no doubt a little stunned at what they see.[21]

Heroic figures of pioneers stand high above the entrance on the south facade of the 1888 statehouse, carved in limestone with bronze embellishments, the work of Herman C. Mueller. There is one family grouping of settlers at the west end, and, interestingly, a comparable family of Native Americans at the other end. The two middle figures subtly imply who ultimately triumphed: a farmer and a blacksmith, symbols for agriculture and industry.

Jesuits were another sort of pioneer. These black-robed priests accompanied the voyageurs as they traveled among the Native Americans seeking furs and other resources along the rivers and lakeshores of the Midwest. A heroic bronze statue of an archetypal Jesuit of the early eighteenth century, such as would have been at Fort des Miamis, the French precursor of Fort Wayne, stands north of downtown where three rivers converge to form the Wabash. Local sculptor Hector Garcia (b. 1933) created *Jesuit Priest* in 1976, America's bicentennial year.

Father Jacques Marquette (1637–1675) was among the early Jesuit explorers who set foot in what ultimately was to become the Hoosier State in the area around Lake Michigan. In 1932 Henry Hering, in between his multifaceted work on the War Memorial and his statue of Lincoln in Indianapolis, created a heroic figure of Marquette to be placed on a monument in Gary designed by the architectural firm of Walker and Weeks. The statue is eleven feet high and is located in the park that was named for the priest. A considerably more modest image of Marquette now stands inside the high school of the same name in Michigan City. Originally the statue, which dates to about 1914, stood in a niche on the outside of a building that was demolished in 1955.[22]

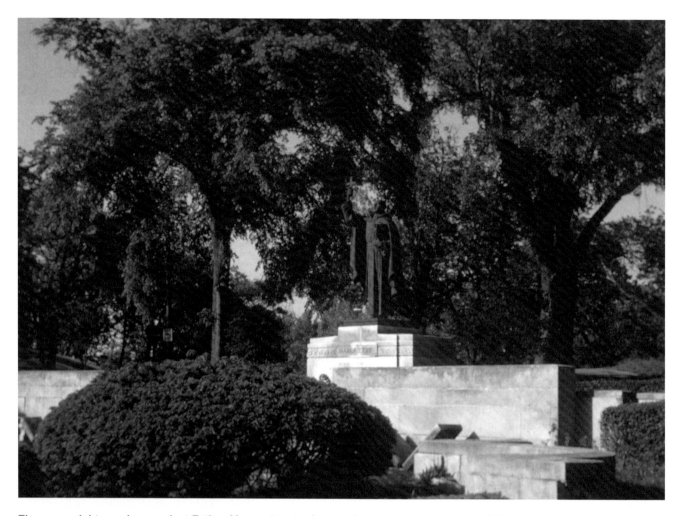

The memorial to explorer-priest Father Marquette stands near the entrance to the park of the same name in Gary.

The Indians of Indiana

It seems that Indiana began to develop something of a conscience in the early twentieth century, since most of the Indians had been removed from the state many decades before. Potawatomi chief Menominee, standing majestically in an isolated area of rural Marshall County in the vicinity of Twin Lakes, was commemorated in granite by appropriation of the state legislature in 1909. Menominee and his band of more than eight hundred Potawatomi were compelled by soldiers to leave their homeland in northern Indiana in the fall of 1838 and force-marched to distant Kansas. Strawtown, on the White River in Hamilton County, was once a Delaware Indian village. A monument to Chief Straw (who probably did not exist) was erected in 1928 on grounds along the river, where

people often picnicked. Although the impressive fieldstone pedestal still stands, the bronze figure it once supported disappeared decades ago.[23]

Chief François (or Francis) Godfroy of the Miami is represented, not very authentically, in downtown Montpelier by a huge fiberglass figure made in Venice, California, about 1960 for a Pontiac dealership in Indianapolis. Later the statue welcomed visitors to the Indian Museum in Eagle Creek Park. After the museum closed, the figure, a generic brave over twenty feet high that at best conjures up images of the Plains tribes, not those of northeastern Indiana, was acquired by Chief Larry Godfroy, a descendant of the nineteenth-century chief. He presented it to Montpelier because it was near the ancestral lands, and the city erected the statue as a monument in 1984. It commemorates

the Godfroy Reserve, established in 1818 by the Treaty of Saint Marys, and honors the memory of François Godfroy.[24]

Another—and probably the best known— Miami chief was Little Turtle, or Mishikinakwa. A pragmatic leader, he tried to work with the whites, even inviting the Quakers to help his people learn agricultural methods. In 1976, the same year he completed *Jesuit Priest,* Garcia created a heroic bronze statue of Chief Little Turtle to be placed at the orientation center of Old Fort Wayne, a living history museum. The imposing nine-foot figure was moved across the river to Headwaters Park when the museum closed.[25]

As the Native Americans in the West were rapidly being subjugated in the late nineteenth century, a number of artists and sculptors who captured their images (and often those of cowboys and soldiers as well) became extremely popular, especially in the eastern states. Among them was Utah-born Cyrus Edwin Dallin (1861–1944) of Boston, whose best-known works were often cast multiple times in smaller sizes, including tabletop pieces. Created in 1909, the original of his *Appeal to the Great Spirit* is in Boston, but in 1929 an eight-foot version was dedicated near the White River in Muncie as a memorial to Edmund B. Ball (1855–1925). The evocative work portrays a Native American chief astride his horse, his eyes raised to the sky and his arms in an attitude of appeal. A considerably smaller version of this piece is on the campus of Culver Military Academy, as is a small version of the same artist's *Scout.* (The original heroic-size work is in Kansas City.) Dallin's heroic *Passing of the Buffalo,* in truth a commentary on the passing of the Indian from the scene, was cast in 1929 and originally placed on the estate of Geraldine Rockefeller Dodge in New Jersey. Decades later, the piece was purchased and donated to the city of Muncie, where it was erected downtown in 1976.[26] At this writing the piece is in storage at the Minnetrista Cultural Center and in danger of being forgotten.

Potawatomie, an imposing fourteen-foot figure of sheet copper by La Porte-born sculptor Howard

A. DeMyer, was another statue honoring Native Americans erected in the bicentennial year. The sculpture, recalling the people who once lived in the region, once stood in a pool behind the courthouse in an area called Independence Plaza. When the space was commandeered for a new jail, the statue was moved to the east side of the courthouse.

Princess Mishawaka is a figure of legend with a decidedly Pocahontas-like quality. The bronze piece is in a garden setting next to the Mishawaka City Hall. Although it appears much older, it was done in 1987 by Fort Wayne sculptor Sufi W. Ahmad (b. 1936).

The Greeting by Illinois sculptor George Carlson (1940–1998), whose work features many portrayals

In recent years many statues have appeared honoring Native Americans in Indiana. *Night Song* overlooks the White River near downtown Muncie.

of Native Americans, stands near the entrance to the Eiteljorg Museum of American Indian and Western Art in downtown Indianapolis. The heroic work depicts a robed shaman or medicine man in an attitude of welcome. A more stylized piece of cast bronze is *Wisdom Keepers* by Bruce LaFountain (b. 1961), a member of the Chippewa tribe. Installed near the front entrance of the museum in 1999, the piece on one side appears to be an elderly chief in full headdress, while on the other side the back of the headdress tapers to become the head of an eagle.

Still a popular subject for public art in Indiana, portrayals of Native Americans are becoming more realistic and less myth laden. A recent example is *Night Song* by Arizona sculptor Joe Beeler (b. 1931), erected in downtown Muncie in 1998. It is a very detailed figure of a Native American seated on a rise overlooking the White River. *The Teacher* portrays a Potawatomi Indian helping a child learn to fish, presumably in the Tippecanoe River. The sculpture, by Winamac native Casey Eskridge, was erected in 2002 at the Pulaski County Courthouse.[27]

Working-Class Heroes

Around the turn of the twentieth century a new sort of subject for commemoration began to appear, the anonymous hero. Initially these pieces tended to honor groups of one type or another of ordinary working people, in contrast to someone whose name was well known (or whose pockets were deep.) Today such figures are becoming quite common, honoring those who serve in the community, even as we continue to honor those who serve in the military.

The earliest such memorial is the Stonecutters Monument erected in 1894 by the Bedford Stonecutters Association in that city's Green Hill Cemetery. A wonderful three-dimensional document, a stonecutter dressed in his work clothes and apron, in front of his workbench and surrounded by his tools, stands high atop a pedestal. Nearby is the grave of a stone carver, Louis J. Baker, who died suddenly in 1917 at the age of twenty-three. To honor his memory his fel-

low stone carvers created an exact replica of his workbench as he had left it. It is a remarkable creation down to the last detail, from the split wood of the bench to Baker's apron left lying across one corner.

The Italian immigrants who journeyed to southwestern Indiana to dig coal are represented by an eager young man with a battered suitcase created by sculptor Carl Avenatti. The bronze figure is supported by a base representing a pile of coal. It was dedicated in 1971 in Immigrant Square on the northwest side of Clinton in Vermillion County. The coal miners worked in deep mines in the late nineteenth and early twentieth centuries, but ultimately, strip mining of vast tracts became the norm.

Nestled amidst the sprawling campus of Memorial Hospital in South Bend is the bronze figure of an 1890s nurse commemorating *The Spirit of Nursing*.

Both are represented in the memorial to coal miners on the west side of the statehouse in Indianapolis, the work of Chicago sculptor John Szaton (1907–1966). The bronze piece, dedicated in 1967, shows a seven-foot-tall coal miner with his headlamp and other gear atop a large pedestal, on the front of which is a bronze relief of a strip-mining operation.

A block to the west, the Workers Memorial, three small figures rendered in bronze by local sculptor Dan Edwards, represents workers in general. While the piece is very nicely detailed, its site, west of the State Office Building and south of the canal, is set too far back from the sidewalk, with no path leading to it, for pedestrians to be able to appreciate the work. In addition, it is of too small a scale to be seen from cars passing by. It was erected in 1995 in memory of workers who died on the job.

The first sculptural monument to firefighters was the Volunteer Firemen's Memorial by Charles Edwards, erected in 1902 in New Albany's Fairview Cemetery. A pewter fireman of the mid-nineteenth century stands atop a limestone pedestal carved with the firefighting equipment of the day. Indianapolis firefighters who lost their lives are honored with a sculptural memorial fountain topped with a bronze phoenix, the elegant work of Bloomington artist Dale Enochs, erected adjacent to the Firefighters Museum in Indianapolis in 1996.

Nurses in South Bend have been honored recently with *The Spirit of Nursing* that commemorates the alumnae of the Memorial Hospital School of Nursing, which closed in 1989 after ninety-five years. Created by Mishawaka artist David M. Layman and erected in 2001, the statue depicts a nurse of the 1890s, when the hospital and school were known as Epworth Hospital and Training School. Sculpture relating to medical matters appears to be increasing. The figures of a smiling physician examining the throat of a young boy, created by local sculptor Gary L. Rittenhouse, were placed at the

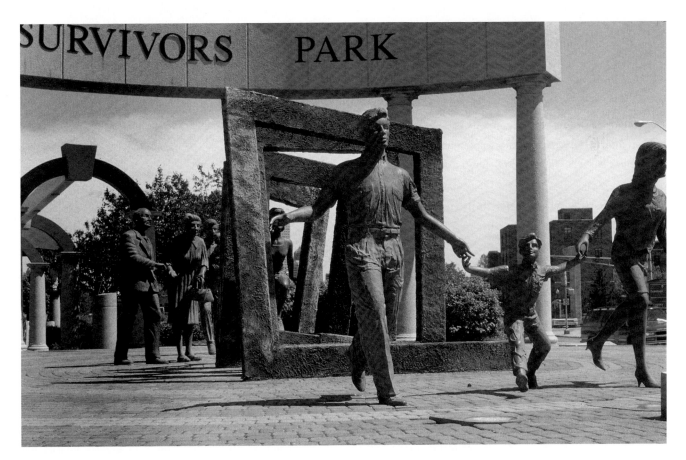

Adjacent to a large hospital complex in Indianapolis is this tribute to survivors of cancer.

The anonymous folk who combed the skies for enemy aircraft during the Korean War are commemorated with this monument in rural Tippecanoe County.

Kendrick Family Medical Pavilion (now Saint Francis Medical Pavilion) near Mooresville in 1997. In Indianapolis, outside the complex of hospitals at Tenth Street and Indiana Avenue, is a small memorial park with life-size bronze figures representing cancer survivors. Dedicated in 1995, the unusual sculpture, called *Cancer . . . There's Hope,* was the work of Spanish artist Victor Salmones (1937–1989).

There are all kinds of heroes. A little-known oddity commemorating the Operation Skywatch civilian volunteers of the early 1950s during the Korean War stands near an isolated crossroads amidst flat farmland northwest of Lafayette. The

Operation Skywatch Memorial was a Bicentennial project designed by Mary McDonald and executed in limestone by her, along with the well-known Bedford stone carvers Frank Arena (1899–2001) and James Saladee (1906–1994). The statue depicts a farmer, his wife, and their son, each alertly gazing up at the sky in different directions.

In 1990 a bronze statue, *The Boy Scout,* by Canadian artist R. Tate McKenzie (1867–1938) was installed outside the Scouts' Indianapolis headquarters. The piece is a reproduction of a statue erected in 1937 in Philadelphia, where McKenzie resided much of his life. In the early 1950s the Boy Scouts carried out "The Crusade to Strengthen the Arm of Liberty"—no coincidence that the Korean War was

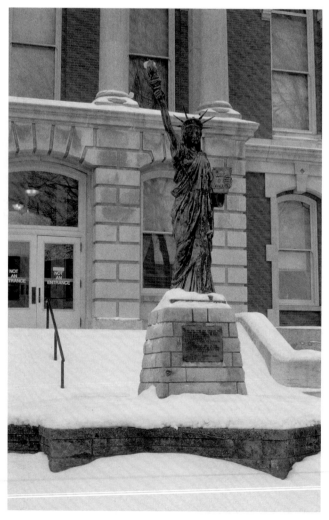

An eight-foot replica of the Statue of Liberty guards the Marshall County Courthouse in Plymouth.

going on—that involved raising funds to erect a monument featuring an eight-foot replica of the Statue of Liberty, which was made in a factory in Kansas. Local communities had to provide the pedestal. There are six "little liberties" in Indiana, erected 1950–52: in Gary, South Bend, Plymouth, Peru, Madison, and one in front of a Boy Scout camp near Dupont. The one in Gary is across from the city hall, and the others are in their respective courthouse squares.

In the Cities of the Dead

Cemetery sculpture is a category unto itself, with numerous articles and books focusing on the ubiquitous tree-stump gravestones, the classical mourning women and allegorical figures, the draped urns and ornate obelisks carved with symbols and flowers, and the religious figures and angels. But there are a number of grave markers that rightly belong in a discussion of commemorative sculpture; these are the portraits in stone, the most poignant of which are the children. There are several around the state, most from the nineteenth century.

Crown Hill Cemetery in Indianapolis has two children in marble. Mary Ella McGinnis, who died in 1875, is forever five years old, with her long hair in ringlets and her short lacy dress, flowers gathered in her apron. Corliss Randle Ruckle was born in 1877 and died in 1889. He sits with an open book in his lap, wearing high-button shoes, knee breeches, and a wide-collared shirt with a floppy bow tie. He rests an elbow on a small spiral staircase next to him, each step representing a year of his short life.

In Bartholomew County the parents of Chester Reynolds, who died in 1889 at age four, commissioned from Italy a marble statue based on a photograph. The child is dressed in Little Lord Fauntleroy fashion and in a long skirt, not uncommon for little boys of that day. For decades it stood on Chester's grave in a rural cemetery until it was vandalized and tossed in a ditch. After it was recovered, the statue was placed in the Bartholomew County Historical Museum in Columbus. In the same city, still standing above her grave, is the marble image of Mary

Ora Mennet, who was only eleven when she died in 1888.[28]

In Madison County, both of George and Caroline Hilligoss's children died, their little daughter Gertrude in 1881 when she was about six and their son Charlie in his sixteenth year in 1887. The grief-stricken parents commissioned a sculptor in Florence, Italy, to create two life-size marble statues, which were placed in Maplewood Cemetery in Anderson in 1892. The daughter sits demurely with a small book in her lap, and young Charlie stands dressed in his Sunday best, holding his hat in hand.[29]

Daviess County native Ira Correll (1873–1964) carved the limestone portrait statue, slightly larger

The Hilligoss children live on in marble in a small cemetery in Anderson.

than life, of Anise Hart for her grave in Saint Peter's Cemetery in Montgomery. She died two months before her twelfth birthday in 1909. Probably the most unusual child portrait in the state was influenced by the art deco style prevalent at the time. In a very isolated cemetery near the hamlet of Ray in Steuben County is a girl, somewhat larger than life, who stands with two doves at her feet and flowers in her hand. Gloria Fisk died in 1936 before she reached the age of ten. These are but some of many stone portraits of children to be found in Hoosier cemeteries.

For poignancy at the opposite end of life, there are two examples in Indiana of portrait gravestones of elderly couples. Robert and Ann Anderson stand side by side in marble above their adjacent graves outside Fort Branch in Gibson County. William and Margaret Hoverstock gaze out from the top of their vault in the Wells County town of Zanesville. Both couples are in late-nineteenth-century dress, and both of the statues were carved in Italy in the 1890s. One spouse long outlived the other in each case; William Hoverstock lived thirteen years after his wife, and Ann Anderson was a widow for twenty-six years.[30]

There are other portrait statues and busts scattered throughout Indiana's cemeteries, and large and elaborate monuments to the dead are hardly uncommon. But for sheer post-mortal swagger, it is hard to beat the Sumner monument in rural Benton County outside the forgotten little town of Earl Park. Edward Sumner (1811–1862), one of the eastern-born land barons of northwest Indiana, despite all his efforts to the contrary is largely forgotten today. The monument features a soaring granite shaft more than twenty feet high, upon which stands an eight-foot marble likeness of Sumner, gazing southward upon the thirty thousand acres that he once owned. Far below the statue is a portrait in relief of his wife Abigail, who outlived him by many years. One cannot help but think of Shelley's poem "Ozymandias" upon encountering this futile effort for immortality.

Saints, Angels, and Graven Images
Religious Sculpture

■

WELL OVER A THIRD OF THE OUTDOOR SCULPTURE IN INDIANA IS OF A RELIGIOUS nature. The greatest percentage of religious statuary—especially that found around Roman Catholic institutions—was created by unknown artisans here or in Italy, particularly the marble figures. Italian immigrants started companies in America as well, such as Daprato in Chicago and Kaletta Studios in Saint Louis, from which many of

the statues gracing Indiana churches, monasteries, and cemeteries have come. The earliest figures tend to be marble or, less often, limestone, and marble statues remain in favor today. Figures from the early twentieth century are often of metal, followed by a rise in statues of concrete, which is still commonly used. Recent figures are often of fiberglass.

These figures, while perhaps less important artistically, take their significance from their age, their location, or their history—and, on occasion, their size. The marble statue of Our Lady of Grace that one encounters at Ancilla Domini, the Poor Handmaids of Jesus Christ Ministry Center, is exactly like countless other representations in niches and shrines around churches, schools, and even the yards of the faithful: the Virgin Mary is portrayed with a serene expression, standing on a hemisphere while treading on a serpent. To the last detail she looks just like the others, except for the fact that she is eighteen feet high. Originally placed at a Catholic

orphanage in Fort Wayne in 1938, the statue was donated by the diocese to the motherhouse of the Poor Handmaids, hauled by train and flatbed truck to its present site in 1978.[1]

Some commemorative sculpture has a religious component, as noted in the previous chapter. The statues of the three early priests of Saint Joseph Church in Jasper, for example, or the bronze figure of Father Pierre Gibault (1737–1804) at Vincennes or that of Father Jacques Marquette (1637–1675) in Gary, all speak in some degree to the role of religion in settling the state. Church leaders and theologians are commemorated for their contributions to the spiritual community. An example is the bronze head of Johannes Paul Tillich (1886–1965) in New Harmony, crafted in 1967 by James Rosati (1912–1988). Of course, cemetery art, commemorative by nature, often centers on a religious theme, regardless of whether or not the cemetery is managed by a religious institution. One need only to

drive through Crown Hill Cemetery in Indianapolis, Oak Hill Cemetery in Evansville, Lindenwood in Fort Wayne, or any other similar nineteenth-century cemetery and start counting the angels and other figures and symbols of faith. In more recent times, abstract interpretations of saints and various spiritual concepts have appeared, along with new but still representational interpretations of traditional themes.

As suggested, Catholic institutions—churches, monasteries, convents, schools, hospitals—are the likeliest locations for religious sculpture. Certain areas of Indiana are particularly blessed with sacred images, owing to their ethnic heritage. In southern Indiana the pattern of German Catholic settlement in the nineteenth century led to a large number of rural parishes, often displaying statuary, and a large number of religious institutions. Among the most notable collections is at Saint Meinrad Archabbey, founded by the Benedictines in Spencer County in 1853. The figures in the niches above the entrance to the church and much of the religious statuary on the grounds of the hilltop monastery are the work of German sculptor Herbert Jogerst (1912–1993). His pieces are easily recognized by their distinctive linear style, the drapery falling in straight geometric folds. Jogerst was a German prisoner of war who spent the last part of World War II incarcerated in Kentucky. He found it difficult to earn a living in postwar Germany and accepted a job at Saint Meinrad filling the niches on the abbey church and Saint Bede Hall. He fulfilled those tasks and much more.

Jogerst also did pieces for communities in the surrounding area. He created *Christ the Victor* for the town of Ferdinand, which is north of Saint Meinrad. This striking statue was installed in front of Saint Ferdinand Church about 1950. For his most famous work, Jogerst traveled a few miles south to Troy. *Christ of the Ohio* was commissioned in 1956 by Doctor and Mrs. Nicholas James,

The works of German sculptor Herbert Jogerst (opposite page) grace the facade of the church at Saint Meinrad Archabbey in Spencer County.

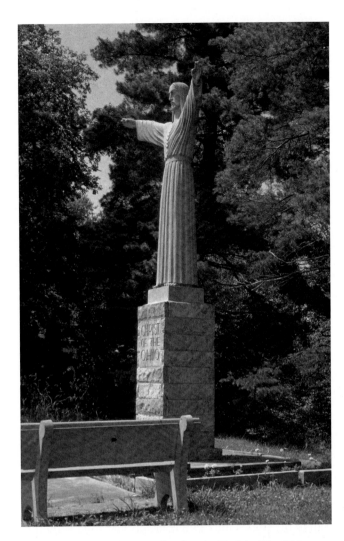

Keeping a watchful eye on the river is *Christ of the Ohio* near Troy.

devoted Catholics, and placed at their summer home high on a bluff above the Ohio River. The family donated the property to Camp Koch, a facility for disabled young people. Eventually the ownership of the statue came to the town itself. The dramatic figure of Christ stands more than eleven feet high on a Saint Meinrad sandstone pedestal of nearly nine feet. The figure is of Colorado travertine, a pinkish limestone. Christ stands with his arms extended on either side in an attitude of blessing for the many boats and barges on the river that can see him from afar.[2]

Most of Evansville's several parish churches display a figure of Christ, the Virgin Mary, or the saint for whom the church is named. Nearly all are by

unknown artisans, but Jasper native Father Earl Rohleder (b. 1937), one of several priest-sculptors in Indiana, created a stylized relief of the Holy Family in rusted steel, which was placed on the Center for Family Life—formerly the Saint Anthony School—in 1989. It stands behind the magnificent Church of Saint Anthony built in the 1890s, which displays a marble statue of the saint in a niche. There is a wealth of late-nineteenth and early-twentieth-century religious statuary (as well as more recent) at Saint Joseph Catholic Cemetery on the northwest side of the city.

Oldenburg is dominated by its historic Roman Catholic institutions, so much so that it was known as the "Village of Spires." Today it is missing the monastery that added to the texture of the town, but it still contains a treasure trove of religious statuary, most of it on the grounds of the Immaculate Conception Convent, the motherhouse of the Sisters of the Third Order of Saint Francis.

In Fort Wayne Hector Garcia (b. 1933) has made something of a career of carving saints and other religious figures, as did the team of Alison Adams (who created the design) and Timothy Doyle (who executed the carvings in stone). Most of the works of Adams and Doyle are in Catholic cemeteries and are full-size reliefs of various saints. Garcia's religious pieces for the most part are in front of churches and are rendered in a variety of media. His 1980 statue of Saint Charles Borromeo is of cement with a base of white sand, for example, while his Saint Frances Xavier Cabrini, done about four years earlier, is limestone. The Catholic Cemetery has several notable examples of religious statuary. The Saint Joseph Medical Center, built downtown in 1965, has a twenty-foot high marble figure of Saint Joseph the Worker affixed to its exterior wall. Several pieces, some of them relocated from demolished schools and churches, surround the Cathedral of the Immaculate Conception downtown.

The Catholic presence manifested through sculpture in Fort Wayne is balanced by that of the Lutherans, who elsewhere rarely display statuary. The city is home to Concordia Theological Seminary and *The*

Luther Statue, a bronze image of Martin Luther (1483–1546) more than twelve feet high. Originally, the statue by German sculptor Friedrich Adolf Soetebier was dedicated at the seminary's campus in Springfield, Illinois, in 1957. In 1977 the seminary returned to Fort Wayne, where it had been founded in 1846. The statue of Luther was then rededicated at its present location. On Saint John Evangelical Lutheran Church near downtown is a large cast aluminum alto relief of *Christ Blessing the Children,* the work of Marshall Fredericks (1908–1998) of the famed Cranbrook Academy in Michigan. It was dedicated in 1962. There is a Lutheran Hospital in Fort Wayne as well. Dedicated on the hospital grounds in 1916 was a statue based upon the painting *The Healing Christ,* which portrays Jesus comforting a mother with her sick child. It was carved in granite by a local monument maker, Herman Scherer. The hospital has since moved to a new location on the west side of the city. The statue stands before what is now the Lutheran Center for Health Services. Concordia Cemetery also has many religious figures.

Fort Wayne is second only to the South Bend-Mishawaka area in its quantity of outdoor religious statuary. The abundance of ethnic churches in the twin cities and the presence of the University of Notre Dame, the associated Moreau Seminary, and the sister campus of Saint Mary's College, all contribute to the huge tally of religious figures in the area. Eastern European immigrants, lured to South Bend and Mishawaka by the prospect of work in the thriving factories, found that the Roman Catholic churches could not—or in some cases would not—accommodate them all. Therefore, in the older parts of the city, surviving churches are often very close to one another, and many are ethnic in their origins. Saint Patrick and Saint Hedwig churches, both built in the 1880s, are only a block apart. The latter church was built to accommodate Polish workers at the Studebaker wagon factory and the Oliver Chilled Plow Works. Both churches, typical for the area, have several outdoor pieces. Notable at Saint Patrick's is Father Anthony J. Lauck's (1908–2001) *Sacred Heart of Jesus.* Born in Indi-

anapolis, Lauck was on the art department faculty at Notre Dame for many years and was the first director of its Snite Museum. As more immigrants poured into the city, new parishes were formed, each, generally, with a strong ethnic identity. With a few exceptions, most of the pieces at the many Roman Catholic churches in the area were fashioned by unknown artisans.

This is also true of most of the religious statuary on the campus of Saint Mary's, with some distinguished exceptions. Noted German-born sculptor Lee Lawrie (1877–1962) created the limestone *Our Lady of the Trinity,* his only work in Indiana. Dedicated in 1926, it stands at LeMans Hall. Sister Monica Gabriel, with the assistance of no less than Ivan Mestrovic (1883–1962), who was sculptor-in-residence at Notre Dame toward the end of his life, created the figure of *Christ the Teacher* in 1955. It now resides on an island in Lake Marian.

The campus of the University of Notre Dame is a gigantic sculpture garden, with well over sixty pieces—some of which are secular and very contemporary. The religious pieces run the gamut from traditional statues of saints—many of which were rendered by faculty or artists-in-residence—to very modern interpretations. An example of the latter is Father James Flanigan's (b. 1935) *Christ the Teacher,* portraying a beardless Jesus in bronze, seated on a rock. Completed in 2000, the piece sits directly on the ground and is very approachable. Mestrovic's bronze works from 1956 are stolid and boulder-like, portraying Christ and the Samaritan woman, Saint Luke and Saint John, all grouped in a garden setting. His successor Waldemar Otto's (b. 1929) bronze pieces, *Jeremiah* and *Pietà,* both completed in 1964, are small, distorted, and, perhaps, anguished. David Hayes (b. 1931) interpreted *The Descent of the Holy Spirit* in 1961 as a bronze abstract, also called *Tongues of Fire.* Father Lauck's *Our Lady of the University* shows medieval influence but is clearly a modern piece. The seven-foot statue, originally carved in limestone in 1954, was cast in bronze in 1992 and prominently displayed at the main entrance to the campus. Of course, the statue

that gives the university its identity is the figure of the Immaculate Conception atop the Golden Dome of the Administration Building. Of cast iron covered in gold leaf, the sixteen-foot statue was created by Italian sculptor Giovanni Meli in 1880. A much newer figure that is largely identified with the campus is the heroic statue of Moses by Croatian sculptor Joseph (Josip) Turkalj (b. 1924), dedicated in 1962 outside the Hesburgh Library. The oldest religious statue on campus, apart from the Immaculate Conception that watches over all, is the figure of Saint Edward the Confessor outside Saint Edward's Hall. The statue, made in France, dates to 1880.

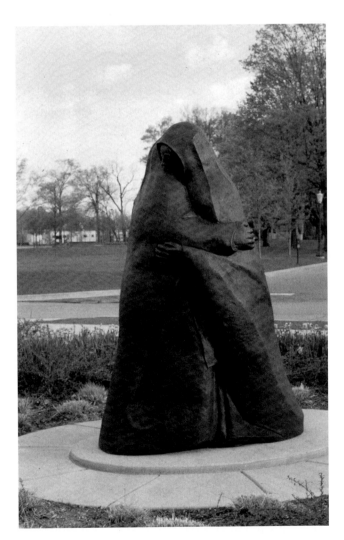

Father Anthony J. Lauck's last work placed on the campus of Notre Dame, *The Visitation,* depicts the meeting of Mary and her cousin, Elizabeth, after each had been told that she would conceive a child.

During the 1940s, two sculptors were put to the task of filling the many empty niches on the residence halls and classroom buildings, most of which were constructed decades earlier. Father John J. Bednar (1908–1998), head of the art department, was joined in the gargantuan task by Hungarian refugee Eugene Kormendi (1889–1959), who became the university's sculptor-in-residence. Between them, they carved more than twenty life-size limestone figures. Bednar also created *Our Gallant Dead*, a religious-themed war memorial originally completed in 1923 outside Sacred Heart Church (now Basilica). In 1944 Bednar enlarged it. Kormendi did pieces off campus as well. His war memorial is the only statue left at the former Shrine of the Seven Dolors in Porter County. A variation of the *Pietà*, it shows the Virgin Mary holding a dead soldier in her arms.

The Grotto of Our Lady of Lourdes on the Notre Dame campus is probably the oldest one in the state. A replica of the grotto in Lourdes, France, where Saint Bernadette saw the apparition of the Virgin Mary, it was erected in 1896 near Saint Mary's Lake. There are several grottoes around the state; another one more than a hundred years old is in Lafayette on the grounds of Saint Elizabeth Hospital. At Saint Mary-of-the-Woods College near Terre Haute is a large grotto dating to the 1920s. It should be noted that Saint Mary-of-the-Woods is another campus with a legion of saints in stone and metal stationed about the tree-filled grounds. Several churches in Indiana have small versions of the Lourdes setting; these seemed to be popular to construct in the 1950s, often by the parishioners themselves, with the statuary ordered from Daprato in Chicago or from Italy.

Bordering on folk art, a number of statuary-filled Catholic shrine complexes were constructed in northwest Indiana. One of the loveliest, the Shrine of the Seven Dolors, built by a Franciscan order in the 1930s northwest of Valparaiso, was demolished in the 1990s and the land sold to developers. One grotto remains behind the church, a more recent building, along with Kormendi's war memorial mentioned above. At Cedar Lake in Lake County is

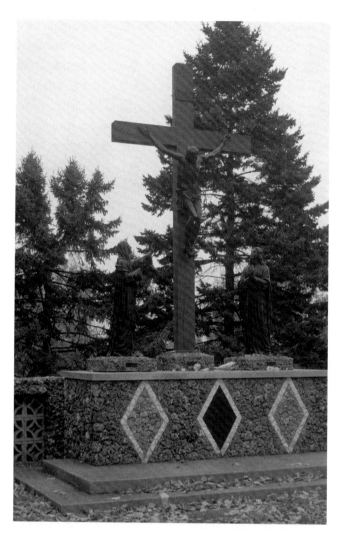

The statuary at the Carmelite Monastery and Shrines in Munster rests on pedestals decorated with minerals from around the world.

a huge grotto at the San Damiano Friary Novitiate, on the grounds of what once had been a resort hotel until the depression of the 1930s. The grotto is a complex of several smaller chambers and caverns. On the grounds are a number of smaller shrines filled with statues, most of them marble. Among the most interesting is that of Blessed Kateri Tekawitha (1656–1680), a life-size figure of the woman who will become the first Native American saint. But even more elaborate is the Carmelite Monastery and shrines in Munster. Indeed, there is an immense Lourdes grotto filled with mysterious caverns and lined with sparkling crystals. Throughout the grounds, all the bases for the statues—which were

carved by Italian craftsmen of the finest Carrara marble—are made of brilliantly colored minerals from around the world. The shrines were constructed starting in the mid-1950s by an order of the Discalced Carmelites, who came to the United States from Poland after World War II.

The town of Jasper in southern Indiana, with its strong German roots, also boasts an ornate complex of shrines just west of the Saint Joseph Church and Cemetery. These were built in the 1950s out of geodes and fossils, incorporating bits and pieces of building ornament—a threshold here, a chunk of cornice there, all in a charmingly artless fashion reminiscent of the Works Progress Administration rock gardens of the 1930s. The Mother of God Grotto and the Saint Joseph Shrine were designed and built by Father Phillip Ottavi with the help of the residents of the Providence Home, a facility for elderly and mildly mentally handicapped men.

A discussion of outdoor sculpture in Indiana based on religious themes must include the various works on display at New Harmony. Founded as Harmonie in 1814 by the practical and thrifty Rappites, who lived simply and prospered, the little town was purchased lock, stock, and barrel ten years later by Robert Owen (1771–1858), who added "New" to the name and started a short-lived experiment in communal living. A center of culture and place of meditation has sprouted amid the remnants of the past scattered throughout this unusual community. The Roofless Church, designed by the world-renowned architect Philip Johnson (1906–2005) in 1960, contains examples of sculpture by several famous artists who have interpreted scriptural references and spiritual themes in new and sometimes disturbing ways. In the center of the Roofless Church is *Descent of the Holy Spirit* by Lithuanian-born Jacques Lipchitz (1891–1973), who also designed the huge bronze and steel main gates that incorporate designs around the Alpha and the Omega. Another piece within the Roofless Church is an abstracted interpretation of the *Pietà* by California artist Stephen DeStaebler (b. 1933), an armless standing figure with a head emerging

from its chest and an amorphous shape hovering above. A ceramic sculpture by Polish artist Eva Sygulska, fashioned in 1968, harkens back to the fifteenth century. The stylized figure of a seated king holding before him the crucified Christ is based upon a wood carving from the 1400s in a museum in Kraków. Just outside the Roofless Church is a figure of Our Lady, Queen of Peace, which purports to be from about the fifteenth century, although its style appears to be later. Father Earl Rohleder, mentioned earlier, more recently created a piece on the grounds of Holy Angels Church called *Global Ethic* that speaks to issues of interdependence and peace. David Kocka (b. 1950), a southern Indiana artist who was once a Franciscan monk, created a writhing

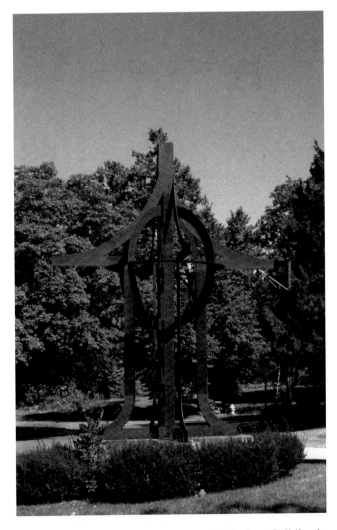

Somos Unos still stands outside the old Missions Building in the Irvington neighborhood in Indianapolis.

and unusual interpretation of *Saint Francis and the Angel of the Sixth Seal* on the north side of Tillich Lake. Kocka spent a number of years in Rome studying the mystic aspects of Saint Francis of Assisi, and much of his work reflects this. Elsewhere he has done several interpretations of the saint, including a figure in Perrin Park in Jeffersonville and figures on the exterior of the Retreat Center at Mount Saint Francis in Floyd County.[3]

Sufi Ahmad of Fort Wayne, along with Kocka and other contemporary artists already noted, occasionally works with religious themes in new ways. Ahmad's *Spirit of Saint Francis,* completed in 1997, was cast three times and installed in three different Franciscan institutions around the state: the motherhouse of the Sisters of Saint Francis in Mishawaka, a hospital outside of Beech Grove on the southeast side of Indianapolis, and Saint Francis College (today, University of Saint Francis) in Fort Wayne. The Sisters were so pleased with Ahmad's lively representation of their patron saint that they commissioned him to produce several more as they acquired more hospitals in the state. There are now a total of twelve castings of this work in Indiana, ten of which grace hospital campuses. Erected at LaLumiere School in rural La Porte County is *God's Hand* by Carl Milles (1875–1955), certainly an evocative piece, depicting the figure of a man held by a huge hand. *Somos Unos* was left behind when the Disciples of Christ vacated its headquarters in Irvington on the east side of Indianapolis. At first glance the piece appears to be a completely abstract design of corrosive steel. After further inspection, however, the viewer realizes it is an expression of the cross and a globe. Installed in 1981, no doubt it speaks to the fact that the structure it stands beside was once the Missions Building, now converted into senior housing.

A nationwide phenomenon based on the book and television drama *The Christmas Box* is represented twice in Indiana. Readers of the book, in which a statue of an angel figures prominently, clamored to know the location of the statue that inspired the story. Finally, the author Richard Paul Evans commissioned the father and son team of

Jared and Ortho Fairbanks to design a bronze childlike angel. About four feet high, the first *Angel of Hope* statue was dedicated in 1994 in Salt Lake City, where Evans lives. By the end of 2001, there were twenty-six placed across the country, wherever grieving parents who lost children waged a successful local campaign to erect one. The statues are provided for cost. In Indiana, one is north of Evansville off US 41 at the Vanderburgh County 4-H Center, which was dedicated in 1998. The other was erected in Pinhook Park in South Bend in 2001.

This "Christmas Box Angel" gives comfort in Pinhook Park in South Bend.

Lions and Santas and Bears, Oh My!
Animals, Children, Whimsies, and Oddities

T HERE IS AN ENTIRE CATEGORY OF SCULPTURE THAT SEEMS TO BE JUST FOR FUN: animals enough to fill Noah's ark, children at play, cartoon and mythical characters, and some that defy all attempts at classification are all over the state, waiting to delight the viewer.

The stone lions in public places throughout Indiana could fill a savanna. Among them is

a pride of ten beasts, mostly male and all similar but with variations on size and tail placement, that surrounds the Fulton County Courthouse in Rochester. An immigrant from Germany by the name of Hedrick (his first name does not appear in records) worked on the ornamental carving of the courthouse and carved the ten reclining lions to guard the entrances. Less interested in quantity, evidently, was Collins James Morgan, who worked on the Washington County Courthouse in Salem and then carved a single lion in 1884 for the steps of the State Bank of Salem on the northeast side of the square. This limestone beast with the charming expression still watches the courthouse, now from the sidewalk in front of the bank, which is housed in a building that long ago replaced the original. A pair of limestone lions flanks the north entrance to the Tell City city hall, which had originally been intended for a courthouse, but the county seat stayed with Cannelton. (Ironically, a new court-

house was constructed in the 1990s on the north side of Tell City, so it is, at last, the seat.) The beasts were carved by local sculptor John C. Meyenberg in 1907 and were originally at a different site.[1]

The limestone lions guarding the entrance to Fairview Cemetery in Linton were sculpted by local carver John Thomas Wright (1903–1978) and originally stood in front of his house in town. Another life-size pair of the big cats silently roar at all who enter what was once a single-family dwelling, now apartments, on M Street in Bedford. They have been flanking the steps since 1923. There are several stone lions in a variety of poses in Woodruff Place, once a separate town, now a historic neighborhood in Indianapolis. All these are but a sample of the state's offerings. One more set needs to be mentioned, however, as they are nothing like their fellow felines. A pair of fanciful Chinese lions watches the gate to the Indianapolis Zoo. The lions, each weighing four tons, arrived in 1988, a gift from Indiana's "sister

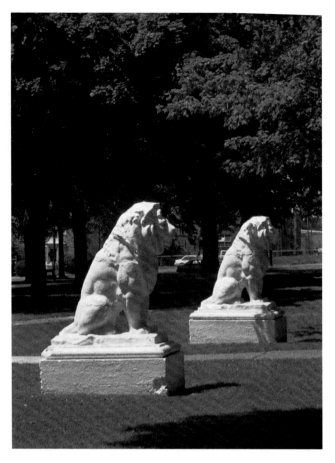

Lions guard the City Hall in Tell City.

province" of Zhejiang in southeastern China. Carved in marble and highly stylized, both have manes, although one represents a female and carries a cub in her front paws, while the other clutches a ball.[2]

The Crossroads Cougar has been a local landmark since about 1969, when it was purchased to help promote an automobile dealership on South Madison Avenue in Indianapolis. About twenty feet high, the big cat was probably made by the International Fiberglass Company of Venice, California. For several years it sat atop the main showroom, but after a major remodeling, the dealership constructed a pedestal for it in the midst of the lot. The space was too valuable to waste, apparently, for now the cougar sits in the back of the property.

The Bears of Blue River in the town square—now taken up by a parking lot—is actually a work commemorating Shelbyville author Charles Major (1856–1913), who wrote the classic children's tale

of that name. Created by Indianapolis-born Elizabeth Stout in 1929, the sculpture portrays a boy wearing buckskin, holding aloft a bear cub in each hand. The statue, a gift from the author's widow, originally stood in front of the Charles Major School, since demolished. A bear in Bluffton is scarcely more formidable. He sits on a branch of a realistic dead tree, along with a squirrel, at the intersection of State Roads 1 and 124. The piece is entirely of concrete and was created about 1936 by a young man from the town of Petroleum. Although it had no thematic connection with the filling station at that corner, which had been built to resemble an airplane, the owner purchased the statue and placed it where it stands today. A modern gasoline station has taken the place of the airplane, but the bear of Bluffton remains.[3]

A pair of highly stylized, polished limestone bears urge patrons of the Monroe County Public Library in Bloomington to return their books on time. The streamlined bruins are the work of C. R. Schiefer, who has peppered the state (and indeed, the world) with an odd assortment of smoothed limestone and marble creatures reduced to their most basic shapes—he calls them "Touchables." A nearby school in Bloomington has his *Rhinoceros,* and in Columbus near the courthouse is his *Dancing Fish* fountain. In Schiefer's home county, a Martinsville bank displays a pair of *Seals Courting.* The artist sculpts people, too, donating several months of work in 1999 to the creation of *Faces of Indiana for the Millennium.* During the project Schiefer carved more than seven hundred Hoosier faces into an eleven-ton block of limestone behind the governor's mansion in Indianapolis. The breadth of his work is most obvious in his ever-growing sculpture garden, begun in 1970, at his studio in rural Morgan County on Low Gap Road.

A cast-iron Newfoundland dog, which until recently was the only known sculpture in sparsely populated Pike County, appears to be straight out of the catalog of the J. L. Mott Iron Works of New York. For more than a hundred years it has watched over the graves of the Hornaday family in Walnut Hill

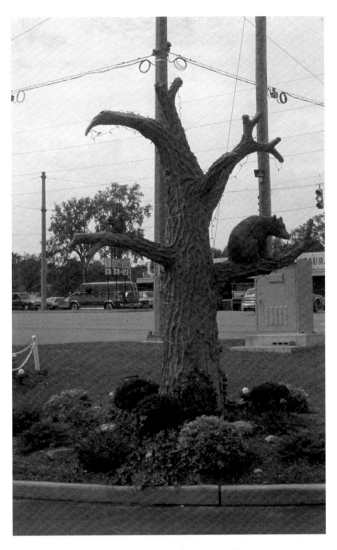

His surroundings have greatly changed, but the concrete bear still sits in his concrete tree on the north side of Bluffton.

Cemetery in Petersburg. Similarly, a limestone Saint Bernard, whose style suggests it may be an unsigned work of Ira Correll, sits near the graves of the Huff family in Locust Hill Cemetery in Evansville.

For years a limestone dog waited expectantly outside the YWCA in Kokomo. Its original location was only a few feet to the east in front of the organization's first building, a former residence razed in the 1960s. When the YWCA closed in 2003, the dog disappeared. However, a similar canine and a lion by the same local sculptor, S. J. Ferguson, turned up the same year. The Howard County Historical Society now owns the pieces, which are dis-

played outside its house museums. Butler University's team mascot has been the bulldog for many decades, but it was not until 1996 that a limestone mascot carved by Ohio sculptor Dale Johnson was placed in a prominent location outside Atherton Center on campus. Another canine school mascot is the greyhound of Carmel High School. William Arnold, who works almost exclusively with wire, created a small pack of them for the school grounds.

Joe LaMantia, noted for his collaborative community sculpture, created *Spot, the Firehouse Dog,* in 1996 for WFHB Community Radio in Bloomington, which is housed in a former fire station. The extra-large dalmatian was fashioned from recycled materials and wood. There is a firehouse dog of cast iron in Lafayette at the Five Points Fire Station on Main Street. The dog's accompanying boy, also of cast iron, is located inside the fire station. The pieces are said to date to about 1850 and were cast in New York.

There are a large number of grounded eagles around the state, many of which originated on far different perches. Among the best examples is the one that once topped the Clay County Courthouse before it was razed in 1914. The eagle was donated to the Brazil Eagles Aerie, where today it sits on a pedestal at the corner of US 40 and State Road 59. Two limestone eagles that once graced the often-lamented Traction Terminal in Indianapolis took on a new role after the building was demolished: guarding the entrance to the old city hall, which housed the Indiana State Museum for over three decades. A bit rough-hewn for street level—they had been intended to be seen from far below—they were carved by Alexander Sangernebo (1856–1930), better remembered for his prodigious output of terra cotta sculpture on buildings throughout the city.

Resembling the stylized eagles that decorate many a New Deal post office, a pair of huge eagle heads flank the entrance to the Indiana Limestone Company north of Oolitic. They were created by local stone carver Criston East in 1983. More realistically, *Golden Eagle,* a delicately balanced work in bronze by Wyoming artist Dan Ostermiller (b. 1956), captures an eagle in flight. It was placed near

the north entrance of Eagle Creek Park on the northwest edge of Indianapolis in 1989.

A small herd of bronze deer splashes through a pond in front of the Eiteljorg Museum of American Indian and Western Art in downtown Indianapolis. The sprays of water add to the illusion of reality. The deer, installed in 1989, are the work of Kenneth Bunn (b. 1938). The Fort Wayne Children's Zoo has peppered its grounds with several realistic animals in bronze. For the Australian Adventure habitat, Connie Phillips created *Koala* and *Platypus*. The zoo was unable to procure the real animals, so the bronze pieces stand in for them. Texas-born artist Tom Tischler (b. 1947), who created *Rongo*, a life-size sitting orangutan placed at the Indonesian Rainforest exhibition, also completed *Galapagos Tortoise* in 1989 and *Komodo Dragon* in 1994.

The bronze animals in White River Gardens in Indianapolis are much more fanciful. Indianapolis artist Jan Martin fashioned forty-nine comical anthropomorphic creatures in fourteen different designs, from a *Contemplating Frog* to *Jigging Tortoises*, who dance in triumph after defeating the *Dejected Hare*. The adjacent Indianapolis Zoo features several examples of William Arnold's wire sculptures. His North American plains animals were installed in 1988 along the rim of the zoo, near where the living examples were located. Arnold's bison, which he had originally created for the Indiana National Bank in 1989, was donated to the zoo after the bank was merged with another lending institution. The bison had been the focal point of the plaza beside the former INB Tower downtown. Arnold's wild stallion gambols at Pendleton High School, and seven coyotes roam the Coyote Crossing Golf Course outside West Lafayette.

As the Indianapolis Children's Museum continues to expand, so, too, has the number of outdoor sculptures on the property. Most are more whimsical than those at the Fort Wayne Children's Zoo and for the most part are displayed where they can be touched or even climbed upon with impunity. There are three art deco creatures carved by Italian sculptor Beniamino Bufano in 1939: a fat, curvy cat, a

snail, and *Penguin's Prayer,* which portrays a stylized mother penguin and her chick. Most recently, a family of life-size alamosauri appears to be breaking out of the museum's "Dinosphere." These marvelous fiberglass creatures are the work of Canadian artist Brian Cooley (b. 1956), installed in 2004.

For whimsical creatures that glow in the dark, one must travel to InTech Industrial Park on the northwest side of Indianapolis. There, five huge frogs of translucent cast resin appear to be right at home in their expansive pond. Installed in 1999, the oversize amphibians were created by Connie Scott of Morristown and cast by her husband David.

These oversize instruments grace a fountain pool outside the Woodwind and Brasswind distribution company in South Bend.

Indeed, industrial parks, seemingly unlikely locations for public sculpture, often harbor surprises. The Woodwind and Brasswind, a company selling musical instruments, is located on the west side of South Bend just off the US 31 bypass, from which passing cars can easily be distracted into running off the road at the sight of a fourteen-foot trumpet and an equally large alto saxophone, perfect in every detail. They stand upright in the middle of a fountain pool outside the company's headquarters. Real objects out of scale often make for interesting sculpture. In the case of Jan Martin's gigantic tulip tree leaf, it is a lovely yet droll work of art that is also functional. Installed in 1992 in an atrium below ground level at the Indiana Government Building South in Indianapolis, the piece contains a drinking fountain. The form of the stainless steel piece is not as obvious to people taking a sip from the bubbler in the upturned stem, but viewed from above, it is a perfectly formed replica of a leaf from Indiana's state tree.

Children have been an especially popular subject for public sculpture in recent years. But as early as 1929, a Mexican immigrant boy, Gabriel Garibay, carved a charming statue of *The Barefoot Boy,* the character in a popular poem by James Greenleaf Whittier, for the Indiana Boys School in Plainfield. The fate of the talented artist after he left the reformatory is unknown.

J. Seward Johnson (b. 1930) has forged a lengthy career creating amazingly real figures of people in active poses in everyday settings, something he calls "celebrating the familiar." Few pieces seem more alive than his rendition of a man struggling to pump up a tire on a Model A Ford, while his little boy wriggles behind the steering wheel. *When I Was Your Age* is part of the corporate collection of Arvin Industries (now ArvinMeritor) in Columbus. There are two castings of Johnson's *Crack the Whip* in Indiana, one at the Sheraton Hotel on the far north side of Indianapolis and the other in Lincoln National's sculpture collection in Fort Wayne. The piece depicts eight children with hands locked and facing alternate directions in a ragged, almost circular, line, each trying desperately

to be the last child standing as they twist and turn. Another bronze piece called *Crack the Whip* is at ArvinMeritor in Columbus; this one, installed in 1998, is the work of Oklahoma sculptor Jo Saylors (b. 1932), who specializes in realistic children in nostalgic poses. Her *Puddles* and *Frog Pond* were erected in 1995 beside a real pond on the property.

In a similar fashion Glenna Goodacre (b. 1939) captures the joy and freedom of children at play in her *Tug of War* and *Olympic Wannabees,* installed at the Children's Museum of Indianapolis in 1991 and 1997, respectively. Goodacre may be best known for her *Vietnam Women's Memorial* in Washington, D.C., and for the design of the Sacagawea dollar coin. Another set of bronze children at the museum is called *Storytime,* depicting a girl and boy sitting back to back, each reading a book, the work of Utah sculptor Gary Price (b. 1955). Muncie's Children's Museum displays two bronze pieces by Paul Moore (b. 1957) of Arizona that likewise preserve something of childhood remembered. *Wait for Me* is on the sidewalk outside the museum's entrance. The other is within a small sculpture garden and outdoor activity space at the rear of the building. *Fireflies* shows a young girl holding, appropriately for Muncie, a Ball jar full of lightning bugs, represented by glowing light tubes. A little boy gazes raptly at the jar, as a frog sits at his feet.

Erected in Plainfield's Friendship Gardens Park at the end of 2002 is *Family First,* a representative—and value-laden—piece in bronze, depicting the ideal American family—mother, father, boy, girl, dog—interacting. Sculptor Connie Scott created the scene inspired somewhat by her own childhood years. Another more stylized bronze family whirls in a swirl of skirts and flying hair at Fort Wayne Children's Zoo. *Dancing Family* by New York artist Milton Hebald (b. 1917) was installed in 1970. The parents and their three children express pure abandon and joy.

In 1990 three figures by Scott O'Hara were placed randomly in front of La Grotte Enterprises, an office building rehabilitated out of the former Indianapolis Public School No. 7, built in the

1870s. From a distance they appear eerily real. A man sits on a bench reading a newspaper, while some distance away a boy in pre–World War II attire hawks newspapers. Also in the same vicinity is a figure of a policeman in the uniform of a hundred years ago. The figures remind many viewers of the so-called ghost figures that were placed inside the renovated Union Station. But those were the work of Mooresville designer and sculptor Gary L. Rittenhouse. Rittenhouse, who created *The Family Doctor* (see Chapter Two) outside Mooresville, walks the line of "commercial" versus "art." With public art becoming so popular, he often creates fanciful or humorous figures for housing subdivisions and recreational facilities, such as the comical golfers he made for the golf course at Heartland Crossing near Mooresville.

Speaking of golfers, there is *Andrew* at the Walnut Creek Golf Course in Grant County, created from a white oak tree that had stood on the course until lightning destroyed it. He stands ten feet high and is dressed in the traditional togs commonly seen on the links until well into the 1960s. Another golfer, wearing casual attire and carrying his clubs, is in a most unlikely place: Green Hill Cemetery in Bedford. Made of granite and perfect in every detail, the life-size figure stands on the grave of Tom Barton, who died in 1938 and clearly loved the game.

Paul Bunyan was among the most popular figures created by International Fiberglass of Venice, California, in the 1960s and early 1970s. One still stands, despite occasional attacks from vandals, in front of a hardware store in Elkhart on Cassopolis Street. Others are spotted occasionally, along with what roadside architecture aficionados call "Muffler Men." Muncie's Paul Bunyan, although also made of fiberglass, was created by artist Richard Kishel in 1964. He has stood at his present location in front of a tavern on Kilgore Avenue since 1993.

The character Joe Palooka, the champion boxer created by cartoonist Ham Fisher, was so popular in 1948 that he seemed an appropriate model for Bedford stonecutters to turn into a large statue in celebration of the centennial of the Indiana limestone

Once a wildly popular comic strip character, Joe Palooka stands outside the Oolitic Town Hall in Lawrence County.

industry. The completed ten-foot statue was erected on a hillside overlooking old State Road 37 between Bedford and Oolitic. However, frequent attacks of vandalism forced it to be moved several times until it was donated to the Kiwanis of Oolitic in 1984. Since then, Joe Palooka, the "Champion of Democracy," has stood proudly beside the Oolitic City Hall.[4]

The town of Santa Claus at one time had several versions of the beloved Christmas symbol standing about; now it has only two. Local artist Carl Barrett erected a concrete Santa in 1935. The huge figure, with a bulging bag of toys, overlooked Santa Claus park with its various entertainments and shops. The statue spawned several local businesses that turned

Santa Claus into a tourist attraction, especially after Santa Claus Land (later incorporated into the Holiday World theme park) opened shortly after the end of World War II. Several Santa figures appeared around the town, but one by one they disappeared, until only Barrett's gift remained—that is, until December 2001, when a fiberglass replica of the Santa on the hill was dedicated in front of the town's post office.[5]

The Mentone Egg, all three thousand pounds of it, was created to call attention to the fact that the town was "The Egg Basket of the Midwest." Whether a true sculpture or a sizable chunk of roadside kitsch, there is nothing else like it in the state.

The egg, ten feet high and almost eight feet in diameter, was created in 1946.[6]

The Stone Head is Indiana's oldest public sculpture in situ (more or less), but it started out as a functional road marker in hilly Brown County, indicating directions to several nearby towns, some of which today do not exist. Fashioned by Henry Cross (1821–1864), a local stone carver, in payment for his taxes, the stone head is believed to have been one of three that he carved, but the others have not survived. It dates to about 1851 and today is one of the many quaint attractions in the county that tourists flock to see.[7]

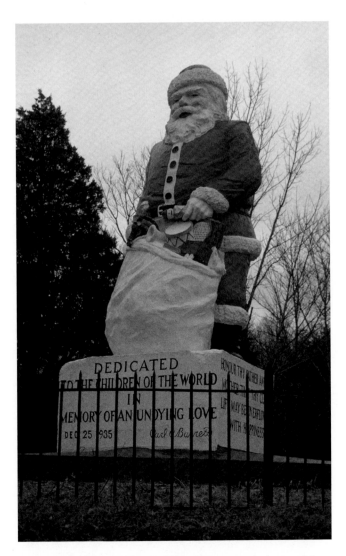

Since 1935 this huge Santa Claus has seen who's naughty or nice in the town of the same name.

Scales and Sheaves, Fountains and Flowers
Allegorical and Aesthetic Public Sculpture

■

SCULPTURE INSTALLED OR APPLIED TO BUILDINGS TO BEAUTIFY THE LANDSCAPE OR streetscape or to edify the viewer with lofty symbols is a centuries-old tradition, but it did not begin to flower in Indiana until the last third of the nineteenth century. The cathedrals of medieval Europe, laden with saints of stone and wood, were three-dimensional documents of morality for a largely illiterate population. In the late nineteenth and early twentieth centuries in Indiana, courthouse sculpture provided lessons in patriotism and history. A number of these magnificent courthouses remain, while others survive only in fragments, their salvaged sculptural ornament displayed in many places as free-standing statuary. Of the state's extant courthouses with significant sculptural ornament, the earliest was constructed in 1874 and the latest in 1911, well into the architectural era of Neoclassical Revival.

The Knox County Courthouse, built in 1874, offers history and ethics, with marble statues of Revolutionary War hero George Rogers Clark (1752–1818) and Justice, as well as limestone reliefs recalling the early days of Vincennes and the state. The Boone County Courthouse in Lebanon, completed in 1911, displays large allegorical figures of

This allegorical figure (opposite page) in Crown Hill Cemetery in Indianapolis once stood high on the Marion County Courthouse.

Agriculture, Industry, and Justice in its pediments. The limestone statues are attributed to architectural sculptor Alexander Sangernebo (1856–1930), whose artistry in stone and terra cotta beautified many buildings in Indianapolis, a good many of which survive. Completed three years earlier, the Monroe County Courthouse in Bloomington was designed by the Fort Wayne firm of Wing and Mahurin. Above the south entrance is the massive sculpture group *Light of the World* by Albert Molnar Sr. centering on a huge Liberty figure brandishing a torch.

A number of courthouses are only a memory. However, some of the sculptural ornaments of these structures linger on as individual pieces, some in bizarre places. The old Marion County Courthouse (1873) in Indianapolis is gone, demolished in 1960, but most of the oversize limestone goddesses that once graced the facade survive, some in better condition than others, in new locations. The three that reside in Crown Hill Cemetery—Themis, Demeter,

and Hebe (or Persephone)—are doing well. Those at Holliday Park are not. The Delaware County Courthouse designed by Brentwood Tolan and completed in 1887 was demolished in 1966. The figures that guarded the east and south entrances, somewhat the worse for wear, now comprise an odd tableau on the edge of a parking lot in downtown Muncie. (The parking lot was where another nineteenth-century building, the Wysor Block, stood. Hence the tiny plot where the statues stand is called Wysor Park.) Carved by Irish-born sculptor John A. Ward, the heavily detailed figures were intended to be seen from below at a distance. Two are female allegorical figures representing Agriculture and Industry; the third is a Delaware chief.

Completed in 1902, the massive Allen County Courthouse in Fort Wayne takes up an entire city block. Walking around it and looking up provides a substantial history lesson, while the sheer number of sculptures boggles the mind. Four continuous sculptural elements in limestone relief (shallow and high) surround the building: pediment figures, a running frieze beneath the cornice, busts, and tympanum figures at the third floor level, along with inscriptions all around at the second floor level. The dome of the courthouse is topped with a copper-sheeted figure of Liberty nearly fourteen feet high.

The former Vanderburgh County Courthouse, on the other hand, completed in 1891, chose themes of enlightenment. Embellished and over the top with cherubs, wreaths, and representative produce and vegetation native to the Ohio Valley, the building displays heroic statues representing Justice, the ubiquitous Agriculture and Industry, Commerce, Learning, and much more, including all of the arts and a grouping called *The Quest for Knowledge and Truth*. The fourteen statues, averaging about twelve feet high, are the work of sculptor Franz Engelsmann. The courthouse served the county until 1969, when the new Civic Center was built.[1]

The sculpture group *Light of the World* (opposite page), by Albert Molnar Sr., dominates the south entrance of the Monroe County Courthouse in Bloomington.

Figures of Justice and Progress dot the cornice of the Clinton County Courthouse in Frankfort.

In the late nineteenth and early twentieth centuries, architectural statuary of metal (zinc, tin, cast iron, and later, sheet copper or sheet bronze) could be ordered from various catalogs, such as J. W. Fiske Ironworks or the J. L. Mott Iron Works, both of New York. The 1882 Clinton County Courthouse in Frankfort, designed by George W. Bunting, was originally adorned with four identical pairs of allegorical figures: a standing Justice above each of the four entrances and a seated Progress holding a cogwheel on each corner tower. They probably came from J. L. Mott. Two Justice figures are now gone, which is more a commentary on the ravages of time and weather than on the victory of progress over justice. The statues are of sheet zinc. The Grant County Courthouse in Marion once had a similar statue of

Justice, most likely a product of the W. H. Mullins Company of Salem, Ohio, dating back to at least 1881 when it was placed on top of the courthouse. The statue was removed from the courthouse in the 1940s and placed in the city's Matter Park, where it was vulnerable to vandalism. In 1980 the city removed the much-abused statue and placed it in storage, but about a decade later decided to junk it. Two local men who saw it on a truck headed to the landfill rescued it, although only the head was salvageable.[2]

Courthouses of the 1890s tended toward the Richardsonian Romanesque style, with heavy massing, rough-faced stone, and round arches, often bordered with a leafy decorative frieze. Frequently there was a face or two peering out of the shrubbery. An early Romanesque-influenced courthouse is that of Gibson County in Princeton, which has faces of humans, animals, and perhaps something in between at various levels. The building was constructed in 1884. Other 1890s courthouses with faces—most often flanking the entrance or forming the keystone above it—are the Pulaski County Courthouse (1894) in Winamac and the Whitley County Courthouse (1890), actually an amalgam of styles, in Columbia City. While the Rush County Courthouse (1896) has faces, it also displays a tribute to agriculture in relief on the cornerstone. The White County Courthouse built in 1894 was destroyed eighty years later by a tornado. The carved keystone, with a face peeking out from intertwining vines, now sits on the old cornerstone as a freestanding sculpture of sorts in front of the present nondescript brick and concrete county building. And finally, one can only wonder what message Wells County commissioners had in mind when they approved the design of their magnificent courthouse completed in 1891, replete with nightmarish grotesques creeping down the corners of the building or peering from the cornices—it is not a building a person wants to pass around midnight!

Courthouses were not the only civic buildings adorned with sculpture, of course. The south entrances to the old Federal Building and Post Office in downtown Indianapolis are flanked by four mammoth allegorical figures in limestone, representing Industry, Agriculture, Literature, and Justice. Completed in 1906, they are the work of Scottish-born John Massey Rhind (1860–1936). An addition on the north of the building, completed in 1938 with funds from the Public Works Administration (PWA), features identical reliefs above the east and west truck entrances by David K. Rubins (1902–1985) of Indianapolis. At first they appear to be abstract, but on closer inspection one finds that the images include highly stylized mail pouches spilling out letters, lightning bolts, and sheaves of wheat and corn.

In Michigan City the La Porte County Superior Court building, built in 1909, is guarded by two Roman soldiers who have held up remarkably well to the winds blowing off the lake. The limestone figures are about eight feet high and stand alertly in mirrored poses. The beautiful Hammond City Hall built about 1931 originally featured three identical pairs of lavish bronze doors with art deco reliefs by Italian-born Alfonso Iannelli (1888–1965), who occasionally worked with Frank Lloyd Wright. The doors were removed in 1976, but happily are displayed inside the library building on the campus of Purdue University Calumet and are visible from outside. Each door centers on a stylized man. On the left door he pushes against a huge cogwheel (representing a worker toiling to meet his physical needs), and on the right he is pulling down on a rope that rings a church bell (representing his toiling to meet his spiritual needs).[3]

In Fort Wayne the Three Rivers Water Filtration Plant, begun in 1931, boasts a series of relief panels, one at the top of each pier, featuring art deco-influenced designs, including a profile of a Native American chief, another of a brave, pairs of exotic fish, an impala or some similar creature, fountains, intricate patterns of grapevines, and several with scenes involving water. As additions were constructed, the carved designs continued, giving consistency to the complex. Wilbur Bybee was the chief designer and carver; it is incredible that so much attention to detail was paid to these very attractive buildings. While they are public structures, people rarely visit a water filtration plant.

Schools and libraries around the turn of the twentieth century often included symbolic ornamentation involving enlightenment. Countless schools throughout the state displayed reliefs with the lamp of learning or a pair of owls, as did libraries. One elaborate terra cotta example displays the head of Athena, flanked by festoons and roundels over the arched entrance, with two cherubs surmounting elaborate cartouches above. Created for the former William Watson Woollen School No. 45 in Indianapolis, completed in 1900, the work is likely that of Alexander Sangernebo, who often worked with the architects Vonnegut and Bohn. Constructed in 1909, the East Washington Street Library in Indianapolis has two gnomish monk figures of terra cotta molded by Sangernebo. They read books as they watch patrons enter the building from perches on either side of the entrance. The former McLean School in Terre Haute, built about 1917, features similar figures that once held lanterns. In Indianapolis an early commission for Robert Davidson (1904–1982), completed in 1929, was to create two large relief panels addressing themes of war and peace for the new Shortridge High School. The result was *The Angel of Victory in Accomplishments* and *The Genius of Learning*. That same year Carl Paul Jennewein (1890–1978) of New York created two terra cotta plaques representing painting and sculpture and additional symbols of the various arts to be placed on the John Herron School of Art's new building. Austrian-born sculptor Rudolf Schwarz (1866–1912) had carved five limestone roundels for the institute's earlier building, completed in 1906. Each was a portrait of a great artist of the past: Rubens, da Vinci, Dürer, Michelangelo, and Velasquez. A series of reliefs depicting stages in the history of Indiana was carved below the cornice of the new Indiana State Library Building in 1934. Designed by Leon Hermant (1866–1936) of Chicago, they were carved by a young Adolph Gustav Wolter (1903–1980), who went on to spend much of his career creating architectural sculpture.[4]

A heroic bronze grouping called *Arts, Sciences, Letters* by German-born sculptor Richard W. Bock (1865–1949) stood atop the old Indianapolis Public Library building constructed a block north of the Circle in Indianapolis in 1892. For most of its life the building was the central office for the School City of Indianapolis. It was torn down in 1967 to make way for a hotel, but the statue group was relocated to Crown Hill Cemetery, which seems to be something of a repository for sculptures that had graced demolished buildings. After thirteen years in the cemetery, the grouping was placed on the west side of the Central Library, the closest thing to a homecoming that could be managed.[5] The piece is in storage at this writing while the library is being enlarged.

Institutions of higher learning were appropriate locations for edifying or instructional embellishment. A number of buildings on the Bloomington campus of Indiana University display sculptures suitable for an institution nestled in the midst of limestone quarries. Memorial Hall has several, dating to 1932, when master stone carver Albert V. McIlveen carved an owl, a professor, and a graduate at the south entrance to the bookstore. The oldest architectural sculptures on campus are the so-called gargoyles (actually, they are grotesques) on Maxwell Hall, which was built in 1890. At Purdue University's Memorial Union Building, California sculptor Frances Rich (b. 1910) carved six pairs of students in relief, displaying various activities typical of campus life in 1939. North Dakota-born Jon Magnus Jonson (1893–1947) carved six heroic allegorical figures in relief on the sides of the new Elliot Hall of Music, completed in 1940.

Most of the pre–World War II classroom buildings and dormitories at the University of Notre Dame have sculpture, much of it in niches that can catch the viewer by surprise. Many of the niches were empty until the university embarked on a program in the 1940s to fill them and enlisted Hungarian-born Eugene Kormendi (1889–1959) and priest-sculptor John J. Bednar (1908–1998) to create statuary. Most of the figures are of saints, but a bit of whimsy was allowed, including two Irish terriers. There is even a figure of the legendary football coach Knute Rockne (1888–1931). At Ball State University, Elmer Harland (E. H.) Daniels (1905–1986) carved several

beautiful reliefs on the new Fine Arts Building in 1936. Most of the older buildings on the campus of Indiana State University are gone, including Reeve Hall, built in 1924, which had exhibited a wealth of lively sculpture. Although the building was demolished in the 1990s, some of the elflike figures were saved and mounted on the salvaged entrance gate that once stood in front of the building.

Theaters grew more ornate in the late nineteenth century and sometimes included sculpture decorating the facades. One such was the Bucklen Opera House in Elkhart, built in 1883 and adorned with a large tin statue of Melpomene, the muse of drama. Although the building was listed in the National Register of Historic Places, it was demolished in 1986. Melpomene was rescued, but she has languished in storage ever since. The Lady of the Grand in Evansville has fared somewhat better. Originally on the Grand Opera House built in 1889, the terra cotta bust graces the sculpture garden of the Evansville Museum of Arts, History and Science. The old Hippodrome Theater in Terre Haute, built in 1915, displays several roundels with protruding lions' heads. Movie palaces continued the grand theater tradition. In Indianapolis both the Circle Theater (1916) and the Indiana Theater (1927) boast the artistry of Alexander Sangernebo on their gleaming white terra cotta facades. The Circle Theater has a more restrained classical frieze of dancing women á la Isadora Duncan, but the Indiana is lavishly covered with all manner of baroque designs, including portrait busts of King Ferdinand and Queen Isabella of Spain—and William Shakespeare.

Fraternal organizations and buildings of similar ilk often displayed symbolic or inspirational sculpture. Not so subtle are the many Elks' lodges that feature a bronze elk's head above the entrance. The Fraternal Order of Eagles' "aeries" often display a large sculpted bird. The one gracing the front yard of Aerie 274 in Brazil, however, was originally perched on the 1877 Clay County Courthouse that was demolished in 1914. The Eagles acquired the bird at that time; today it is prominently displayed at the intersection of US 40 and State Road 59. The

Scottish Rite Cathedral, a lavish temple of Freemasonry built in 1929 near downtown Indianapolis, features various Masonic figures on its main east facade carved by John Baugh and others from the Bybee Stone Company in Ellettsville.

German culture dominated Indianapolis until World War I, and a number of buildings from that heyday still stand. The Southside Turnverein, constructed in 1900, has an exuberant sculpture group on its west pediment, although it has deteriorated to the point of being unrecognizable. Rudolf Schwarz is usually credited with this work. But he was busy with the Soldiers and Sailors Monument at the time, and Sangernebo is as likely a possibility. The glorious Maennerchor Building, constructed in 1906, originally housed an academy of music and later, the Indianapolis Law School of Indiana University. English-born artist Henry Saunders carved its many limestone embellishments, including four medieval elfin or child figures playing musical instruments. Virtually all that was saved when the building was demolished in 1974, the charming figures, each of which protrudes from a volute (a scroll shape), now reside inside the Children's Museum, but unfortunately are not on public display. The Turnverein on North Meridian Street, designed by architect Adolph Scherrer (1847–1925) and built in 1913, displays, appropriately, several caricatured athletes in limestone. The building was converted into housing in the 1980s. While on the subject of athletes carved in stone, those on Perry (later, Bush) Stadium, built in 1931, are worth noting. August A. Marchetti (1887–1944) fashioned the stylized baseball players in keeping with the art deco influence of the structure.

Banks and other commercial structures occasionally were embellished with sculpture. Eagles are a common theme. A good example is the fierce-looking creature in carved limestone on the former Fort Harrison State Bank in Terre Haute. The former First Merchants Bank on the courthouse square in Lafayette displays a small limestone statue of the town's namesake, flanked by two very large winged Victories in relief. The ornate Indiana National Bank, built in 1897 in downtown Indianapolis at

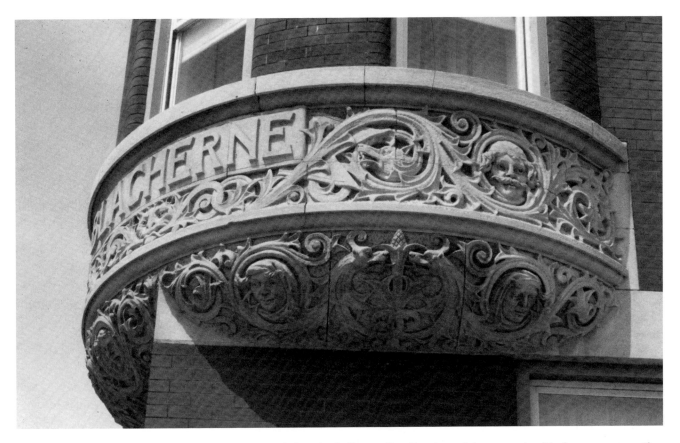

General Lew Wallace owned this apartment building in Indianapolis, its stone trim carved with faces representing characters from his books.

the intersection of Virginia Avenue and Washington Street, boasted an allegorical limestone grouping featuring Mercury and representations of progress and commerce. The work of Henry Saunders, the piece was saved when the old bank was demolished and placed, inappropriately, in the courtyard of the new Indiana National Bank Tower about 1970. After being neglected and ignored by subsequent bank owners, the once impressive sculpture is badly eroded and marred by repeated vandalism. The McKeen Bank Building in downtown Terre Haute, constructed in 1875, featured a zinc alloy statue of Mercury atop its corner dome. When the building was demolished in 1958, the statue was saved and placed on display at the Vigo County Historical Society, where it stood for thirty years. Earlier damage to the supporting ankle ultimately caused collapse, and the unrepaired statue still languishes in storage. Efforts toward restoration, however, are under way.

A few other commercial buildings with notable sculptures include the Blacherne Apartments, built in 1895, on Meridian Street in Indianapolis. The sills and entrance are embellished with characters from the novels of Lew Wallace. He was the author of *Ben-Hur* and owned the building. The carvings are probably the work of Saunders, who did a somewhat similar frieze for Wallace's study, now a museum in Crawfordsville. The Old Trails Building (1928) in downtown Indianapolis is trimmed with beautiful terra cotta work based on various Native American designs, with two chieftains facing each other above the main entrance. Joseph Posey of the Indianapolis Terra Cotta Company modeled the work. The entrance to the Ross Building (1918) on the courthouse square in Lafayette was once lit by lanterns held by two monkish figures in terra cotta. The lanterns are gone, but the whimsical characters remain. The Terminal Arcade in Terre Haute, a former interurban station built in 1911, is rife with

limestone fruits, flowers, garlands, and wreaths fashioned by master carvers J. W. Quayle and Fred Edler.

Street art in the form of elegant light fixtures, fountains, and decorative statuary started to become popular toward the turn of the twentieth century and remained so for several decades. This was the Progressive Era, a time when many cities were developing parks and other civic spaces. The city block that became University Park in Indianapolis originally was to be used for a state university. A seminary opened in 1833 and lasted twenty years, but a university never materialized. After the Civil War the city took over the land for a formal park. In the 1910s funds became available through a legacy, and the city commissioned noted New York sculptor Karl Bitter (1867–1915) to create a centerpiece fountain. Bitter created a joyous bit of fancy with dancing children and fish spewing water but died unexpectedly in an automobile accident in 1915. A. Stirling Calder (1870–1945) stepped in to complete the work, making some slight changes from Bitter's model. Unveiled that same year, the Depew Fountain (named for the donor) was soon the center of controversy because the children were mostly nude. The fountain stayed and has been refurbished a number of times. In Shelbyville George Honig (1874–1962) was commissioned to create a fountain and parklike surroundings for the town square. Quite impressive when it was dedicated in 1923 with plantings, walks, and urns, all that remains of the original fountain is the charming bronze sculpture of three little children. The basin has been replaced, and the truncated fountain is hidden by parked cars much of the time. The city considered the space to be much more valuable as a parking lot. Not a fountain (although it resembles one), the first city beautification project of the Rotary Club in Vincennes still stands. The two-tiered planter, which originally had urns on each side, was designed by architect Louis H. Osterhage and dedicated in 1915.[6]

For cities and towns that did not have the desire—or perhaps the funds—to hire a sculptor, a variety of fountains, along with urns, drinking fountains, light standards, and statuary could be ordered from any number of catalogs. Erected in 1924, the Newtown Fountain on Eads Parkway in Lawrenceburg came from the J. W. Fiske catalog. After years of neglect, the fountain was restored in the 1990s. Woodruff Place, a planned suburb of the 1870s and today an elegant neighborhood of Indianapolis, originally teemed with fountains and sculpture made by the J. L. Mott Iron Works. Three large, multitiered fountains, each different, stood on Cross Drive at the intersections of the community's three long drives. The fortunes of Woodruff Place spiraled downward after the 1920s, and by the 1970s most of the statuary had been stolen, scrapped, or had simply disintegrated. In the late 1970s one of the big fountains was reproduced, and the community gradually turned around. Today the three reproduced fountains along with six smaller ones and numerous pieces of garden statuary grace the revitalized neighborhood.

The landlocked Elkhart County Courthouse in Goshen may seem an unlikely spot for a fountain featuring Poseidon/Neptune. Nevertheless, the classical god of the sea rises, trident poised, from a fountain pool on the grounds. The figure, straight out of the J. L. Mott company catalog, was donated to the city in 1912 by a grateful local confectioner, who had come from Greece as a penniless immigrant less than ten years earlier. Another J. L. Mott fountain is a focal point of the expanded Eckhart Public Library in Auburn. The Eckhart Fountain was originally dedicated in 1912 behind the library; now, refurbished, it is in an attractive courtyard setting.[7]

As ornate and fanciful as it is, the Broadway Fountain in Madison came from a nineteenth-century catalog distributed by the Janes, Kirtland Company. The cast-iron fountain, dating to 1876, was designed by French sculptor J. P. Victor Andre. The present fountain is a bronze recasting, completed in 1980. It is a study in classically inspired excess, with Triton, four times over, spewing water from his horn into the lowest of three basins, sea creatures, cranes, and a goddess on top.[8]

The fashion for garden sculptures and fountains that characterized the decades immediately follow-

Frog Fountain was perhaps the most popular piece created by Terre Haute-born Janet Scudder. This casting now resides in the Swope Museum.

ing the turn of the twentieth century gave more opportunities for commissions to the seeming plethora of female sculptors at work in this period. Many, including Janet Scudder (1869–1940) of Terre Haute, studied with Lorado Taft (1860–1936) in Chicago and found work as assistants in his studio. Scudder alternated between New York and Paris, and her pieces found their way into many gardens of the rich and famous. Her bronze *Frog Fountain* was first purchased by prominent New York architect Stanford White for a house he was designing. The fountain was quite popular and was cast several times. One is on display at the New York Metropolitan Museum of Art

and another in Terre Haute at the Sheldon Swope Art Museum. Still another casting of the piece once graced the clubhouse garden of the Women's Department Club in Indianapolis. Decades after the clubhouse property was sold, the *Frog Fountain* was sold at auction to a private collector in 2002. The Women's Department Club in Terre Haute, however, has thus far kept its Janet Scudder statue. *Boy with Fish* was placed in a fountain in 1941 to create the Janet Scudder Memorial behind the clubhouse. Weather was taking its toll, so the group had the piece restored and moved inside. The Swope Museum is seeking to acquire the work. Until the 1990s Scudder's *Boys at Play* was on the Rose-Hulman campus in Terre Haute, but it was recently reclaimed by the Vigo County Historical Society. Pieces by several other women sculptors who worked in similar genres are scattered around Indiana. Gratitude must be extended to the good taste of the Ball family of Muncie, since works by Harriet W. Frishmuth (1880–1980), Edith Baretto Parsons Stevens (1878–1956), Grace Helen Talbot (1901–1971), Brenda Putnam (1890–1975), and others that once beautified their estates are now on public display, either at Ball State University or the Minnetrista Cultural Center and its adjacent Oakhurst Gardens.

In terms of surviving work in the state, Indianapolis native Myra Reynolds Richards (1882–1934) appears to have been the most successful of the early-twentieth-century women sculptors in Indiana. A pupil of Rudolf Schwarz (1866–1912), she spent much of her career in Indianapolis and was head of the sculpture department at the John Herron Art Institute. During her career Richards fulfilled a number of large commissions in Indiana and elsewhere, created garden pieces, and sculpted numerous commemorative works, including a statue of James Whitcomb Riley. Her finest work in Indiana may be the beautiful allegorical figure *Subjugation*, a memorial to journalist Juliet V. Strauss (1863–1918), erected in Turkey Run State Park. Among her other notable works is the Murphy Memorial Fountain in the courthouse square in Delphi. Dedicated in 1918,

Unfortunately badly eroded, several of these charming scenes of children at play, created by WPA stone carvers in the 1930s, dot Thornton Park in Bedford.

the piece has an appealing figure of a winsome young girl in bronze holding a drinking fountain. In Columbus, *Bird Boy,* a little sculpture of an elflike boy playing a pan flute in a fountain, was commissioned as a memorial to a beloved music teacher and placed in front of Columbus High School in 1924, where it stood for decades. When the school closed, the piece was relocated for a time but is now in storage. Richards had several small public pieces around Indianapolis that were stolen over the years, most notoriously her *Pan* and *Nymph* drinking fountains that once flanked the Depew Fountain in University Park.

So-called garden sculpture was not (and is not) exclusively the realm of women. Indianapolis artist Robert Davidson designed *Eve,* a lovely female nude, while he was studying in Munich in the early 1930s. The Alumni Association of the Indiana University Training School for Nurses purchased the piece as a gift for the school and commissioned Davidson to design a fountain for it, to be placed in a sunken garden at the nurses' residence. It remains today, although its surrounding campus has changed a great deal.[9]

The New Deal of the 1930s brought public art to the fore, and it was art for the people. The skills of many of Indiana's unemployed stone carvers were put

to good use through Works Progress Administration (WPA) projects. Bedford's city parks benefited immensely from the program. The entrance to Wilson Park features decorative urns and other typical garden paraphernalia, and Otis Park has classically inspired musical reliefs on its WPA-built band shell. Thornton Park has several small but exquisite reliefs of various scenes of children at play, which unfortunately are neglected and largely ignored. In Vincennes WPA stone carvers created four different scenes glorifying Indiana's pioneers at the entrances to Kimmel Park.

Aesthetic sculpture exploded in several different directions after World War II, some veering into abstract or other contemporary concepts, which will be discussed in the next chapter. Many sculptors, however, continued to work in traditional modes and themes, while nonetheless clearly showing modern influences. French-born Robert Laurent's (1890–1970) bronze *Birth of Venus,* cast in 1958 and placed three years later in the Showalter Fountain on Indiana University's Bloomington campus, is one example. So is his *Veritas, Filia Temporis* ("Truth, Daughter of Time"), a heroic classically themed relief carved on Ballantine Hall in 1959. Included, too, are more modern aesthetic pieces such as *Reaching* (1987) on the campus of Indiana University South Bend, figurative but exaggerated, suggesting—or perhaps hoping to inspire—student aspirations. A quite different work of the same title, *Reaching* by Zenos Frudakis (b. 1951) of Philadelphia may foster entirely dissimilar suggestions, yet it still maintains ties to earlier traditions of sculpture. In this piece, Frudakis has placed two bronze nudes, a male and a female, horizontally on separate poles, causing the figures to move with the wind, surely a commentary on the ebb and flow of communication and intimacy in relationships. The sculpture resides in a linear courtyard beside an office building on Illinois Street in downtown Indianapolis. In a companion piece of sorts, a bronze nude male called *Flying* is on the other side of the building. Both pieces were installed in 1987.

Contemporary sculptors in Indiana creating traditional aesthetic pieces—but often with a modern

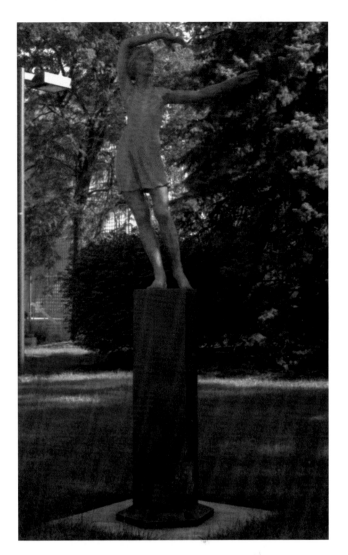

Tuck Langland's *Dance of the Awakening Day* on the campus of Indiana University Northwest in Gary.

twist—include Harold R. "Tuck" Langland (b. 1939), professor emeritus of art at Indiana University South Bend, and Kenneth G. Ryden (b. 1945), who teaches at Anderson University. Langland's work, so obviously influenced by the dance, has an element of spark and movement that sets it apart. He has fashioned an entire series of allegorical dancers, although only one has been installed in Indiana, *Dance of the Awakening Day,* erected on the campus of Indiana University Northwest in Gary in 2000. The piece shows a young girl poised at the beginning of life. In another series Langland has created allegorical figures of the seasons that also speak poignantly of life. Again, only one has found

a home in Indiana, *Autumn,* which shows a mature woman studying her reflection in a mirror. The piece was installed in Portland in 1990, and town boosters had hoped to erect her three companion pieces in the future.[10]

Ryden has produced several fine commemorative works in bronze, but his aesthetic pieces have a quality that seems to combine human characteristics with something almost mystical, while trying to capture the element of inspiration. Such a work is *Illumination,* erected in front of the new Daleville Community Library in 1998, depicting a spritelike creature poised on one toe on a stack of books, gazing at the light she holds aloft. *Compassion,* an angel figure Ryden created for Anderson Memorial Park Cemetery, expresses both comfort and hope. In downtown Anderson is the sculptor's contemporary take on a favorite classical theme, *The Graces,* a focal point of the city's emerging arts and theater district.

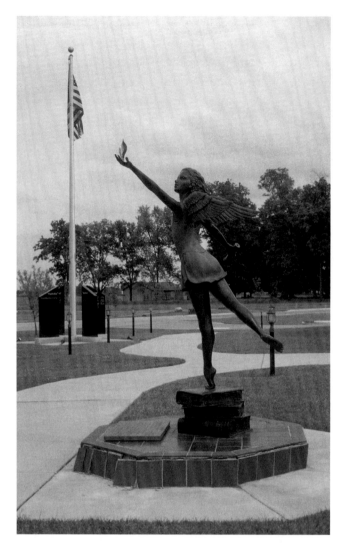

Illumination by Ken Ryden stands in front of the Daleville Community Library.

What Is That Supposed to Be?
Public Encounters with Contemporary Sculpture

■

HOOSIERS DID NOT COME FACE-TO-FACE WITH LARGE ABSTRACT PIECES OF OUTDOOR sculpture until long after World War II, and such experiences seldom occurred beyond the confines of art museums. Art museums were the harbingers of contemporary sculpture in Indiana, and as more museums were established throughout the state, many erected at least one piece outside their doors. Some even began the rudiments

of a sculpture garden. The Evansville Museum of Arts and Sciences (today, Museum of Arts, History and Science) opened near downtown at a turn of the Ohio River in 1959. It began to acquire pieces for its outdoor sculpture garden from its inception and now boasts a pleasing collection of abstract works. Among the museum's first acquisitions was *Earth Mother,* a marble work reminiscent of the carvings of prehistoric peoples by Chicago artist Abbott Pattison (1916–1999). The museum's outdoor sculpture holdings now include the marble *Pink Torso* by Seth Velsey (1903–1967), who was born in Logansport, and the architectural abstract *The Planes of Nature* by Don Gummer (b. 1946), who was raised in Indianapolis and attended John Herron Art Institute.

The largest permanent collection of outdoor sculpture is that of the Indianapolis Museum of Art (IMA), which for years displayed its acquisitions on fifty-two beautifully landscaped acres. The museum is creating an art and nature garden on undeveloped

land on the opposite side of the Indianapolis Water Company Canal, which will boast both permanent and temporary pieces. The IMA's first acquisition was Robert Indiana's Cor-Ten steel version of his famous block-letter piece *LOVE.* After more than thirty years as the museum's signature outdoor work, the piece will be moved inside when the current expansion project is completed. The IMA opened in its present location in 1970 with a temporary exhibition of outdoor sculpture called "Seven Outside." Although some of those pieces were purchased and are now part of the permanent collection, the museum has often used its broad spaces for temporary installations.

The Fort Wayne Museum of Art, which opened in 1984, began with a small but significant collection of outdoor sculpture, starting with *Crossings* by Massachusetts-born David Evans Black (b. 1928), an eighteen-foot white-coated aluminum structural piece. Within two years it was joined by two monu-

The massive *Helmholtz* by Mark diSuvero stands in Freimann Square near the Fort Wayne Museum of Art.

mental steel works donated to the museum by the Alcoa Foundation on behalf of the Rea Magnet Wire Company. *Quake* by Wyoming-born Peter Forakis (b. 1927) is bright red, geometric, and suggestive of its name. The second piece was donated in part by the artist himself, the internationally acclaimed Mark diSuvero (b. 1933). *Helmholtz,* a bolted assemblage of geometric forms rising twenty-three feet in height, was completed in 1985 and erected at the museum the following year. There are smaller pieces on the grounds as well.

Among the first locations that contemporary public sculpture was publicly displayed in Indiana was the historic town of New Harmony, which today maintains a fascinating juxtaposition of modern works of art and architecture with some of the oldest extant buildings in the state. The town's walk on this cultural tightrope began in 1960 with a piece by Jacques Lipchitz (1891–1973) underneath the curve of Philip Johnson's (b. 1906) Roofless

Church. Pure abstracts such as the terra cotta *Arch* (1971) by New York sculptor Bruno La Verdiere (b. 1937) joined the collection that grew to include harmonious contemplative pieces alongside others that jar or even disturb, such as *Pietà* by internationally known sculptor Stephen DeStaebler (b. 1933). The common thread of a spiritual theme ties most of the disparate works together.

Similarly, the town of Columbus, sometimes labeled the "Athens of Indiana," balances its late-nineteenth-century commercial main street with modern and often controversial architecture and sculpture created by world-famous artists. The first public outdoor artwork was dedicated in 1971, created by one of the guiding lights of modern monumental sculpture, Englishman Henry Moore (1898–1986). His huge bronze work, simply called *Large Arch,* suggests Stonehenge, from which the artist took his inspiration. The stunning work stands in the Library Plaza on Fifth Street. The library itself

was designed by world-famous architect I. M. Pei (b. 1917), who recommended that Moore be commissioned for the sculpture. With the help of federal and state funds for the arts, local artist Richard (Ric) Bauer became sculptor-in-residence in the late 1970s for the Columbus Parks and Recreation Department. Among his projects was the city's second monumental sculpture, *Skopos,* erected in 1979 in Mill Race Park. A hulking abstract of Cor-Ten steel fifteen feet high, the piece is angular and has a sense of massiveness, yet with something of an organic quality. New contemporary works continue to appear regularly in Columbus. Among the most recent is *Acier Roole 2 Arcs de 212.5 Degrees,* a C-shaped work of rolled steel by French artist Bernar Venet (b. 1941), erected in 1998.

Almost tentatively, starting in the late 1960s and early 1970s, a few odd works began to appear on college campuses—places where one might expect to find the embodiment of new ideas. Among those at the forefront was Indiana University, where world-renowned artist Alexander Calder (1898–1976) erected his huge stabile, *Peau Rouge Indiana,* in front of the Musical Arts Center in 1970. Forty feet high and of bright red steel, the piece was a bold statement for that time and place. Another early abstract piece appeared in 1965 on the new Kokomo Regional Campus of Indiana University, *Phoenix Rising from the Ashes,* by local sculptor Robert E. Hamilton—not so huge and bright as the Calder piece, but bold, nonetheless, for a small central Indiana city in the mid-1960s. Sculptor Harold R. "Tuck" Langland (b. 1939) came to Indiana University South Bend in 1971 and within two years graced the campus with an abstract work of steel called *Ring Ribbons II.* By the mid-1970s most state universities, as well as many private campuses in Indiana, most notably the University of Notre Dame, displayed one or more contemporary outdoor pieces.

Corporate funding of art has had a long history of donations to museums and other institutions, but in Indiana in the 1970s a number of companies began to seek out artists to create outdoor pieces for their businesses or corporate headquarters, an activ-

ity that greatly increased in the 1980s. Among the earliest to install a work in a public place was Jefferson National Life Insurance Company, which commissioned Seattle artist George Tsutakawa (1910–1997) to create *Obos,* a bronze water sculpture, for its new Jefferson Plaza in downtown Indianapolis in 1971. The pocket park, on the site of a nineteenth-century bank that had been demolished the previous year, set off the insurance company's new quarters. The work is twenty feet high and, when the water is turned off, has a very oriental appearance, befitting its Tibetan name.

Some Indiana businesses support modern outdoor sculpture in quantity. Lincoln National Life in Fort Wayne began its collection of contemporary outdoor sculpture in 1978 with a piece by South Bend-born George Rickey (1907–2002). Rickey's kinetic *Two Open Rectangles Eccentric, Variation IV* consists of two long open rectangles fastened to slender uprights in such a way that the rectangles move in the slightest breeze.

In the 1970s Borns Associates in Indianapolis developed two suburban apartment complexes in the northern reaches of the county, and Robert Borns commissioned Gary Freeman (b. 1937) to create sculptures to be placed about the residential properties. Freeman, head of the sculpture department at the Herron School of Art, and several of his students erected monumental pieces that gave residents the effect of living in a contemporary sculpture garden. Other developers were not inspired by Borns's bold idea, however, and when one of the complexes was sold the new owner wanted the sculptures removed. Most of them were relocated to Pickwick Farms, which is still owned by Borns Management. More recently, Celadon Trucking, on the far east side of Indianapolis, entered into a partnership arrangement with Herron, wherein students compete for commissions to install permanent pieces in an outdoor sculpture gallery on the corporation's property. The first artworks were placed in 1999. Celadon's CEO, Steve Russell, believes that "art makes people feel better about where they work. It adds a degree of thought and character."[1]

Prominently displayed in front of the New Albany-Floyd County Public Library, Barney Bright's *The Search* (1984) still evokes comments after all these years.

In the 1970s individual contemporary pieces began to appear in publicly owned spaces and in front of civic buildings. Louisville artist Barney Bright's (1927–1997) wriggling work of bronze, meant to suggest the Devonian era, whose fossils are found in the region, was erected in front of the new public library in Jeffersonville in 1970. *Quaestio Librae,* a twenty-five-foot work of painted steel, was accepted by the city of Indianapolis to be erected in front of the City-County Building in 1975. The artist in this case was local; Jerry Dane Sanders taught at an outlying high school but left the state not long after his artwork was installed. Mark diSuvero's *Keepers of the Fire* was extremely controversial when it was erected in 1980 in the middle of the Saint Joseph River near South Bend's Century Center. The project had been conceived before the building was completed but was not installed until three years after the convention and exhibition building opened. Constructed

of bright orange-painted steel, the kinetic work rises thirty-two feet above its concrete platform in the river. The glass wall of the Century Center facing the water brings the work visually into the building, and its color and size make it hard to miss from any of several bridges. The title is a tribute to the native peoples of the region; it is the English translation of Potawatomi.

A plethora of abstract sculpture appeared in Indiana—and nationwide—as federal funding through the National Endowment for the Arts and the Artists Development Project of CETA (Comprehensive Employment and Training Act) became available in the 1970s. *Skopos* in Columbus was funded partly through CETA. So was *Man of Steel,* which was erected in Hammond's Harrison Park in 1976. The twenty-five-foot-high steel abstract bust was created by German-born Hermann Gurfinkel (1916–2004).

Erected in 1976, Hermann Gurfinkel's massive *Man of Steel* lurks in Harrison Park in Hammond.

The General Services Administration of the federal government initiated a program in 1963 that set aside one half percent (since reduced) of funding for new federal buildings to be used for art commissions. Under this program New York artist Ed McGowin (b. 1938) created an interesting terra cotta sculpture in 1985 for the Roudebush Veterans Administration Medical Center in Indianapolis. A decade later the piece, largely disliked by the patients and the employees of the hospital, was dismantled to make way for a subsequent expansion. The work, which detractors likened to a smokestack, was a hollow column covered with small figures running up a spiral all around the piece.[2]

Politics and art rarely make for a compatible mix. In 1988 New York artist Dennis Adams designed a public project, as much architecture as sculpture, called *Twin Gazebos* for Evansville. Adams made every effort to involve the community and spent considerable time in Evansville getting to know the area and its people. He was especially careful to do so after Don Gummer's work at the Evansville Museum received an icy reception the year before and was greatly downsized from its original monumental concept. Adams's efforts were to no avail. The mayor called a halt to the project, even though a public panel had chosen Adams's design. As a result the city lost the $30,000 grant from the National Endowment for the Arts (NEA), which the mayor's office had sought and won. The project chosen in its stead was a commemorative work rendered in a contemporary manner, but no new NEA funds were forthcoming, and the city agreed to cover only the cost of the site preparation. The artist Amy Musia and her supporters had to raise the money themselves to fabricate and erect the work.[3]

Indianapolis sculptor Jan Martin's piece *Symphony #1,* a monumental abstract work fashioned of various shapes of stainless steel and cable that from certain angles suggested a clipper ship, was completed in 1985 on the east bank of the Indianapolis Water Company Canal north of downtown. Ten years later the city acquired the property and demolished the four-ton work without notifying Martin of its intent. Martin sued the city under the 1989 federal Visual Artists' Rights Act, which requires that artwork of "recognized stature"—*Symphony #1* had won awards and was widely known in the arts community—may not be destroyed without notifying the artist. He won a landmark decision in the federal Circuit Court of Appeals in 1999 and was awarded material costs and legal fees.[4]

The problem with some contemporary outdoor sculpture is that it often has no relationship to its surroundings, apart from a jarring one. In this manner it shares the same problem as some modern architecture, making a statement without regard to its con-

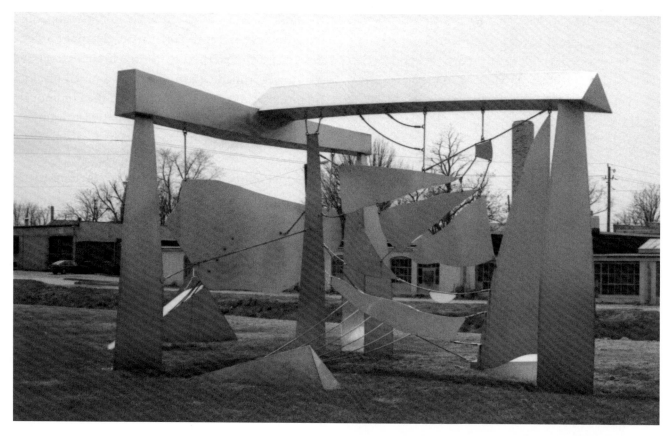

The destruction of Jan Martin's *Symphony #1* resulted in a landmark court decision recognizing the value of public art.

text or its audience. It is one thing when a piece is in a gallery or museum, where one may expect to be confronted with art. It is quite another when a work is installed in a public place where people are forced to encounter the piece—perhaps on a regular or even constant basis—whether they want to or not.

Contemporary sculpture is most sensitive to being out of place. The same piece, in a more suitable setting, might be better appreciated by a greater number of viewers. But as Indianapolis architect Wayne Schmidt noted in 1983, "all too often a sculpture is designed, and then we try to find a place to put it. . . . It's more important to find a place that sculpture can enhance. Then you find a sculptor who can work within that context." Gummer certainly tried in Evansville, believing that "outdoor public sculpture is not an isolated object totally sufficient unto itself. It . . . derives much of its character from the environment that embraces it." Those beliefs, however, did not stop his piece from

being downsized from its original concept because of unfavorable public reaction.[5]

Not all modern sculptors would agree with Schmidt and Gummer in any case. Artists and arts writers differ on whether public art should ever be confrontational, and some even wonder whether contemporary art should be placed in a public setting at all. Anderson artist Kenneth G. Ryden (b. 1945), who renders modern interpretations of aesthetic representational art, believes "there is a need to make art inviting to everyone and to make it diverse so that it reaches a larger segment of people." Sculptor Don Robertson thinks contemporary abstract art is suitable for the street but believes public art should complement the architectural environment. His twenty-five-foot steel monolith *Trigonum* would appear out of place in a historic setting but is very much at home amidst the faceless office buildings of Keystone at the Crossing on the far north side of Indianapolis. Mark diSuvero, on

the other hand, makes bold artistic statements that often clash visually with their surroundings. His *Keepers of the Fire,* despite its name, does not evoke thoughts of Potawatomi Indians. At the same time, the piece is adjacent to a very contemporary building, the Century Center, which also houses the South Bend Regional Museum of Art. Far more controversial was his *Snowplow,* a work of found materials that started out in downtown Indianapolis but was so widely reviled that it seldom remained in one location more than a few years. It finally found a home at the Indianapolis Museum of Art.[6]

In 1983, on the brink of an avalanche of public sculpture throughout the state, arts commentator Martha Winans wrote, "Public art that reacts to particular features of a place, whether temporal, geological, social, or historical, is extremely effective and locally relevant." No one could agree more than David Jemerson Young of 2nd Globe, who strives to create what he sometimes refers to as "indigenous art" that incorporates "the genetic code" of its site and works carefully to choose what is the appropriate medium for a specific project on a specific site. Nowhere is this philosophy more fully realized than at the new Indiana State Museum, where Young,

with his partner in 2nd Globe (a sculpture design company whose mission is "merging art and commerce"), Jeff Laramore, created the *92 County Walk.* Longtime creative partners in an advertising agency, the two artists split the workload, each taking forty-six counties for which to create designs. On, above, and adjacent to the exterior walls of the museum are ninety-two distinct sculptures in a variety of media, each one a separate work unto itself, but as a whole forming a composite—and often whimsical—view of Indiana's counties. Each piece is an abstraction—or at least a very contemporary interpretation—of two or three aspects of a county's identity, which might be anything as general as agricultural tradition or natural resources to historical events or personages. Often a material that is identified with the county is incorporated in that county's sculpture, such as glass in the piece representing Delaware County, birthplace of the Ball jar.[7]

Some abstract pieces are more "abstract" than others. Certain works are clearly derived from recognizable forms and represent an alternative way of viewing something familiar. An example might be William King's (b. 1925) *Dance in the Fountain* (1980) in Fort Wayne, an exuberant piece using

Flowing River is one of several contemporary pieces in the sculpture garden at the Evansville Museum of Arts, History and Science.

other. Other abstract pieces are completely nonobjective, which is to say that they do not represent anything tangible in form. But even these range from works that are intended to be evocative of an abstract idea, such as S. Thomas Scarff's (b. 1932) *A Light Unto All Nations* (1997) in front of the Sinai Temple in Michigan City, to those designed to be considered for their shape or interplay of form and space, such as Rickey's *Two Open Triangles, Up Gyratory IV* (1986) at Temple Beth-El in South Bend.

Some viewers find abstract art not only difficult to understand but also seem to find it offensive. Beauty—or lack of it—is in the eye of the beholder, of course, but while some nonobjective works use

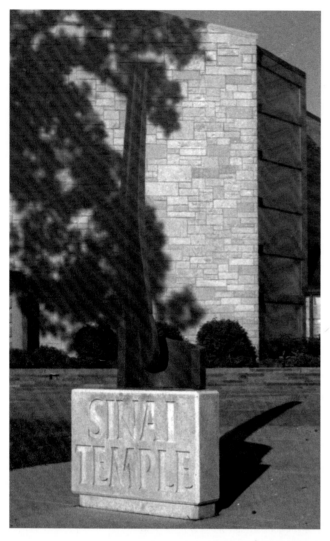

Tom Scarff's bronze-and-neon *A Light Unto All Nations* graces the Sinai Temple in Michigan City.

stylized but recognizable human figures. Or, artists might take one or more aspects of an object or scene and translate the line or shape into an unrelated medium. Evansville sculptor John McNaughton's *Flowing River* (1976), a curving piece of steel that evokes the bends of the nearby Ohio River, might be one such work. Bruce White's *Twister* (1986) on the campus of Purdue University Calumet creates the terrifying vision of looking through the doorway and seeing a tornado coming, reducing it into minimal outlines of painted blue steel. Some pieces are vaguely symbolic. Marcia Wood's (1933–2000) *Avec Compassion,* installed in front of La Porte Hospital in 1982, suggests two crosses bending toward each

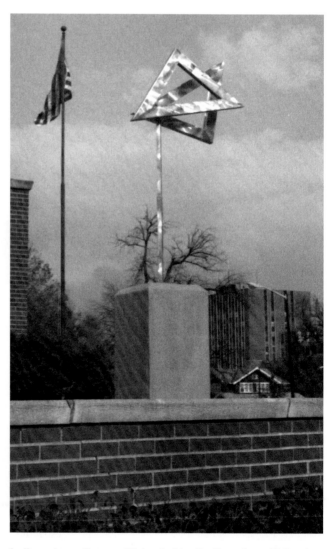

Indiana-born George Rickey's kinetic *Two Open Triangles, Up Gyratory IV* dances before a synagogue in South Bend.

pleasing textures and harmonious shapes, others do set out to make a statement—sometimes a very boisterous and disturbing one. Still, as Young puts it, while art may "reveal truth that is unpleasant," it should "not belittle the viewer."[8]

Indeed, it is incredibly difficult to label modern sculpture. Some artists, of course, continue to work in traditional representational modes, which does not mean that everything else being created is abstract, even though it may not be representational. The rules, bent long before World War II, have been tossed aside. Some artists try to express the inherent qualities of the material with which they are working, while others try to make it do or express unexpected qualities.

Some contemporary sculptors work with natural materials, celebrating their essence and timelessness. Dale Enochs (b. 1952) of Bloomington, for example, works mostly with limestone and often covers it with intricate carvings or embeds the stone with designs of copper or bronze. Enochs believes that "the voice of the stone plays an integral part in the making of my work," which has been described as a "delicate Stonehenge." Amy Brier (b. 1960), also of Bloomington, carves the forms of nature into the surfaces of limestone shapes, such as her *The Four Seasons* spheres at White River Gardens in Indianapolis. In his environmental sculptures near Spencer and Bloomington, Marc Wallis used the earth itself, as well as large chunks of limestone straight from the quarry. Wallis works in other media as well but has created a number of additional environmental works for private commissions.[9]

Other artists prefer to experiment with new materials or traditional media used in new ways. John Mishler of Goshen fashions monumental pieces that are abstract yet evocative, such as his *Thunder Dance* in downtown Elkhart, with its zigzag suggesting a lightning bolt. Using scrap metal almost exclusively, Mishler's works are colorful or shiny or both and generally have a kinetic element. So, too, do most of the works of Michigan City's Tom Scarff, who has his studio in Chicago, although his pieces, usually of stainless steel or alu-

minum, move more subtly. Many of Scarff's recent works have incorporated neon, giving distinct nighttime and daylight appearances.

The ballyhoo of the Millennium celebrated in and around the year 2000 stimulated several sculpture projects around the state. There are the traditional (the Hamilton Women Memorial in Fort Wayne's Headwaters Park, the whimsical C. R. Schiefer's *Faces of Indiana for the Millennium* in Indianapolis), and others that are boldly contemporary and outsized in scale. Both the *Hammond Rotunda* and Anderson's *Crystal Arch* are arguably as much architecture as sculpture, but both were created by sculptors. David Black was commissioned for the Hammond project, which was completed in the summer of 1999 and is essentially an imaginative and gigantic fountain. It is an open dome supported on polished granite columns, rising to a height of nearly thirty feet, around and through which water cascades. Stark white by day, the piece takes on an even more dramatic appearance at night with special lighting. The location of the *Hammond Rotunda* is significant: downtown in the city's emerging arts district. The *Crystal Arch* in downtown Anderson was dedicated in November 2001 and was more than five years in the making. The chief artists were Arlon Bayliss (b. 1957), who specializes in glass sculpture, and Jason Knapp (b. 1951), both of Anderson University, but the project was a community collaboration. The work is a fifteen-foot skewed arch with a stainless steel framework clad in sheet glass. Within the transparent wall are 360 diamond-shaped forms of blown glass engraved with names, events, and places relating to the history of the county, each lit with fiber optics. By night or day it is a stunning sight.[10]

A recent trend that has exposed more of the general public to contemporary monumental sculpture is the concept of large-scale outdoor temporary exhibitions that remain in place a year or more in unexpected locations. NiSource, a huge power company headquartered in Merrillville, held a yearlong outdoor sculpture exhibition on its property, ending in September 2001. The South Bend Regional

David Black's *Hammond Rotunda* was a Millennium project to stimulate the growth of an arts district downtown.

Airport began its *Sculpture at the Airport* program in 1998. Every two years nine pieces are selected from regional artists' submissions. The winners are installed along the winding drive leading from the entrance to the terminal and out again. The building serves not only the airport but also is a bus depot and the eastern terminus of the state's last interurban electric train, the South Shore and South Bend Railroad, offering tremendous public exposure to the pieces.[11]

In 1999 White River State Park, adjacent to downtown Indianapolis, began its annual *Sculpture in the Park* exhibition. Indiana sculptors submit slides of their work, and approximately six pieces are selected each year to be artfully installed on the old Washington Street bridge (now for pedestrians only) across White River. Artists receive compensation. Just as in a gallery exhibition, the pieces are for sale, and some have found permanent homes, such as Matthew Berg's (b. 1970) *Bear,* now in Eagle Creek

Park on the city's northwest side. But in the main, the project is intended to showcase Indiana sculptors to out-of-state visitors as well as Hoosiers.[12]

The *Odyssey* project began in 1999 on the campus of Purdue University North Central just south of Michigan City and is curated by Tom Scarff. Each year about ten large contemporary pieces, chosen from submissions by regional artists, are exhibited on campus, open to the public for drive-by viewing or more careful examination on foot. The pieces in the exhibition are available for sale. The trend is growing, and there are many similar projects being planned throughout the state.[13]

Outdoor contemporary sculpture on public display in Indiana largely began on college campuses. With something of a new twist, two different programs on the campus of Indiana University–Purdue University Indianapolis began in the late 1990s. The University College held its first call for sculpture entries in 1998, seeking submissions from students

and alumni of the Herron School of Art. The winning entries are installed around the University College building and remain in place for three years. The Campus Arts Committee dips into the same pool of artistic talent for works to be displayed on campus. The winners receive a stipend, and the pieces are exhibited for two years. The result is that there are generally eight to twelve works of contemporary sculpture on campus at any given time.[14]

In many ways the University of Notre Dame was ahead of the trend because for several years it has provided spaces to exhibit student-created outdoor sculpture on a rotating basis outside Riley Hall. The sculptures are located near the Snite Museum of Art and the Ivan Mestrovic (1883–1962) pieces that thousands come to see, thus giving the student work extra exposure.

In the last decade there has been an explosion of public art. Today it is scarcely necessary to visit a museum or gallery to encounter sculpture, even in small towns. Communities such as Connersville and Batesville have a strong art base, starting, happily, with programs in the schools. In both communities schoolchildren work with professional artists to create permanent public sculptures that are bright and contemporary with a local identity. The concept of community art, in which professional artists work with students, parents, and teachers and materials and labor are donated by the local community, seemed to appear full blown in the 1990s. One can find no greater advocate in the state than Joe LaMantia, who insists he is a collaborative artist. He works with schools and youth groups around the state, helping in the early stages to create workable design ideas, taking the concepts and turning them into measured charts and plans, and coming in for an intensive two-week period to work with the students and their adult

An emerging urban neighborhood in Indianapolis received a grant to fund a sculpture for its new park. *Play* by local artist Lars Jonker brightens tiny Hendricks Park just south of downtown.

helpers. Then LaMantia, who lives in Bloomington, is off to another project, leaving in his wake a permanent piece of art that truly belongs to and reflects the community. Not-for-profit groups such as Very Special Arts and Young Audiences of Indiana have helped create direct encounters between children and art—and the artists themselves, including sculptors. Historic Landmarks Foundation of Indiana offers a *Study Outdoor Sculpture* education resource kit available free for classroom use in grades four through eight anywhere in the state. Such programs will aid in creating future audiences that will be well educated and better equipped to appreciate contemporary public art.[15] For a viewer to appreciate a work fully, it helps not only to have been exposed to art but also to understand the processes involved in creating it.

At the beginning of the twenty-first century new artworks in new and unexpected places continue to surface ever more frequently. All to the good, Martha Winans would say, for as she once wrote, "A significant point to be made for placing art in heavily trafficked areas is that it catches people by surprise and allows an aesthetic experience to occur where people are, not just in the isolation of a gallery or museum."[16] Art lives.

Outdoor Sculpture around the State
A County-by-County Odyssey

Crossings by David Evans Black is one of several monumental pieces in the vicinity of the Fort Wayne Museum of Art.

Decatur's Peace Monument stands in the courthouse square.

ADAMS

ALLEN

Largely rural, Adams County has little public sculpture but is graced with the first Peace Monument in Indiana in the courthouse square in Decatur. The piece is also called the Soldiers' Monument, as it was dedicated to the soldiers of "all our wars. It represents Peace, for which they fought." Ironically, the monument was dedicated in 1913, not long before the start of World War I. The work is by Irish-born Charles J. Mulligan (1866–1916), who was head of the sculpture department at the Art Institute of Chicago. Saint Mary of the Assumption Church, to the west of the courthouse square, displays a heroic relief sculpture in limestone of its namesake.[1]

At Woodcrest Commons, a retirement community in Decatur, is a five-foot-high limestone piece by Dale Enochs (b. 1952) of Bloomington. *Haiku* was installed in 1998.[2]

Allen County contains the third largest accumulation of outdoor sculpture in Indiana, nearly all of it within Fort Wayne's city limits. It has the state's largest number of traditional commemorative statues in park settings. Several of the city's parks boast at least one; Memorial Park has three. The largest is the statue of General Anthony Wayne (1745–1796) on horseback by Chicago sculptor George Etienne Ganiere (1865–1935). Twenty feet high, it was originally—and properly—set on a substantial twelve-foot base and dedicated in little Hayden Park in front of Harmar School on July 4, 1918. A parade with five thousand participants preceded the ceremony; the principal speaker was vice president and Indiana native Thomas Marshall. In 1973 the city decided that the statue should be in a more prominent location downtown. The statue, but not its

The heroic statue of Anthony Wayne astride his prancing horse in Freimann Square.

granite base, was moved to Freimann Square. The mighty work, designed to be viewed from below, now stands ignominiously and perilously on a low concrete base, where it is often climbed upon and has sustained unintentional damage as well as vandalism. Its original base, which displayed a number of bronze reliefs, including portraits of Little Turtle and Tecumseh, remained behind and was later removed. On the Anthony Wayne Building downtown, completed in 1963 at the corner of Berry and Clinton streets, is a six-foot-high, cast-aluminum relief patterned after the sculpture.[3]

Frederick C. Hibbard (1881–1950) of Chicago modeled several of Fort Wayne's movers and shakers. His earliest is the bronze bust of civic leader Perry Randall (1847–1916), erected in Swinney Park the year of his death. Six years later, at the same park, Hibbard's bronze statue of David N. Foster (1841–1934), a developer, businessman, and president of the city's Board of Park Commissioners, was dedicated in gratitude for his service to the commu-

nity. He and his brother Samuel donated Foster Park to the city in 1909, which may seem to have been a more logical site for the monument. In Lakeside Park is Hibbard's statue of Major General Henry W. Lawton (1843–1899), who had been a student at Fort Wayne Methodist Episcopal College but left school to fight in the Civil War, receiving the Congressional Medal of Honor for his actions during the Battle of Atlanta in 1864. Lawton made a career of the military and was killed by a sniper's bullet in 1899 in the Philippines in the aftermath of the Spanish-American War. The statue, more than ten feet high, was dedicated in 1921. In 1930 Hibbard created a lovely aesthetic statue of cast stone as a memorial to the veterans of World War I and former Fort Wayne resident Olen J. Pond. Pond's widow donated the funds for the piece, erected in Memorial Park. *Memory* is a figure of a provocatively draped woman that was originally flanked by two drinking fountains and backed by a semicircle of trees. The fountains are gone, the trees now obscure

Fort Wayne's parks are filled with statues, such as this of community leader David Foster in Swinney Park.

Company of Louisville. Flanking the middle arch are two life-size bronze figures by Owen County sculptor Ernest Moore Viquesney (1876–1946), *The Spirit of the American Doughboy* and *The Spirit of the American Navy*. The doughboy was very popular, and casts of it are found all around the country; Indiana has eleven. However, this is the only example of the navy statue, which was intended as a companion piece to the army figure, in the state.

Lawton Park—originally known as North Side Park but renamed in 1900—does not contain a statue of Major General Lawton, but a Civil War Monument dedicated in 1893. The bronze figure depicts Liberty crowning a kneeling Union soldier with a laurel wreath. In Orff Park, a tiny patch in the

The nostalgia for boyhood fun is captured in stone in the *Old Aqueduct Club Memorial.*

the statue, and the statue's head was knocked off the figure in 1990. Memorial Park also contains *The Spirit of Flight,* a memorial to Art Smith (1890–1926), a pioneer aviator from Fort Wayne, who was killed while flying in the United States Air Mail Service. Created by New York sculptor James S. J. Novelli (1885–1940), it was dedicated in 1928, two years after Smith's death. The heroic figure of an aviator who has sprouted wings stands poised atop a column more than twenty feet high, and the base displays four bronze relief plaques with themes of transportation and mail. That same year the Allen County World War Memorial was dedicated in the park, an impressive triple-arched structure designed by John K. Shawvan of the Muldoon Monument

900 block of West Main Street, is a whimsical bit of history captured in stone, the *Old Aqueduct Club Memorial,* erected in 1927. It depicts two barefoot boys of the mid-nineteenth century, typical of the youngsters who had once gone swimming in the wooden aqueduct that carried the Wabash and Erie Canal across the Saint Marys River. The structure was removed in 1880, and in 1912 a group of businessmen, feeling nostalgia for their former "swimming pool," organized the club and fifteen years later erected this memorial. A limestone lion guards Lions Park, established by the Lions Club in 1953. The Franke family donated the beast at that time.

Local sculptor Hector Garcia (b. 1933), a professor emeritus of art at Indiana University–Purdue University Fort Wayne, has created a number of commemorative bronze works. One of two that he did in 1976 is a statue of a Jesuit, representative of the black-robed priests that came to this area with the French traders in the eighteenth century, which stands outside the Three Rivers Water Filtration Plant, where the Saint Marys and Saint Joseph rivers conjoin to form the Maumee River. More than seven feet high on a tall pedestal, the figure, hand pointing to indicate the confluence, is best seen from across the river. Later in the year Garcia's even larger statue of Little Turtle, or Me-She-Kin-No-Quah, the chief of the Miami Nation, was dedicated near the entrance to Old Fort Wayne, a living history museum. After the facility closed, the statue of Little Turtle was moved across the river to the new Headwaters Park. In 1985 Garcia sculpted a bronze bust of John Nuckols, a prominent district councilman and activist. The likeness sits upon a pedestal of Indiana limestone in Harmar Park, where the equestrian statue of Anthony Wayne once stood. The park was renamed John Nuckols Park when the bust was dedicated there.

The tradition of honoring the community's best by rendering likenesses in bronze continues into the new millennium. A piece in Headwaters Park memorializes the Hamilton women. Sisters Edith and Alice and their cousin Agnes were descendants of Fort Wayne pioneers. A Hoosier Millennium Project, the three statues, set apart in a landscaped triangular area, are the work of Anthony Frudakis (b. 1953) and were unveiled in fall 2000. Edith (1867–1963), the classical historian best known for her work *The Greek Way,* is portrayed as writing. Alice (1869–1970), a doctor renowned for her efforts in industrial medicine, is often considered the "mother of OSHA" and stands in her lab coat. Agnes was an artist and humanitarian who founded the Fort Wayne YWCA. She is depicted as crouching at eye level to a child.[4]

A heroic sculpture of bearded Charles Louis Centlivre (1827–1895), who founded a brewery in 1862 on Spy Run Avenue, was erected by his employees in the 1880s on top of the brew house, which was restored after a fire that year. The statue remained for decades, long after Centlivre Brewery became the Old Crown Brewing Corporation. Even when the nine-foot metal figure was blown down in a horrific spring storm in 1964, it was put back in place for another ten years. In 1974 the statue was moved, recoated, and placed atop the roof of a downtown restaurant on Superior Street.

Two four-foot limestone eagles perch on the cornice above the entrance of the former Central High School (today the Anthis Career Center) built in 1903 on South Barr Street. In front of the building is a thirteen-foot welded aluminum sculpture called *American Flyer* by retired art teacher Robert R. Johnson. The piece was erected in 1991 with the help of welder Cecil Blain. Although a solid tower, the piece gives the illusion of a string of kites in the wind.

On the main facade of the city's art deco masterpiece, the Lincoln Tower, are seven different bronze relief panels depicting events in the life of Abraham Lincoln. The building was completed in 1930. On the Three Rivers Water Filtration Plant, completed in 1933, are dozens of relief panels carved at the top of the limestone pilasters in an art deco style,

Hector Garcia's bronze statue, *Jesuit Priest* **(opposite page), stands at the confluence of three rivers north of downtown.**

depicting fish, impalas, vines, and heads of Native Americans, among other subjects. The primary artist was Wilbur Bybee of the Woolery Stone Company. Completed in 1963, the home office building of the Midwestern United Life Insurance Company on West Jefferson Street features fifteen panels or scenes in a continuous frieze about six feet high that wraps around the structure. Of concrete with embedded stone, the scenes portray the history of Fort Wayne from the Ice Age to the 1960s. The artist was Bill J. Hammon (b. 1922) of Omaha, Nebraska.

The Allen County Courthouse, designed by Brentwood S. Tolan (1855–1923) and completed in 1902, is a massive sculpture collection unto itself. The dome is topped with a copper-sheeted figure of Liberty nearly fourteen feet high, and the exterior of the building abounds with several statue groupings, busts, reliefs, and friezes. In the pediments on all four sides, for example, are large groupings of seven figures interpreting aspects of broad themes. The Berry Street side speaks of Justice, the Main Street side, the workings of Government, and both the Court Street and Calhoun Street pediments, aspects of Civilization. Below the dentilled cornice all around the building is a frieze of significant historical figures in various fields of endeavor: exploration, war, science and invention, law, literature, and so on. Although names are inscribed beneath each figure, they are virtually impossible to see from four stories below. And there are still more; the building is a three-dimensional encyclopedia!

Fort Wayne is blessed with several collections of outdoor sculpture. The Fort Wayne Museum of Art established a sculpture garden on its grounds in the 1980s. Local stone carver Timothy Doyle created a sundial, *Helitec I,* for the museum in 1980. The piece is a block of limestone with a swooping curve over which is set a stainless steel rod that casts the shadow that tells the time. Doyle made an identical piece, *Helitec II,* which was given to Fort Wayne's Japanese sister city, Takaoka. Each piece indicates the time in both cities. David Black, who was born in Massachusetts in 1928 and earned his master's degree at Indiana University, where he was a student of George Rickey (1907–2002), created his massive work *Crossings* of aluminum and white epoxy in 1984. Site specific, its planes and arches suggest those of the museum and the adjacent Performing Arts Center as well as other nearby buildings. Originally on loan, the piece later was purchased by supporters of the museum. The Alcoa Foundation donated two major works, *Quake,* created in 1982 by California artist Peter Forakis (b. 1927), a red-painted steel piece ten feet high, and the massive *Helmholtz* by Mark diSuvero (b. 1933). Both artists were among the earliest to embrace the concept of large-scale outdoor pieces in the 1960s.[5] *Helmholtz* was recently moved from the Performing Arts Center to nearby Freimann Square. Quite different from these monumental steel works is Stuart Fink's (b. 1938) sculpture of pigmented cast concrete, called *Station.* Located on the northeast side of the museum, it stands a little more than eight feet high and resembles a column composed of architectural elements. An older piece by Chicago sculptor Abbott Pattison (1916–1999), completed in 1960, which had been donated to the Fort Wayne Art School and placed into storage for several years, is now on the grounds of the museum. *Animals in Motion,* an amorphous piece in bronze, seems intended to convey the blur of several moving creatures.

The commitment to art made by Lincoln National Life began in 1928 when the new company commissioned Minnesota-born sculptor Paul Manship (1885–1966) to create a heroic bronze statue of a young Abraham Lincoln, commemorating his years growing up in Indiana. Four years later *Abraham Lincoln, the Hoosier Youth* was unveiled in front of the company's home office on South Harrison Street. The work portrays Lincoln sitting on a stump and dreamily patting the head of his hound. On the base are four medallions, representing Fortitude, Patriotism, Justice, and Charity.

In 1978 the corporation expanded its collection, creating an outdoor sculpture garden along Clinton Street. A piece by Indiana-born sculptor George Rickey was the first to be acquired. His kinetic *Two Open Rectangles Eccentric, Variation IV* is just that, two long open rectangles, delicately mounted on slender uprights, which move in the slightest wind. A steel work by Philadelphia-born Richard Stankiewicz (b. 1922) followed. The untitled piece, twelve feet high, juxtaposes basic shapes in a striking manner. Also erected in 1978 was *Black Prow* by New York-born artist George Sugarman (1912–1999), a colorfully painted steel work that is an interplay of curvilinear shapes. In 1980 Lincoln National installed the whimsical *Dance in the Fountain* by Florida artist William King (b. 1925). It portrays four highly stylized human figures of aluminum prancing about a fountain spray and conveys a joyful exuberance even in the cold weather months when the water is turned off. The corporation dedicated a second, smaller sculpture garden on Harrison Street in 1987 and erected J. Seward Johnson's (b. 1930) super-realistic piece *Crack the Whip,* depicting eight children with hands linked dashing about in an attempt to knock each other down in the boisterous game. Johnson has done several casts of this work; another is in Indianapolis. *LVII,* a welded aluminum work by California-born artist Bill Barrett (b. 1937), was also installed in 1987; the title means "Love Two" and is the second of his abstract pieces relating to love. The sculpture suggests two people dancing together.

The Foellinger-Freimann Botanical Conservatory has assembled a fine collection of sculpture, the latest a heroic bronze figure of the Roman goddess Flora by Anthony Frudakis, dedicated in 2000. *Freedom,* local artist Robert R. Johnson's celebration of Macedonian patriotism, was dedicated in 1986. The eleven-foot piece is a close formation of peace doves swooping and flying upward together, forming a *V* for victory. A small cast-iron statue of the fairy tale character *Cinderella* was donated to the conservatory the next year, which also saw the dedication of *The Muse* by local sculptor Sufi W. Ahmad (b.

1936). The bronze piece, commissioned upon Fort Wayne's winning the designation of All American City, is not large, but is very lively and complex. Its three figures represent the union of industry and the arts (a male worker and a woman holding a lyre) and the future of the city (a child).

The Fort Wayne Children's Zoo has several realistic bronze sculptures of animals by Texas-born artist Tom Tischler (b. 1947). In 1989 he fashioned a *Galapagos Tortoise,* located near the Petting Farm, and five years later, *Rongo,* an orangutan (named in a citywide contest), was placed at the entrance to the new Indonesian Rainforest. Tischler also created a life-size *Komodo Dragon* about ten feet long. Artist Connie Phillips sculpted a *Koala* and *Platypus* in 1987 for the Australian Adventure exhibition, since the real animals could not be procured. Also at the zoo is Milton Hebald's (b. 1917) *Dancing Family* (1970), a bronze piece depicting a stylized mother and father whirling with their three children.

Animals in Motion, a bronze abstract by Abbott Pattison, stands outside the Fort Wayne Museum of Art.

During an effort at downtown revitalization in the early 1980s, the city held a competition for sculptural commissions to enhance the retail area along Calhoun Street. The winners were Yvonne Zalkowski Tofthagen with *Wind Dance* and Harold R. "Tuck" Langland's (b. 1939) *Polyminia*. *Wind Dance,* a solid bronze form eight feet high that is somewhat suggestive of a shining sun, was completed in 1981. Langland's piece is a highly stylized armless female figure in bronze. Both pieces were dedicated in October 1984.

New York-born Hector Garcia taught art for many years at Indiana University–Purdue University Fort Wayne. A permanent outdoor sculpture in Franke Park was the result of a student competition held to create a work in situ during a Fine Arts Festival. The students and Garcia constructed the piece based on the winning design and submitted it in the form of a maquette (small model). The untitled piece somewhat resembles two very large vertebrae. On the campus, on the exterior of Neff Hall, is *Indiana Landscape,* a very large terra cotta mosaic relief depicting multiple aspects of the state: corn, wheat, grasses, trees, a cornucopia, wagon wheels, farmland, cities, lakes, and faces, all grouted and edged with an aluminum band. The piece, installed in 1984, was done by nineteen students of the Department of Fine Arts, supervised by professors Garcia and Nancy E. McCroskey, and four students of the Department of Construction Technology and their professor, Robert C. Kendall.[6]

At Lutheran Hospital on West Jefferson Street is a striking arrangement of ten huge vertical stainless steel leaves in a misted, landscaped setting. *Lifestarts,* installed about 1991 not long after the hospital relocated there, was the collaboration of Eric Ernstberger and Jan Martin. A hometown business, Phelps Dodge Magnet Wire Company, erected a ten-foot statue of the company's logo character *Questor* in 1998 outside its headquarters. Something of a cross between a stick figure and the standard depiction of an alien, the statue was designed by Richard I. Lemberg Sr. Fashioned of copper, brass, and steel, the figure holds aloft an open sphere with encircling bands.

On a hill adjacent to the Kelly Box and Packaging Company on Covington Road are three twenty-foot abstract figures representing the *Three Fates.* Local artist George McCullough (b. 1923), a native of California, originally submitted the design for an Indianapolis competition in the 1970s. More than two decades later, Tom Kelly, owner of the factory, agreed to allow the artist to erect the work on his property. Clotho, Lochesis, and Atropos are constructed of steel, and each weighs half a ton. They were installed in 1998 and 2000.

An eight-foot figure of a Shriner holding a child with a crutch is prominently displayed at the corner of Ewing and West Berry streets at the Mizpah Temple. Based on an actual photograph, the fiberglass statue was modeled by Fred Guentart and erected in October 1999. It is called *Silent Messenger,* although the same figure at the Shriners headquarters in Tampa is called *Editorial without Words.* There are at least three more of these statues in Indiana, in Evansville, Indianapolis, and Michigan City.[7]

Fully half of the outdoor sculpture in Allen County is religious in nature. Fort Wayne is the episcopal seat of the Fort Wayne–South Bend Diocese and has a large Roman Catholic presence. The Lutheran influence is also strongly felt, with Concordia Theological Seminary located in the city. The seminary is the home of a heroic bronze statue of Martin Luther (1483–1546) at age thirty-eight. The seminary, founded in Fort Wayne in 1846, relocated to Springfield, Illinois, and the piece, created by German sculptor Friedrich Adolf Soetebier, was installed in 1957 on the campus there. Twenty years later the seminary returned to Fort Wayne, and Luther's statue was moved and rededicated at its present location. The base contains four cornerstones from buildings on the Springfield campus. In 1916 *The Healing Christ* was donated to Lutheran Hospital by its cofounder and first chief surgeon, Dr. Herman A. Duemling. The statue was placed prominently at the front of the hospital's grounds at its original location south of downtown off Fairfield Avenue. The granite statue, based on a painting,

portrays Jesus comforting a worried mother with a sick child. Herman Scherer, a local monument maker, carved the piece. The hospital later moved to a new location on the west side, and the statue now stands before the Lutheran Center for Health Services. Near downtown, on the north facade of Saint John Evangelical Lutheran Church, is a large cast-aluminum relief, *Christ Blessing the Children*, dedicated in 1962. Noted artist Marshall Fredericks (1908–1998) of Michigan's Cranbrook Academy created the work. Trinity English Evangelical Lutheran Church, completed in 1925, has two life-size figures that seem to emerge from the limestone quoins above the arched window of the main facade. Moses represents the Law, or the Old Testament; Saint Paul represents the Gospel, or the New Testament. At the old Concordia Cemetery at Anthony and Wayne streets is a life-size figure of Christ of Carrara marble, dedicated in 1958. Another different, life-size statue of Christ graces Concordia Cemetery at 5300 Lake Avenue. Also in the cemetery is an intriguing interpretation of Christ in the Garden of Gethsemane by Saint Louis artist William C. Severson (1924–1999). It is an eight-foot-high pillar of granite carved in simple lines showing Jesus with his hands covering his face, which somehow manages to express all the anguish of the moment. It was dedicated in 1962.

Catholic Cemetery, also on Lake Avenue, is filled with sculpture. Hector Garcia carved a sixteen-foot relief in limestone of Saint Frances Xavier Cabrini (Mother Cabrini) in 1976. In 1987 Timothy Doyle carved a fifteen-foot image of Saint Elizabeth Ann Seton from Alison Adams's design, and in 1993 the two collaborated on a sixteen-foot relief of Saint John Neumann. All three limestone reliefs grace mausoleums. *Mystery of Faith* was dedicated in 1974. Made of granite and designed by Bert J. Gast of Chicago, it was carved in Barre, Vermont, where the stone originated, by Aldo Venetti. It portrays a crucified Christ in high relief on a solid concave cross. The Center Altar, a traditional scene of the Crucifixion with Mary, the Mother of Christ, the Apostle John, and Mary Magdalene mourning at

the foot of the cross, was dedicated in 1932. The Orbronze (a sheet metal alloy) figures are from the Daprato Statuary Company in Chicago. A concrete rendering of the *Pietà* dating from the early twentieth century was relocated to the cemetery in 1971. It originally graced Saint Hyacinth Church, which was established in 1910 but closed in 1995. A marble rendering of Christ praying in Gethsemane that originally was located at the now-demolished Crosier House, the home of a religious order, was moved to the cemetery in 1990. Also in the cemetery are two life-size granite statues placed in the 1960s, one of Saint Vincent de Paul and the other of Saint Francis of Assisi. The Grotto of the Blessed Mother contains a large concrete statue of Mary.

The Cathedral of the Immaculate Conception on South Clinton Street is surrounded with religious statuary. The figure of the Immaculate Conception (Mary) that graces the church itself high above the main entrance dates to 1896 and is close to ten feet high. The statue is an alloy of lead and zinc. There are two figures that once were on Central Catholic High School, which opened in 1939. A nine-foot Carrara marble figure of Christ that once stood atop the cornice above the school's main entrance on Lewis Street is all that remains of the school, which was demolished in 1984. It stands on the school's site and is referred to as the *Christ of Lewis Street*. A figure of Our Lady started out as a high relief on the Clinton Street side of the school. Timothy Doyle carved a back for the relief and converted it into a statue, now on the grounds of the cathedral. A concrete statue of Saint Christopher dating from the early twentieth century was originally erected practically on its current site, which is where Library Hall, built in 1881, once stood. At one time the building housed a Catholic boys' school. A small statue of Saint Joseph purports to have come from Saint Augustine Church, which before it was destroyed by fire in 1859 had occupied the site where the cathedral now sits. The material and style suggest the piece is later, however. The MacDougal Chapel in Cathedral Square displays bronze works by art students from the University of Notre Dame, com-

pleted in 1949. On each side of the facade are two angels adoring a radiant cross. In front of the chapel is a huge limestone figure of Christ holding a chalice, also carved by Notre Dame art students.

At the University of Saint Francis at 2701 Spring Street is *Spirit of Saint Francis,* a very lively interpretation in bronze by Pakistani-born Sufi Ahmad, who teaches there. Cast in 1997 and funded through a donor's generosity, the nine-foot statue shows Francis kneeling and reaching upward to birds landing all about him. The piece was originally commissioned by Saint Francis Hospital in Beech Grove outside of Indianapolis. A third casting was made at the time for a Franciscan convent in Mishawaka. Subsequent commissions for the piece have resulted in nine more placed at various Franciscan hospitals around the state. The university also displays a statue of the Blessed Mother near the Campus Ministry Center and a statue of Saint Francis outside the chapel door.[8]

A twenty-foot, almost full-round marble figure of Saint Joseph the Worker can be seen hovering over the entrance of the Saint Joseph Medical Center, built in 1965 on Broadway Street. Another interpretation of Saint Joseph, this one in bronze, was dedicated four years earlier on the facade of the new Saint Joseph Church at Brooklyn and Hale streets. Lem Joyner of Saint Christopher's Workshop in Bremen executed the piece, about eleven feet high, which shows Joseph as a rugged carpenter surrounded by his tools.

In 1980 Hector Garcia created a life-size statue of Saint Charles Borromeo of "cultured marble," which is a mix of powdered marble in a matrix, in this case an epoxy resin. It stands at the church of the same name on Trier Road. A life-size marble statue of Saint Therese, the Little Flower, placed in 1962, graces the church named for her on Lower Huntington Road. Saint Jude Catholic Church on Pemberton Drive displays a life-size statue of its patron saint.

Queen of Angels Church at 1500 West State Street was completed in 1951. It displays a ten-foot limestone statue of Mary built into the main facade. In 1955 a seven-foot marble figure of the Blessed Virgin holding the Christ Child was placed between

A huge marble sculpture of Saint Joseph is affixed to the exterior of the downtown medical center of the same name.

the church and the school at Precious Blood Church on Barthold Street. The church also displays a life-size fiberglass statue of the Sacred Heart. Both Saint Andrew Church on New Haven Avenue and Our Lady of Good Hope Church on Saint Joe Road display life-size figures of the Blessed Virgin. The one at Saint Andrew dates to before World War II. Bishop Dwenger High School on East Washington Center Road also has a life-size marble figure of Mary.

In 1993 Sister Margaret Beaudette of the Sisters of Charity completed a statue of Saint Elizabeth

Ann Seton surrounded by children in modern dress. The piece stands at the Saint Elizabeth Ann Seton Church on Aboite Road and is made of reinforced fiberglass. Another casting of the work is in Richmond. Saint Vincent Catholic Church on Auburn Road displays a life-size marble figure of Saint Vincent de Paul, placed in 1968. The adjacent cemetery contains a stunning bronze interpretation of the Sacred Heart by Giovanni Giane of Rome, installed in 1993.

In the community of Yoder, south of Fort Wayne on Bluffton Road, is Saint Aloysius Church, which has several life-size religious figures dating from the early 1950s through the 1970s.

Covington Memorial Gardens on Covington Road contains Italian marble statuary of the type often found in these sorts of cemeteries. A giant rendition of the praying hands and a veterans memorial comprised of six life-size figures representing different branches of the military, erected in 1975, are among the typical pieces. Lindenwood Cemetery on West Main Street contains a smaller version of the praying hands, acquired from Italy in 1972. The cemetery also has a marble angel about five feet high of undetermined age that had been stored for many years. In the Sunset View section, a nine-foot block of granite is carved on each side with a figure of one of the four apostles in relief.

BARTHOLOMEW

Bartholomew County's sculpture tally is higher than one might expect, owing to the generosity of corporate and individual donors and collectors, and are set off by the mighty works of renowned architects for which Columbus is famous. Chief among them is Henry Moore's (1898–1986) *Large Arch* in bronze, an abstract piece twenty feet high that suggests to many Stonehenge, which indeed was its inspiration. Difficult to miss, the piece dominates the Library Plaza on Fifth Street and one can walk through it. Moore, an Englishman who was one of the giants of

modern sculpture, completed the piece in 1971. The equally famous architect of the library, I. M. Pei (b. 1917), had suggested that a Moore sculpture would enhance the building. The sculpture was a gift from local philanthropists Mr. and Mrs. J. Irwin Miller.[9]

The comprehensive design plan of Parkside Elementary School on Parkside Drive on the east side of town included an open courtyard to display a work of sculpture, also donated by the Millers. In 1978 Harris Barron of Massachusetts created *The Family*, an abstract piece in granite that hints at a father, mother, and child.

Columbus is home to several works by notable out-of-state sculptors, such as J. Seward Johnson Jr. (b. 1930) and Jo Saylors (b. 1932), both of whom have works on display at the ArvinMeritor (formerly Arvin Industries) campus. Johnson's *When I Was Your Age* is a wonderfully realistic tableau in bronze of a man pumping up the flat tire of a 1931 Model A Ford. The car is the real thing, including a weathered 1931 license plate, although many of the materials have been replaced with those more impermeable. Sitting on the front seat gripping the steering wheel is a little boy who appears to be squealing with delight as his father struggles with the tire. The piece, dedicated in 1990, pays tribute to Arvin's beginnings as the Indianapolis Air Pump Company. Saylors, of Oklahoma, also specializes in realistic portrayals in bronze, usually of children. *Crack the Whip*, installed in 1998, shows four youngsters engaged in the age-old game of trying to pull each other down. Three years earlier, her *Puddles* and *Frog Pond* were erected adjacent to each other at the edge of a small pond. Each shows the wonder of children interacting with nature. Also on the Arvin property is the figure of a deer, installed in 1993, a wire sculpture by William Arnold, formerly of Indianapolis.[10]

Another realistic work of bronze represents not a person, but a sixteen-cylinder Cummins Diesel Engine. An exact likeness, the piece, erected about 1985, stands in the plaza in front of the corporate headquarters at Fifth and Jackson streets.

Downtown, French artist Bernar Venet (b. 1941) created *Acier Roole 2 Arcs de 212.5 Degrees,* a rolled-

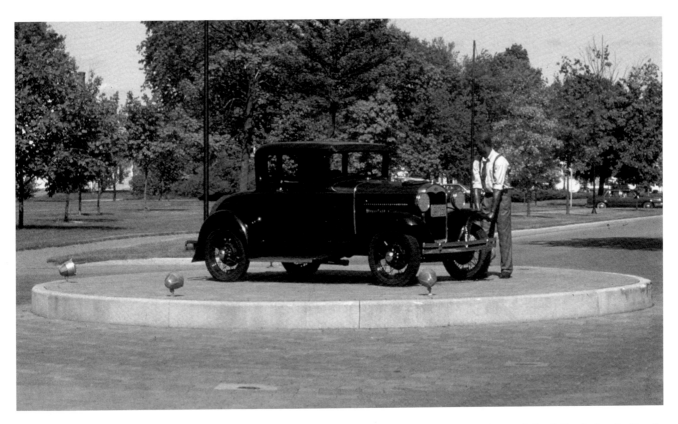

J. Seward Johnson's remarkably lifelike *When I Was Your Age* captures both the child's glee and the father's frustration in struggling to pump up the tire.

steel piece more than seven feet high shaped like the letter C. It was erected outside the Commons in 1998. That same year an untitled neon sculpture by San Francisco artist Cork Marcheschi was installed in Friendship Way, off Washington Street between Fourth and Fifth streets. The work consists of thirteen different pieces, in which light moves and changes colors, extending about eighty feet along the walkway.[11]

Through the CETA (Comprehensive Employment and Training Act) program of the late 1970s, sculptor Richard (Ric) Bauer created *Skopos*, a fifteen-foot curvilinear abstract piece of Cor-Ten steel in Mill Race Park on the west edge of town along the river. The name, the result of a public contest to christen the work, means "guardian" in Greek. As artist-in-residence to the Columbus Parks and Recreation Department, Bauer taught classes to children and adults and created another sculpture, *Memorial Artillery*, in Donner Park on Twenty-second Street. Standing outside Donner Center, the welded steel piece is an abstraction of the typical surplus ordnance often found in parks.

Perhaps the abundance of sculpture in Columbus was the inspiration behind a six-year collaboration of students and teachers at Columbus North High School. The project, the result of brainstorming between Dale Patterson and Malcolm Stalcup, art and welding instructors, respectively, brought students of different disciplines together. It was also an exercise in delayed gratification, as students who were involved at the beginning graduated before the work was finished. The eighteen-foot, three-piece abstract work of Cor-Ten steel was erected at the Hamilton Center on Twenty-fifth Street in 2000.[12]

A piece by regional artist C. R. Schiefer of Morgan County, the *Dancing Fish* fountain, graces the

British sculptor Henry Moore's *Large Arch* (opposite page) broods in downtown Columbus.

courthouse square on the northwest side. A Bicentennial project, the original piece was erected in 1976 but vandalized and damaged two years later. The present sculpture is a replacement, somewhat larger than the first. The Bartholomew County Veterans Memorial is more a work of architecture than sculpture—indeed, it was designed by Massachusetts architects Mary Ann Thompson and Charles Rose—but is one of those memorials that blurs the line. Set in a grid pattern, its twenty-five limestone pillars, each forty feet high, are a striking presence, and given the broad boundaries of what is called sculpture today, may well qualify. It was erected in 1997.

The Irwin Gardens, a lovely retreat on Fifth Street, is open to the public on warm-weather weekends, but many of its sculptures are clearly visible to passersby on the street at any time. The space is modeled after a smaller garden discovered in the ruins of Pompeii and is filled with terraces, pergolas, pools, and numerous pieces of garden sculpture. Probably the most impressive is a one-ton bronze elephant, a replica of one that William G. Irwin had brought from the 1904 Saint Louis World's Fair. The realistic creature, four feet high, was cast locally at Golden Foundry in 1932. A small bronze fountain piece of a boy on a dolphin was also made at the foundry. Another impressive bronze piece is a stork in flight, placed on a marble birdbath. The piece was originally at an estate in Harrison Lakes and moved here. About 1910 several marble pieces of undetermined origin were placed in the garden, including two boys intertwined with a fish, a boy with a duck, and four sculptured heads of Greek philosophers, which were copied after those found in a temple on the grounds of Emperor Hadrian's villa at Tivoli.[13]

Bartholomew County boasts a piece by Myra Reynolds Richards (1882–1934), one of Indiana's premier artists in bronze of the early twentieth century, called *Bird Boy.* In 1924 the Nature Study Club commissioned the little sculpture of an elflike boy playing a pan flute in a fountain as a memorial to music teacher Mary L. Leach. Originally it stood in front of Columbus High School but was moved to the Henry Breeding Farm a few miles north of the city after the school was closed. It has since been removed from that location, and its fate is uncertain at this writing.

Another statue far from its original location is that of Chester Reynolds, who died in 1889 at age four. His grief-stricken parents sent a photograph of the boy to Italy and ordered a life-size marble statue for his grave marker. Today one would assume the little statue is of a girl; the child is dressed in a lace-trimmed shirt, jacket, and a long skirt, not uncommon for small boys of that day. Little Chester's grave in rural Harmony Cemetery was vandalized in the 1970s. Fortunately, the statue was later found in a ditch, and it was placed in the safer confines of the Bartholomew County Historical Museum.

Another grave marker statue of a child is still in place in Garland Brook Cemetery in Columbus. Mary Ora Mennet died at the age of eleven in 1898. Atop a cylindrical granite gravestone is a three-foot marble statue, presumably the child's portrait. The curly-haired girl wears a loose-fitting short garment, perhaps something she might be supposed to wear in Heaven, and clutches a lily in her left hand. Garland Brook Cemetery has some fine examples of funerary art, not the least of which are its entrance gates, built in 1911. The west gate is topped with a large limestone figure of Christ as the Good Shepherd. There are also several marble religious figures, such as *Sermon on the Mount,* acquired in the mid-1960s, typical of those found in new sections of cemeteries and memory gardens of that time period. The cemetery also contains an unusual war memorial that was dedicated in 1972 by a coalition of veterans' organizations. The bronze piece replicates a rough wooden cross draped with a cartridge belt and topped with a helmet. Whether intended as part of the monument or not, a real pair of worn combat boots also hangs from the crossbar.

Now in storage, *Bird Boy* (opposite page), by Myra Reynolds Richards, started out in front of Columbus High School, then was moved to the Henry Breeding Farm, where this photo was taken.

The Columbus City Cemetery on Sixteenth Street also has funerary art worth noting. The marble Hartman monument with its beautiful angel carved in relief dates to about 1915 and is among the best. The Ruddick monument, carved in limestone about 1910, is also notable with its poignant figures of two young girls in flowing robes, clinging to each other.

Little outdoor sculpture is found outside Columbus, with the exception of a commemorative work hidden away at the Columbus Youth Camp. On a pedestal near the entrance is a roughly life-size bronze head of Quintin G. Noblitt (1882–1954), an early conservationist and the founder of Arvin Industries, who donated seventy acres and a farmhouse to the Columbus Foundation for Youth in 1935. Sculptor W. Douglas Hartley (b. 1921), whose father worked for Noblitt, created the portrait sculpture in 1949.

Community sculptor Joe LaMantia of Bloomington worked with the students of the Taylorsville Elementary School to create *Bear Necessities,* a brightly colored contemporary piece that is a play on the school's mascot. It was erected in 1999.[14]

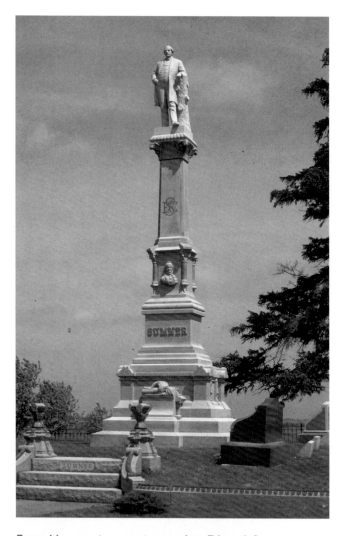

From his cemetery vantage point, Edward Sumner gazes upon the vast acreage that once was his.

BENTON

Sparsely populated Benton County for years had only one significant outdoor piece: Indiana's version of Ozymandias, erected in 1882. In a tiny cemetery outside the bypassed hamlet of Earl Park is the grave marker of land baron Edward Sumner, who died in 1862. Atop a granite pedestal more than twenty feet high, an imposing eight-foot statue of Sumner stands overlooking the thirty thousand acres to the south that once were his. Almost as an afterthought and several feet below the statue is a portrait bust of Sumner's wife Abigail. Just across the road in a Catholic cemetery is a Crucifixion scene dating to about 1946.[15]

In more recent years one of Morgan County sculptor C. R. Schiefer's whimsical works was erected behind the public library in the county seat of Fowler. The limestone piece, only about three feet high with the appropriate title of *Make a Joyful Noise,* depicts a caricatured choir.

BLACKFORD

Tiny Blackford County is home to three outdoor sculptures that are significant in very different ways. The county seat, Hartford City, boasts one of Ernest Moore Viquesney's (1876–1946) *The Spirit of the American Doughboy* statues, dedicated in September 1921 in the courthouse square. The women of the

Chief François Godfroy looked nothing like this, but the huge fiberglass statue was erected in Montpelier in his honor.

Service Star Legion raised funds to procure the monument.

Montpelier offers two unusual works. A huge fiberglass figure that purports to represent a Miami Indian stands downtown on land that once belonged to Chief François (Francis) Godfroy. The fiberglass statue originally was created about 1960 as an advertising icon for a Pontiac dealership and later stood before a now-defunct Indian museum in Eagle Creek Park in Indianapolis. Recycled once more, it was placed in its present location in 1984. Not far down Main Street is a rare statue of a World War II soldier standing outside the American Legion.[16] The piece was rendered in concrete by W. A. Hoover in 1945.

BOONE

Traditionally an agricultural county that is now being overtaken by urban sprawl, Boone County has very little significant outdoor sculpture, apart from the huge limestone allegorical figures on the 1911 courthouse. The figures of Justice, Agriculture, and Industry

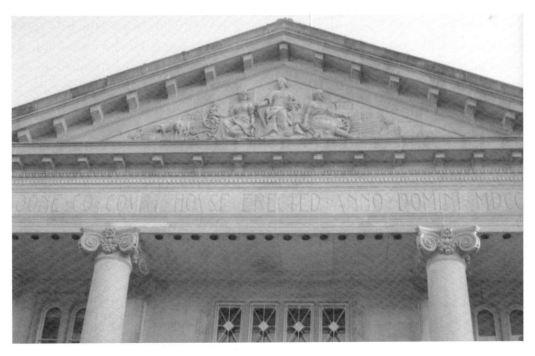

The work of Alexander Sangernebo graces the courthouse in Lebanon.

(or Progress) are attributed to the master architectural sculptor Alexander Sangernebo (1856–1930), who is best known for the wealth of terra cotta ornamentation on many Indianapolis buildings.[17]

Thorntown once boasted two large fountains at either end of its Main Street, funded by General Anson Mills in 1909 to memorialize his parents, who were buried in the town's cemetery. They became a traffic hazard as the number of automobiles increased and were removed sometime before World War II.

Lincoln Memory Gardens, southwest of Lebanon on old Lafayette Road south of State Road 234, is a fairly early example of this type of cemetery and is filled with large marble religious statuary imported from Italy, the like of which is duplicated in similar memorial gardens throughout the state.

In 2001 collaborative artist Joe LaMantia of Bloomington worked with the pupils of Unionville Elementary School near Zionsville to create a colorful sculpture of scrap metal and wood called *Sunshine*.

BROWN

What little sculpture is to be found in Brown County is almost serendipitous. A weathered Guardian Angel that protects a private driveway near Beanblossom once watched over Sacred Heart High School, built in 1914 just south of downtown Indianapolis. The sculptor was William Kriner, who had worked on the Soldiers and Sailors Monument in Indianapolis. Kriner's son Leo was his model for the child the angel guards. Leo rescued the limestone piece from the wrecking ball when the school was demolished in the late 1970s and placed it on his family's property in Brown County.[18]

The oldest in situ sculpture in the state is Stone Head, in actuality a road marker crudely sculpted in the early 1850s by stone carver Henry Cross (1821–1864), one of three similar pieces he created in payment of his property tax. The other two stone markers have not survived, and this piece has been stolen and vandalized several times. The Stone Head gives directions and mileage to a number of towns, some of which are no longer extant. It is easy to spot driving south from Brown County State Park on State Road 135.

At the once thriving hamlet of Story, today a small cluster of buildings forming a popular bed-and-breakfast, stands a gigantic replica of the many hundreds of tree-stump gravestones that dot virtually every county in Indiana. The seventeen-foot high limestone work, perfect in every detail, was commissioned about 1992 by the previous owners of the inn as a tribute to the area's heritage. William Galloway, who lives and works in the county, carved the piece.

CARROLL

Two sculptures grace the courthouse square in Delphi. The Carroll County Soldiers and Sailors Monument, dedicated in 1882 (some sources say 1888), is topped with a ten-foot-high bronze color-bearer. Around the base are four reliefs, depicting a farewell scene, two battle scenes, and a homecoming. At each corner of the top of the base are stacked rifles with bayonets, fashioned in bronze. This piece is sometimes mistakenly attributed to Austrian-born sculptor Rudolf Schwarz (1866–1912), but it was completed fifteen years before Schwarz arrived in Indiana.[19]

On the southwest corner of the square is the lovely Murphy Memorial Drinking Fountain, erected in 1918, featuring a winsome young girl in bronze. The wistful creation is the work of Myra Reynolds Richards (1882–1934) of Indianapolis, seemingly the most prolific (at least in terms of surviving work) of several women sculptors working in Indiana in the early twentieth century.

Artist William Galloway carved this over-size replica celebrating the many tree-stump gravestones in Indiana for the Story Inn (opposite page).

The charming Murphy Memorial Drinking Fountain in Delphi.

CASS

The state's signature river, the Wabash, runs through Cass County, along with its tributary, the Eel. The county's terrain is pleasantly rolling, even hilly in spots, and otherwise largely agricultural. Most of the outdoor sculpture is found in the county seat of Logansport, with the exception of one of the state's numerous Grand Army of the Republic Union sentry monuments, erected in 1919, which stands in the Galveston Cemetery.[20]

Logansport's Mount Hope Cemetery contains several significant examples of cemetery sculpture;

among the most intriguing is the Reighter monument, depicting a life-size marble farmer in Wellington boots. A Knights of Pythias monument depicts a member of the fraternal order in full nineteenth-century uniform, complete with plumed helmet. Carved in limestone in the late 1880s, the figure kneels with his hands resting on a sword hilt—or at least they would be, had the sword, which was probably of bronze, not been stolen. Nearby stands the bronze sculpture *Elk's Rest,* a product of the W. H. Mullins Company, that watches over the graves of members of the local Elks lodge. Probably erected in the 1890s, this statue is one of several found in cemeteries around the country where the Benevo-

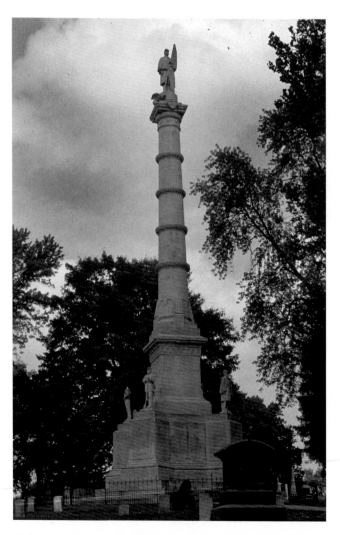

Entirely made of limestone, this impressive Soldiers and Sailors Monument is the pride of Mount Hope Cemetery in Logansport.

lent and Protective Order of Elks maintained a section of plots for their members. (A similar statue is in Highland Cemetery in Terre Haute.) A bronze elk's head that had graced the town's lodge for almost ninety years was sold and relocated to Johnson County in 1996.

Just within the entrance to Mount Hope stands the earliest example in the state of the type of Soldiers and Sailors Monument that features a soaring shaft with four life-size figures at the base, representing Infantry, Cavalry, Artillery, and Navy. The shaft is topped with a flag bearer. Erected in 1887, the work is especially unusual in that the entire monument is of limestone. The sculptor was Schuyler Powell.

Logansport's City Hall at Sixth and Broadway streets displays a World War Memorial in the form of a limestone doughboy, erected in 1929. The All Saints Catholic Church and School display, respectively, an Orbronze (a sheet metal alloy) Sacred Heart of Jesus figure dating to 1931 and a concrete statue of Mary from the 1940s.

CLARK

Clark County is ruggedly hilly, except where it spills into the Ohio River. Most of the population, as well as the outdoor sculpture, is in the county seat of Jeffersonville. Kentucky sculptor Barney Bright's (1927–1997) tentacled bronze work, which is not titled, is displayed at the Jefferson Township Public Library on Court Street. The piece seems almost to wriggle, intentionally calling up images of Devonian undersea creatures, appropriate for this region where great fossil beds from that era have been discovered. The work was installed in 1970, immediately generating much interest and controversy. As with most public sculpture, it is now largely ignored, all the more since the piece was relocated in 1978 from its original limestone bench to the top of a seven-foot pedestal. Library officials had found it to be an "attractive nuisance." Nearby is the Veterans Monument, erected in 1987, which blurs the line

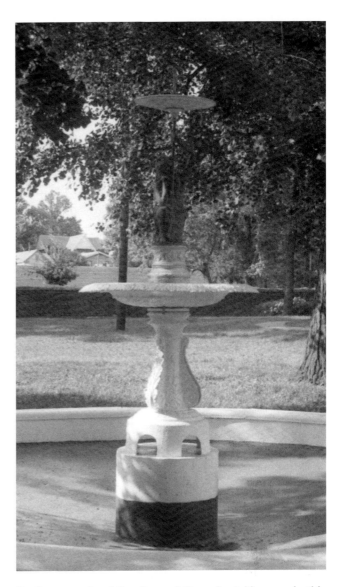

On the grounds of the Howard Steamboat Museum is this lovely fountain, artist Norman Kohlhepp's re-creation of his wife's childhood memory.

between sculpture and architecture. Entirely of limestone, it is a simple monument consisting essentially of two intersecting arches surmounted by a small sphere.[21]

At Warder Park is a heroic bronze figure of Thomas Jefferson, for whom the city was named, erected in 2003. The statue shows Jefferson in an active pose with his coat blowing in the wind. Fashioned by local sculptor Guy Tedesco (b. 1962), the piece stands on an eight-foot boulder landscaped with a water feature.[22] More sculpture is planned for the area.

Some library patrons in Jeffersonville tend to keep their distance from this writhing untitled piece by Kentucky sculptor Barney Bright.

The Howard Steamboat Museum is located in the nineteenth-century mansion erected by shipbuilder Edmund Howard. Three of Howard's granddaughters were born in the house and often played in the yard around a lovely lady in a fountain. The three sisters grew up, and over time, in the hurly-burly of shipbuilding during World War II, the statue disappeared. One of the Howard sisters married a Louisville artist, Norman Kohlhepp (1892–1986), and as a gift to the museum the three sisters commissioned him to re-create the statue from their memories. The new lady in the fountain, dedicated in 1975, was christened Rebecca. The figure is typical of early-twentieth-century fountain statuary and looks very much like the original must have, except the upraised hand has been juxtaposed. Laura Jean Howard Kohlhepp posed for her husband, and she was left-handed.

In Perrin Park is a life-size interpretation of Saint Francis of Assisi in bronze by David Kocka (b. 1950), who lives and works in rural Harrison County. The Saint Anthony of Padua School in Clarksville has a statue of Saint Anthony dating to when the school was built in 1949. There is an older statue, variously identified as Saint Francis (the figure wears Franciscan robes) or Saint Peter, which came from Saint Peter's Church in Louisville in 1970.[23]

Slated to be completed at the end of 2006 is the Lewis and Clark Plaza, near the western edge of the Falls of the Ohio State Park, where George Rogers Clark's cabin site is located. The plaza will mark where the Lewis and Clark expedition set off on its epic journey in 1803. Originally a huge design comprised of several separate bronze tableaux composed of figures and reliefs by Guy Tedesco, the city of Clarksville was unable to raise the considerable funds needed and has since scaled the project back. Although much more modest in scope, there still will be a series of scenes, some in bronze relief and some carved into the stone walls of the plaza. Upstream, at the park's Interpretive Center, the meeting of Meriwether Lewis and

William Clark is depicted in bronze, the work of Montana artist C. A. (Carol) Grende (b. 1955). The title of the piece, "*When They Shook Hands, the Lewis and Clark Expedition Began,*" is taken from the text of the late Stephen Ambrose's book *Undaunted Courage.* Dedicated in October 2003, the sculpture first stood outside the Southern Indiana Visitor Center in Jeffersonville and was moved to its present site a year later.[24]

CLAY

Clay County is laden with the mineral of its name, as well as coal, especially in the southern half. The agricultural northern half boasts the old National

This eagle once perched atop a now-demolished Clay County Courthouse.

Road, now US 40, which passes through the county seat. Brazil appears to have the only outdoor sculpture in the county. In Forest Park on the south side of town is *Chafariz Dos Contos* by Tito Bernucci, a gift to the town in 1956 from Brazil's sister city. As much architecture as sculpture, it is an ornate fountain wall twenty-six feet high and forty feet wide, easily visible from State Road 59.[25]

In front of the Fraternal Order of Eagles Aerie 274 at the intersection of US 40 and State Road 59 is, appropriately enough, a bronze eagle on a pedestal. This raptor has a glorious past, having once topped the Clay County Courthouse that had been built in 1877. When the present courthouse was built, the eagle was saved from destruction and presented to the lodge in 1914.

The old Brazil Junior High School gymnasium is decorated with several relief panels featuring stylized athletes. The Indianapolis architectural firm of McGuire and Shook designed the structure, built in 1928 at the corner of Washington and Blaine streets.

CLINTON

A largely agrarian region, Clinton County's sculpture appears to be confined mostly to its county seat of Frankfort, where multiple representations of Justice and Progress fashioned in zinc loom above the cornice on the courthouse, built in 1882. The figures are probably from the J. L. Mott Iron Works. In TPA Park is a small, seemingly insignificant little stone fountain, but it is the work of Jon Magnus Jonson (1893–1947), a noted architectural sculptor, who spent several years living and working out of a farmstead near town. Born in North Dakota, Jonson studied with Lorado Taft (1860–1936) in Chicago and married a fellow pupil, Lelah Maish, a Frankfort native. Jonson created the fountain, a large limestone urn supported by acanthus leaves and pelican heads, in the 1920s. Greenlawn Cemetery on the south edge of Frankfort has two large marble religious figures, placed in the mid-1950s.[26]

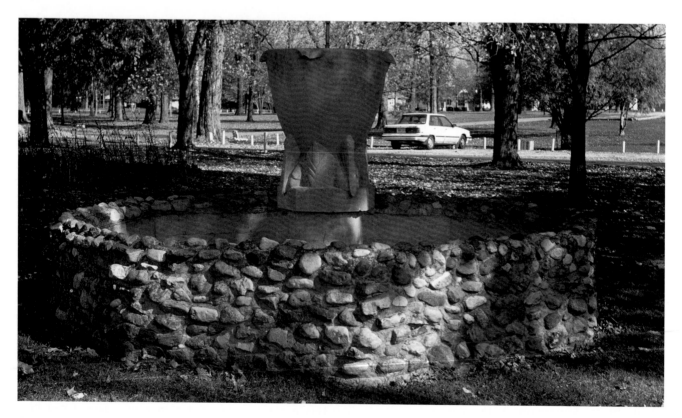

This seemingly insignificant fountain urn in Frankfort's TPA Park is an early work by renowned sculptor Jon Magnus Jonson.

In the courtyard of Clinton Central Elementary School near Michigantown, collaborative artist Joe LaMantia worked with the pupils to create *Hoosier Landscapes*. The piece, fashioned from automobile hoods, plow parts, and other recycled metal, was installed in 2004.

CRAWFORD

One would not expect to find much in the way of sculpture in the rugged and wooded terrain of Crawford County. Nevertheless, in what until recently was the town of English, there stands a heroic bronze likeness of William H. English (1822–1896), one of Indiana's nineteenth-century movers and shakers. Dedicated in 1900 in the town's Reunion Grounds, later the city park, the statue seems to have been forgotten when the town fled to high ground in the 1990s after too many disastrous floods. This seems especially odd since the

town, originally called Hartford, had renamed itself in 1865 in honor of English. An identical statue is in the courthouse square in Scottsburg (Scott County). Created about 1898, they are the work of Irish-born John H. Mahoney (1855–1919).[27]

DAVIESS

Odon native Ira Correll (1873–1964) carved numerous pieces, signed and unsigned, around southwest Indiana, but his most famous is probably the statue of Abraham Lincoln, dedicated in 1922 in Old Settlers Park in his hometown. In the churchyard at Saint Peter's in the hamlet of Montgomery is one of Correll's loveliest cemetery pieces, a portrait sculpture of Anise Hart, who died in 1909 at the age of twelve.[28]

In front of the courthouse in Washington is the impressive Soldiers Monument, dedicated in 1913 and designed by local artisan John Walsh. Made

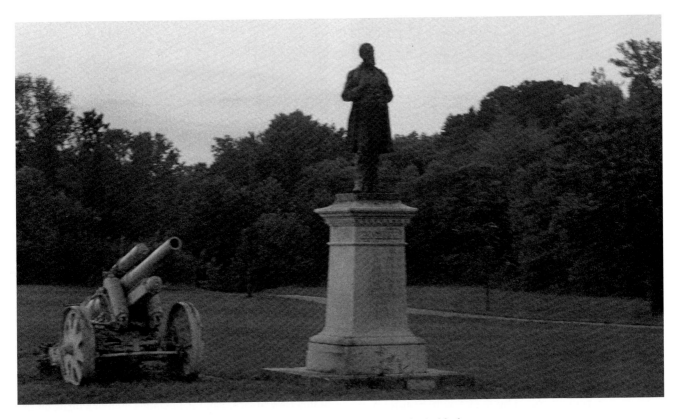

The town of English has moved up the hill and left the statue of its namesake behind.

The poignant statue of young Anise Hart is in Saint Peter's churchyard in Montgomery.

entirely of granite, it stands about thirty feet high and features a life-size flag bearer atop the pedestal, flanked near the base by an artilleryman and an infantryman.

DEARBORN

Most of the population of this hilly county is concentrated along the Ohio River in some of the oldest settlements in the state. With one exception, all the outdoor sculpture appears to be in the county seat of Lawrenceburg. The Newtown Fountain in Newtown Park on Eads Parkway is surely the most

visible sculpture in Dearborn County. Erected in 1924, the fountain is a product of the well-known J. W. Fiske Ironworks of New York. The fountain had deteriorated over the decades and was restored in the 1990s. Greendale Cemetery has a fine collection of funerary art, including an unusual marble relief portrait of John Anderegg affixed to his family monument. Saint Lawrence Catholic Church on Walnut Street displays a large statue of its patron saint dating to 1867. Alongside the church is a War Memorial with a life-size statue of the Blessed Mother.[29]

The hamlet of New Alsace on Dearborn Road is little more than its parish church, which displays a large figure of Saint Paul in a niche on the facade.

In tiny New Alsace, Saint Paul stands high in a niche on the church named for him.

DECATUR

Outdoor sculptures in Decatur County are widely scattered throughout its hilly and rural landscape, which has a mix of agricultural and forested land and few towns. Most significantly, in the small Wesleyan cemetery near the hamlet of Westport is the state's only statue of a veteran of the Spanish-American War. Badly vandalized and in several pieces, it purports to be a portrait statue of twenty-three-year-old John W. Shaw, who died in the Philippines in 1900. In the Westport town cemetery is a poignant life-size portrait statue on the grave of a twelve-year-old boy. Charles Robert Sample, forever young, is depicted holding a baseball in one hand and his bat in the other. The work was carved in limestone by Lawrence County sculptor D. Jack Busch (1902–1997) in 1972.[30]

Vandals have left the portrait statue of John W. Shaw, who died in the Spanish-American War, in pieces.

At the cemetery of the Church of the Immaculate Conception in Milhousen is a charming limestone angel and child on the Picker monument, dating from the early 1940s. The church itself displays a large statue of Mary, Queen of Heaven. At Saint Mary School on East Street in the county seat of Greensburg is a marble statue of a child that probably dates to the 1910s. At the House of Rebekah nursing home is a six-foot white bronze figure of Rebekah, originally erected in 1904. The base is decorated with several symbols relating to the International Order of Oddfellows. The statue once stood several hundred feet from its present location in front of the original building, which was demolished in 1975.

DE KALB

De Kalb County is filled with lakes and patches of forest intermingling with cultivated land in the rolling moraine topography. Its public sculpture is widely distributed among the little individual communities of the county and is primarily commemorative or religious. In the county seat of Auburn, the restored Eckhart Fountain stands in a courtyard behind the Eckhart Public Library. Dedicated in 1912, the fountain is straight out of the J. L. Mott Iron Works (New York) catalog. After a new addition was built on the rear of the library, the fountain was restored and rededicated in 1997.

The entrance to the Catholic Cemetery north of town features the large concrete reliefs of Henry R. "Hank" Mascotte, who had once pastored the Immaculate Conception Church in Auburn. Dedicated in the spring of 1986, the front of the work, which faces the main road (former US 27), is an amalgam of symbols having to do with life and death. On the east side, facing in toward the cemetery, is a collage of buildings and structures representing the various communities and rural areas that comprise the parish. The Immaculate Conception Church on Seventh Street displays a life-size marble

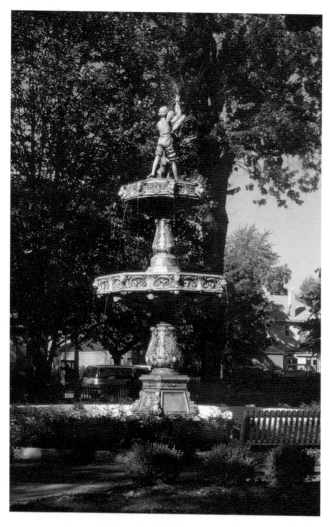

The restored Eckhardt Fountain is the centerpiece of a courtyard addition on Auburn's historic library.

This charming little monument marks the grave of Captain Samuel Edge in the Waterloo Cemetery.

figure of Our Lady of Lourdes, placed in 1963. Outside of Waterloo at Saint Michael Catholic Church Cemetery stands a life-size figure of the Resurrected Christ on a fieldstone base. There are other smaller sculptures at Catholic churches throughout the county.

A granite sentry of the Union army, similar to several others scattered about northern Indiana, tops the Soldiers Monument (1911) in the cemetery at Saint Joe. The Soldiers and Sailors Monument in Butler's town cemetery is also of granite, but the figure is that of a flag bearer. The memorial was dedicated in 1908.

Crudely carved in the 1890s, the poignant little limestone statue of Captain Samuel Edge resides in

the cemetery at Waterloo on the northwest side of town.[31]

DELAWARE

Delaware County's sculptures are scattered all over and around Muncie, running the gamut from conventional military monuments and heroic statues to whimsical children and huge abstracts. On the campus of Ball State University is perhaps the best known, the final work of no less than Daniel Chester French (1850–1931): a bronze female figure symbolizing *Beneficence*. French was the sculptor of the

Lincoln Monument in Washington, D.C. *Benefi-cence* stands atop a fountain in a semicircle of five limestone columns, a setting designed by noted architect Charles Henry Dana. The memorial commemorates the five Ball brothers who came to Muncie to start a glass factory in the 1880s. Public subscription funded this tribute to the family that returned so much to the city, including the university campus (then Ball State Teachers College) on which the memorial stands. Not far from the memorial is a piece by British sculptor Lynn Chadwick (1914–2003), a stylized figure of a woman with her hair and skirts blowing as she walks in a stiff breeze. *High Wind IV* was erected in front of the Administration Building in 1995.[32]

North of the Bracken Library is a fountain dedicated in 1993 as a new home for an old work of art. The local firm of Rundell Ernstberger Associates designed the large basin lined with bronze frogs spewing streams of water that complement the focal point of the installation, *Frog Baby,* by Edith Baretto Stevens Parsons (1878–1956). One of a large num-ber of women sculptors working in the early twentieth century, Parsons specialized in garden pieces featuring small children in winsome poses. She created *Frog Baby* about 1917; at least one other casting of it survives. In 1937 Frank Ball purchased the piece and placed it on permanent loan to the Ball State art museum. Alexander Bracken, to whom the fountain was dedicated, was Frank C. Ball's son-in-law. Inside the library is a bronze work by a contemporary of Parsons, Harriet W. Frishmuth (1880–1980). The piece, created in 1929, was originally on the grounds of the E. B. Ball estate and is rightly a fountain sculpture. Frishmuth's specialty was female figures in active poses, and this is a wonderful example of her work. A young nude woman is balanced on one foot as if prancing amidst streams of water—which she did in her original setting. Grace Helen Talbot (1901–1971) was a pupil of Frishmuth and lived and worked primarily in New York. On the former E. B. Ball estate (now a university and community center) at 400 West Minnetrista Boulevard is Talbot's bronze fountain with two giggling nude children playing in

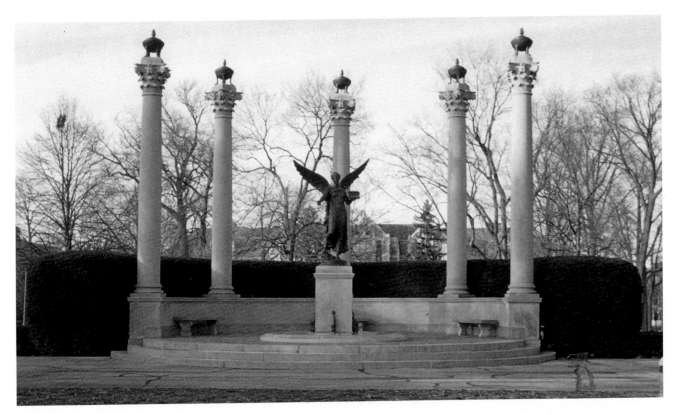

Muncie is honored with the last major work of Daniel Chester French, *Beneficence,* a tribute to the Ball brothers.

the spray. The fountain was installed on the Ball property in 1930.

Opened in 1995, Oakhurst Gardens is located on the more than six-acre estate that once was owned by G. A. Ball. On the property are two pieces of garden sculpture that originally were on the Frank C. Ball estate, the present location of the Minnetrista Cultural Center. The *Fountain of Joy* features an exuberant child in bronze, mounted on a limestone base. Records are sparse on this piece and the artist is unknown, although it resembles the work of Janet Scudder (1869–1940), another of the many women sculptors working in the early twentieth century. The subject matter is also typical of the work of Parsons and Talbot. Around the base are three upright rabbits that spew water. Located in the Children's Garden is *Bronze Baby,* depicting an infant lying on its back on a lily pad. It was sculpted in 1916 by Minnesota-born Brenda Putnam (1890–1975).[33]

Since the Ball family supported so many women artists in the past, it was fitting that a contemporary female sculptor be commissioned for the long-planned major work to set off the Minnetrista Center. South Bend native Beverly Stucker Precious (b. 1952), whose work is recognized nationwide, created the monumental *Catalyst* as a tribute to Edmund F. Ball. Precious, who now lives in Indianapolis, said the work speaks of "movement, vitality, and strength." The stainless steel and glass piece is open and roughly spherical, resting on three shaped supports of Indiana limestone. *Catalyst* was dedicated in June 2004.

Ball State's Fine Arts Building was constructed in 1936 with funds from the Public Works Administration (PWA), a New Deal agency. On the facade are reliefs by Elmer Harland (E. H.) Daniels (1905–1986), who was commissioned only a few years later to create the limestone relief murals for the Lincoln Memorial in Spencer County. Also on

the campus are two large abstract works in steel by New York sculptor Lila Katzen (1932–1998), both installed on West Riverside Drive in 1977: *Maxi-Antecedent II* and *X Series-Like a J.* On Neeley Street is Richard Kishel's large steel abstract—*Tribute to Mankind,* erected in 1973. A few blocks farther west is an untitled abstract work by William R. Pruett, installed in the early 1970s.

Kishel's work is not limited to abstracts, although in 1966 he did create a most unusual relief along the side of the Slavin Building in the 300 block of West Washington Street in downtown Muncie. In 1964 he sculpted a huge fiberglass statue of Paul Bunyan for a lumber company. The thirty-eight-foot figure outlived the business for which it was made and was moved to its present site, a tavern on West Kilgore Avenue, in 1993. In 1981 Kishel created a sixteen-foot figure of Christ as the Good Shepherd for the Fountain Square United Methodist Church at 4600 South Madison Street.

Newspaper publisher and civic leader George F. McCulloch (1855–1915) donated the city park that bears his name. After his death, the people of Muncie raised funds for a memorial to be erected in a prominent location near the entrance, but its ultimate placement was considerably more isolated. The full-size bronze likeness of McCulloch dressed in evening clothes, based on a photograph, was created by Illinois sculptor Leonard Crunelle (1872–1944).

Turning to military memorials, Muncie boasts one of the several castings of *The Spirit of the American Doughboy* by Ernest Moore Viquesney (1876–1946). The lineage of this one, however, is a bit muddled. The figure does not appear to be bronze—Viquesney did offer the statue in various materials and sizes—and the story goes that the piece was languishing in the basement of the old Muncie City Hall when Elizabeth Sears purchased it in 1939 and had it bronzed. In any case, she donated it to be erected at Elm Ridge Cemetery on State Road 67, where it stands today. That cemetery also displays a large number of life-size marble statues of children and family groups, as well as

Frog Baby (opposite page), by Edith Baretto Stevens Parsons, has been refurbished and placed in a new fountain basin on the Ball State University campus.

religious figures, most of which were imported from Italy in the 1950s. There are also two bronze pieces by Mabel Landrum Torrey (1886–1974), a contemporary of Frishmuth and Parsons. Both bronze pieces portray children. *Innocence,* originally titled *Our Little Lamb* and placed in the cemetery in the late 1960s, was the joint work of Torrey and sculptor Florence Gray, who had originally received the commission. It shows a little girl gazing raptly into the face of a lamb, who is staring back at her. *Buttercup, Poppy and Forget-Me-Not,* created about 1948, is Torrey's interpretation of the three figures from the poem by Eugene Field. The cemetery has another bronze grouping of three children, done in the 1960s, that although unattributed may also be the work of Torrey.

While there is some question whether it should be considered as a sculpture, the Vietnam Veterans Memorial was designed by sculptors Ray Parish, a former professor of art at Ball State, and one of his students, Mikel Marker. Dedicated in 1986 on Veterans Day in Heekin Park, it is a large slab of polished black granite acid-etched with the silhouettes of three soldiers and, in the upper corners, two helicopters. A ten-foot-high trapezoidal slab at one end displays the names of those dead or missing from Delaware County.

Tree-filled Beech Grove Cemetery on Kilgore Avenue is filled with numerous examples of high cemetery art, allegorical statuary, and religious figures. Scarcely noticed near the entrance is a small memorial to the Spanish-American War, with a bronze relief plaque featuring the ubiquitous USS *Maine,* the ship whose unexplained sinking in a Cuban harbor set off the war. Placed in 1913, the piece is the work of New York sculptor Charles Keck (1875–1951).[34]

Saint Mary Church at 2300 West Jackson Street features two heroic limestone statues at its entrance carved by George Yostel and dedicated in 1965. The twelve-foot figure of Christ on the Cross is prominently placed between and above the double doors. But overpowering even that is the huge figure of the Virgin Mary that gazes down in an attitude of bless-

ing upon all who enter the church. She is somewhat stylized and more than twenty feet high. At Saint Mary School nearby on West Gilbert Street, there are several examples of religious statuary as well as the bronze bust of Monsignor Edgar Cyr, completed in 1985.

The Children's Museum displays two bronze pieces by Paul Moore (b. 1957) of Oklahoma that capture the innocent wonder of childhood. *Wait for Me* was dedicated in 1999 on the sidewalk outside the museum's entrance on South High Street and depicts a ragged line of charming small children in various attitudes and outfits. Moore's other piece is within the Outdoor Learning Center off the west side of the building that one must enter through the

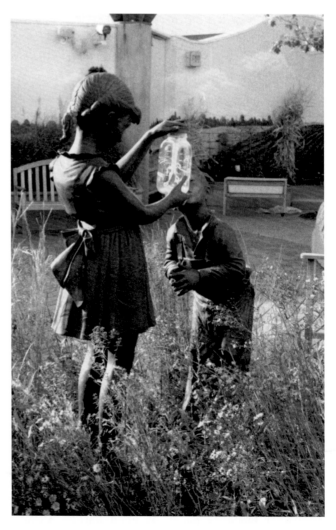

Paul Moore sculpted this lovely piece that captures one of the chief joys of childhood: chasing fireflies to put in a jar.

Statues that once graced the old Delaware County Courthouse now glower at ground level in downtown Muncie.

museum. *Fireflies,* placed in 1996, is a nostalgic composition of a young girl holding a Ball jar (of course) filled with fireflies as a little boy stares at the jar in wonder. The fireflies are represented by glowing tubes of light. In the same area is a contemporary limestone work by Bloomington sculptor Dale Enochs (b. 1952), *Earth, Air, Fire, Water,* completed in 1997.[35]

Muncie was named for a Delaware chief, and Native Americans are well represented in the city's sculptures. Dedicated in 1929 as a memorial to Edmund Burke Ball is Cyrus Edwin Dallin's (1861–1944) famous *Appeal to the Great Spirit.* It is an eight-foot-high bronze replica of the original in Boston, which was cast in 1903. The piece depicts an Indian chief astride his horse, his face turned skyward and his arms stretched outward in supplica-

tion. Another well-known work by Dallin, *Passing of the Buffalo,* was created in 1929 and installed on the New Jersey estate of Geraldine Rockefeller Dodge in 1931. It was acquired by the Margaret Ball Petty Foundation and given to the city of Muncie in 1975, which installed the statue in front of the Ball store building downtown the following year. The heroic bronze figure, bow in hand, stood on its rough boulder base guarding the store until the building was demolished in 1989. For several years after, the figure maintained a lonely vigil downtown. It currently stands inside the Minnetrista Center, awaiting a new location downtown. Near the White River, a lone seated brave plays a *Night Song* on his wooden flute. Arizona sculptor Joe Beeler (b. 1931) created the detailed work, which is placed on a sandstone pedestal

overlooking the High Street Bridge. It was dedicated in 1998.[36]

A Delaware chief is among the three outsized limestone figures standing on a corner in downtown Muncie, survivors of the courthouse designed by Brentwood S. Tolan, built in 1885–87 and demolished in 1966. The other two statues are allegorical, representing Agriculture and Industry, which were typical subjects for sculpture on late-nineteenth-century public buildings. The pieces were carved by John A. Ward, an Irish immigrant who apprenticed to a stonecutter and eventually became a sculptor. Today the statues are arranged on a tiny landscaped patch next to a parking lot, where another nineteenth-century building, the Wysor Block, once stood. Its salvaged entrance remains, just west of the courthouse pieces.

Chicago-born Kenneth G. Ryden (b. 1945), a professor in the Art Department at Anderson University, has crossed the county line several times. Recently he created *Threshold* for the Edmund F. Ball Medical Education Center at 221 North Celia Avenue near the edge of the Ball State campus. Dedicated in 2001, the bronze statue, sited beneath a stainless steel arch, portrays a doctor of undetermined age and experience, holding in his hand a flame representing knowledge and new discoveries in medicine. *Illumination* is a lovely ethereal work that graces the front of the Daleville library. The library, possibly anticipating further sprawl, is considerably east of town off State Road 67. Dedicated in 1998, the spritelike creature stands tiptoe on one foot, atop a stack of books, holding aloft what is presumably the light of wisdom.[37]

DUBOIS

For a mostly rural area, Dubois County boasts a surprising amount of sculpture, much of it religious, owing to the large German Catholic population that settled in this region in the nineteenth century. Although many of the towns found on the map are merely parish centers consisting of a church and a few houses, most will have the statue of their patron saint on or in front of the church. In Saint Henry, for example, there is a larger-than-life statue of Saint Henry in a niche above the church door. This is worth noting as it appears to be the only outdoor statue of Saint Henry in the state. There is similar religious statuary on the parish churches of Ireland, Saint Anthony, and Schnellville, and large Crucifixions in the church cemeteries at Saint Anthony, Ireland, and Celestine.[38]

The Monastery Immaculate Conception at Ferdinand has a sizable shrine to Our Lady of Fatima. Its cemetery and that of the parish church contain limestone crucifixes carved by the late nineteenth-century German stone carver Zuckriegel of Rockport.

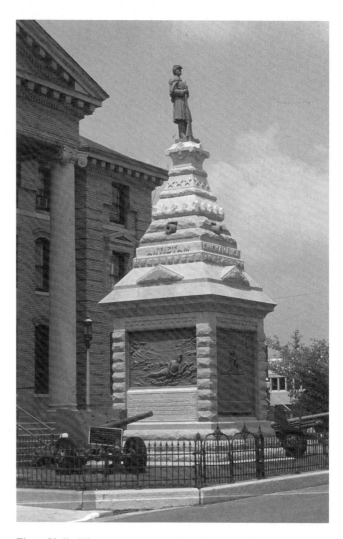

The Civil War monument in Jasper displays relief sculptures as well as a sentry atop a stone vault.

The limestone abstract *Endarchy* graces a bank in Jasper.

The namesake church at Ferdinand also displays traditional religious statuary, along with *Christ the Victor*, a heroic statue of Christ intended as a World War II memorial. The stylized figure, dating to about 1950, is typical of the work of Herbert Jogerst (1912–1993), a former German prisoner of war who, after his repatriation, returned to southern Indiana to work for several years, carving numerous statues at Saint Meinrad Archabbey and in other nearby towns.

The county seat of Jasper boasts the magnificent Saint Joseph Church with a statue of its patron saint in a high niche, along with Saints Peter and Paul. On the south side of the church is the *Deliverance Cross*—or rather, a copy of the large stone crucifix that was erected about 1848 by German Catholic immigrants in gratitude for a safe crossing through a storm at sea. Ironically, a storm destroyed the original *Deliverance Cross* in 1928, but four years later a replacement carved by Harry Melchior and Otto J. Blessinger was dedicated. The figure of Christ is metal, unlike the original, which was stone. Southeast of the church are three heroic statues of its earliest pastors—the "founding fathers"—sculpted in limestone by E. H. Daniels in 1943–44. Father Joseph Kundek (1810–1857) helped found Saint Meinrad Abbey and the parishes of Ferdinand, Celestine, Rockport, and Fulda. German-born Father Fidelis Maute (1837–1897) was the architect and builder of the Saint Joseph Church. Swiss-born Father Basil Heusler (1860–1942) added the bell

tower to the church and built the convent and school. All three priests are buried in the cemetery directly west of the church, which features beautiful works by nineteenth-century German stone carvers as well as a Crucifixion. West of the cemetery is a unique grotto and a shrine to Saint Joseph, built of geodes and architectural salvage in the 1950s. The work blurs the line between sculpture and architecture.

On the east side of the courthouse is the Dubois County Soldiers and Sailors Monument, which features a white bronze (a zinc alloy) sentry figure. The oversize limestone pedestal is actually a sort of mausoleum for relics pertaining to the companies formed in Dubois County, although the artifacts did not fare well. The Soldiers and Sailors Monument was dedicated with great ceremony in 1894 in what was then a small separate plot east of the 1845 Greek Revival-style courthouse. The much-larger present courthouse, completed in 1911, crowded into the space surrounding the limestone monument, as did the later widening of the street. It was created by local stonemason and architect Michael F. Durlauf, the metal work contracted with the Monumental Bronze Company of Bridgeport, Connecticut. The monument includes a poignant relief commemorating two soldiers from the nearby village of Celestine. Nicholas Kremer, a German immigrant, and his American-born son, John, both died the same day in May 1863 in the Battle of Champion Hill in Mississippi, part of General Ulysses S. Grant's Vicksburg Campaign.[39]

Gateway to the Heart is a memorial to Bill Schroeder of Jasper, "the longest living, permanently implanted heart recipient." He survived 620 days (1984–86) on the Jarvik-7 artificial heart. Designed and executed by local artist Bernard Hagedorn (1915–2001), the abstract piece of unpolished stainless steel was dedicated in 1988 at the site of the planned Bill Schroeder Sports Complex on Second Street.

Endarchy is a smooth and curvy abstract work by David L. Rodgers, formerly of Bloomington, commissioned by the Dubois County Bank and erected in front of its building on East Sixth Street in 1982.

ELKHART

Most of Elkhart County's sculptures are located in its namesake city, although its seat of Goshen boasts the studio of John Mishler in the Old Bag Factory, where visitors can watch the sculptor at work. Goshen College, where he teaches, has two of Mishler's large and colorful kinetic sculptures in outdoor settings on campus: *Broken Shields*, erected in 1981, and *Sky Rhythms*, unveiled in 1994 in front of the new Recreation-Fitness Center.[40] Notable on campus more for its age than its sculptural qualities is the Adelphian Fountain, a frequent gathering place

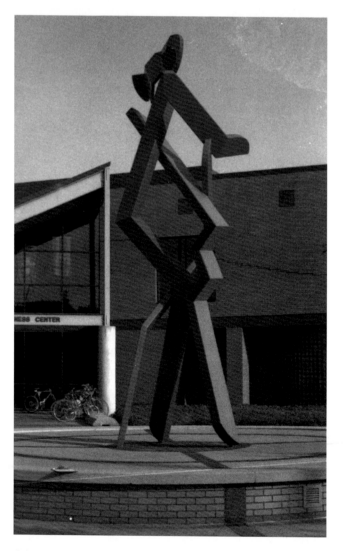

John Mishler's *Sky Rhythms* on the campus of Goshen College.

for students. The cast-iron piece was installed in 1904, a gift of the Adelphian Literary Society for the new campus.

In front of the courthouse is the unlikely figure of Poseidon, or Neptune, donated in 1912 as a gift of gratitude from a local Greek immigrant, James Polezoes. Polezoes, one of the proprietors of the Candy Kitchen, a Goshen confectionery, had come to America as a young teenager only nine years before. The figure, placed in an attractive fountain setting, was ordered from the J. L. Mott Iron Works catalog. The fountain was completely refurbished in the 1990s.

The children of Chandler Elementary School in Goshen collaborated with artist Joe LaMantia to create a fanciful hornet of steel, perched on a ten-foot-high flower. *Sting* was erected in 2003.

The city of Elkhart has more installations of John Mishler's work; he is not a prophet without honor in his own county. The earliest is *Windstream* in High Dive Park, dedicated in 1988. *Thunder Dance* was erected in 1994 directly north of the Midwest Museum of American Art (itself a recycled former bank) on Main Street. Mishler usually finds the building blocks of his works in scrap yards, and this piece appropriately incorporates a discarded light pole that had once stood downtown. His *Cloud Catcher,* completed for the museum two years before, has been placed on permanent loan to the city and erected on the Riverwalk, south of Island Park. Mishler's piece that probably speaks most of the city is *River Passage,* which is comprised of flowing shapes colored blue and green, with a rotating heart as the signature kinetic element. Mishler oversaw the installation at the corner of Jackson Boulevard and Johnson Street in August 2000.[41]

Mindful of its heritage as the home of several manufacturers of musical instruments, Elkhart commissioned local artist Mark Lorentz (b. 1962) to create *The Sax Player* in 1996, a whimsical bronze work that stands at the Jackson Street bridge across the river from downtown. The work interprets a saxophone player that Lorentz saw playing at a local jazz festival.[42]

The Sax Player is silhouetted along the Elkhart River in celebration of Elkhart's heritage of musical instrument manufacture.

More recently, an entire band of stylized figures fashioned from scrap metal now marches in place on the Riverwalk at the Jackson Boulevard bridge near the YMCA. The institution donated the land, and the president of the local civic group, Elkhart Improvements, Inc., raised sufficient funds to purchase the twenty figures from sculptor Stuart Padnos of Holland, Michigan. The Elkhart Jazz Festival gathered up the actual instruments the statues appear to play. Called simply *The Marching Band,* the work was dedicated in November 2004.

In November 2002 a memorial to firefighters and police officers who died in the line of duty was erected on the east bank of the Riverwalk. Bronze statues depicting a firefighter in full gear and a police officer holding a child by the hand stand next to a wall on which the names of those honored are engraved. The sculptures are the work of California artist Ron Pekar, perhaps best known for his work at Disneyland and Disney World.

Elkhart's founder Havilah Beardsley (1795–1856), who laid out the original plat in 1832, is honored with a life-size bronze statue on Riverside Drive. After building a sawmill, Beardsley spent two decades establishing several water-powered industries along the river, including two flour mills and a paper mill. The statue, the creation of Pietro Bazzanti from Florence, Italy, is placed in a fountain memorial designed by E. Hill Turnock, the city's leading architect of the time. Beardsley's nephew Albert provided the funds for the memorial, erected in 1913.

On the Church of Saint Thomas the Apostle at 1405 North Main Street is an eleven-foot bronze crucifix, the work of Father James Flanigan (b. 1935), a professor of art at the University of Notre

One of northern Indiana's numerous granite sentries tops a Civil War monument at Middlebury.

Dame. The crucifix, cast in 1983 and installed the following year, shows the image of Christ as negative space on a solid cross.

At a hardware store at 1635 Cassopolis Street is a twenty-foot-high statue of Paul Bunyan, one of many such figures made during the 1960s by the International Fiberglass Company of Venice, California. Those that remain have usually become local landmarks, and this sturdy fellow has survived several attacks from vandals.[43]

A Civil War monument in Elkhart's Rice Cemetery once stood downtown at the south end of Main Street. The street later became part of the Lincoln Highway, the first cross-country automobile route, and the statue proved to be a hazard to the growing traffic—and vice versa—so the monument was moved to the cemetery in 1928. The monument, originally dedicated in 1889, was designed and built by Nelson P. Doty. The ornate pedestal, which supports a bronze sentry, includes numerous inscriptions and bronze symbolic images. Silas Baldwin, a prominent Elkhart businessman and civic leader, bequeathed the funds for the monument in memory of his son. A plaque on the monument tells of eighteen-year-old Lieutenant Frank Baldwin, Company I of the Forty-fourth Indiana Infantry, who was killed in the Battle of Stone River the last day of 1862.

One Civil War monument was evidently not enough for Elkhart. A Soldiers and Sailors Monument designed by local firm Moore and Dickerhoff was dedicated in 1909 in Gracelawn Cemetery on Middlebury Street. This one features a marble sentry and a granite base, with lengthy inscriptions on all four sides. At one time the cemetery had a rare and lovely bronze piece by Harriet W. Frishmuth (1880–1980), one of several women sculptors working in the early twentieth century. *Roses of Yesterday* (1928), a life-size figure of a young woman, was stolen in the 1990s from its isolated site deep in the cemetery.

In Middlebury's Gracelawn Cemetery is still another Soldiers and Sailors Monument, also erected in 1909. It is one of several basically identi-

cal granite Union sentries that are scattered throughout northern Indiana.

In Bristol, Saint Mary Catholic Church on Chestnut Street is adorned with Henry R. "Hank" Mascotte's abstract reliefs in cast concrete, completed in 1978.

FAYETTE

Fayette County is largely rural farmland, rugged in spots and crisscrossed with creeks. In the past there had been little outdoor sculpture, apart from a statue of Saint Gabriel the Archangel at the school

Gabriel the Archangel guards the pupils of Saint Gabriel School in Connersville.

of the same name on West Ninth Street in Connersville. That is no longer the case today. A contemporary metal sculpture in Roberts Park on Connersville's north side is an example of true community art. It was designed by Les Yeager with input from elementary school pupils throughout the county. Students from the Whitewater Technical Career Center executed the designs in metal and welded the pieces into place. The *Millennium Art Sculpture* celebrates the history of Connersville, including such elements as a covered bridge, a canal boat, and an automobile. It was installed in June 2001.[44]

FLOYD

Little Floyd County nestles along the Ohio River, as do its inhabitants. Away from the river the terrain is hilly and forested. Public sculpture lies almost entirely within the county seat of New Albany.[45]

One of the more thought-provoking and unusual bronze works in the state stands ("writhes" may be more appropriate) in front of the New Albany–Floyd County Library at 180 West Spring Street. *The Search*, dedicated in 1985 and, according to contemporary newspapers, New Albany's first "modern" public sculpture, is the work of Louisville artist Barney Bright (1927–1997). The intriguing piece is comprised of no less than eleven figures intertwined. It evolved from a scrapped concept originally called *The People Tree*. Mounted on a seven-foot pedestal and stretching about thirteen feet in length, *The Search* is difficult to miss.

When Paul Fields, also of Louisville, first created his seven-ton marble sculpture *Eye to the Future* in 1988, it had no name. The owner of the Kelley Building at 2113 State Street purchased the piece, described by many as "snail-like," in 1992 and held a contest to name it. The curvy abstract piece stands in front of the building, which is a dental laboratory. More recently, Fields created what is known as the *Braeutigam Sculpture* in honor of the

This wonderful tribute to mid-nineteenth century firemen stands in New Albany's Fairview Cemetery.

donor, longtime New Albany teacher Ruth Braeutigam. The abstract work was dedicated in 1997 outside the Ogle Center at Indiana University Southeast. It is fashioned of two huge pieces of limestone, with warm curves to "soften up the lines" of what the donor perceived as a bleak building. Less than three years later, another Fields piece was erected inside the Ogle Center Lobby.[46]

Floyd County also has numerous examples of historic traditional sculpture. On the Carnegie Center for Art & History, built in 1902 at 201 East Spring Street, are several limestone allegorical figures above the west and south entrances. The sculptor was local artist James L. Russell (1872–1937), who later concentrated exclusively on painting.

Amidst the wooded hills of the historic Fairview Cemetery is a treasure trove of funerary art and historic grave markers. A particularly stunning monument is the Volunteer Firemen's Memorial dedicated with great fanfare in 1902. The piece, by Charles Edwards, commemorates the Volunteer Fire Department that served the city from 1825 to 1865, before a professional fire department was established. A life-size pewter statue depicts a fireman of the mid-nineteenth century cradling a child. The figure stands on a limestone pedestal carved with images of the fire-fighting equipment used at the time, making the monument a superb three-dimensional display.

Saint Mary Church and its companion school on East Eighth Street both display traditional religious figures of painted metal and marble. Near the entrance to the Kraft Graceland Memorial Park on Charlestown Road is a bronze work called *Companion,* commissioned in 1978. It depicts a life-size couple in long robes, gazing heavenward, their arms about each other. Outside the urban center of the county at Mount Saint Francis, there are several figures of the saint, some of which came from the Novitiate of Saint Anthony in Auburn, which closed in 1975. At the entrance of the Retreat House is *Sol-Luna Canticle,* an interpretation of Saint Francis of Assisi in bronze by sculptor David Kocka (b. 1950), done in 1986.[47]

FOUNTAIN

Fountain County, bordered by the Wabash River, creek-laden and rugged in spots, has but one major sculpture, one of Ernest Moore Viquesney's (1876–1946) tributes to World War I soldiers. *The Spirit of the American Doughboy* stands outside Attica's public library on Perry Street. It was erected in 1927.[48]

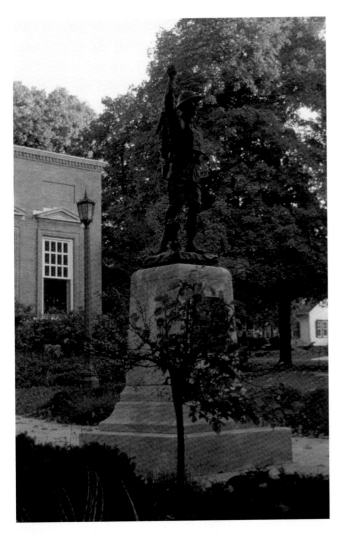

The Spirit of the American Doughboy was erected in front of the library in Attica in 1927.

FRANKLIN

This hilly county with a rural heritage was settled largely by German Catholics, which helps explain the fact that, until quite recently, the only outdoor sculptures to be found were of a religious nature. Oldenburg, once known as the "Village of Spires" because of the several buildings of its church, convent, and monastery (the monastery was demolished in the 1980s), still has the highest concentration, most of which are in or around the Immaculate Conception Convent, the motherhouse of the Sis-

ters of the Third Order of Saint Francis, or its academy. There is a cast-metal statue of the patron saint in an interior courtyard that dates to 1882. Above the entrance to the convent, in niches, are large limestone figures of Saint Francis and a Guardian Angel placed in 1901. An even older statue of the Immaculate Conception graces the convent chapel, placed when the structure was built in 1889. An oversize marble grouping of Our Lady of Fatima and the children, located on a hill near the academy, was carved by the Heuschler artists of Italy in 1950. The shrine itself was designed by Sister Ruth Michaelis. Also on the convent's grounds are shrines to Christ the King and Jesus, Friend of Children,

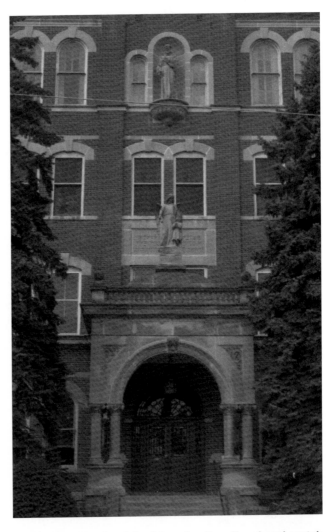

Both Saint Francis of Assisi and a Guardian Angel watch over the entrance to the Immaculate Conception Convent of the Sisters of Saint Francis.

both created in the 1930s, and a Grotto of Lourdes, built in 1904.

Not far away, at the Church of the Holy Family in town, is the oldest piece, a large limestone rendition of the Holy Family from the 1860s. The *Friedlichgarten,* or Friendship Garden, on Main Street was created in 1978. In it is a cast-aluminum plaque designed by Joe Geier (1935–2002), depicting the founding of the Oldenburg parish, the monastery, and the convent.[49]

A marble figure of Christ (the Sacred Heart), notable for its age, stands at the Saint Cecilia of Rome Catholic Church at Oak Forest. The statue dates to about 1870.

In the county seat of Brookville, there are several religious statues around Saint Michael Catholic Church and at its cemetery on State Road 101. The most impressive is surely the heroic granite Saint

Michael the Archangel and the dragon at the entrance to the cemetery, which dates to about 1925. The cemetery apparently erected a new Crucifixion grouping with limestone figures in 1963. The cemetery's earlier Crucifixion, with figures of Orbronze (a sheet metal alloy) from Daprato Statuary, was reerected about ten years later at the rural cemetery of Saint Mary of the Rock in the vicinity of Batesville.

While Batesville is in Ripley County, its edges spill over into Franklin. The Batesville Community School Corporation has a lively arts-in-education program that has produced outdoor art works that are a few yards within Franklin County. *Sands of Time* (1997), a tower constructed of several materials, and *Waters of Time* (2001), a fountain, are discussed in more detail in the Ripley County section.[50]

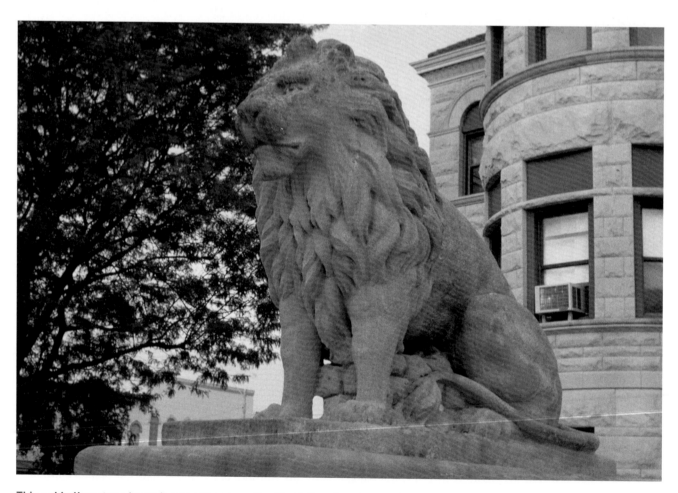

This noble limestone beast is one of ten guarding the Fulton County Courthouse in Rochester.

FULTON

Fulton County is best known for its round barns, indicative of its rural character. The courthouse in Rochester is surrounded with a pride of limestone lions, ten in all, carved by a German immigrant named Hedrick in 1895. Prior to completing the lions, he had worked on the ornamentation of the courthouse.[51]

GIBSON

The courthouse square in Princeton boasts two Civil War monuments. The first, erected "by the 58th Regiment, Indiana Volunteer Infantry, in honor of its dead" in July 1865, purports to be the only one erected to and by its regiment while still in service. It is the earliest Civil War monument in the state. The contract was let to a Cincinnati firm in November 1863 and paid for with donations from surviving members of the regiment and the community. Gibson County cherished this memorial enough to repair the ravages of seventy-odd years and in July 1940 rededicated the refurbished monument.[52]

The second monument on the square, erected almost fifty years after the first, is an impressive sixty-foot shaft of Wisconsin granite topped with a bronze heroic figure of a flag bearer, designed by the gifted sculptor Rudolf Schwarz (1866–1912). Four military figures surround the top of the base. Although Schwarz completed the designs, he died before he could finish the figures and an assistant did the casting. The monument was dedicated in November 1912, seven months after the sculptor's death.

Princeton's courthouse, with its fanciful human and animal faces on all four sides, should not be ignored. The visages are formed of both terra cotta and limestone and include classical female countenances, roaring lions, and unidentified bestial faces. The courthouse was built in 1884 by the McDonald Brothers architectural firm of Louisville, Kentucky.

Collaborative artist Joe LaMantia of Bloomington worked with the pupils of Lowell Elementary School in 2004 to produce *Community United by Children*. The piece uses Toyota parts and other scrap metal to reflect aspects of the county's identity.

Gibson County boasts yet another Civil War monument in Oakland City, the Company F, Forty-second Indiana Monument, erected in 1894. Constructed entirely of Green River limestone, the memorial features a sentry figure atop a tall shaft. Presently standing in front of the American Legion Post 256 at 211 East Washington Street, the figure was moved from its original location, a donated plot in the 300 block of West Oak Street. The monument was neglected and had begun to sink, and with the best of intentions the American Legion not only moved it to a new foundation but also cleaned the structure with acid, which unfortunately eroded much of the detail.

Walnut Hill, a small cemetery north of Fort Branch, has an impressive collection of unusual funerary art. Especially notable is the double portrait statue, one of only two in the state, of Robert and Ann Anderson. Widowed in 1895, Ann sent portraits of her husband and herself to Italy so a sculptor could create their full-length likenesses in marble. The life-size figures show a handsome elderly couple in late-nineteenth-century attire. Ann died in 1921 at the age of ninety, finally joining her husband beneath their images of stone. Another marble portrait statue, this one of a handsome youth neatly attired in a suit fashionable for its day, poignantly tells what the world lost when eighteen-year-old Marshall Heuring was given the wrong medication in 1916. An unusual weeping widow—a classic theme in funerary art—serves as the Vickery monument, showing a heavily robed woman kneeling in grief behind the grave marker, all carved from one block of limestone. Will Vickery died in 1901 in a grain elevator accident at the age of thirty-one. His wife Martha lived another forty years.

GRANT

For a county that still boasts sweeping landscapes of open farmland, Grant County boasts more sculpture than one might suppose. At the north and south approaches to the county seat of Marion via State Road 9 are two identical bronze portraits of Dr. Martin Luther King Jr. in high relief, mounted on large blocks of limestone. Installed in 2000 to mark the Dr. Martin Luther King Jr. Memorial Way, the pieces are the work of Kenneth G. Ryden (b. 1945) of Anderson.[53]

In the National Cemetery on the south side of Marion, located next to the Veterans Administration facilities (formerly the National Soldiers Home), stands the Soldiers Monument by Lorado Taft (1860–1936). Dedicated in 1915, it is a ten-foot-high bronze copy of a work originally commissioned for the Chickamauga Battlefield. North of Swayzee along State Road 13 is a Civil War memorial in a lonely cemetery called Thrailkill. Erected in 1910, this Grand Army of the Republic monument features a limestone flag bearer.

A surprising collection of sculpture—both in quantity and content—resides at Taylor University near Upland. In the 1980s Craig Moore, an art professor at the school, learned that the contents of a sculpture park in Chicago were threatened by development. Sculpture Chicago, the nonprofit organization that created the park, offered the sculptures free to a good home. A Fort Wayne construction company donated its services to haul three huge and unwieldy pieces from Chicago to Upland. The sculptures, placed in prominent locations on the campus in 1988, are all large abstract works. Detroit artist Robert Sestok's *Space Grip* weighs three tons and is twenty-two feet high. It is an abstracted gigantic fist of welded steel. *The Hurl* by Richard Tucker of Manchester, Michigan, resembles a fat tornado but is meant to suggest a huge twisted col-

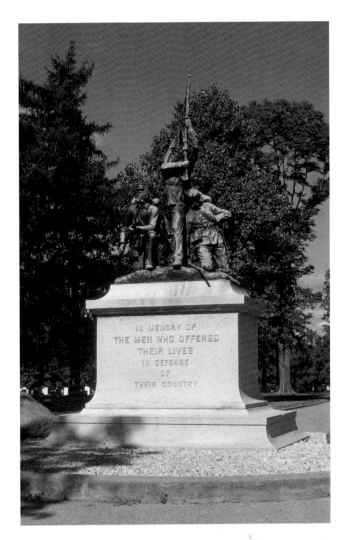

A smaller casting of Lorado Taft's Soldiers Monument stands at the cemetery of the Veterans Administration at Marion.

umn. The six-ton piece of welded steel and concrete is painted black. Chicago sculptor Roger Machin created *The Flexing of Florida, Part 1* (*Part 2* is in Toronto), using galvanized pipe and copper. Standing forty feet high, the piece hints at both the palm trees of Florida and a launchpad at the Kennedy Space Center. In 1995 Ken Ryden completed a trio of life-size bronzes commemorating the young nineteenth-century Liberian prince Samuel Morris, who attended Taylor University. The pieces stand in a fountain setting in a small park in front of the Rupp Communication Arts Center on the campus.[54]

A beautiful white oak on the Walnut Creek Golf Course near Upland was struck by lightning in

The marble figures of the Andersons watch over the cemetery at Fort Branch (opposite page).

A Union sentry stands guard over the grave of Civil War veteran Levi Price in the cemetery at Linton.

GREENE

A pair of lions created by local stone carver John Thomas Wright (1903–1978) guard the entrance to Fairview Cemetery in Linton, the county's largest town. Originally the lions were in front of Wright's house. In the cemetery is a nearly life-size figure of a Union sentry carved in granite on the grave of Levi Price, who died in 1910.[56]

Southwest of Bloomfield, the county seat, in a rural cemetery is the grave of Malinda Clark (1804–1896) that features a seated woman with flowers—a common figure on gravestones of the 1890s. What makes this particular work significant is that it is believed to be the work of Ira Correll (1873–1964), an Indiana sculptor of some renown in the early twentieth century, who carved several significant cemetery monuments in southwestern Indiana.

HAMILTON

One of the state's oldest Civil War monuments is located in Crownland Cemetery in Noblesville. Erected in 1869, the badly weathered marble shaft is topped with an eagle. Another Civil War-related sculpture is a few miles north of Noblesville in the cemetery of the Church of the Brethren on the eastern edge of Arcadia off State Road 19. Topped with a marble Union sentry is the grave of war veteran Jacob A. Bryan, who died in 1916. He served in the 123rd Indiana Infantry.[57]

The same cemetery contains a religious statue in marble, *Garden of Faith*, dating to the mid-1960s. Similar marble statuary with sacred themes is found in abundance in the Oaklawn Memorial Gardens north of Castleton on Allisonville Road. Most were carved in the 1960s. Some of the less common examples include the figures of Ruth, Saint Therese, and John the Baptist. At Saint Vincent–Carmel Hospital is a life-size bronze statue of Saint Vincent de Paul and a beggar, placed in 1990.

1994, leaving a sixteen-foot trunk standing. The owner of the course decided to make lemonade from lemons and hired wood-carver and sculptor Jeremy Bernards from Iowa to create a statue. The result, completed in the summer of 1995, is *Andrew*, a stylized ten-foot-high golfer in traditional garb, standing six feet above the ground.[55]

World famous as the hometown of James Dean, Fairmount displays in a tiny park downtown a bronze head of the 1950s actor, designed by Kenneth Kendall in 1955. The original cast was placed in 1957 but promptly stolen, which, unfortunately, has been the fate of any number of items associated with Dean. A new casting was placed on a new pedestal at the present site about 1995.

One of the earliest Civil War monuments in the state, this soaring shaft topped with an eagle stands in Crownland Cemetery in Noblesville.

Erected in 1994, a contemplative statue of the Virgin Mary stands in front of the parish hall of the new Saint Maria Goretti Church on Spring Mill Road in Westfield.

In front of the Carmel headquarters of Browning Investments on 116th Street at Pennsylvania is *Three in One,* a stainless steel abstract by Pennsylvania artist Philip Thompson, erected in 1990. About a block to the north at the headquarters of REI Investments is an eighteen-foot aluminum abstract by James Darr, winner of a student competition at Herron School of Art to create a design for the site. The piece, consisting of seven vertical interlocking rings at various angles to one another, was erected in 2001.[58]

At the Noblesville–Southeastern Public Library on the eastern edge of the county seat is a scarcely noticed abstract piece by local artist Roberta Fay Shell. The untitled work of painted stainless steel was presented to the library at its former location (now the city hall) at Tenth and Conner streets about 1971. The sculpture was moved when the present building was built in 1985.[59]

Britisher Arlon Bayliss (b. 1957), a professor of art at Anderson University, works with glass. *Flame of Life* was done in collaboration with graduates of his glass program, Debbie Graham, Lori Stolt, and Perry Trentaza, as Studio 4 Glass Inc. The ten-foot-high tapered tower of stacked glass was dedicated in July 2000 outside the Surgery Center at Riverview Hospital on the west side of Noblesville.[60]

Bloomington artist Joe LaMantia, who works with children and communities to create bright and charming public sculptures that often include donated and scrap material, has collaborated on several pieces at schools throughout the county. The first one, called *Rings,* was dedicated in 1996 at

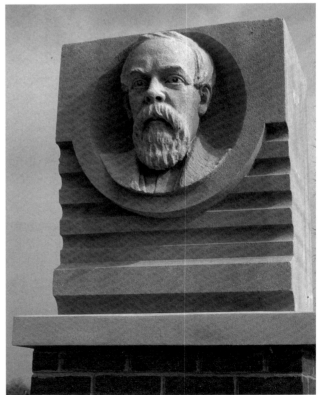

One of the reliefs salvaged from the English Hotel in Indianapolis, Governor Oliver P. Morton must wonder what he is doing in a sprawling subdivision west of Carmel.

Cumberland Elementary School in Fishers. At Cherry Tree Elementary School on North Hazel Dell Parkway, the students worked with the artist to produce *Celebrating Our Teachers* in 2004. Among others around the county are *Ribbons* (also known as *Woven Lives, Hopes and Dreams*), an especially colorful piece of steel, wood, and plastic on poles, dedicated in 1998 at Noblesville Intermediate School. The same year the artist and the children of Hazel Dell Elementary in Westfield created *Maypole*, which incorporates metal and ceramic tiles on a donated telephone pole. Quite visible from State Road 32, the piece evokes a springtime custom of the past. A fanciful metal kite was produced by LaMantia and the students of Westfield Intermediate School in 2004. A year earlier, he and the pupils of Washington Woods Elementary School created *A Walk in the Woods* of steel and wood, based on a third grader's drawing of a doe and its fawn. In 1999 collaborations in Noblesville produced the *Stony Creek Mustang*, which some observers have likened to a horse by Picasso, at Stony Creek Elementary and *Trees of Knowledge* at Forest Hill Elementary. In 2000 *Nature's Way* was placed at Lantern Road Elementary in Fishers. *Launching Toward Success*, erected in 2002, was a collaboration of LaMantia and the pupils at Smoky Row Elementary School in Carmel.[61]

Two other Hamilton County schools display outdoor sculpture, the work of William Arnold, who works with wire. Carmel High School has three greyhounds, and a life-size lion keeps watch over Hamilton Southeastern High School on 126th Street.[62]

Along the lanes of the Village of West Clay, several miles west of Carmel, are two remnants of the famous English Hotel and Opera House that once stood on Monument Circle in Indianapolis: limestone relief portraits of Indiana governors that were carved by English sculptor Henry Saunders in the 1890s. Both are properly mounted into their pedestals, but one is misidentified. One is the recognizable visage of Civil War-era governor Oliver P. Morton. The other is mislabeled as George Rogers Clark, but it neither resembles accepted images of him, nor was Clark ever an Indiana governor.[63]

The Carmel Clay Veterans Memorial will soon be erected at the southwest corner of Third Avenue and City Center Drive. The impressive monument, expected to be completed by 2006, features two life-size bronze soldiers, male and female, brandishing a flag, the work of sculptor Bill Wolfe of Terre Haute.

HANCOCK

At the company offices of Irving Materials at the junction of State Roads 9 and 234 near the hamlet of Eden is an unusual abstract relief of concrete. The sculptor, Robert Youngman, was an art professor at

James Whitcomb Riley stands in front of the courthouse in his hometown of Greenfield.

Anderson College at the time he created this work around 1961.[64]

In Greenfield, on the north side of the courthouse square facing US 40, is an almost life-size bronze of Hoosier poet James Whitcomb Riley, whose birthplace stands a few blocks to the west. The sculpture, dedicated in 1918, two years after the poet's death, is the largest work in Indiana of Myra Reynolds Richards (1882–1934). In Park Cemetery on South State Road 9 is the grave of Sergeant Paul D. Stine, who died in 1940 at the age of twenty-six. The grave is marked with a life-size marble statue of Stine in uniform, wearing a campaign hat.

HARRISON

Historic Harrison County is rugged and beautiful, a land of hills, caves, creeks, and rivers. Corydon was Indiana's first state capital, but among the many historic buildings there appears to be only one public sculpture, although there are numerous nonsculptural monuments (including one dedicated to peace) and markers. The one sculpture is recent, a project of the Corydon Millenium Committee, dedicated in 2001. Appropriately, the large limestone relief features historical images of Harrison County and includes William Henry Harrison, the first state capitol, and the Constitution Elm, among others. The relief was carved by sculptor Larry Beisler on a four-ton chunk of limestone and placed in front of the visitor center on North Elm Street.[65]

Saint Mary Catholic Church in Lanesville has a Shrine of Our Lady of Grace, dedicated in 1953.[66]

David Kocka (b. 1950), a sculptor in bronze who has his studio at Laconia, usually does work with a spiritual theme. In 2003 he completed a three-quarter-size figure of Squire Boone, a minister and man of many talents, at the reconstructed Old Goshen Church. Squire Boone, the brother of Daniel, spent the last several years of his life in the area.[67]

David Kocka created this interpretation of Squire Boone, which stands north of Laconia.

HENDRICKS

Erected in 2003 in Plainfield's Friendship Gardens Park is *Family First,* which depicts the ideal American family—mother, father, boy, girl, dog—interacting. Sculptor Connie Scott of Morristown created the scene inspired in part by her own family life.[68]

In 2004 sporting goods retailer Galyans moved into a new corporate headquarters in Plainfield. A pond in front of its entrance features a whimsical thirty-two-foot fish by Matthew Berg (b. 1970).

Soon after, Galyans merged with another company, but the fish remains in place at this writing.

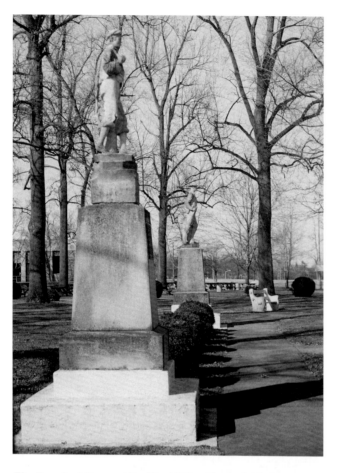

The Barefoot Boy **and the World War Memorial in Plainfield.**

The correction facility in Plainfield began as a boys' reform school but now also includes an adult prison. In the 1920s talented inmates created two limestone statues that stand in the administration area. A World War [I] Memorial, a life-size statue of a doughboy, was erected about 1922 to honor former Boys' School residents who served in the war. In 1929 a Mexican immigrant, Gabriel Garibay, carved a charming statue of *The Barefoot Boy*, the character in a popular poem by James Greenleaf Whittier. The fate of the gifted artist after he left the reformatory is unknown.

Apart from some religious statuary at Mary Queen of Peace Church in Danville and Saint Susanna Church in Plainfield, there appears to be no other public sculpture in Hendricks County. The rapidly increasing urbanization of much of the county, however, will likely prove to be an incubator for more public art in the future.

HENRY

Henry County is largely a land of creeks, farms, and small towns struggling to survive. Its fine courthouse in New Castle was designed by Indianapolis architect Isaac Hodgson and completed in 1869. In a niche at the second-story level above the entrance is a heroic limestone figure of Justice, holding bronze scales. In front of the courthouse is a Civil War monument, one of the last to be erected in Indiana, the Henry County Soldiers Memorial. The heroic bronze sentry figure on a pedestal was dedicated in 1924. On the granite pedestal is a bronze plaque honoring veterans of the Spanish-American War as well. Only six years later, Ernest Moore Viquesney's (1876–1946) popular bronze statue *The Spirit of the American Dough-boy* was erected in Memorial Park, north of town. While visible from the highway, the monument is in a remote location that is not readily accessible. Since

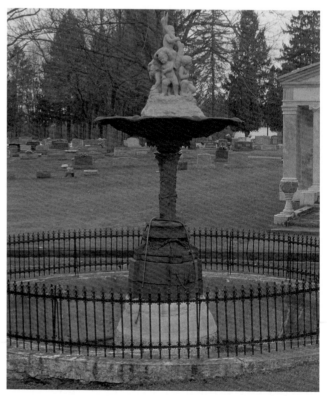

This little cast-iron fountain dating from the early twentieth century resides in Glen Cove Cemetery in Knightstown .

it is not on a high pedestal, the statue is easily missed amidst the trees in which it stands.[69]

West of New Castle on State Road 38 is a huge marble statue of Moses, imported from Italy. Erected in 1992, it stands in the Green Hills Memory Garden.

Glen Cove Cemetery on the northwest side of Knightstown, with its designed romantic landscaping, displays a cast-iron fountain from the J. W. Fiske Ironworks dating to the 1920s. In town, the old Knightstown Academy, a marvelous building that barely escaped the wrecking ball in the 1980s, has been transformed into housing for seniors. Constructed in 1876, the building's twin towers still display two whimsical gigantic symbols fashioned of metal: a globe, twelve feet in diameter, and a twelve-foot-long telescope.

At the Interstate 70 interchange north of Knightstown is one of wire sculptor William Arnold's lifelike creations. A bald eagle perches in front of the Gas America Travel Plaza.

HOWARD

All the outdoor sculpture in Howard County appears to be within the boundaries of Kokomo. The oldest is the Howard County Soldiers and Sailors Monument, a multitiered base supporting a granite shaft topped with a heroic flag bearer and flanked by two life-size Union soldiers, one an officer, one an infantryman. Built by the Indianapolis firm of Whitehead and Wright, the monument was prominently placed in Crown Point Cemetery on East Sycamore Street in 1886. A more recent war memorial seems to encourage considerable public interaction. *The Clasping Hand* features a bronze Vietnam-era soldier, kneeling and reaching forward as if to shake hands. Pennsylvania artist John Chalk created the piece, the first casting of which was erected in his home state. The Howard County Veterans Memorial was dedicated in September 2000 in Darrough Chapel Park on Kokomo's far east side.[70]

Local artist Robert E. Hamilton fashioned *Phoenix Rising from the Ashes,* a monumental abstracted bird out of stainless steel and fiberglass. It was dedicated in 1965 on the then-new Indiana University Kokomo campus on South Washington Street. Since Hamilton was a city fireman, his subject of the mythical bird, which is consumed by fire and rises from its ashes, seems particularly apt.

Several buildings in downtown Kokomo exhibit significant sculptural elements. The Howard County Courthouse, an art deco gem constructed in 1937 under the auspices of the Public Works Administration (PWA), features large bronze doors decorated with reliefs of David Foster, the founder of Kokomo, and the inventor Elwood Haynes. The former city hall, built in 1894 at the southeast corner of Walnut

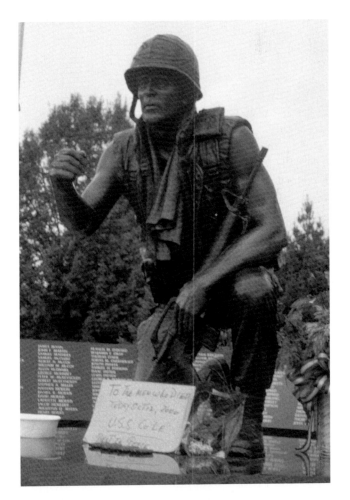

The Howard County Veterans Memorial in Kokomo promotes healing with its bronze figure of a Vietnam-era soldier offering his hand.

A rare (for Indiana, at least) outdoor statue of Saint Joan of Arc stood in front of the church of the same name since 1950. She was recently moved to a new church building on South Dixon Road.

and Washington streets, displays the head of a Native American in the keystone of the Romanesque arch on the main north facade. Today called City Venture One, the building was rehabilitated in the 1980s, and four stone lions were imported from Italy to guard the entrances of the parking lot to the east.[71]

For many years outside the YWCA at 406 East Sycamore Street, a limestone dog lolled at his ease. He had started out only a few feet east in front of a residence that was razed in the 1960s in order to build the present building. The YWCA closed in 2003 and the dog disappeared for a time, but happily was recovered and donated to the Howard County Historical Society, where he now resides inside the museum. The perky canine dates to the early twenti-

eth century and is the work of local sculptor Samuel J. Ferguson (1845–1926). A similar dog, along with a whimsical lion, had been in private hands for several decades, but both were donated in 2003 to the Historical Society. That dog now guards the back door of the Seiberling Mansion, while the lion sits outside the Elliot House. Yet another of Ferguson's pieces—a second lion—has not fared so well. It sits, minus its head, in Highland Park.[72]

Another critter now prowling Kokomo is more recent. At Northwestern Middle School, Bloomington artist Joe LaMantia worked with the students in 1998 to create *Tiger*, a fanciful beast created from scrap metal and installed outside the school.[73]

Some of the churches in the city exhibit religious statuary; indeed, Saint Joan of Arc Church at 900 South Purdum Street had displayed two statues of its patron saint. A life-size limestone figure was carved by Dominic Mazzullo of Bloomington about 1950, when the church building was constructed, and a large relief in cast aluminum of a three-quarter figure of Saint Joan astride a horse was placed in a gothic arch above the doors. When the church moved to a new building on South Dixon Road in 2004, the parish moved its saints as well. Only a few blocks to the south on Dixon Road is Christ Lutheran Church, which has a life-size figure of Christ near its entrance. On Southway Boulevard, the Lutheran Church of Our Redeemer displays a heroic statue of Christ on the northwest wall. It was sculpted in Italy of Carrera marble.[74]

HUNTINGTON

Huntington County is a land of rolling terrain and many rivers and creeks. The county's most prominent outdoor sculpture consists of the marble religious figures dating to about 1957 in the Gardens of Memory, a few miles north of Marion. A pair of identical cast-metal lions of indeterminate age resides in Huntington's City Park. Although the pair originally was downtown in front of a dry goods store, they have been in the park since the 1930s. Victory Noll, the

Visible at least part of the year from West Park Drive is this shrine to the Sacred Heart of Jesus at Victory Noll.

motherhouse of the Missionary Sisters of Our Lady of Victory, displays a shrine with a statue of the Sacred Heart of Jesus visible from West Park Drive. Outside the main building is a large marble statue of the Blessed Mother. The town of Roanoke, northeast of Huntington, dedicated a sculptural drinking fountain

in 1928 to those from the county who died in World War I. There were but two: a soldier killed in action and a nurse who died in an English hospital. The fountain memorial disappeared years ago.[75]

JACKSON

Until recently, the only known sculpture in Jackson County was a large marble angel on a high pedestal marking the graves of H. C. Smith (1813–1897) and his wife Eliza (1813–1873) in a tiny hilltop cemetery near Vallonia. Its placement enhances its significance. In a large urban cemetery this beautiful statue would be one of many. However, in this rural location, rising above the ripened corn along State Road 135, the angel is a startling sight and a widely known landmark.[76]

In Shields Park, the town of Seymour once had a Civil War monument erected in 1890 in honor of

Seymour, Ind.

2615. City Park. 6th Street and Broadway

MANUFACTURED BY CURT TEICH & CO. CHICAGO

This Civil War monument once stood in Shields Park in Seymour.

the town's founder Meedy Shields. The decorative pedestal included a fountain and supported a sentry figure ordered from the W. H. Mullins Company of Salem, Ohio. In the late 1960s vandals seriously damaged the statue, and after repairs it was again damaged in the mid-1970s. The city put the sentry into storage, and recent efforts to restore the monument have thus far been unsuccessful.[77]

It is only fitting that the Southern Indiana Center for the Arts at 2001 North Ewing Street should display a sculpture. *Guitar Man,* a life-size figure created of wire, was installed in 2000, the work of Jackson County native Nathan Montgomery (b. 1974). The piece is something of a tribute to the owner of the building in which the center is housed, the musician and painter, John Mellencamp.[78]

JASPER

Much of Jasper County is marsh and prairie turned farmland. Sculpture appears to be confined to the county seat of Rensselaer. On the campus of Saint Joseph College are several traditional religious statues, including a limestone rendering of the Immaculate Conception that dates to 1894. There is also a statue of the institution's first president, the Reverend Augustine Seifert, which was donated to the college in 1941.[79]

On the south side of the town in a small triangular park bordered by a curve in US 231 is a heroic bronze statue of Major General Robert H. Milroy (1816–1890), the commander of the Ninth Indiana Regiment in the Civil War. Born in Salem, Milroy served in the Mexican War, studied law at Indiana University, and opened a law practice in Rensselaer. There Milroy raised Company G of the Ninth Indiana when the Civil War began. Milroy had been dead twenty years at the time of his statue's dedication in 1910. The sculpture is all the more significant as one of the few large works of Mary Washburn (1867–1965), who had studied with noted sculptor Lorado Taft (1860–1936) in Chicago. Washburn was a native of Rensselaer.

Local Civil War hero Major General Robert H. Milroy guards the south side of Rensselaer.

JAY

Jay County is largely rural with few towns of any great size, although in the late nineteenth century it was thriving in the midst of Indiana's natural gas boom. Portland native Elwood Haynes (1857–1925), before inventing metal alloys and automobiles, worked in the gas fields. In 1936, as part of its centennial celebration, the town commissioned a bronze bust of Haynes and erected it in front of his birthplace. Two of the inventor's children were on hand for the dedication. Marion sculptor Jacquelyn Judith Jones created the piece, which today sits inside the Jay County Public Library a few blocks away. The Haynes birthplace is gone.[80]

Portland, which is the county seat, boasts three modern sculptures within its limits. The earliest,

Tuck Langland's *Autumn* (opposite page) studies her face in the mirror at the Jay County Center for the Arts in Portland.

erected in 1978, is an assemblage of metal and wood by Bruce Fordham called *18.5 Knots*. It stands in front of the local radio station on State Road 67. Also along that highway, on the grounds of Jay County High School, is an environmental sculpture by Gordon Woods of Northern Ireland, who was an artist-in-residence in 1992. *The Three Patriots* is composed of three large boulders of different colors; on the largest is carved a spiral runelike symbol.[81]

In 1990 Harold R. "Tuck" Langland (b. 1939) erected his bronze statue *Autumn* in a tiny garden area adjacent to the Center for the Arts on East Main Street. Commissioned by Portland 2000, a downtown revitalization group, it was intended to be the first of four sculptures representing the four seasons; the other three have yet to be erected. At the time Langland was a faculty member at Indiana University South Bend. His bronze works, usually graceful interpretations of the human figure, enhance many Indiana locations.

JEFFERSON

Rugged Jefferson County slides its way down toward the cliffs and bluffs along the Ohio River. Its roads wind through forests, over creeks, and past picturesque farmland.[82]

At Camp Louis Ernst, a Boy Scout camp along State Road 7 near Dupont, is an eight-foot replica of the Statue of Liberty, covered in sheet copper, erected in 1951. There are six of these in Indiana. The figures were made by the Friedley, Voshart Company of Kansas City, Missouri, and sold through the Boy Scouts of America in the early 1950s.

Another little Liberty, erected in 1950, stands beside the courthouse in Madison. This one is the oldest in Indiana, and its plaque touts the original slogan, "The Crusade to Strengthen the Arm of Liberty," which was shortened after the first year to "The Crusade to Strengthen Liberty." Just to the east is the bronze Soldiers and Sailors Monument by Norwegian-born Sigvald Asbjorsen (1867–1954). Dedicated in 1908, the statue features four Civil War military fig-

One of Jefferson County's two "little Liberties" stands in front of a Boy Scout camp near Dupont.

ures clustered together, representing the Navy, Infantry, Artillery, and Cavalry. The sailor doubles as the flag bearer. The monument was renovated and rededicated in 1991 during Operation Desert Storm.

Just north of Main Street on Broadway is an ornate three-tiered fountain that originally came from the 1876 Philadelphia Centennial Exhibition. The cast-iron work, replete with Triton and his horn spewing forth water in quadruplicate, was designed by French sculptor J. P. Victor Andre. The ornate piece could be ordered from the Janes, Kirtland catalog in the latter half of the nineteenth century. The International Order of Oddfellows purchased the centennial fountain a few years later and presented it to Madison after the organization held its national convention there. Over many decades the fountain deteriorated badly. As a Bicentennial project in

1976, the city council established the Broadway Fountain Preservation Fund to restore the piece. What is presently in the esplanade is a complete recasting in bronze, done by Eleftherios Karkadoulias, a Greek sculptor living in Cincinnati. The fountain, surrounded by all new landscaping, was rededicated in 1980.

New York sculptor George Grey Barnard (1863–1938) is sometimes claimed as an Indiana sculptor, even though his parents had a greater Indiana connection. His father, Joseph Barnard, was the pastor of the Second Presbyterian Church in Madison and the chaplain of the South Eastern Hospital for the Insane (later renamed Madison State Hospi-

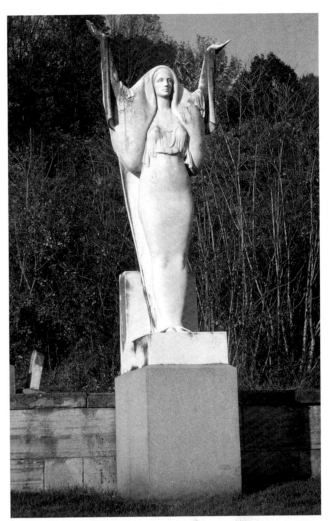

George Grey Barnard's *Immortality* graces his parents' graves in Springvale Cemetery in Madison.

Original or copy? The exuberant Broadway Fountain, first cast in iron, was entirely recast in bronze as a Bicentennial project in Madison.

tal). Barnard's one work in the Hoosier state is in Springvale Cemetery, erected on the graves of his parents in 1928. It is a stylized marble figure of a woman, a replica of a piece commissioned by a group of women as a memorial placed in an arboretum near Shepardsville, Kentucky. The original statue is titled *Let There Be Light,* but the work in Madison is called *Immortality.*

Downtown atop the tower of the old Fairplay Fire Company Number One on East Main Street is a reincarnated *Little Jimmy,* a life-size copper figure of a nineteenth-century fireman, which is also a functional weather vane. The original figure was erected in 1889 and, except for the period of 1946–55, when it was removed and given to a local school, *Little Jimmy*

remained in place until 1996. Deteriorated beyond repair (at least in that it could no longer function as a weather vane), the figure was remade by a New Jersey coppersmith to original specifications, except this version is unpainted. It was installed in 1998.[83]

JENNINGS

Sparsely populated, with a mix of farmland and forest, Jennings County is crisscrossed with rocky rivers and creeks. There seems to be little sculpture. A life-size marble statue of Christ was donated to the Vernon Cemetery in the early 1960s. In North Vernon a pride of limestone lions—two male, two female—guard the entrance of a house known as Breeze Hill on Fourth Street on the north side of town. They were carved by stonemason Thomas Brolley for the family house about 1890.[84]

JOHNSON

The farmland of Johnson County is rapidly giving way to suburban sprawl, especially in the northern half, so it is likely that more public sculpture will appear in the next few decades. In the county seat of Franklin, on the north side of the courthouse, is a Civil War monument known as the Vawter Memorial, in honor of the man who donated the funds to erect it. Rudolf Schwarz (1866–1912), who came to Indiana to work on the Soldiers and Sailors Monument in Indianapolis and stayed after that work was completed, did the bronze work on this piece. The monument, dedicated in 1905, was restored in the 1990s. It depicts a Union soldier in slouch hat, peering into the distance with a rifle in his hand. Bronze lions' heads spew water into fountain basins, and below the pedestal's cornice is a fierce bronze eagle perched to fly.[85]

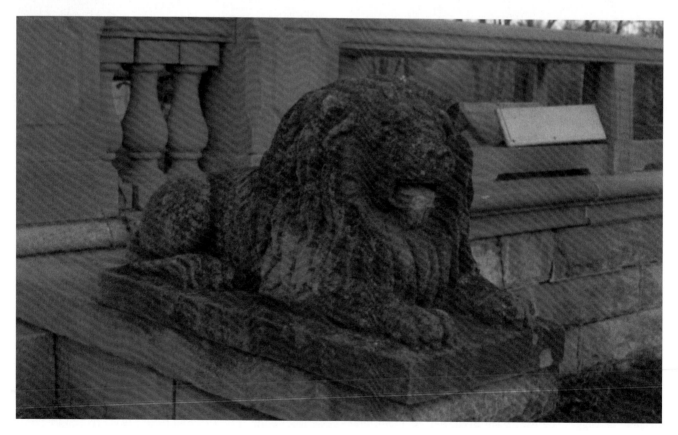

Irish stonemason Thomas Brolley carved this limestone beast and three others in the late nineteenth century to guard his family home in North Vernon.

A large bronze elk's head looms above the BPOE 1818 Lodge on Water Street. Placed in its current location in 1996, the head originally was erected on the Elk's Lodge in Logansport in 1907, where it remained until 1995.

At Franklin College is, appropriately enough, a statue of Benjamin Franklin. Although the figure dates to 1875, it has graced the campus only since January 1963. The marble statue was the work of John H. Mahoney (1855–1919), who later did three of the outer figures for the Soldiers and Sailors Monument. Benjamin Franklin originally stood in a niche on the facade of an insurance company on the Circle in Indianapolis. When that

The founder of Prince's Lakes in southern Johnson County stands proudly at a rural intersection.

Secure in his third location at Franklin College, Benjamin Franklin started off as a nineteenth-century insurance company icon in Indianapolis.

building was demolished in 1929, the statue was saved and moved to the Typographical Workers Union on North Meridian Street in Indianapolis. That building, too, was demolished, but with the financial help of Indiana AFL-CIO president Dallas Sells, whose children were attending Franklin College, the venerable statue was moved to the campus. As often as not, it is painted in garish colors by students who ought to be given the daunting task of cleaning up their artistic endeavors. The statue has so many coats of paint it is impossible to identify it as marble.

Recently installed on campus is *Transcendence*, an abstract work by Indianapolis sculptor Matthew Berg (b. 1970). Essentially an arch, aluminum

bands meet at the top. In the middle are shapes of painted steel with glass, and at the bottom are rough-shaped limestone blocks. Erected in July 2002 in front of the Johnson Center for Fine Arts, the piece is about eighteen feet high and speaks of the relationship of body, mind, and spirit.[86]

As part of the fiftieth anniversary celebration of Camp Atterbury, an army training camp established in 1942 southwest of Edinburgh, a memorial was created under the direction of post commander Colonel Jorg Stachel. The focal point of the memorial is a tall bronze GI in full kit by sculptor Alexa K. Laver. Behind the statue is a wall emblazoned with the medallions representing military units that have deployed from Atterbury. The area around the memorial is filled with all manner of military vehicles from World War II, Korea, and Vietnam.

In the 1940s entrepreneur Howard Prince developed an area in southern Johnson County in the vicinity of Nineveh that he called Prince's Lake. Later, as the area expanded, the town became known as Prince's Lakes. In 1996 Prince's daughter commissioned a statue of her father that stands at the entrance to the community. The cast stone—a specialized form of concrete—sculpture depicts a pleasant-looking man in 1940s attire wearing a Panama hat.[87]

On the grounds of Sugar Grove Elementary School in the northwest corner of the county is a colorful contemporary sculpture called *Tree of Life,* a collaboration of the students of the school and Bloomington artist Joe LaMantia, completed in 2000.[88]

KNOX

Sculpture in historic Knox County appears to be confined to Vincennes, where there is a considerable collection of traditional commemorative sculpture, much of it placed in and around the George Rogers Clark Memorial on the bank of the Wabash River south of downtown. Most of these date to the 1930s. Inside the rotunda of the memorial (thus not an outdoor sculpture) is the heroic bronze statue of Clark by New York artist Hermon A. MacNeil (1866–1947). Francis Vigo, the trader who provided the funds for Clark's enterprise to march overland from Kaskaskia to recapture Vincennes from the British, is depicted in all his humanity, overweight and seated against piles of his goods. Rendered in granite by New York sculptor John Angel (1881–1960), the piece appears just as it did when it was erected beside the river in 1936. Granite is virtually impervious to weather and thus is very difficult to carve. It took Angel two years to complete the heroic statue. So masterful is the work, however, that the man seems to breathe. To the north, carved on pylons flanking the Lincoln Memorial Bridge (built in 1931) that carries US 50 over the river into Illinois, are two forty-foot figures in relief of Native American chieftains. Although initially planned to represent generic Indians present when Clark took Fort Sackville from the British, public sentiment resulted in the figures being identified as Tecumseh and his brother, the Prophet, who were not on history's stage until a few decades later. The granite pylons were carved by French sculptor Raoul Josset (1900–1957) and dedicated in 1933.[89]

Nearby, in front of the Old Cathedral, Saint Francis Xavier Church, is a nine-foot bronze statue of Father Pierre Gibault (1737–1804), the "Patriot Priest" who gathered local French support for Clark in Kaskaskia and gave his life savings to the young American colonel to help the cause of the Americans. Czech-born sculptor Albin Polasek (1879–1965) of Chicago created the work in 1935. It was dedicated, along with the rest of the George Rogers Clark Memorial, on June 14, 1936. In 1908 three life-size religious statues were placed in the niches on the facade of the church: Saint Patrick, Saint Francis Xavier, and Saint Joan of Arc.

The beautiful Knox County Courthouse, completed in 1874, is embellished with several sculptures that have deteriorated badly over the years. Two very eroded limestone relief panels flank the west entrance. Third-story niches hold two heroic

This remarkably human portrait in granite of Francis Vigo, who helped fund George Rogers Clark's campaign to take Vincennes, sits beside the river south of downtown.

marble statues, one a barely recognizable George Rogers Clark, the other a Union soldier. On the south side a niche contains a marble figure of Justice. Above the niche is a carved sheaf of wheat and the scales of Justice; below the niche is a mustachioed face. The marble statues were carved in Carrara, Italy, by Andrea Barrot. It is not clear what skilled carver did the reliefs.

On the northwest corner of the courthouse square is the final work of Austrian-born sculptor Rudolf Schwarz (1866–1912), whose five bronze figures of Infantry, Cavalry, Artillery, Navy, and a color-bearer were completed posthumously. They grace the Soldiers and Sailors Monument designed by C. N. Clark and Company of Urbana, Illinois. The granite monument, well over sixty feet high, consists of a vaultlike structure from which rises a granite obelisk, topped with the color-bearer and prominently displaying a

large bronze Grand Army of the Republic (GAR) medallion. It was dedicated in October 1914.

A statue of William Henry Harrison did not appear in Vincennes until 1972, even though the city is the site of Grouseland, his home built in 1804, which today is recognized as a National Historic Landmark. Harrison, the first governor of Indiana Territory (1800–1812), was the highly touted hero of the 1811 Battle of Tippecanoe, and the nation's ninth president, although he died one month after his inauguration. The statue, carved from a block of oolitic limestone by Harold "Dugan" Elgar (1910–1984), was originally placed in front of the Humanities Building at Vincennes University, which Harrison founded in 1801. Repeated damage by students resulted in the statue's being removed and placed in storage ten years later. In 2002, in celebration of the university's

entering its third century, the founder's image was rededicated in a new location in front of the Matthew Welsh Administration Building.[90]

A concrete planter with classical relief figures at Rotary Point, proclaimed as Vincennes's first city beautification project, is modest artistically but significant historically. Designed by architect Louis H. Osterhage, the piece appears to be a former decorative fountain but in fact has always been the two-tiered planter it is today. The Vincennes Rotary Club, a service organization dedicated to civic and cultural improvement, formed in 1915. Their first project was the improvement of an unattractive bit of land where three streets—Seventh, College, and Washington—converge. Originally there were two additional urns, but they were gone by the 1930s.

During the latter half of the 1930s, the Works Progress Administration (WPA) put several unemployed stone carvers to work to create four different reliefs relating to early pioneer settlement at the entrances to Kimmel Park. Completed about 1936, some of the reliefs, unfortunately, are badly eroded from decades of exposure.

Green Lawn Cemetery on Willow Street has a good collection of carved limestone monuments, including one for the King family showing in some detail the train wreck in which Mr. King died. Not far away in Mount Calvary Cemetery is a Crucifixion dating to about 1900 with Orbronze (a sheet metal alloy) figures from the Daprato Statuary Company, significant mainly for its age. In 1995 the students of Tecumseh–Harrison School and artist Joe LaMantia of Bloomington collaborated to produce *Brave*. Standing tall outside the main entrance, the piece is a gigantic feather of painted wood.

Local artist Robert Donnoe fashioned two abstract works of steel for the city's parks in 1979.

The heroic bronze figure of Father Gibault stands before the Old Cathedral, its niches filled with statues of saints.

The Knox County Courthouse displays this beautifully carved variation on Indiana's state seal.

Although it appears neglected, even ignored, *Ryan's Slide* still stands in Four Lakes Park. Donnoe's other piece, *Le Mantis,* however, has disappeared from Gregg Park.

But the worst example of the mistreatment of a significant work of sculpture lies in an alley off Indiana Street. One of the limestone portrait medallions from the razed English Hotel and Opera House in Indianapolis is being used as a buffer between the corner of a residential garage and the alley. In the 1890s sculptor Henry Saunders carved several portraits of Indiana governors to decorate the hotel's facade. When it was demolished in 1948, most of the medallions were sold and scattered all over the state. Local people who are aware of this particular medallion believe it is Jonathan Jennings, the first state governor, but it appears actually to be Thomas Posey, the territorial governor who preceded Jennings.

KOSCIUSKO

A region of rolling terrain and lakes, this largely rural county has only a few examples of outdoor sculpture, but they include some of the state's most interesting pieces. At the courthouse in the county seat of Warsaw is a simple work of carved limestone that is historically fascinating. A piece of Civil War artillery was placed with much fanfare on a specially prepared limestone pedestal at the southeast corner of the courthouse square, remaining until it was sacrificed to a scrap metal drive of World War II. That in itself was hardly unusual. Much of the state's rusting Civil War ordnance was lost forever in this manner. But the town kept the pedestal inscribed with the cannon's history and commissioned a stone carver to create a limestone replica to put in its place.[91]

The community of Winona Lake once was filled with statues such as this, but only *The Student* survives.

Warsaw High School commissioned Goshen sculptor John Mishler to do a kinetic sculpture for its courtyard adjacent to the art department. *Wave Rhythms* was installed in 2003.

Nearby Winona Lake, once the home of evangelist Billy Sunday and the site of a famous chautauqua in the early twentieth century, still has visible remnants of its glorious past, including some pieces of outdoor sculpture. Wealthy industrialist H. J. Heinz, an avid supporter of the Winona Institute, donated about twenty pieces of European sculpture to be placed around the grounds. *The Student* in Winona Park is all that remains. Originally the marble statue was placed about 1902 on an island in a swan pond, which is long gone. The piece, by Jean Turcan, who worked with Rodin, depicts an exuber-

ant young man in mid-nineteenth-century attire, waving a rolled diploma. Not far away, adjacent to where Billy Sunday's huge Tabernacle once stood, is a monument honoring Doctor Solomon C. Dickey (1858–1920), founder of the Winona Assembly and Bible Conference. A bronze bust of Dickey sits atop a limestone pedestal. The bust was modeled by Baltimore sculptor Mabel Jane Hess, who worked from a photograph. The monument was dedicated in 1938 before a large crowd, but today it appears isolated without the backdrop of the tabernacle.

At the Epworth Forest Conference Center at North Webster is a large marble statue of Christ erected in 1966. It is a reproduction of an 1823 work by Danish sculptor Bertel Thorwaldsen (1770–1844).

Worth noting in the Mentone Cemetery is the Summerland monument, topped by a life-size figure of a seated young girl engaged in embroidery. It is possibly a portrait statue of fourteen-year-old Waneta Summerland, who died of tuberculosis in 1897. The statue caught the attention of a brother and sister, unrelated to the Summerlands, who visited the graves of family members in the cemetery a few times a year. With the best of intentions—but not the best way to treat a limestone statue—they paid to have the neglected figure sandblasted in the 1990s.[92] The town of Mentone is far better known, however, for a particularly quirky bit of public sculpture in its downtown, the Mentone Egg. Because of its processing plants, Mentone has long called itself "The Egg Basket of the Midwest." In 1946 Hugh Rickel fashioned a huge concrete egg as a roadside attraction on Main Street, where it stands today. The three-thousand-pound egg, emblazoned with the town name and slogan, is ten feet high and nearly eight feet in diameter.

LAGRANGE

There seem to be no public sculptures in this rolling rural county with its large Amish population.

LAKE

Lake County, in the far northwest corner of the state, is half urban and industrial, half prairie and wetland. Outdoor sculpture is scattered throughout the cities hugging the shore of Lake Michigan, with a sprinkling in the small towns that still remain in the southern half. Throughout, the county is laden with numerous examples of religious statuary, much of it reflective of the waves of immigration to the factories of the Calumet Region.[93]

Toward the bottom of the county in downtown Lowell stands the Three Creeks Monument, featuring a granite Union sentry on a twenty-five-foot pedestal, dedicated in 1903. At Crown Point is a nearly life-size statue of a World War I doughboy that dates to around 1920, but its origins are vague. Somewhat crudely carved in limestone, it stood prominently in two different private yards for several decades before it was donated to the Veterans Garden of Maplewood Cemetery in 1979. Also in Crown Point are several religious figures in a complex of related buildings consisting of Saint Anthony Hospital, Medical Center, and Home. A casting of Sufi Ahmad's *Spirit of Saint Francis* was recently added to the collection.

At Cedar Lake, at what was formerly a resort hotel before the Great Depression, is the San Domiano Friary Novitiate and the Lourdes Friary. The beautiful wooded grounds are filled with shrines and marble statuary by unknown artisans, including images of Saint Francis of Assisi, Christ at Gethsemane, and a tomb and Resurrection that form part of the stations of the cross. Most of these date to about 1950. In a secluded corner of the woods is the life-size figure in limestone of Kateri Tekawitha (1656–1680), dating to about 1941. She is a Native American who converted to the Christian faith. The dominant feature on the grounds is a huge grotto constructed of coral in 1945 containing the figures of Our Lady of Fatima with the three children kneeling in awe. In front of the grotto are statues of

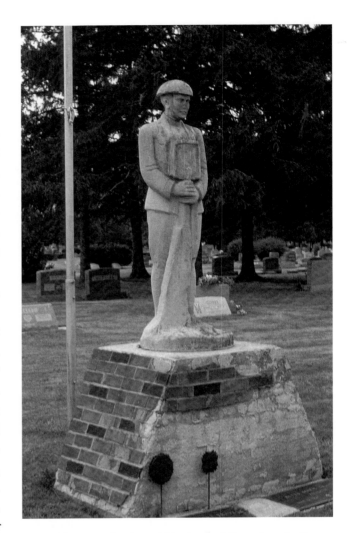

In the Veterans Garden at Maplewood Cemetery in Crown Point is this small limestone figure of a soldier that dates to about 1920.

Christ the King and Saint Michael the Archangel. On the opposite side of the grotto are additional chambers containing figures of Saint Joseph, Saint Anthony, and the Infant of Prague. Another round of stations of the cross is sited around the edge of the grotto. In 1961 a Lourdian Shrine was created, incorporating a small lake. In the middle of the lake is a small island with a statue of Our Lady of Lourdes and Saint Bernadette; on the shore is a sixteen-foot crucifix. All around the lake is a path where worshipers can walk the Rosary, the oversized beads—fashioned from bowling balls—connected by a chain.

A few miles south of Saint John on US 41 is a roadside shrine erected in 1956—an interesting commentary on the ubiquitousness of the automobile. A

The beautiful grounds of the San Domiano Friary Novitiate at Cedar Lake are filled with statues and dominated by the huge multichambered grotto containing several shrines.

twelve-foot marble statue of the Virgin Mary stands upon a twelve-foot pedestal that is generally laden with floral tributes and offerings and peppered with written petitions. Under way nearby is a new project that is expected to be completed by 2006. A Way of the Cross with life-size figures in bronze will extend some fifteen hundred feet, starting at the statue of Mary. It will end near the new Saint John the Evangelist Church that is also being constructed. The bronze figures are the work of Texas artist Mickey Wells, who also has been commissioned to complete a life-size figure of the patron saint and two angels.

Saint Michael Catholic Cemetery in Schererville displays an Orbronze (a sheet metal alloy) Crucifixion scene from the Daprato Statuary Company of Chicago, from where many of these pieces come. It dates to the 1920s. Not far to the west in Saint Joseph Cemetery in Dyer, along US 30, is a beautifully carved crucifix, twelve feet high, dating to 1890. On the base are carved the words of John

11:25 ("I am the Resurrection and the Life") in German, with an English translation beneath. The inscriptions regarding the donor and the date are all in German. At Saint Margaret Mercy Healthcare Center South on Joliet Street in Dyer is a casting of Sufi Ahmad's *Spirit of Saint Francis*. The original sculpture was created in 1997.

Calumet Park Cemetery in Merrillville has reliefs of the Crucifixion and the Holy Family, both in granite. At Saint Stephen the Martyr Catholic Church on Waite Street is a seven-foot concrete statue of the saint by the Egyptian artist Naguib, dedicated along with the church in 1970.

In Hobart is one of Ernest Moore Viquesney's (1876–1946) popular World War I statues, *The Spirit of the American Doughboy*, on a concrete pedestal. The figure was dedicated in 1925 at the intersection of Seventh and Lincoln.

In Munster, a large-scale Community Veterans Memorial, honoring the participants in all the wars

of the twentieth century, was dedicated in 2003 after several years in the making. On a grand scale rivaling anything in Washington, D.C., it is comprised of five sections or settings, one for each conflict from World War I to Desert Storm. The husband-and-wife artist team of Julie (b. 1958) and Omri (b. 1954) Rotblatt-Amrany, from Highland Park, Illinois, has created life-size bronze statues as well as reliefs in settings created from large granite pieces, rubblestone, and battlefield artifacts. Even the topography of the open land along Calumet Avenue has been altered to resemble the terrain of various battlefields. The memorial is north of Community Hospital, which donated the land and set up a fund-raising campaign for the huge project.[94]

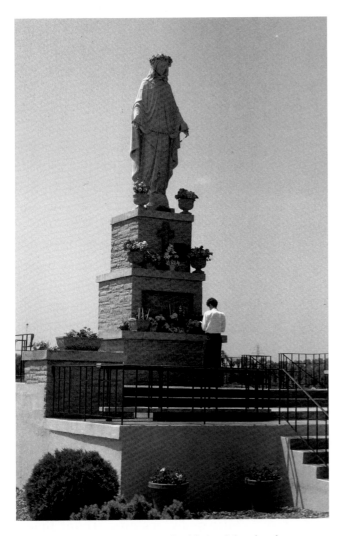

This huge roadside shrine south of Saint John clearly serves a spiritual need as it is always covered in flowers and petitions.

To say that the Carmelite Monastery on Ridge Road in Munster contains many statues, most of them beautifully rendered in gleaming white Italian marble, does not begin to describe the place. It is also a geologist's delight, as the bases and shrine and even the huge grotto are all fashioned out of colorful minerals from around the world, arranged in geometric patterns. Many of the outdoor pieces were sculpted by Alberto Arrughini of Rome and erected in the late 1950s and early 1960s, shortly after the monastery and shrine complex was begun by an order of Discalced Carmelite Fathers who had fled Poland. Arrughini's works include a six-foot seated figure of Our Lady of Mount Carmel, a life-size portrayal of Saint Therese (the Little Flower) with her father, a heroic figure of the Sacred Heart of Jesus, two statues of kneeling supplicants, and the figures of Mary and Saint Bernadette on the grotto. The grotto is itself a work of art, about thirty feet high with the colorful minerals that cover it forming patterns of stars and a huge crown. The grotto contains a series of interior chapels lined with sparkling crystals, each containing exquisite statuary of Carrara marble. The other large shrine on the grounds features a Calvary scene of bronze; the artists' names have been lost, but it was completed in two stages in 1959 and 1965. Also amidst all this fervent splendor are two shrines of a different nature. One evokes a traditional Polish Highlanders Chapel, once common in the homeland of Pope John Paul II. Inside the triangular chapel, which is made entirely of wood, is a relief depicting the pope as a young Polish priest. Beneath the shelter is a figure of Christ in contemplation. A Madonna and Child known as Our Lady of Ludzmierz stands in a gabled niche above the entrance to the shelter. The entire shrine/chapel is the work of Polish-born artist Jerzy S. Kenar (b. 1948). A more disturbing figure is the Saint Maximilian Kolbe (1894–1941) Memorial, fashioned in concrete and somewhat larger than life, the work of artist Christopher Domalski in 1975. Kolbe, a Franciscan priest, was a prisoner at Auschwitz, where he sacrificed his life for a fellow prisoner. Somewhat stylized, the figure is of a gaunt,

Bruce White's bright blue *Twister* enlivens the Purdue Calumet campus in Hammond.

erect man with a shaved head and robes hanging loosely from his skeletal limbs.

There are still more sculptures in Munster. *Yesterday and Today for Tomorrow,* three heroic stylized figures of Cor-Ten steel, stand in Rotary Park off Ridge Road. The figures represent an Indian holding an upright spear, a farmer with a plow, and a steelworker in front of his oven. Ironically, although this piece dates only to 1976, today all three figures are prototypes of the past. The work was a collaborative effort of Fred Holly and William Ores. Munster recently effected an ordinance requiring corporations that receive tax abatements from the town to donate one percent of their improvement costs to a public art fund. Quickly resulting from this

policy was the installation in 2000 of several pieces of public sculpture along West Forty-fifth Street. Four oversize animals by Chicago artist John Kearney (b. 1924), who characteristically uses chrome bumpers as his medium, appeared: a family of three deer on a hill and a huge horse at the entrance to Staley General Transportation, which paid for the pieces. Another Chicago artist, Karl Wirsum (b. 1939), oversaw the installation of his eleven-foot statue of a very colorful and bizarre baker in front of Dawn Foods.[95] In 2003 the regional grocery Strack and Van Til funded the installation of a nine-foot piece at its store on Ridge Road. Muralist and sculptor Kathleen Farrell of Joliet, Illinois, created a work called *Boy and Nutrition,* a bronze statue of a boy atop a mosaic column. The boy is encircled by a wreath of cabbages, and the mosaic depicts various vegetables. In front of the Pepsi bottling plant on Calumet Avenue are two groupings of bronze figures sitting on benches by Colorado sculptor Mark Lundeen. *Little Sisters* depicts two little girls sharing a picture book. The other, a variation on the artist's *Double Dipper,* is a grandfather cuddling his grandchild, who holds a Pepsi can. Both sets of figures are just under life-size. Another new piece was erected in summer 2004 at the new Collision Revision auto body shop on Forty-fifth Street.

The *Hammond Rotunda,* dedicated in 1999, was one of several projects throughout the state undertaken to install permanent artworks in celebration of the Millennium. Ohio sculptor David Evans Black (b. 1928) fashioned a twenty-first century fountain: an open-work white dome supported by granite columns, the whole piece nearly thirty feet high. Water swirls and cascades within the dome through a specially designed system, and at night dramatic lighting completely changes the character of the dome. As in other cities, the work is intended as a catalyst for an anticipated downtown arts district.[96]

Immediately north of the rotunda is an open space dedicated to sculpture, both permanent and temporary. Indianapolis sculptor Todd Bracik (b. 1972) has installed two abstract pieces, both created from scrap metal, which the artist calls

"mechanical artifacts." *Lornac* and *RJ* were erected in 2001 and 2002, respectively.

Twenty-five years earlier, German-born sculptor Hermann Gurfinkel (1916–2004) created *Man of Steel,* a mammoth work of just that, celebrating the industrial heritage of the area. The piece, placed on the edge of Harrison Park, is an angular, highly stylized bust of a man looking upward. When the Howard Branch of the Hammond Public Library on Grand Avenue was built in 1965, dedicated along with the structure was an abstract metal sculpture called *Flight of the Phoenix,* placed on the patio. The piece was by Clyde Ball, a graduate of Hammond High School. Over time the sculpture suffered damage, and it was removed in 2002 and placed in storage.[97]

On the campus of Purdue University Calumet are several sculptures. Near the Anderson Building is *Triskelion,* an eleven-foot nonobjective piece of steel and concrete created in 1970 by student Stanley J. Dostatni with the help of his professor, Charles R. Hutton, and erected on the site the following year. Lynn Olson's *Color Concerto* was installed north of Lawshe Hall in 1985. The curving wall of colored glass in a framework of reinforced white cement mortar forms a partial enclosure. Sunlight passing through the glass panels constantly changes the look of the piece. From a distance, it is easy to see why Bruce White's sculpture is called *Twister,* for it appears as the outline of a tornado framed by a doorway. Twelve feet high and of blue-painted steel, the piece, erected in 1989, stands outside the campus library. North of the Physical Education Building is an untitled work by David de Cesaris, a nearly eight-foot-high nonobjective piece of layered wood and aluminum created in 1991. A Cor-Ten steel sculpture portraying herons in a natural setting of native grasses stands in the middle of campus in Founders Park. The work of sculptor David Scott, who until recently ran an art foundry in Indianapolis, it was installed in 1997. The Hammond City Hall, built in 1931, boasted art deco doors designed by noted sculptor Alfonso Iannelli (1888–1965) with reliefs that focused on the theme of the industrial worker. When the doors were removed, the city

of Hammond placed them on permanent loan to the university, where they are displayed inside the Library Center but are visible from the outside through the glass walls.[98]

Many of Hammond's Roman Catholic churches display outdoor sculpture. All Saints Church, built in 1929, has beautifully carved limestone panels above the Gothic-arched door, on each side of the entrance on the north, and on the tower on the northeast corner. Next door, All Saints School has a marble statue of the Sacred Heart of Jesus. Saint Catherine of Siena Church has a large marble statue of the saint in a niche, dating to about 1959. Above the entrance to the rectory of Our Lady of Perpet-

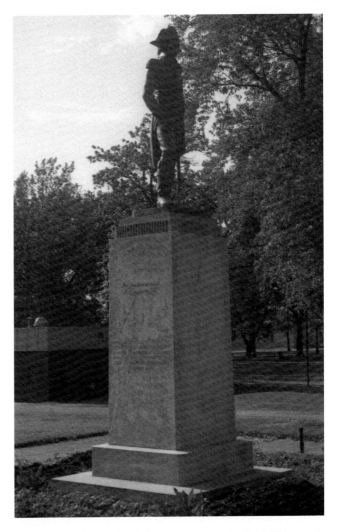

Standing in the park of the same name in East Chicago is this bronze statue of Thaddeus Kosciuszko, who aided George Washington in the Revolutionary War.

Elbert Gary, erected in 1957, stands downtown in his namesake city.

ual Help Church is a very large limestone relief of the Virgin Mary holding the Christ Child, dating to 1957. In the courtyard between the church and rectory is a modern interpretation of the Virgin Mary in bronze by sculptor Jerzy Kenar, erected in 1989. Kenar fashioned several pieces for the interior of the church as well, including the altar and the pulpit. At Saint Margaret Mercy Healthcare Center on Hohman Avenue is Lynn Olson's *Franciscan Sister,* recently joined by a casting of *Spirit of Saint Francis* by Sufi Ahmad of Fort Wayne.

Saint John the Baptist School in Whiting has two huge carved figures, both collaborations of Pedro Teran and Joseph Slinkard. Teran did the modeling and the finishing work on the final figures after Slinkard roughed out and carved the stone. The fifteen-foot-high figure of Mary (Teran's wife was the model), surrounded by seven stylized stars, is depicted holding the child Jesus in her arms. The fig-

ure is above the entrance to the school's auditorium. John the Baptist, or *John, the Forerunner of Jesus,* holding a lamb in his arms, is roughly as tall and is mounted on the side of the building next to the school's name. Both were completed for the new school in 1955. A life-size stone figure of Mary stands in a shrine at Saint Adalbert Church on 121st Street.

Local sculptor Chris Diersen created two limestone abstract works in 1998. *Progress* stands at the entrance into Whiting on Indianapolis Boulevard at Clark Street. A smaller piece, *Grace,* an abstraction of a swan, rests on a pedestal in Binhammer Common next to city hall.[99]

On Saint Mary School on West 144th Street in East Chicago is a heroic figure of Mary in bronze. Mounted directly over a second-story window of the school, this image, twelve feet high, is not the typical portrayal of serenity. This Mary with her robes and hood flying as if she were striding or running forward—or else being pushed back by the wind—seems profoundly disturbed and anguished. Completed in 1984, the work is that of John Mullin of Chesterton. The adjacent Saint Mary Church displays a large statue in front of the church of the Virgin Mary holding the infant Jesus. It is a replacement by an anonymous donor of one that had been destroyed by vandals in 2002. Reflective of the large Polish population in East Chicago is the life-size bronze statue of Thaddeus Kosciuszko (1746–1817) by Chicago sculptor Angelo Ziroli (1899–1948), erected in 1939. Kosciuszko was the Polish general who fought alongside George Washington in the Revolutionary War. The statue is in a park named for the general on Indianapolis Boulevard.

A commemorative statue erected in 1932 in Gary is the oldest work of public sculpture in that city, which itself was not established until 1906. An eleven-foot figure of early explorer and Jesuit priest Jacques Marquette (1637–1675) stands at the entrance to Marquette Park, a site which is said to have been where the missionary camped not long before his death. The base, a substantial structure in a formal garden setting, was designed by the architectural firm of Walker and Weeks and completed in

1931. Henry Hering's (1874–1949) heroic statue was not cast until the following year, at which time the formal dedication took place.

Elbert H. Gary (1846–1927), a lawyer, judge, industrialist, and chairman of the board of the United States Steel Corporation, founded the company town that bears his name. Downtown next to city hall stands an eight-foot bronze statue of the judge, the work of London-born sculptor Bryant Baker (1881–1970), erected in 1957. Across busy Broadway is a "little Liberty," one of six extant in Indiana, which local troops of Boy Scouts installed in the early 1950s in "The Crusade to Strengthen the Arm of Liberty." This one was erected in 1950. Formed out of a sheet-copper alloy, the figure was

Richard Hunt's *Soaring Interchange* in downtown Gary is evocative of the nearby scramble of elevated highways.

manufactured by the Friedley, Voshart Company of Kansas City, Missouri. A block to the west—for something completely different—is a twenty-foot abstract of stainless steel, erected in 1985, by noted Chicago sculptor Richard Hunt (b. 1935). Somewhat treelike in overall form, *Soaring Interchange* blends shapes reminiscent of dolphins, arrows, and geese, while calling to mind the nearby elevated expressway.

South of downtown on the campus of Indiana University Northwest are two fine figurative works in bronze. *Woman in the Sun* actually sits in the shade outside the entrance to Raintree Hall. The stylized woman is seated with her legs straight forward and her hands crossed in her lap, almost mummylike. Created in 1961 by Pino Conte (1915–1997), the work was given to the university in 1980. Twenty years later Harold R. "Tuck" Langland's (b. 1939) *Dance of the Awakening Day* was dedicated outside the Library Conference Center. The piece speaks of innocence and anticipation as well as the artist's attention to the movement of dancers.[100]

Some of Gary's Roman Catholic institutions display religious statuary. Notable on Saint Mary of the Lake Catholic Church, designed by architect James M. Turner and erected in 1961, is a twelve-foot stone figure of Mary, barefoot, poised on the shape of Lake Michigan, which is composed of blue mosaic tiles, as is the halo around the statue's head. Above the entrance to the Cathedral of Holy Angels, built in 1950 on Tyler Street, are seven limestone relief panels. The center panel is of the Crucifixion, and the three panels on each side mirror each other and depict angels in clouds.

LA PORTE

La Porte County is a land of rolling prairies (with even a village by that name), several lakes, and just a tiny remnant of duneland in its northwest corner at Michigan City. The county's largest concentration of sculpture is here. Noteworthy, too, is the ongoing

Entrance to Washington Park,
Showing Soldiers' and Sailors' Monument,
Michigan City, Ind.

The Soldiers and Sailors Monument dominated the entrance to Washington Park in Michigan City. Today it is surrounded by a traffic circle.

Odyssey exhibition of large outdoor pieces at Purdue University North Central. Approximately ten works are on exhibit for a year at a time, offering sculptors the opportunity to show their monumental works and the public easy accessibility to this type of art. Local artist S. Thomas Scarff (b. 1932), whose studio is in Chicago, curates the exhibit.

Scarff has produced three public pieces in Michigan City, plus his polished bronze *Wind Dancer* (1995) visible in his front yard in Sheridan Beach. Born in Iowa, Scarff's earliest public sculpture in the area is *Sky Tool*, installed in 1985 at what was then Sprague Devices on Eastwood Road. From a distance the ten-foot-high aluminum piece suggests a sailboat. At the Michigan City Public Library is *Centura*, a work of bronze installed in 1996. In front of the Sinai Temple on South Franklin is *A Light Unto All Nations*, a work of bronze and neon completed in 1997.[101]

An interesting pair of fitted blocks of burnished bronze called *Lovers* by California sculptor Archie Held (b. 1955) graces the Horizon Bank on South Franklin Street. A piece by Chicago sculptor Richard Hunt, *Hybrid Figure*, is in the entrance courtyard of the Lubeznik Building downtown at 101 West Second Street. The seven-foot abstract female form of welded bronze was installed in 1978.[102]

Not to be ignored is the fifteen-foot milk bottle atop the building that once housed the Scholl Dairy on South Franklin. It was built of wood and installed when the dairy opened in the early 1930s. The current owners of the building repaired it several years ago and coated it with fiberglass.

Michigan City has several traditional commemorative sculptures, many of them in Washington Park along Lake Michigan. The impressive Soldiers and Sailors Monument, at the terminus of Franklin

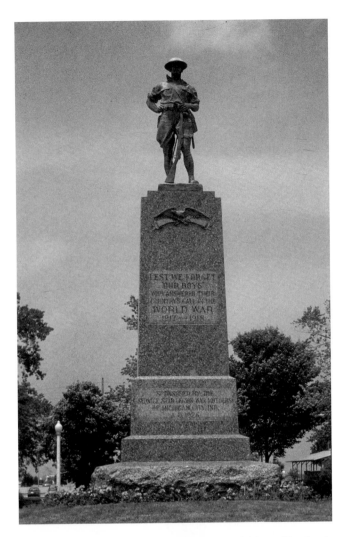

The Service Star Legion War Mothers of Michigan City funded this World War monument in Washington Park in 1926.

Armistice Day. It is topped with a life-size bronze doughboy standing in an informal pose atop a granite pedestal. Originally erected downtown at Tenth and Franklin streets in 1909, the Hutchinson Fountain, named for its donor, was restored and rededicated on the grounds of the Old Lighthouse Museum in 1981. The granite fountain was carved by local prison labor (at the Indiana State Prison) under the direction of Oliver Green of Logansport. The fountain is topped with a triple light standard flanked by the figures of two small boys. Worth noting is the Water Wheel Garden, a project of the Federal Emergency Relief Administration (FERA) in 1934, which today might be classified as environmental sculpture. A fanciful serpentine creation of

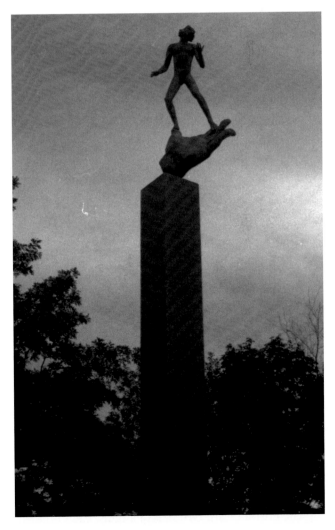

The figure of an awestruck youth in *God's Hand* stands high above the campus of LaLumiere School north of La Porte.

Street, was a gift of local businessman John H. Winterbotham (1813–1895). Dedicated in 1893, the monument, topped with a bronze allegorical figure representing Peace, soars over sixty feet high. Around the base is a continuous bronze frieze depicting leave-taking, battle, and homecoming. The bronze work was that of two New York sculptors, William R. O'Donovan (1844–1920) and J. Scott Hartley (1845–1912). A Spanish-American War veterans memorial was erected near the Old Lighthouse in 1936. A bronze relief plaque featuring a soldier standing with the fabled USS *Maine* in the background is mounted on a large granite boulder. Ten years earlier the Service Star Legion War Mothers dedicated a World War Memorial on

water and stone, chiefly granite, it extends nearly
three hundred feet along the north edge of the
park's main green space between its entrance and
the beach parking lot. Most of Washington Park is
listed in the National Register of Historic Places.

The La Porte County Superior Court building,
completed in 1909, features two heroic Roman sol-
diers carved of limestone beneath the pediment
above the entrance. Between them is other decora-
tive carving.

The Orak Shrine on Frontage Road displays a
Shriner in full regalia, cradling a little girl with leg
braces. The eight-foot fiberglass statue was modeled
by Fred Guentart and is called *Silent Messenger*. It
was erected in May 2000.[103]

In Greenwood Cemetery is a Grand Army of the
Republic (GAR) Monument, also known as the Sol-
diers Monument, erected by the local post of the
Women's Relief Corps on Memorial Day, 1926. It
features a granite life-size Union sentry on a tall gran-
ite pedestal. Also in the cemetery, at the entrance, is a
life-size marble figure of Christ erected in 1959.

A life-size metal figure of Saint Anthony of Padua
was created for a niche in the main facade of Saint
Anthony Hospital built in 1903. In 1987 the hospi-
tal expanded, obscuring the original facade, so the
saint was moved inside the entrance off Wabash
Street. A new figure of Saint Anthony was then placed
outside the new main entrance on Homer Street. The
hospital also has a concrete figure of Saint Joseph that
dates to its founding. Saint Anthony recently merged
with Memorial Hospital under the auspices of the Sis-
ters of Saint Francis of Perpetual Adoration. A new
casting of *Spirit of Saint Francis* by Sufi Ahmad was
erected to honor their patron saint.

Saint Stanislaus Church at Washington and Ann
streets was built in part in 1916 but not completed
until 1935. In the large tympanum above the
entrance is a seven-foot relief with a mosaic back-
ground, depicting Christ bursting forth from his
tomb as Roman soldiers shrink away in fear. Flank-
ing the entrance are two herald angels, each holding
a scroll. At Saint Mary of the Immaculate Concep-
tion Church is a World War Memorial on Tenth

Street dedicated in 1921, surmounted with a large
Carrara marble figure of Christ. At nearby Marquette
High School is a large concrete figure of Father
Jacques Marquette, the seventeenth-century Jesuit
missionary. The statue, which probably dates to
1914, was originally located in a niche above the
entrance to Marquette Hall. Built as a parish hall,
that structure became Saint Mary High School in
1925. When the new high school was built in 1955,
the statue was moved to the lobby of the auditorium.

At the entrance to the Queen of All Saints
Church on Barker Street are two contemporary
limestone relief panels. One panel portrays Saint
John comforting Mary at the cross and a depiction of
Mary, Queen of All Saints. The other tells the story of

Potawatomie originally was placed in this fountain setting
north of the courthouse in La Porte.

the Annunciation. Carvers from the Indiana Lime-stone Company followed the designs of the Bernard Gruenke Studio of Wisconsin. The architect Norbert Schaaf sketched out the original concept. Also at the church is a painted marble figure of the Madonna and Child from about 1950, when the congregation began to meet in the basement of the school. In the courtyard of the school is a somewhat stylized figure of Saint Francis of Assisi, purchased in Italy in 1986. At the Notre Dame School on Moore Road is a Madonna and Child of marble, dedicated in 1955.

The International Friendship Gardens began at the 1933 Chicago World's Fair with an exhibition by three nurserymen from Hammond, the Stauffer brothers. After the fair, a philanthropist donated a hundred acres near Michigan City so the brothers could create their dream—a garden of peace that blended landscapes from all over the world. Opened in 1935, the gardens, filled with statuary and displaying examples of gardening techniques from around the world, gave joy to thousands of visitors for more than three decades. By the 1970s, however, they were languishing in virtual ruin. Today, hardworking volunteers are bringing the gardens back to life. Sculpture of all sorts abounds, and in recent years some pieces that had been buried were unearthed, their origins a mystery.[104]

South of Michigan City in the little community of Otis is Saint Mary Church, built in 1918. On it is a six-foot-marble figure of the Assumption of Mary, placed about 1960 after the nearby Indiana Toll Road was completed so that she could watch over the travelers. A large standing figure of Mary is part of a World War II memorial constructed at the church in 1946.

East of Michigan City are the Swan Lake Memorial Gardens, one of the earliest cemeteries of this type in the state. It contains large marble figures of Christus and Christ the Good Shepherd by Dominic Zappia, dating from 1954 to 1955.

North of La Porte, a few miles north of US 20, is LaLumiere School, where the striking work *God's Hand* (1954) by Carl Milles (1875–1955), one of his final works, overlooks the school's playing field.

Mounted on a marble pedestal eighteen feet high, the bronze piece depicts an awestruck youth balanced on the thumb and forefinger of a huge hand. A donor purchased the work in Italy in 1965 and presented it to the school. On the grounds also is a small brick grotto containing a metal statue of Mary.

In the county seat of La Porte is a fourteen-foot figure of a *Potawatomie*, by La Porte-born sculptor Howard A. DeMyer. Fashioned of sheet copper, the statue honors the Native Americans who once lived in the region. It was erected as part of the Bicentennial celebration in 1976 in a fountain plaza behind the courthouse. The space was needed for a new jail, and in 2003 the statue was unceremoniously moved to the east side of the courthouse, where it stood

Valparaiso sculptor Hermann Gurfinkel created this piece for La Porte Hospital after one of its many expansions.

behind wooden barriers for a time. Happily, in 2004 a base of material closely matching the red sandstone courthouse was erected, and on it the figure now stands majestically.

At nearby La Porte Hospital is a twenty-foot stainless-steel piece resembling two crosses bending toward each other. *Avec Compassion* was created by Marcia Wood (1933–2000) and erected in 1982. Earl Marhanka and his wife, owners of K & M Machine Fabricating in Cassopolis, Michigan, where many modern art pieces are assembled, donated the materials and time. Marhanka grew up in La Porte and wanted to give something back to the town. A four-foot bronze stylized figurative piece called *Mother and Child* by Hermann Gurfinkel (1916–2004) of Valparaiso was dedicated in a new courtyard on the east side of the hospital in 2000.[105]

At Sacred Heart Catholic Church on Bach Street is a marble figure of the Virgin Mary on a base of rough-hewn stone with long planters of the same material angling out from either side. Supposedly the stone was brought in on sailing ships, used as ballast. The stonework was the last project of Roscoe Hensell. Also at the church is a life-size marble statue of the Sacred Heart of Jesus, from about 1942. It was formerly located between the old church and the rectory, across the intersection from its present site. A cast-stone statue of Saint Anthony stands at Saint Peter Catholic Church at Michigan and Noble streets.

Outside the village of Rolling Prairie was the former Saint Joseph Novitiate that later became LeMans Academy, a preparatory school. There had been numerous examples of religious statuary on the grounds. The property and its contents were sold at auction in 2004.

LAWRENCE

Since Lawrence County is the self-proclaimed land of limestone, one may expect to find an abundance of outdoor sculpture, scores of significant limestone

In Bedford's Green Hill Cemetery, this exquisitely detailed memorial to stone carver Louis Baker was fashioned by his fellow workers in 1917.

buildings, and a substantial assortment of interesting gravestones, with many variations of the tree stump so popular in the late-nineteenth and early-twentieth centuries. One that is of particular interest, because it includes a portrait of the deceased, is the nearly six-foot trunk on the grave of Eberle Martin in the Mitchell City Cemetery. His profile likeness is carved as if the picture, framed with a bent branch, were nailed to the tree trunk. In other respects it is typical of this type of gravestone, with a rifle carved as leaning against the tree and a squirrel at the base. Since Martin was a fox hunter, a dog chasing a fox is also depicted. It was carved by Charles Underwood of Bedford sometime after

1891. South of Mitchell in the Freedom Cemetery off State Road 37 is the grave marker of Wallace Brown, which sports a perfectly detailed log cabin only fifteen inches high, carved around 1940.[106]

There is another monument in Mitchell, just north of the Municipal Building. Mitchell is the hometown of Virgil I. "Gus" Grissom (1926–1967), one of the original seven Project Mercury astronauts, who died tragically with two other astronauts in a fire in 1967 while running tests in a Project Apollo capsule. More than thirty feet high, the Grissom Memorial takes the form of a Redstone rocket topped with a space capsule. Surrounding the base, inscribed limestone tablets give a detailed biography of Grissom's life. Designed by D. J. Busch (1902–1997), the monument was erected in 1981.[107]

Green Hill Cemetery in Bedford is widely known for its large collection of exceptional grave markers. Among them is the limestone doughboy with his helmet in the crook of his arm, carved by Frank Arena and Fred Edler for the grave of Michael Wallner, who in 1940 died at last of the wounds he received in World War I. The grave of Tom Barton, an avid golfer who died in 1937, is marked with a life-size figure of the man wearing casual clothes of the 1930s and carrying golf clubs. In a city devoted to limestone, this statue is of granite. The grave of stone carver Louis Baker displays his wooden workbench with the stone cornice he was carving, his tools, and his apron laid across the top, all carved in limestone just as he had left it on his last day of work in 1917. Baker was struck and killed by lightning on his way home. Another version of the tale has it that Baker died of pneumonia a few days later. In either case, his fellow carvers honored his memory by duplicating his workbench in stone. Nearby is the Stonecutters Monument, which is a remarkable three-dimensional document depicting a stonecutter in his working garb, surrounded by all his tools, erected in 1894 by the Bedford Stonecutters Association.

Wilson Park, near Green Hill Cemetery, once had a World War I monument featuring a limestone doughboy, dedicated in 1932. Frequent attacks of vandalism resulted in the remaining pieces ultimately being carted away. The base remains, not far from the ball field.[108]

Thornton Park on the west side of Bedford features two limestone replicas, roughly ten feet high, of the mysterious heads found on Easter Island. Criston East of the Indiana Limestone Company carved them in 1983. Of particular historic and artistic interest are the several scenes of children at play, with structures of the park in the background, that were carved by Works Progress Administration (WPA) stone carvers about 1937. There are at least six of these, about two feet square, each showing children engaged in a different activity, such as playing leapfrog or swinging. Unfortunately, decades of

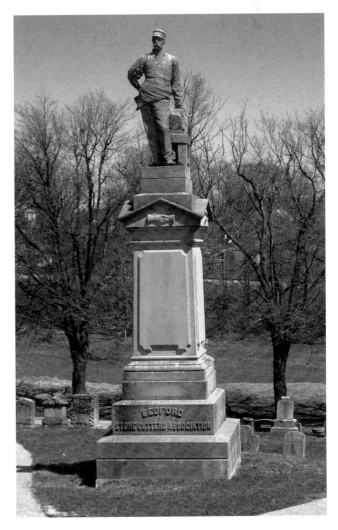

The Bedford Stonecutters Association erected this monument honoring its own in 1894.

exposure to the weather have resulted in some of the images being almost completely worn away. The WPA workers did several other park improvements that involved stone carving, but much of this has disappeared through subsequent remodelings. In Otis Park, created by the WPA from a former country club on the east side of Bedford, there is a magnificent band shell built in 1938 and decorated with classical allegorical reliefs and musical motifs.

Downtown on the west side of the courthouse square is the Pioneers, Soldiers and Sailors Monument, also known as the Moses F. Dunn Memorial in honor of the donor. Reliefs are carved all around the base, and the monument, designed by Charles Dodd, is topped with a fourteen-foot allegorical fig-

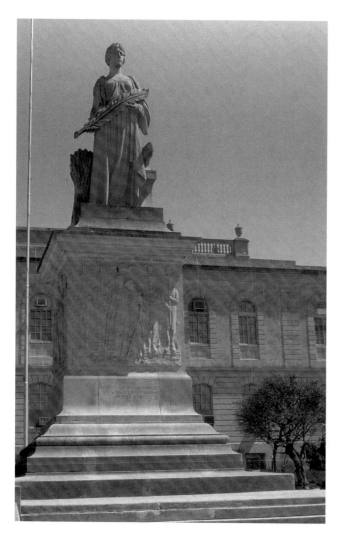

The Pioneers, Soldiers and Sailors Monument on the court-house square in Bedford.

ure representing Indiana. It was carved by Harry Easton. Dedicated in 1924, the monument is both a war memorial and a tribute to the early settlers of the county. Above the south entrance of the limestone courthouse itself, designed by architect Walter Scholer and completed in 1930, is carved a bust of Athena (Minerva).

On the Elks Lodge (1913) downtown are four carved limestone relief panels depicting allegorical figures and, of course, elks, each accompanied by an appropriate text.

Saint Vincent de Paul Church at Eighteenth and I streets has a large stone crucifix carved in the 1890s by A. G. Meister. There are other odd pieces of sculpture scattered about town. At 1405 M Street is a magnificent pair of limestone lions carved in 1923, guarding the entrance to the house. On the porch of 1603 West Sixteenth Street, a little barefoot boy in a straw hat holds a nest with eggs. The four-foot statue, dating to at least 1893, is said to have been exhibited at the Columbian Exposition in Chicago.

Just north of the town of Oolitic, named for the abundant limestone surrounding it, is the Indiana Limestone Company mill, at the junction of old and present State Road 37. Its entrance is guarded by two fierce eagles that resemble those commonly seen on New Deal projects of the 1930s. These are much more recent, however, carved by Criston East in 1983. Beside the Oolitic Town Hall is a statue of the once-popular cartoon character Joe Palooka, now in its fourth location. The figure was carved by George W. Hitchcock Sr. and Harry Easton in 1948 in celebration of the centennial of the Indiana limestone industry. The completed ten-foot statue of the boxer was erected on a hillside overlooking old State Road 37 between Bedford and Oolitic. Vandals soon began to wreak havoc on the figure, so it was moved to the Highway Limestone Mill in 1952. The Fraternal Order of Police decided to "adopt" the figure around 1960 and, after tending to his wounds, moved Joe to Dickerson Park in Bedford, on the driveway leading into the FOP Lodge. When the land was purchased by a private owner, the FOP

donated the statue to the Kiwanis of Oolitic in 1984, at which time it was erected in its present location.

MADISON

It was in his hometown of Elwood that lawyer and industrialist Wendell L. Willkie (1892–1944) began his 1940 campaign for president against Franklin D. Roosevelt. On the twenty-sixth anniversary of his acceptance of the nomination, the Wendell L. Willkie Memorial was dedicated by the city's chamber of commerce. It is a simple granite memorial

The Willkie Memorial in Elwood, where Willkie officially declared his candidacy for the presidency of the United States in 1940.

featuring a bust of Willkie in relief. On the south side of Elwood, Sunset Memorial Gardens has several marble figures of Christ scattered about the grounds. They are imported from Italy. Similar statuary is common in many memory gardens and newer sections of cemeteries throughout the state.[109]

A wire sculpture by William Arnold, formerly of Indianapolis, of a stallion, the school mascot, prances outside Pendleton High School, erected in the 1990s.[110]

In the town of Chesterfield is a spiritualist camp that was founded in 1886, although most of the extant buildings are from the early twentieth century. Scattered around the wooded grounds and gardens of Camp Chesterfield are several statues of interest, although the sculptors are unknown. *The Shrine* is a seven-foot figure of a Native American emerging from a rock that sits upon a large random-stone base. Dedicated in 1940 on the part of the grounds known as Inspiration Hill, the shrine is "a memorial to the American Indian" that was created because of a suggestion "from the spirit world." *The Sentinel Angel,* also dedicated in 1940, is a life-size painted stone figure on a pedestal watching over the entrance to the Garden of Prayer. A few years later the Trail of Religions was created. The trail leads to a plaza with a back wall of fieldstone along which are placed nine marble busts of the leading figures of the world's religions; the center bust is of Christ. In 1974 the Julia Urbanic Memorial, a life-size granite statue of Christ, was dedicated next to the Administration Building.

Most of the remaining outdoor sculpture of Madison County is in the county seat of Anderson. In West Maplewood Cemetery on Alexandria Pike are two life-size marble statues of the Hilligoss children, sixteen-year-old Charlie Ingersoll and six-year-old Gertrude Pauline, both of whom died in the 1880s. The grief-stricken parents, left childless, ordered the statues made in Florence. They were placed on the graves about 1892.

There are a number of religious figures at various churches around Anderson. A limestone relief of

The Shrine **is one of several interesting statues on the grounds of the Spiritualist Camp at Chesterfield.**

Christ as the Good Shepherd is on the north facade of Mounds Baptist Church, built in the early 1950s. A few blocks to the west is another statue of Christ at Unity Church. Both are on Mounds Road.

An abstract work by Donald Weisflog (b. 1944), consisting of three bronze pieces on four pedestals, stands at the corner of Thirty-eighth and South Main streets. It was completed in 1979, when he was a member of the faculty at Anderson University.[111]

Shadyside Park on the city's north side streets has become something of a sculpture repository in recent years. Not far from the marina is a Cor-Ten steel piece by Seattle artist Doris Chase (b. 1922) called *Changing Form,* comprised of three U shapes. In the northeast corner of the park is an untitled Cor-Ten steel abstract (the artist informally refers to it as "Life Sculpture") by Anderson native Phil Simpson (b. 1947). Dedicated in 1980, the piece was originally located outside the Anderson Fine

Arts Center when the facility was housed in a former residence on West Eighth Street. The center moved into the old Carnegie Library on Tenth Street a few years ago, and in 2001 the sculpture was moved to Shadyside. On the west side of the park is a bronze work by Kenneth G. Ryden (b. 1945), who teaches at Anderson University. Ryden has completed so many large pieces in the past few years, it is a wonder he has time! Erected as part of a war memorial in 1999, *The Spirit of Liberty* depicts a fierce eagle with outstretched wings rising phoenix-like out of flames.[112]

Ryden created a piece for Anderson Memorial Park Cemetery, expressing both comfort and inspiration. Installed in 1999, *Compassion,* a modern interpretation of an angel holding a dove, stands seven feet tall and tops a fountain, as do many of Ryden's pieces. *The Graces,* completed in 2003, is a contemporary approach to a traditional subject. The

three women look as if they are performing modern dance, quite appropriately since the fountain in which they pirouette, located on Meridian Plaza at Twelfth Street, enhances the newly designated Florentine Arts and Theater District downtown.[113]

At Saint John Medical Center at 2015 Jackson Street is Ryden's heroic figure of Saint John the Apostle, *The Beloved,* set on a boulder amidst several others in a fountain pool. Completed in 1994, the fountain is dramatically lit at night. Completed two years later at the nearby Erskine Center of Saint John's on Meridian Street is a life-size bronze statue of Carl Erskine (b. 1926), fabled pitcher for the Brooklyn Dodgers.[114]

Ryden's eight-foot statue of Dr. Martin Luther King Jr. stands in a small triangular park at the inter-

Kenneth G. Ryden created this striding figure of Martin Luther King Jr. placed in a landscaped traffic island in an African American neighborhood on the south side of Anderson.

section of Twenty-second Street and Pendleton and Madison avenues on the south side of town. Dedicated in 1988, the statue portrays King purposefully striding forward.

Certainly the largest sculptural work—and not without controversy—in Anderson is the *Crystal Arch* by Arlon Bayliss (b. 1957) of the art faculty and Jason Knapp (b. 1951), chair of the Department of Art and Design, at Anderson University. The two artists collaborated with several businesses in the area, and every part of the piece was made locally. Standing prominently outside the Anderson City Building, the piece, thirteen feet high and forty feet long, is a shifted arch of glass, stainless steel, and fiber optics. Inside the hollow wall hang 360 individually blown, diamond-shaped "crystals," each lit with fiber optics and engraved with a person, group, place, or event significant to the history of the county. Begun in 1996, it was at last completed five years later.[115]

On the campus of Anderson University, where so many of the city's sculptors dwell, are a number of pieces, including yet another statue by Ryden. Dedicated in 1988, it is a life-size figure of John Arch Morrison (1893–1965), Anderson University's first president, who served from 1919 to 1958. It depicts Morrison as he looked in the prime of his presidency, wearing a suit over which is an open academic gown. On the north side of Hartung Hall is a work by Bayliss called *Helios,* created of 150 pieces of green sheet glass stacked in a spiral configuration. The name is both a play on the fact that sunlight sparkles through it and that the shape of the piece suggests the double helix of DNA. Bayliss was born in Warwickshire, England, but came to Anderson in 1990 to direct the university's fine arts glass program.

The campus seems for sometime to have attracted artists who work in unusual media. Robert Youngman, who returned to his home state to teach at the University of Illinois at Urbana–Champaign, created other pieces around Indiana, but he literally left a concrete legacy to Anderson. Two twenty-foot abstract reliefs grace the north end of the Russell

Olt Student Center, built in 1963. The reliefs are difficult to describe, but some of the shapes suggest the influence of Picasso. Near the Krannert Fine Arts Center is a large welded steel abstract called *Passages,* done in 1987 by James K. Johnson of Northern Illinois University. It is a shifted arch with a large askew rectangular piece functioning as a sort of keystone.

MARION

Certainly one could write a book on the outdoor sculpture of Marion County alone, where, even taking into consideration the annual disappearance of some, there are close to three hundred works and counting. The heaviest concentration of outdoor sculpture is, not surprisingly, in Center Township, the center of the city of Indianapolis, closely followed by Washington Township to the north, which has a high population density, with large pockets of affluence and several cultural institutions.[116]

Starting in the middle of the county and the city, the Soldiers and Sailors Monument on the Circle is by far the most prominent work of sculpture in the county and indeed, the state. The idea of building such a monument was advocated as early as the end of the Civil War by Governor Oliver P. Morton (1823–1877). A decade later the Grand Army of the Republic (GAR) veterans organization formed a Monument Association. After winning the commission in an international competition, German architect Bruno Schmitz (1858–1916) signed a contract to undertake the monument, and a little more than a year later the cornerstone was laid. It took thirteen years to complete. Schmitz hired Austrian sculptor Rudolf Schwarz (1866–1912), whom he had employed on projects in Germany, to do the War and Peace groupings on the east and west sides of the monument. Schwarz designed two additional smaller heroic groupings beneath each one to translate the themes into more intimate terms. *The Dying Soldier* makes it clear there is little glory in war. *The*

Return Home shows a son surprising his parents in a joyous postwar reunion. Schwarz created the four limestone military figures, representing Infantry, Cavalry, Artillery, and Navy, around the base of the shaft and designed and executed all the bronze entrance doors. The bronze army astragal (the sculptured band surrounding the shaft) is a grim depiction of a battlefield by Nicolaus Geiger (1849–1897) of Berlin, who cast his work in Germany and shipped it to Indianapolis, without ever seeing the monument. Geiger died before it was completed. Farther up the shaft is another bronze astragal representing the Navy, with bowsprits jutting from each corner and a portrait relief of Admiral David Farragut. Near the top is a relatively plain astragal with the dates 1861 and 1865. These and the large figure of Victory (sometimes interpreted as an allegorical Indiana) atop the shaft are the work of Ohio sculptor George W. Brewster (1862–1943). Surrounding the monument on its outer rim are four heroic bronze statues of figures representing Indiana's participation in all the American wars up to the Civil War. The statue of Governor Morton predates the monuments. The work of Franklin Simmons (1839–1913), it was first erected in the center of the Circle in 1884, which at the time was a public park. The Morton statue was placed in its present location about 1899. Welsh-born John H. Mahoney (1855–1919) was commissioned to create the three other figures in the same proportions as the Morton statue. George Rogers Clark (1752–1818), representing Indiana's participation in the Revolutionary War, was completed in 1895. By 1899 Mahoney had finished William Henry Harrison (1773–1841), famous for the Battle of Tippecanoe, which was a precursor to the War of 1812, and James Whitcomb (1795–1852), who was governor during the Mexican War of 1846–48. The monument, which at 284.5 feet stands only fifteen feet lower than the Statue of Liberty, was dedicated May 15, 1902.

The statehouse lawn is crowded with bronze men. The largest is Thomas A. Hendricks (1819–1885), eleven feet high, standing stalwart on an impressive granite pedestal flanked with two alle-

gorical figures representing Justice and Enlightenment. Hendricks was a United States senator and later governor of Indiana in the 1870s. He died in 1885 while in the first year of his vice presidency under Grover Cleveland. The work of New York sculptor Richard Henry Park (1832–1902), the statue was dedicated in 1890 at the southeast corner of the statehouse grounds. Nearby to the west is George Washington, decked out in his Masonic accouterments, designed by Donald DeLue (1897–1988) in 1959. There are a number of these figures around the country; this one was erected in 1987. Directly north of Washington was once a bronze bust of reformer Robert Dale Owen (1801–1877) by New Castle native Frances Goodwin (1855–1929), dedicated in 1911. The bust disappeared in the 1970s, but the pedestal remains. To the west and around the corner is a bronze bust of Christopher Columbus by Indianapolis sculptor Enrico Vittori, presented in 1920 as a gift from organizations of Italian immigrants around the state. The piece rests on a carved granite pedestal.

On the east side of the statehouse at the Capitol Avenue entrance is a large bronze statue of Governor Morton. Dedicated in 1907, it is the only one of Rudolf Schwarz's commissions on which he did not lose money. Schwarz, who remained in Indianapolis after completing his work on the Soldiers and Sailors Monument, was a masterful artist in stone and bronze, but an extremely poor businessman. He died in poverty in his forty-fifth year. The ten-foot-figure of Morton is flanked by two heroic Union soldiers and two exquisite relief panels, which are often overlooked. Displaying wonderful perspective, one panel depicts Morton exhorting the troops, and the other shows the governor visiting a field hospital, a grim subject for a commemorative sculpture.

On the west side of the statehouse is a heroic bronze statue of a coal miner, erected in 1967, by Chicago sculptor John Szaton (1907–1966). The statue portrays a deep-shaft miner of the early to mid-twentieth century, with all his equipment. A bronze relief panel on the front of the base shows a strip-mining operation. The 1965 General Assembly

appropriated the funds for the statue as a memorial to Hoosier coal miners who were killed on the job.

On the statehouse itself, high above the south entrance facing Washington Street, are limestone figures of an Indian family, a farmer, a blacksmith, and a pioneer family. The twelve-foot figures were carved by Herman C. Mueller about 1888, when the statehouse was built.

Built in 1934, the Indiana State Library and Historical Building boasts sets of reliefs designed by French-born Leon Hermant (1866–1936) of Chicago and carved by German-born Adolph Gustav Wolter (1903–1980), who came to Indianapolis for this project and remained to build a distinguished career as a sculptor. Below the cornice on the north and south elevations of the library are eight related panels representing lofty themes: Philosophy, Art, Charity, and Justice on the north and Science, History, Invention, and Religion on the south. The main east facade offers a carved pageant of the history and development of the state that runs from south to north, starting with the Explorer (LaSalle), the Soldier (the capture of Vincennes), the Pioneer, the Farmer, the Legislator (the writing of the state constitution), the Miner, the Builder, the Constructor, the Manufacturer, the Educator, and a final group, Aspiring Students.

Westward along what once was Market Street is the heroic statue *Young Abe Lincoln* by David K. Rubins (1902–1985), for many years head of sculpture at Herron School of Art. It was originally dedicated on the southeast side of the older State Office Building in 1969. The intentionally gawky figure was relocated to its present site on the north side of the Indiana Government Center South about 1991. Nearby, in the lower level courtyard, a gigantic leaf of a tulip poplar, the state tree, is rendered in stainless steel; the leaf's copper stem is a drinking fountain. The piece, by Eric Ernstberger and Jan Martin (b. 1948), was installed in 1992 when the building was completed. On the opposite side of the building, along Washington Street, is a finely rendered bronze plaque designed by a high school girl, Marie Stewart, winner of a citywide contest in 1906.

Rudolf Schwarz executed the design, which commemorated a speech Lincoln had given at the Bates House in 1861, on his way to assume the presidency. The plaque was dedicated on Lincoln's birthday in 1907 on the Claypool Hotel, which stood where the Bates House had been. The Claypool succumbed to the wrecking ball in the late 1960s, and in 1971 the plaque was relocated westward on Washington Street, ultimately reaching its present site in 1991.

On the west side of the Indiana Government Center North is the Workers Memorial by local sculptor Dan Edwards, a fine work in an ill-conceived location. The bronze sculpture of three workers on a limestone base is set back some distance from West Street and is too small to be readily seen by the passing heavy traffic. Also, the memorial has not benefited from the increased pedestrian traffic along the canal as new attractions in White River State Park open, since there is not even a path leading from the sidewalk to the sculpture. Erected in 1995 by a consortium of labor organizations, the piece commemorates those who died on the job.[117]

Across West Street is the Eiteljorg Museum of American Indian and Western Art on the edge of White River State Park. Several sculptures are permanently displayed around the Eiteljorg. Along its east elevation is an environmental sculpture by Alan Sonfist (b. 1946) that is scarcely noticed and always changing. Begun in 1989, *Time Landscape of Indianapolis* originated as plantings of native vegetation, but over time it has evolved into a patch of young forest. In the southeast corner of the grounds are five very realistic leaping deer, the illusion made more so by the water splashing about them. The untitled bronze work, installed in 1989, is by Kenneth Bunn (b. 1938). Standing before the entrance to the museum on the south is *The Greeting* by George Carlson (1940–1998), a heroic bronze figure of a shaman of the northern Plains. Bruce LaFountain (b. 1961) of the Chippewa tribe created an unusual bronze piece called *Wisdom Keepers* that originally was erected west of the museum in 1999,

but will go into the new sculpture garden in 2005. At first the statue appears to be the stylized figure of a chief, but the feathers of the headdress in the back come together to form the head of an eagle. Also in the new sculpture garden, which is sited along the canal opposite Military Park, is a bronze statue of a Navajo woman holding an umbrella by Native American artist Doug Hyde (b. 1946). The museum envisions this as a vital space that will embrace additional permanent pieces. A small limestone sculpture of a bison had been displayed on an outdoor terrace of the museum. The piece became homeless when the Indiana National Bank (INB), for which the bison was the logo, was taken over by another bank in 1999. Carved by William A. Galloway, the critter had been installed in the lobby of the INB Tower and now is sheltered inside the museum.[118]

West of the Eiteljorg is the new Indiana State Museum, opened in 2002, which is literally teeming with outdoor sculptures on its exterior walls, each representing one of Indiana's ninety-two counties. The sculptures, created by the Indianapolis sculpture design company 2nd Globe, are all different in concept, design, and medium, and may each be regarded as an individual work, as well as part of the overall concept called *92 County Walk*. The pieces were designed by the company's founding artists David Jemerson Young and Jeff Laramore, who, after lengthy research and travel, found unique, notable, prideful, or historic attributes for each county and then wove them into whimsical designs of appropriate materials.[119] Startling strollers along the canal are two life-size bronze mastodonts created by the Canadian design firm of Research Casting International. They were installed near the museum's north entrance in the fall of 2004.

In what essentially is the museum's front yard is a work that was installed in 1982 in very different surroundings. *Totem*, by Rinaldo Paluzzi (b. 1927), who studied at Herron School of Art and Indiana University, is a thirty-foot abstract stainless steel tower. At one time it reflected some of the angles and shapes of the industrial buildings around it; now

all it may evoke are memories of those structures, all of which have been demolished.

A number of outdoor sculptures can be seen at any given time on the old Washington Street bridge. The pieces are exhibited for a year (soon to be two years) under the auspices of a program that began in 1999 called *Sculpture in the Park*. All the pieces are by Indiana artists and are on loan to the program. The bridge in essence functions as a large open-air gallery, putting contemporary art before the public eye.[120]

In the summer of 2004 White River Park purchased Goshen artist John Mishler's (b. 1948) *Sky Waltz,* one of his trademark kinetic pieces. The fourteen-foot aluminum abstract, created in 1998, stands between the bridge and the pumphouse.

On the west end of the bridge is William Arnold's wire bison, originally placed in 1989 in a downtown plaza next to the former INB Tower to represent the bank's logo. When INB was taken over by another bank, the bison statue was donated to the zoo, where it stood near the main entrance at the southeast corner until the bridge entrance was built in 1999. Arnold also created various North American Plains animals that appear to graze along the perimeter on the opposite side of the zoo. They were installed in 1988 when the zoo opened, and from a distance they seem to breathe. Near the entrance to the zoo sits a pair of highly stylized Chinese lions of marble, a gift presented upon the zoo's opening by the Chinese province of Zhejiang, which established a sister program with the state of Indiana. The Riverwalk Promenade, designed by landscape architect Angela Danadjieva and dedicated in June 1988, was installed along the White River skirting the northeast side of the zoo. The half-mile walk is lined with blocks of limestone, which at intervals bear reliefs and inscriptions relating the

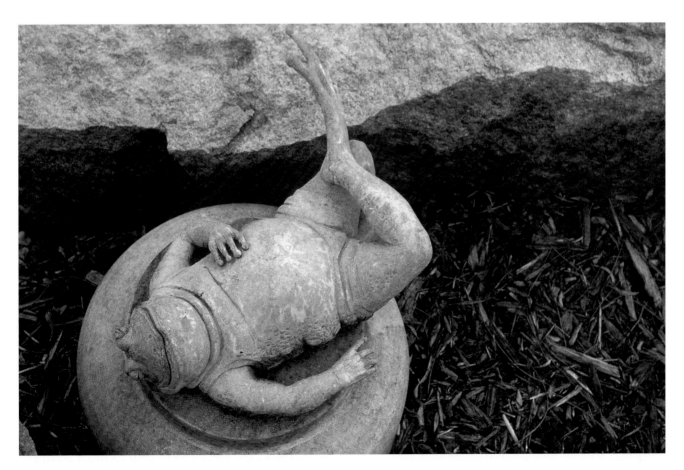

White River Gardens sports several comical frogs designed by Eric Ernstberger and executed by Jan Martin.

geological and historical story of limestone. Carvers from the Bybee Stone Company of Ellettsville created a rose window of delicately filigreed stone through which the river beyond may be viewed. Significant structures that have been built of Indiana limestone are depicted in relief: the National Cathedral, the Empire State Building, and the Indiana State Capitol.[121]

White River Gardens, designed by Rundell Ernstberger Associates, opened in 1999 adjacent to the zoo and is filled with a variety of sculpture. Bloomington sculptor Dale Enochs (b. 1952) created the twelve-foot *Earth Stone,* the centerpiece of the gardens, an intricately carved piece that, indeed, evokes the earth and neolithic artifacts. He has also created seven "water tables," whose jagged, meandering carvings cause the water that bubbles over the top to sparkle and dance. Some forty sculptural stones are placed throughout the gardens, and Enochs has carved images in a hundred individual limestone bricks, some enhanced with designs of copper or bronze. Amy Brier (b. 1960), another Bloomington artist who works with limestone, created an interactive sculpture called *The Four Seasons.* Four separate stone balls, fourteen inches in diameter, are each carved with natural images representative of one of the seasons. There are four pedestals, three of which are occupied with the stone spheres that are not in season. In the center of the space on a pedestal is a basin filled with sand, in which the sphere that is in season can be rolled by visitors to make imprints. Based on designs by Eric Ernstberger, Indianapolis sculptor Jan Martin fashioned fourteen different comical creatures in anthropomorphic poses, some duplicated, for a total of forty-nine animals scattered about the gardens. A laid-back frog spews water into a pool while a heron does the backstroke in another, and a trio of companionable ducks stroll by, deeply immersed in conversation. There are tortoises jigging for joy, presumably celebrating their victory over the woeful hare, panting with exhaustion. Martin also fashioned two huge stainless steel leaves for the outside of the conser-

vatory and four windmill-like towers twenty-five feet high.[122]

A lovely bronze figure called *Eve* stands in a rehabilitated fountain behind the Ball Residence Hall in the 1200 block of West Michigan Street, now part of the campus of Indiana University–Purdue University Indianapolis (IUPUI). Indianapolis sculptor Robert Davidson (1904–1982) made the nude figure while working in a bronze foundry in Munich in the early 1930s. The Alumni Association of the Indiana University Training School for Nurses purchased the statue as a gift to the school for a planned fountain and sunken gardens. The statue was installed about 1937.

In 1976 two faculty members of the Herron School of Art each created a piece for the campus outside the Lecture Hall. David Freeman (b. 1937), who was born in Kansas and came to Herron to head the sculpture department in 1968, produced a small steel piece called *Broken Walrus I* in 1976. The work is presently in storage. Florence-born Adolfo Doddoli's untitled limestone work, installed the same year, suggests a giant clam that has been petrified. About two years later Yale sculptor David Von Schlegell (1920–1992) created his untitled work for the Main Quad in front of what was then the University Library, but today is University College, the student activities center. A geometric abstract, the piece consists of three huge right angles fabricated of stainless steel, each fifty-five feet high with a thirty-foot leg resting along the ground. The Herron School of Art recently moved into its new building (the former law school, completely remodeled) and boasts not one, but two sculpture gardens that will ultimately include some permanent installations as well as temporary exhibits. Anticipated for the front of the building is a twenty-foot-high painted aluminum abstract by Herron alumnus James Wille Faust. The University College sponsors the Showcase of Art, which gives Herron students and alumni the opportunity to propose and create sculptures to place around or in its building, the pieces to remain in place for three years. Since the late 1990s the IUPUI Campus Arts

Garry Bibbs created this large abstract called *Glory*, which recalls the office building's former identity as the Second Baptist Church.

Committee in a separate competition has called for submissions from which to choose outdoor sculptures for display on campus. The pieces are exhibited for two years, and the artists receive an honorarium.[123]

Immediately east of the university at 422 West Michigan Street is the former Second Baptist Church, which has been remodeled into an office building. Above its west entrance is a large and exuberant figurative abstract in stainless steel and bronze called *Glory*, the work of sculptor Garry Bibbs, who teaches at the University of Kentucky in Lexington. Installed in 1999, the piece speaks to the building's past use, with images of angels and the trumpets of Gabriel—or are they from the long-

gone jazz clubs of nearby Indiana Avenue? In front of the entrance is a limestone work by Dale Enochs called *Table of Contents,* a platform of limestone on which four different geometric solids are placed in a harmonious composition.[124]

Artist John Spaulding (1942–2004) was born in Lockefield Gardens, a beautifully designed public housing project constructed along Indiana Avenue in 1938 through the auspices of the Public Works Administration (PWA). Most of the buildings in Lockefield Gardens were demolished in 1983 as part of a controversial revitalization project. New apartment buildings were built adjacent to the seven surviving original buildings, forming a new complex. In

Saxophones, trumpets, and other instruments now make a joyful noise in this fountain at the entrance to the Lockefield Gardens Apartments.

Sculpture is everywhere—look up! This history-themed relief by Adolf Wolter is on a former bank building in the 100 block of East Market Street.

1989 at the south entrance of the new Lockefield, Spaulding created a joyful work comprised of parts of brass instruments: saxophones, trumpets, trombones, and others all welded into a column in the middle of a fountain called *Jammin' on the Avenue*. It celebrates Indiana Avenue's jazz heritage from the early 1900s until well into the 1960s, where this vibrant music spilled out of the many clubs along the Avenue. A few years later Spaulding completed another piece in homage to the neighborhood's musical history. On West Street, across from the famed Walker Theater, is a highly stylized jazz combo, a quintet of musicians reduced to the simplest lines and fashioned from steel.[125]

Up Indiana Avenue at the edge of the complex of hospitals along Tenth Street is a small park dedicated to cancer survivors. It is dominated by an unusual sculpture, dedicated in 1995, called *Cancer . . . There's Hope*, the last work of artist Victor Salmones (1937–1989). The work depicts several people of different ages going through a series of

doorways. Those who are entering are careworn and troubled, while those that emerge appear light-hearted and energetic.[126]

Turning back to the downtown area, a number of buildings feature significant examples of architectural sculpture. The entrance and cornice decorations on the Old Trails Building on West Washington Street show an influence of art deco overlaid with Native American motifs. The polychrome terra cotta was the work of Joseph Posey of the Indianapolis Terra Cotta Company, located in Brightwood on the city's northeast side. Designed by architects Pierre and Wright, the building was constructed in 1928. Completed in 1924, the Test Building on the Circle, designed by one of the city's premier architectural firms, Rubush and Hunter, is decorated with limestone reliefs depicting modern transportation of the day—a biplane, a dirigible, an automobile—and two local landmarks, the Soldiers and Sailors Monument and the statehouse. In 1955 Adolph Gustav Wolter created a large cast-aluminum relief portraying a collage of Indiana history that was installed above the entrance of 120 East Market Street, then a bank.

Much of the ornamentation on surviving early twentieth-century buildings downtown is the work of the terra cotta master Alexander Sangernebo (1856–1930), from the lavish Spanish baroque facade of the Indiana Theater built in 1927, with its portrait medallions of Ferdinand and Isabella, to his more restrained classical frieze of Grecian figures across the facade of the Circle Theater (1916). Both buildings, on Washington Street and Monument Circle, respectively, were designed by Rubush and Hunter. Outside of downtown, Sangernebo fashioned whimsical little monks that sit reading books above the entrance to the East Washington Library at Rural Street. The charming building was constructed in 1909. The former Indianapolis Public School No. 45 at 2315 North Park Avenue features early terra cotta work likely by Sangernebo, including a fully modeled head of Athena above the entrance. Among Sangernebo's limestone works that survive are two large eagles that once ornamented

the roofline of the Traction Terminal at Illinois and Market streets built in 1904. When the structure was demolished in 1968, the eagles were rescued and moved to the entrance of the former city hall on Alabama Street, which served for over thirty years as the Indiana State Museum. The museum moved west into its new building in White River State Park, but the eagles remained. Although not verified, the four limestone eagles that guard the Rink Building at 401 North Illinois are likely Sangernebo's work.

A downtown sculpture that is seasonal, but worth mentioning because of its pedigree, is the Ayres Cherub, a fat little bronze angel that perches on the old Ayres clock at the corner of Washington and Meridian streets during the Christmas season. David K. Rubins created the half-ton piece in 1947, basing the design on a drawing that the store was using in its holiday advertising. The Ayres department stores were purchased by an out-of-town company in the late 1980s. The downtown flagship store was closed in 1992, and eventually the space was remodeled into part of the Circle Centre Mall. The cherub was missing for a year, but the company donated it back to the city and the tradition continues.

Outside the Indiana Convention Center near the corner of West and Maryland streets is a large beautifully rendered bronze lion about twelve feet long. It was purchased in 2000 and erected shortly after.

In a landscaped area adjacent to the vastly remodeled Faris Building on what was once South Meridian Street is a stunning piece by Don Gummer (b. 1946), who grew up in Indianapolis. Installed in fall 2004, *Southern Circle,* of stainless steel and stained glass, is twenty-five feet high.

Installed in 1987 at the Capital Center in the 200 block of North Illinois Street are two once-controversial bronze works by Zenos Frudakis (b. 1951), a Philadelphia artist who was raised in Gary. *Reaching* consists of two nude figures, male and female, in twisted positions almost as if leaping or falling, mounted on separate poles. As the wind moves the figures, they seem to alternately reach for and turn away from each other. Around the corner on the building's south side is *Flying,* a male figure

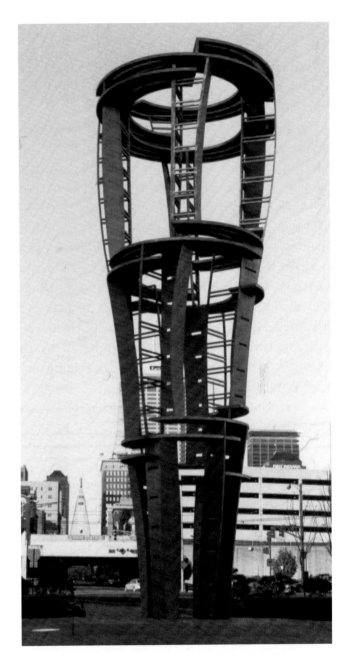

In 2004 artist Don Gummer returned to Indianapolis, where he was reared, to erect *Southern Circle* just south of downtown.

reaching upward as if, indeed, he is expecting to fly.

In the open courtyard of the AUL (now One America) Building at Illinois and Ohio streets is a polished limestone piece called *Unity of Life,* actually a model for a larger work that was never made, by David L. Rodgers, formerly of Bloomington. The model, dating to about 1983, was kept in storage for several years before it was decided to display the piece in the courtyard. Also in the courtyard are

four bronze stylized classical musicians (a pianist, a horn player, a violinist, and a cellist), mounted on limestone blocks of varying heights, created by Mike Cunningham. They were installed in early 1984, not long after the building opened.

English-born Henry Saunders carved large allegorical figures of Progress and Commerce, along with Mercury, for the top of the Indiana National Bank at Virginia Avenue and Pennsylvania Street in 1897. The venerable structure was demolished after the new INB Tower was completed two blocks north in 1969, but the statue group was rescued and placed in the plaza north of the new building, where today it endures a lingering demise from neglect and vandalism. Saunders also likely was the artist who carved the faces and characters in the limestone trim on the Blacherne, an early downtown apartment building at 402 North Meridian Street, which was owned by the author and Civil War general Lew Wallace.

In Jefferson Plaza, created at Virginia Avenue and Pennsylvania Street after the old Indiana National Bank was demolished, a fifteen-foot bronze fountain sculpture, *Obos,* was installed in 1971, the work of Seattle artist George Tsutakawa (1910–1997). The word is Tibetan, referring to an Oriental custom of building folk monuments as an offertory gesture. *Quaestio Librae,* which translates to "A Question of Balance," is a monumental work of painted steel erected in 1975 at the southeast corner of the City-County Building plaza along Washington Street. The work, nine rectangular solids attached at angles to one another, was created by Jerry Dane Sanders (b. 1949), who taught art at Warren Central High School.

Pairs of huge seated allegorical figures in limestone flank the main entrances on the south side of the old Federal Building, completed in 1906. The work of noted Scottish-born sculptor John Massey Rhind (1860–1936), Industry and Agriculture guard the westernmost entrance and Literature and Justice, the east. The building originally housed a post office, and in 1938 an extension was added on the north, which included large truck entrances for mail delivery. Above each entrance are reliefs by David K. Rubins. At first glance they appear to be simply art deco designs, but

a longer look reveals stylized mail pouches with letters spilling out, as well as sheaves of grain and other references to the allegorical figures on the opposite end of the building.

Standing in University Park is the statue of Schuyler Colfax (1823–1885), the first large commission of Illinois sculptor Lorado Taft (1860–1936). Colfax, who was vice president under Ulysses S. Grant, was raised in Saint Joseph County in northern Indiana. The statue was funded by the International Order of Oddfellows in 1887 and placed in the center of the square. In the mid-1910s the park was reconfigured and the statue was moved to create a setting for the Depew Memorial Fountain, designed by Austrian-born Karl Bitter (1867–1915), who died in a traffic accident in New York before his designs could be executed. A. Stirling Calder (1870–1945) took over the project, making only a few changes, the result of which is the joyous creation unveiled in 1919. A ring of romping children circles a pedestal in the center of the fountain, on which perches a wildly dancing female figure, clashing a pair of cymbals. Various fish spew water in the fountain pool. Some locals found the work controversial as the children were very scantily clad, but happily, the fountain remained. After some decades and eventual neglect, the fountain was restored. In 1923 Indianapolis sculptor Myra Reynolds Richards (1882–1934), head of the sculpture department at Herron School of Art, fashioned two small bronze statues on pedestals that included drinking fountains, on the west and east sides of the fountain. One was a figure of Pan, the other a companion nymph, or Syrinx. *Syrinx* disappeared in 1959, *Pan* about 1970. The parks department in 1973 commissioned Adolph Gustav Wolter to create replacements, which were of his own design, not replicas of Richards's work. The lovely *Syrinx* he fashioned is still in place, although the pedestal is a newer version and does not contain a drinking fountain. Nor does the pedestal for *Pan,* which is not Wolter's *Pan,* for it was stolen only a few years after it was installed. Sculptor Roger White (b. 1929) was commissioned to create a third *Pan* in 1980. This piece has been vandalized and severely damaged numerous times, and the present

Jerry Dane Sanders created *Quaestio Librae* ("A Question of Balance") for the City-County Building plaza in 1975.

Pan has a different look than White's original version. At this writing, *Pan* has once again been stolen.

Another statue on the south edge of the park faces New York Street. More than ten feet high, it is the image of Benjamin Harrison, the twenty-third president of the United States, by New York sculptor Charles Niehaus (1855–1935). The monument, erected in 1908, honors Indiana's favorite son, who ran his presidential campaign from the front porch of his house, still standing on North Delaware Street. To the east of the Harrison statue is a heroic depiction of Abraham Lincoln, seated on a hefty chair decorated with fringe. The beauty of the work lies in the little details, such as Lincoln's gloves resting on his stovepipe hat behind the chair. The work of New York sculptor Henry Hering (1874–1949), it was completed in 1934 and dedicated the following year. Hering had already done a massive amount of work in Indianapolis on the World War Memorial begun in 1927. The Cleveland architectural firm of Walker and Weeks designed the building, but Hering did all the major sculpture on and adjacent to it. Most notable are the six heroic limestone statues above the colonnade that appear on all four sides. Completed in 1928, the allegorical figures represent Courage, Memory, Peace, Victory, Liberty, and Patriotism. The following year Hering completed his massive *Pro Patria,* a twenty-four-foot bronze casting of an ideal youth, strategically enfolded in the American flag, which stands on the landing in front of the south entrance. Across Michigan Street to the north is Obelisk Square, centering on a granite shaft rising a hundred feet. Near the base on each of the four sides are bronze reliefs by Hering, completed in 1930. The allegorical figures on the tablets represent Religion, Law, Science, and Education.

At the east and south entrances of the magnificent Scottish Rite Cathedral in the 600 block of North Meridian Street, designed by architect George Schreiber and completed in 1929, are several sculpted limestone figures. They are historical

COLFAX MONUMENT, INDIANAPOLIS, IND.

The monument to Schuyler Colfax by Lorado Taft was the only statue in University Park in the late nineteenth century.

and biblical personages relevant to Masonic tradition, carved by John Baugh and others from the Bybee Stone Company of Ellettsville.

The entrances to the former Turnverein building at 902 North Meridian Street are decorated with caricatured athletes carved in limestone, appropriate for its original use as a gymnastics club in 1913. Designed by Swiss-born architect Adolph Scherrer (1847–1925), the building was rehabilitated into apartments in the 1980s. Just two blocks to the west at 902 North Capitol Avenue is *Structure Man,* a legitimate sculpture that also happens to hold the logo (a stylized *S*) for the company that occupies the building. The abstracted steel figure, who has a giant lunch box at his feet, was designed by David Jemerson Young and erected in 2000 by the Shiel Sexton Company.[127]

Arts, Sciences, Letters by German-born Richard W. Bock (1865–1949) is a large bronze allegorical sculpture group created in 1892 for the top of the library building (later the headquarters for Indianapolis Public Schools) that once stood downtown on Meridian Street at Ohio Street. When the building was torn down, the sculpture was salvaged and moved to Crown Hill Cemetery. In 1981 the piece, beginning to qualify for frequent traveler miles, was erected on the west side of the Indianapolis–Marion County Public Library in the 800 block of Meridian Street. It went into storage while the library undergoes its huge expansion.

On the east and west facades of a row house building originally called Tuttle Terrace, built about 1904 at Eleventh and Alabama streets, are two virtually identical relief panels depicting Apollo in his chariot drawn by fiery steeds and the Three Graces in the foreground. The panels are probably terra cotta but are covered with so many layers of paint that the material cannot be verified.

Since 1997 a ten-foot-high aluminum abstract has graced the sidewalk in front of a framing shop

Exuberant children romp around a pedestal topped by a woman dancing for joy on the Depew Memorial Fountain in University Park (opposite page).

in the 600 block of North Delaware Street. The owner of the business, Scott Westphal, created *Iris,* composed of three gently curving upright elements. A few blocks to the south, at the foot of Massachusetts Avenue at Delaware and New York streets, is a piece that helps to identify the avenue as an arts district, where there are many galleries, theaters, restaurants, and arts-related shops. In a competition, local artist Eric Nordgulen (b. 1959) won the commission for *Viewfinders,* installed in 1996 on a small traffic island in the intersection. Three twelve-foot abstract figures of glass and aluminum reflect light during the day and shine at night. Farther up the avenue, Dale Enochs created an evocative work of limestone topped with a bronze phoenix for the Indianapolis Firefighters Memorial in 1996. It occupies a small plaza outside the Firefighters Museum. In the triangular space on the other side of the museum, which is located in an 1890s fire station, another firefighter-related work is contemplated. Since 1999, Bloomington artist Jerald Jacquard's piece, *Visual and Mental Paradoxes,* has stood between Blake Street and Massachusetts Avenue near the point of the triangle. The Murat Shrine (formerly, Murat Temple) at North and New Jersey streets displays an eight-foot fiberglass figure of a Shriner holding a child with a crutch. Modeled by Fred Guentart, the statue was erected in 2001.[128] Massachusetts Avenue began in 2003 to sponsor annual competitions for public sculpture to be exhibited at several locations in the district for approximately ten months. One of these temporary installations was made permanent through a grant from the city in the fall of 2004. Indianapolis artist James Tyler's piece, *Brick Head 3,* is a huge head composed of more than five hundred handmade bricks that sits in Davian Park. The sculpture emits electronically produced sounds.

To the south, a bust of James Whitcomb Riley graces the outside of the Riley Home on Lockerbie Street in the Lockerbie Square Historic District on the east edge of downtown. Myra Reynolds Richards modeled the piece from life in 1916, the year the poet died. Richards later did a full figure of

Riley for the courthouse square in Greenfield, where Riley was born. The bust, which had been displayed inside Riley's Lockerbie home, was relocated to its present site in the side yard in 1993.

Farther east, Woodruff Place, platted in 1872 and incorporated as a town four years later, is a nineteenth-century suburban dream. James O. Woodruff planned for a parklike atmosphere distant from the noise and crowding of downtown, seemingly so far away. Consisting of six oversize blocks, Woodruff Place originally was entered from the north or south through ornate entrances, and its esplanades were filled with cast-iron urns and statuary, as well as some of stone or concrete. The life-size lions in a variety of poses were a particular delight. Three large multitiered fountains stood in Cross Drive at its intersection with the other three drives, and six smaller fountains were placed in the esplanades. Over time most of the statuary disappeared, either through theft or neglect. Eventually, the fountains became a traffic hazard and were removed. In 1962 Indianapolis, which had grown well beyond Woodruff Place decades before, annexed the town. The seeds of a renaissance were soon planted, and the first of the restorations of the three big fountains took place in the late 1970s. Today Woodruff Place is once again filled with garden pieces typical of the late nineteenth century, and all nine of the fountains have returned to life. Nearby, in front of Marian Inc. at 1011 East St. Clair Street is a stylized bronze bear, roughly life-size, by Canadian-born sculptor Tim Cherry (b. 1965). It was installed in 2003.

On the west side of 748 East Bates Street, which had once been a public school and is now an office building, are three realistic life-size figures of plastic resin, created by Scott O'Hara. Installed in 1990, they portray an 1890s policeman, a newsboy hawking papers, and a man seated on a bench reading a newspaper.

In the west gable of the Southside Turnverein on Prospect Street just east of Madison Avenue is a heroic allegorical relief, nearly full round, completed in 1900. The terra cotta work has been attributed to Rudolf Schwarz, although he would

have been working on the Soldiers and Sailors Monument at the time. A more likely candidate might be Alexander Sangernebo, who was already recognized for his work in terra cotta as well as other architectural sculpture. Both Sangernebo and Schwarz were members of the Turnverein in Das Deutsch Haus (Athenaeum) on the north side.

A few blocks south on Madison Avenue is Hendricks Park, created in the fall of 2002. Although very small, the park's plans included a contemporary sculpture. *Play*, a curvilinear painted steel piece by Lars Jonker of the nearby Wheeler Arts Community, was vandalized almost immediately after its installation but has since been restored.

A grimly determined *Pioneer Family* stands above the fountain at the intersection of three streets in the Fountain Square neighborhood of Indianapolis. It is neither the original statue nor the original fountain basin for which the square—more of a triangle, really—was named. The first statue was a classically inspired cast-iron figure, very likely ordered out of one of several catalogs available in the late nineteenth century. Its pedestal included light fixtures as well as lower basins out of which animals could drink. In the 1920s Myra Reynolds Richards was commissioned to create a new fountain and a sculpture to top it. Her bronze *Pioneer Family*, with a slate and marble pedestal, was dedicated in 1924. When the fountain was deemed a traffic hazard in the early 1950s, it was removed and the statue was placed in the conservatory in Garfield Park. In 1969 a newly formed community group led a successful effort to restore the fountain as a symbol for the south-side neighborhood. The fountain was reinstalled and rededicated in 1980.

After well over a hundred years, the park named for President James A. Garfield (1831–1881) following his assassination acquired a statue of him. Carved by Chie Kramer of Lawrence from a felled sycamore tree, the twelve-foot statue was erected in front of the recreation center in Garfield Park in 2002. But nearly a century earlier, Major General Henry W. Lawton (1843–1899) found a new home in this lovely place. In 1906 Andrew O'Connor (1874–1941) created a bronze statue of the Civil War hero, who was later killed in the

The Pioneer Family **by Myra Reynolds Richards, like its human counterpart, has moved a great deal.**

Philippines. The following year, with President Theodore Roosevelt present, the eight-foot statue was erected at the southwest corner of the courthouse square. The statue was fairly close to the street and soon proved to be a hazard for the growing automobile traffic downtown. It was moved to Garfield Park in 1915. A secluded corner of the park once displayed a bronze head of Lucius B. Swift (1844–1929), a local civic leader, attorney, and crusader for civil service reform. Modeled by Indianapolis artist Robert Davidson and erected in 1933, it was stolen decades ago.[129]

Turning back to the near north side, Rudolf Schwarz carved five portrait medallions in limestone for the facade of the former John Herron School of Art building (later Herron Gallery) completed in 1906, which was designed by architects Vonnegut and Bohn. Each medallion is a little more than four feet in diameter. The portraits are of the artists Rubens, daVinci, Dürer, Michelangelo, and Velasquez. The annex to the north of Herron was built in 1929 and designed by Paul Phillippe Cret (1876–1945). Noted classical and art deco sculptor

Carl Paul Jennewein (1890–1978) created three terra cotta reliefs for the building in a transitional style between the two. Allegorical figures of Painting and Sculpture are duplicated, as is a smaller ornamental panel depicting several artists' tools.

About six blocks to the east is an unusual monument commemorating Robert F. Kennedy and Dr. Martin Luther King Jr. Kennedy came to Indianapolis during his presidential campaign in spring 1968 and was scheduled to speak in an African American neighborhood. Before his speech, he was informed of King's assassination in Memphis, and it fell to Kennedy to inform the crowd. His poignant

Lawton Monument, Indianapolis, Ind.
Dedicated by Pres. Roosevelt, May 30th, 1907

The statue of Henry W. Lawton stood in its original setting at the Marion County Courthouse for less than ten years before it was moved to Garfield Park.

words calling for peace are widely believed to have helped Indianapolis avoid the frustrated violence that took place in other large cities around the nation that night. *A Landmark for Peace,* designed by local artist Greg Perry and executed by Dan Edwards, depicts the figures of Kennedy and King each emerging from a wall and reaching across the space between them. The powerful work was erected in 1995 at Seventeenth Street and Park Avenue.[130]

Local sculptor Gary Freeman (b. 1937), who headed the sculpture department at Herron for many years, created *For Endless Trees IV* for the offices of the Indiana Gas Company at 1600 North Meridian Street in 1991. The piece, indeed, is a geometric abstraction of four trees. Three blocks farther north is a representational piece, a life-size boy scout in bronze, a work by R. Tate McKenzie (1876–1938). The original sculpture was created in

1937 in Philadelphia. This is a reproduction installed in 1990 outside the state headquarters of the Boy Scouts of America.

The former Perry Stadium on West Sixteenth Street, which became Victory Field during World War II and later was renamed Bush Stadium, was built in 1931, designed by noted architects Pierre and Wright. Much influenced by the art-deco style are several limestone relief panels on the outside of the stadium that feature stylized baseball players. They are the work of Italian-born sculptor August A. Marchetti (1887–1944).

At 1250 West Sixteenth Street, not far from the stadium, is a figure perhaps classified more properly as roadside architecture than sculpture, but one that has become a familiar local landmark after more than forty years. One of the many figures created by International Fiberglass of Venice, California, in the 1960s, Mr. Bendo looms in front of Ralph's Muffler

Beniamano Bufano's sleek fat cat is a touchable delight outside the Children's Museum.

and Brake Shop. More than twenty feet high, the figure's intended identity was that of Paul Bunyan, the company's most popular statue. (One still stands in front of a hardware store in Elkhart.) Aging fiberglass attention grabbers such as Mr. Bendo have gained legions of fans in recent years.

The Children's Museum, which continues to grow, displays a collection of outdoor sculpture that is of and for children. Most recently, an exciting sculpture was installed on the outside of the museum's new Dinosphere exhibit. Canadian artist Brian Cooley (b. 1956), who specializes in creating these creatures of another time, fashioned a full-size alamosaurus and two juveniles as if they were breaking out of the building. The largest project of Cooley's career to date, the huge sculpture was modeled of plasticine over a steel and mesh armature, then cast in fiberglass at his studio in Calgary, Alberta. Alas for poor *Rex,* a thirty-foot-long fiberglass tyrannosaurus rex made in Chicago, who started out inside the museum as part of a display on dinosaurs in 1976. After one of the museum's many remodelings, *Rex* was placed outside, no doubt to the delight of many children, but years of weather and wear took their toll. But another fiberglass dinosaur, *Spike,* the ankylosaurus, created about 1985 by museum employee Alex Black, remains on the property. About 1984, a troop of boy scouts erected a totem pole on the grounds. The west side of the museum has several sculptures, many of which are regularly climbed upon by young visitors. Beniamano Bufano's silky granite art deco creations are irresistible. His delightfully complacent *Cat*; *Penguin's Prayer*, depicting a sleek penguin with her two babies at her feet; and *Snail* were created in the 1930s and acquired by the museum in the 1980s. Fortunately, granite is virtually impervious to both weather and clambering. A small sphinx, shown at three stages—the limestone block straight out of the quarry, the roughed out shape, and the final detailed sculpture—visually demonstrates the art of stone carving. John O'Brien, James Saladee, and Frank Arena—three fabled stone carvers from the Bedford area—created the pieces in 1983. New Mexico

sculptor Glenna Goodacre (b. 1939) captured in bronze the essence of active children at play in *Tug of War*, erected outside the museum in 1991. A second Goodacre piece, *Olympic Wannabees,* which shows a group of children showing off, doing handstands and similar feats, was installed at the entrance along Illinois Street in 1997, but was moved to Festival Park closer to the building to make room for a pedestrian bridge from the new parking garage across the street. Utah sculptor Gary Price (b. 1955) has created numerous pieces depicting the forgotten joys of childhood. His *Storytime,* created in 1993, was placed on display not far from the *Tug of War* figures in 1996. It portrays a boy and a girl, sitting back to back, each engrossed in a book. It should be noted that inside the museum, in an office not open to the public, are four former outdoor sculptures, architectural pieces that once graced the Maennerchor Building at Illinois and Michigan streets, demolished in 1974. The four medieval elfin musicians each emerge from a bracket and each plays a different instrument. They were carved in 1906 by Henry Saunders.[131]

Just west of the museum along Thirtieth Street in front of Fire Station 14 is *Firefighter,* a very contemporary piece comprised of bronze plates shaped like houses and trees that all together form a figure, suggesting the ties with the neighborhood. Erected in 2004, it is the design of Jeff Laramore of 2nd Globe.

Shortridge High School (today a middle school) opened on North Meridian Street in 1929. Local sculptor Robert Davidson, a Shortridge alumnus, was commissioned by the school's art committee to create two relief panels for the front of the building. With the horrors of World War I still fresh in people's minds, Davidson molded allegorical themes of War and Peace in concrete. One panel depicts a Victory figure with classical military figures in the background. The other shows a youth indicating Truth in an open book as he stands on the threshold of the future. In the background are figures representing the arts.

Crown Hill Cemetery, the country's third

largest, was established in 1863 and encompasses over 550 rolling, wooded acres and a wonderful collection of impressive funerary art. Included among the best examples are the beautiful bronze doors of the Holcomb mausoleum, the classical frieze on the Claypool crypt, and the granite Sayles monument from the early twentieth century that features a beautiful angel in high relief standing over a mourning woman. The Duden monument is a huge granite boulder with an exquisite marble statue of a woman kneeling in prayer before it. The themes of angels and women in mourning are interpreted in countless poses and media in Crown Hill. Guarding the Marott tomb, which was built in 1924, are two beautifully rendered fierce lions in different poses. On the grave of Charles Frese is a limestone tree stump more than six feet high, draped with hunting accouterments. Guarding the stump is a life-size dog with a dead duck across its paws. The dog was stolen in 1995 but amazingly was recovered in upstate New York four years later and returned. The stone carvings date to the 1880s.

There are portrait sculptures of the famous and influential, such as the marble bust of Governor Oliver P. Morton atop his grave, and nearby, the bronze visage of Civil War colonel Abel D. Streight (1828–1892) of the Fifty-first Indiana Volunteers. A life-size marble statue of nineteenth-century businessman Henry W. Hildebrand, who died in 1876 at age forty, stands atop an eighteen-foot pedestal. In contrast, there are life-size marble portrait statues of children who never lived to achieve fame, Corliss Randle Ruckle, who died of diphtheria in his twelfth year in 1889, and five-year-old Mary Ella McGinnis, who died in 1875.

Several well-known artists created commemorative pieces at Crown Hill, notably Rudolf Schwarz, who fashioned the lovely and poignant *Woman in Repose* for the small Greek temple that marks the grave of Albertina Allen Forrest. The bronze figure, completed about 1905, depicts a kneeling woman, head resting on outstretched arms and clasped hands holding a palm leaf, seemingly more an attitude of mourning than repose. For the Lilly family,

Mary Ella McGinnis, forever five years old, holds an apron full of posies at Crown Hill Cemetery.

Indianapolis artist David K. Rubins created a heroic classical female with blowing drapery and a shawl that suggests wings. The piece, completed in 1960, stands on a granite pedestal before a huge granite tablet. In 1946 New York artist John Gregory (1879–1958) carved the four sides of a marble block for a monument to Senator Albert J. Beveridge. Each side depicts a different classical figure in a sort of allegorical pageant of Beveridge's life as a politician, author, and orator. A very unusual monument is a twelve-foot bronze abstract comprised of seven upright rectangular solids at various angles with textured planes. The work was created by artist Jeffrey Bratton (1957–1980) and marks his grave. He had fashioned a model of the work before his death, and

his students and parents saw to it that a full-size version was completed as a tribute to him. In a somewhat similar situation, the grave of arts patron Robert D. Beckman Jr., who died in 2001, was topped a few months later with a granite copy of a favorite piece, Georgia Strange's *Do Not Go Gentle.* The Bloomington artist's original work, an abstracted disembodied head, was created in 1996 of alabaster. The lines from the poem by Dylan Thomas from which the sculpture takes its name are carved on the gravestone.

Memorials to groups of the dead are scattered about the cemetery, and some are sculptural. Erected in 1889 in the National Cemetery section is a Grand Army of the Republic monument, topped with an eagle, by local sculptor James F. Needler (1855–1895). In more recent times the Indiana AIDS Memorial, an unusual bronze work by Indianapolis artist Guy R. Grey (b. 1958), remembers those who fell victim to the disease. Dedicated in 2000, the piece depicts a pair of gigantic hands forming a loop reminiscent of a memorial ribbon. It is the first such permanent memorial erected in a cemetery in the United States.[132]

Also standing in various places around the cemetery are three of the original eight classical figures from the old Marion County Courthouse, built in 1873 and demolished in 1960. Ten feet high, the substantial limestone statues represent the Greek goddesses Themis (also called Justice), Demeter, and one that is interpreted as Persephone but is more probably Hebe, the goddess of the hearth and home.

Finally, in front of the mausoleum at Thirty-eighth Street and Clarendon Road is the *Crown Hill Equatorial Sundial,* a sensuous work of polished limestone by sculptor David L. Rodgers. Installed in 1987, the piece is a functioning equatorial sundial, purporting to be the state's largest, standing eight feet high. In 2003, to celebrate the cemetery's 140th anniversary, Crown Hill sponsored the Hoosier Artists Contemporary Sculpture Walk. Ten pieces were chosen to be displayed for eight months in a "sculpture meadow." One of the pieces, Michael B. Wilken's aluminum abstract

Social Attachments, was chosen for permanent placement in The Gallery, an area along a hillside leading to the Thirty-eighth Street underpass, where other sculpture will be displayed on both a permanent and temporary basis. The response to the first competition was so positive that another exhibition was held the next fall.

Washington Township, running from Thirty-eighth Street to the north county line also has a large number of public sculptures. Two institutions raise the tally considerably, the Indianapolis Museum of Art (IMA) and the Indianapolis Art Center. The IMA property was once the estate of Josiah K. Lilly Jr., and numerous pieces of classically inspired sculpture that had been part of the estate grace the planned landscape, including several gardens that were restored in the late 1990s. Among the most notable pieces of this type is *The Three Graces,* a marble reproduction of a well-known classical statue group, probably placed in the 1920s. There are various statues of cherubic children, often clutching flowers or fruits, and a pair of marble entrance posts with the head of Bacchus topping one and a lusty nymph the other. Two statues of Diana, the huntress, date to the days of the estate, one with a deer and the other with a hound. There are even bits of architectural salvage: a few column capitals from the old Indiana National Bank downtown.

Scattered about the grounds are several traditional aesthetic pieces by noted artists. A charming statue that also is a functional sundial—or would be, if the pointer were not missing—is the bronze *Boy with Spider* by Connecticut artist Willard Dryden Paddock (1873–1956), cast in 1916. The spider is also missing. A lovely bronze classical piece by Isadore Konti (1862–1938) of New York stands in the formal garden of the Lilly house, the life-size figures *Nymph and Fawn.* The piece, based on an earlier, smaller marble work by the artist, was originally the centerpiece of a fountain. The art deco-inspired bronze work *Mother and Child,* completed in 1964 by Estonian-born Dora Gordine (1900–1991), is a beautiful, stylized depiction of a mother kneeling to

greet her child. The piece was commissioned by the John Herron Art Museum (now the IMA) with funds from Anton "Tony" and Mary Fendrich Hulman, owners of the Indianapolis Motor Speedway. Indianapolis sculptor David K. Rubins sculpted *Stumbling Man* in plaster in 1968. Eventually it was cast in bronze about 1975. The life-size work has been at different sites around the museum grounds; remarkably lifelike, it is capable of evoking a startled cry if one comes upon it unaware.

The museum has undergone a number of expansions and at this writing is about to complete its largest expansion and remodeling to date. The Hulman Pavilion was added in 1990 and displayed massive bronze doors of abstract design by New York artist Richard Pousette-Dart (1916–1992). The work, called *Cathedral,* was moved inside in 2005 to accommodate changes in the configuration of the buildings. Designed by Stuart O. Dawson, the Sutphin Fountain was dedicated in the fall of 1972 in front of the museum entrance. It is a circular arrangement of alternating blocks over and through which the water jetting upwards from the center pool flows. The original blocks were limestone but were replaced in 1998 with granite, which is less prone to erosion. Seventy feet in diameter overall, the fountain inspired the IMA logo. But the museum's best-known piece is Robert Indiana's *LOVE,* installed originally on the building's main plaza when it opened in 1970. The twelve-foot Cor-Ten steel work has been moved a number of times and has suffered from exposure to the weather, so after more than thirty years it will become an indoor sculpture when the museum's latest round of construction is completed. Indiana, born Robert Clark in 1928, was commissioned by shopping mall magnate Melvin Simon in 1980 to create a set of large three-dimensional numbers from zero to nine. Executed over a period of about three years, the colorful cast-aluminum digits are eight feet high. As planned, after exhibiting the numbers at some of his malls, Simon donated them to the IMA. These pieces, too, have been exhibited in several locations.[133]

George Rickey (1907–2002) is another Indiana-born sculptor with an international reputation represented in the IMA collection. Rickey's kinetic *Two Lines Oblique Down, Variation III,* created in 1970, was acquired in 1975. Its first siting on the museum's main terrace proved disastrous for the piece; however, after storage and repair, a less risky location was found. Rickey's work will now be prominently displayed near the new oval entrance pavilion.

Mark diSuvero's (b. 1933) *Snowplow* is now in its fourth and clearly most appropriate location. The piece met with widespread disdain and ridicule when it was accepted by the city as a gift in 1973. The assemblage, considerably less monumental than other examples of di Suvero's work in Indiana, was originally placed in front of the Convention Center downtown, then moved westward to the headquarters of the White River State Park Commission in the old pump house on West Washington Street. From there it was relocated in 1984 to the city's Department of Parks and Recreation offices on West Thirtieth Street, several miles from downtown. Finally, in 1993 the IMA purchased the piece and installed it near the main gate.

Other outdoor works in the IMA collection include the abstract bronze *Two Figures* (1968) by British sculptor Barbara Hepworth (1903–1975) and the iron-and-bronze work *Spaces with Iron,* created in 1972 by New York sculptor Will Horwitt (1934–1985). *La Hermana del Hombre-Boveda* is an intriguing amorphous mass of bronze out of which a sphere appears to be emerging. Set in a fountain, the piece was originally executed in 1963 by Spanish sculptor Pablo Serrano (1910–1985). Another oddly shaped bronze work that is suggestive of a bat is *Ouranos II,* created in 1957 by Hungarian-born Etienne Hajdu (1907–1996). New York artist Sasson Soffer's *East Gate/West Gate,* a piece composed of great loops of stainless steel twenty-four feet high, was completed in 1973 for a temporary exhibition at the museum and later added to the permanent collection. *Scan* (1986) is an installation by controversial New York artist Dennis Oppenheim (b. 1938). Michigan-born John

Torreano (b. 1941) delights in humorous exaggeration. His aluminum *Mega-Gem* (1997) is just that. Fashioned to resemble a faceted jewel, the piece is more than seven feet high.[134]

Contemporary Indiana artists are included in the IMA collection. Gary Freeman's *Broken Walrus II*, a monumental steel work from the 1970s, originally installed at a far-northside apartment complex, was acquired in 1995. Pennsylvania-born David L. Rodgers no longer lives in Indiana but produced a large body of work in the state during the 1970s and 1980s. His *Memories of Prague*, completed in 1985, is a one-ton three-dimensional Mobius strip.[135]

The lovely green space of the IMA property unfortunately recently has been compromised with the construction of several new parking lots, all of which are to be reconfigured after the present massive construction project is completed in 2005. Across the canal, in what had long been a tangled natural habitat, an art and nature garden is being developed in which visitors will encounter both temporary and permanent installations of outdoor sculpture. For now, the museum's contemporary sculpture collection is placed willy-nilly around the grounds or in storage out of harm's way while the work goes on.

Located on Sixty-seventh Street east of College Avenue, the Indianapolis Art Center (IAC), formerly the Indianapolis Art League, in an ever-expanding program of outreach is developing its Arts Park along White River. Designed by Michael Graves, who created the center's present building in 1996, the park will eventually include more permanent pieces as well as temporary exhibitions and spaces where artists will work. The origins of today's sprawling IAC are in the New Deal, not precisely with the WPA as its publicity suggests, but a similar program.[136] It began in 1934 with art classes taught by William Kaesar in a southside school and relocated in 1975 in Broad Ripple, once the undisputed center for arts activities in the city. *Rondo,* a cruciform steel abstract with geometric shapes by Ruth Medernach, was acquired in 1974 and installed at the new facility when it was completed. In 1979 the Art League, using both public and private funds,

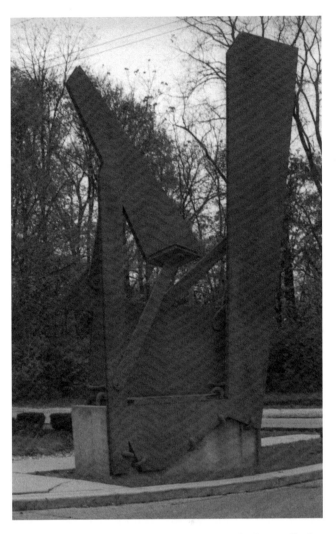

Gary Freeman's *Monumentalment IV* at the Indianapolis Art Center is proof that sculptures do not always stay in one place. The piece has been moved at least twice.

commissioned local sculptor Gary Freeman to create a monumental outdoor work. *Monumentalment IV* was installed in 1981 in front of the building. The piece was moved during an expansion in the mid-1990s and today is located on the west side of the current building. At the west end of the Art Center on the roof of the library are several sail-like elements of fabric over a framework, lit by night with blue neon. Nearly twenty feet across, *Vicarious* is the work of Richmond-born Greg Hull, who teaches at Herron. Indianapolis artist John Spaulding's stunning *Black Titan,* a heroic head of a young black man, was acquired in 1985. The work has been prominently exhibited in the garden area between

the center's building and the river and will be displayed in the Arts Park emerging there. This ambitious project's centerpiece is a massive collaborative work by Robert Stackhouse and his wife Carol Mickett called *Confluence,* an arrangement of Indiana limestone sixty feet long and twelve feet high at its peak. Artists and amateurs were invited to participate in the creation of the piece, which was done entirely on site in summer 2004. Arts Park, opening in 2005, will include numerous other permanent installations as well as temporary exhibits. Among them, installed in 2004, is *Imploding Cube* by Wyoming sculptor John Simms. The steel concave cube, nine feet on a side, is upended and turns on a shaft in the middle of a pond. Michigan artist Sadashi Inuzuka's (b. 1951) *Circle* consists of a large round glass disk set at an angle, sheltering a ring of stone surrounding a center of white sand. The piece includes sound elements and was created with the help of Indianapolis artist Tim Ryan and students from the Indiana School for the Blind, located not far to the north of the Art Center. Fourteen acres comprise Arts Park, and several more permanent pieces are expected. Near the southeast corner of the IAC parking lot on the edge of the Monon Trail, a hiking and biking trail created out of a former railroad right-of-way, is a nine-foot-high abstract steel-and-concrete piece erected in 1996. Created by John Curtis of Chevy Chase, Maryland, in 1981, the work was exhibited in Chicago and Milwaukee before being donated to the IAC. It rests on a chunk of limestone that originally was part of a bridge abutment along the railroad, and the work itself "relates to the iron railroad and . . . matches the muscular theme of the trail," according to Joyce Sommers, executive director of the IAC.[137]

In 1999 Morgan County sculptor C. R. Schiefer created *Faces of Indiana for the Millennium,* more than two thousand individual faces carved on an eleven-ton limestone block. The faces came from drawings, ranging from detailed likenesses to crudely rendered cartoonlike visages, submitted by people from all over the state. Schiefer, who donated his time and skills over several months to finish the piece, began over the Fourth of July weekend in the American Legion Mall and asked observers to draw faces. The huge block, about five feet high and ten feet wide, was then moved to the governor's mansion, where it stood until 2003. The piece then journeyed to a site alongside the Monon Trail, north of Sixty-fourth Street.[138]

Butler University's team mascot has been the bulldog for many years, and in 1996 it was finally carved in stone. Erected outside the Atherton Center is a limestone bulldog, sculpted by Dale Johnson of Columbus, Ohio. On the campus, bordering the canal, are the wonderful Holcomb Gardens, designed in the early 1950s by philanthropist J. I. Holcomb, a

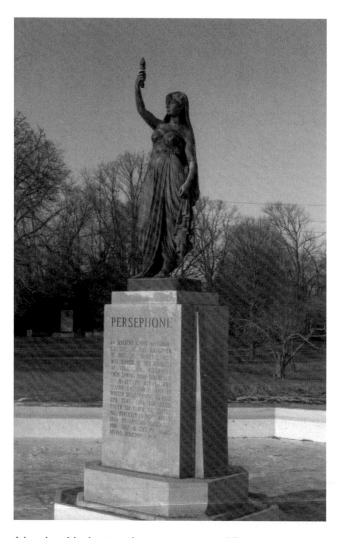

A lovely mid-nineteenth century statue of Persephone is the centerpiece of Butler University's Holcomb Gardens, developed in the early 1950s.

very talented amateur landscape architect, and Arthur Lindberg. The centerpiece of the lower garden is the bronze statue of Persephone, the goddess of spring, by French sculptor Armand Toussaint (1806–1862), sited in the midst of a reflecting pool. The figure dates to about 1840 and was purchased by Holcomb from the Swift estate in Chicago. The statue was erected in its present location in 1950, as was the large bronze portrait mask of Socrates by W. V. Casey.

In Holliday Park is a sculpture within a sculpture. Much of the facade of the Saint Paul Building (1896) in New York, including three heroic figures, *The Races of Man,* by Karl Bitter, was salvaged when the structure was demolished in 1958. The pieces were offered to the city that came up with the best plan to use them. Indianapolis artist Elmer Tafflinger created what is essentially an environmental sculpture known as *The Ruins,* incorporating an area roughly fifty by a hundred yards, with a reflecting pool, plantings, the facade with the Bitter sculptures, a colonnade, and other assorted architectural salvage. The result calls to mind a nineteenth-century contrived Romantic landscape or, in today's world, a post-apocalyptic ruin. Although the statues arrived in the park in the mid-1960s, the setting was not finished until 1978. In the bordering area are two heroic Greek goddesses from the old Marion County Courthouse. They have been so badly vandalized over the years that most of their identifying accouterments are gone.

What began simply as an unorthodox and creative approach to advertising an optical business, *The Glasses* has become a local landmark in Broad Ripple. The brainchild of the Young and Laramore advertising agency, the gargantuan pair of glasses that takes up an entire billboard is assembled of well chosen scrap metal pieces. Erected in 1993, the piece, which continues to undergo periodic change as components are replaced, was designed by Chris Beatty, David Jemerson Young, and Jeff Laramore. The sculptor, with some assistance from Herron students, was David Bellamy. Not long after *The Glasses* was erected, 2nd Globe, a sculpture design company, emerged from Young and Laramore as a sister

organization. On the Guilford Street bridge over the canal in Broad Ripple is the *Turtle,* designed by Young in 2002. The highly stylized piece depicts a pair of upstretched arms holding aloft a turtle, which is a functioning light fixture.[139] On the west wall of the Junior Achievement Education Center in the 7400 block of North Keystone Avenue is Laramore's huge work *Commerce City,* well over thirty feet tall and more than fifty feet long. Installed in 2004, the aluminum piece depicts a stylized cityscape.

Although today they are interior pieces, the stylized *Penguins* within Glendale Mall started life outside. Glendale, built in 1959, was originally a terraced open-air shopping center. The three sleek polished bronze birds gathered around a little ball were created by Kansas City artist Arthur Kraft (1922–1977) and erected in 1960.

At Pickwick Farms, an apartment complex near the Hamilton County line, are six untitled pieces by Art Spellings, erected in the 1970s. All are colorful geometric designs set atop tall poles, perhaps modern interpretations of weather vanes, perhaps influenced by the mobiles and stabiles of Alexander Calder. The developer built another apartment complex across the street and also commissioned sculptures for it. He later sold the property and removed the sculptures, most of which were relocated into Pickwick Farms. These additional pieces include another whimsical piece by Spellings, clearly visible from Interstate 465, called *Tightrope* (also known as *Balancing Act*), which shows two colorful, almost toylike figures, one on a unicycle, the other holding an umbrella. Spellings had just graduated from Herron in 1974 when he received the commission for this piece, erected in 1975. The remaining pieces scattered about Pickwick Farms are all steel abstracts and include works by Charles Hook, Ron Kroll, and Gary Edson, each of whom graduated from Herron in the mid-1970s.[140]

Several blocks east, in front of 350 East Ninety-sixth Street, is a polished aluminum abstract called *Equipoise 14,* the work of Arizona sculptor Lyle London. Dedicated in 1992, its curving shapes may

suggest a porpoise leaping from the sea. To the southeast, along Eighty-sixth Street, is North Central High School, which displays on its grounds an abstract stainless steel work called *Arrows of Direction,* designed by the winner of a student competition, Martina Nehrling (b. 1970), a sophomore at the time. The piece was erected in 1989, in part with a gift of funds from the senior class of that year. The work consists of four pieces of multiple triangles, which have been compared to origami. Indeed, the young artist said she got the idea for the sculpture when she was folding paper into different shapes while babysitting.

Eastward along the county line is the complex known as Keystone at the Crossing. In front of the Sheraton Hotel is one of two castings in Indiana of J. Seward Johnson's (b. 1930) *Crack the Whip,* this one erected in 1986 when the hotel was under different ownership. It depicts eight children, hands gripped tightly, twisting and turning in efforts to knock one another down. About a block to the north is a fifteen-foot steel abstract by Don Robertson, called *Trigonum,* erected about 1979. Continuing eastward, development has been rampant, but a piece erected in 1987 still stands at 8500 Allison Pointe, in the area where there once was a town called Allisonville. By Hoosier-born artist James Wille Faust (b. 1949), the steel abstract, seventeen feet high in a grid pattern set at an angle, bears an eerie resemblance to the wreckage of the World Trade Center destroyed in 2001, an image burned in the minds of all through constantly repeated appearances in print and broadcast programs.

Joe LaMantia is a collaborative artist who works with schools and community groups to help create permanent pieces of public art. Some of these pieces are inside schools and centers, but others are outdoor sculpture. Among the most delightful are two pieces at Spring Mill Elementary School called *Showtime,* featuring stylized circus performers, erected in 1997. In 1998 LaMantia worked with the students of Mary Bryan Elementary School in Southport to create *Time Keeper.* In the courtyard of the Amy Beverland School at Oaklandon in the

northeast corner of the county is a collection of trees made of recycled metal scrap called *Stars Bright,* completed in spring 2000. The following year LaMantia guided the students of Anna Brochhausen Elementary School on East Sixteenth Street in creating *Anna Bee,* a joyous stylized bee outside the school. In 2002 the students of North Wayne Elementary School and community supporters erected *Panther Totem,* which resembles a totem pole and is brightly painted with images reflecting the school and its environs.[141] The IPS Center for Inquiry on North New Jersey Street completed a peace mandala in 2003, and the same year saw the installation of *Exploring Our World* in front of Florence Fay School No. 21 at the convergence of Rural Street and English and Southeastern avenues.

In Pike Township in 1996, LaMantia and the students of Eagle Creek Elementary School created *Peacetime,* in which four painted poles meet over a colorful mosaic, intending to represent the multicultural nature of the school. For the YWCA Community Park on Guion Road, LaMantia and his collaborators from the children's summer camp created in 2000 *Welcoming Garden,* a gateway made of painted steel scrap leading into the vegetable and flower garden maintained on the grounds.[142]

The developers of InTech Park, a technological complex in suburban Pike Township, included a wetland habitat amongst the buildings. In the pond are gigantic frogs of cast resin, a translucent material, which at night are lit from within. Artist Connie Scott of Morristown modeled the frogs, and her husband David cast them. Installed in 1999, the glow-in-the-dark amphibians have unfortunately become targets for vandals.[143]

To the west is Eagle Creek Park. Commemorating its name and the fact that these glorious birds can be seen in the area is a bronze sculpture near the park's north entrance. *Golden Eagle* was dedicated in 1989 as a memorial to philanthropist Samuel Sutphin. The piece portrays an eagle in flight and appears as if the giant bird—its wingspread is over twelve feet—is skimming over the pedestal. Supported at only the tip of the wing, the piece, by

Captured in bronze and so real it looks like the very ones that fly over Eagle Creek Park, Dan Ostermiller's *Golden Eagle* swoops near the north entrance.

Wyoming-born Dan Ostermiller (b. 1956), demonstrates mastery of engineering as well as artistry. On the south side of the park at the Fifty-sixth Street bridge is *Bear*, by local sculptor Matthew Berg. The piece was originally erected in 1999 on the old Washington Street bridge downtown as part of the first year of the *Sculpture in the Park* program. In 2002 the work was donated to Eagle Creek Park. The sculpture, an abstracted framework of a bear, is about twenty-five feet high. Berg also completed a work for the headquarters of Kiwanis International in the College Park area. Dedicated in 2000, *Children of the World* is fashioned of stainless steel and glass. The piece is an open sphere ringed by a line of children

reminiscent of the cutouts made of folded paper.[144]

Among Adolph Wolter's most impressive sculptural achievements is the heroic bronze bust of Louis Chevrolet, cast in 1968, which is the centerpiece of the *Louis Chevrolet Memorial*. The memorial stands in front of the Indianapolis Motor Speedway Hall of Fame Museum. It was completed in 1971 and consists of the bust of Louis Chevrolet (1878–1941) on a pedestal before an exhedra, designed by Fred Wellman, on which are placed four bronze relief panels displaying images of early automobile pioneers and early race cars. North to south, the panels depict Louis Chevrolet in 1911 in the first Chevrolet, with William C. Durant; Tommy Milton in 1921 in a Frontenac, with Captain E. V. "Eddie" Rickenbacker; Gaston Chevrolet in 1920 in a Monroe, with Carl Fisher, James Allison, Lem Trotter, and T. E. "Pop" Myers; and Henry Ford in 1923 in a B-W Fronty-Ford, with Barney Oldfield, Louis Chevrolet, and Harvey Firestone.

Near Mann Road on the city's southwest side is an astonishing sight, visible from nearby Interstate 465. A huge carousel horse, constructed entirely of old car parts, stands in a field behind the Horizons Apartments. Twenty feet high, the work is that of Florida sculptor Robert Shinn. It was completed in 1999.[145]

In 1906 a new bridge was constructed taking East Thirtieth Street over Fall Creek. Local sculptor William Kriner was commissioned to carve a pair of limestone mermaids to flank the center pier of the bridge, which would be visible only from the river's edge or the stream itself. The lovely bridge was demolished in 1959, but the contractor, A. T. Gravelie, could not bear to destroy the mermaids, so he stored them for years at his business, first on Massachusetts Avenue, later on Sumner Avenue, near a gravel pit. After Gravelie died, the figures were relocated to McFarland Road, next to the home of his son. There they sat, patiently waiting for their next move, which came about ten years later. The mermaids now occupy part of a lot along South Madison Avenue, south of Interstate 465—their fifth

location. Each of the eight-foot figures, virtually identical, holds a shell to her ear, perhaps receiving directions for the next move.

Although it is only an advertising icon made of fiberglass, the twenty-foot-high Crossroads cougar is a southside landmark. Sources at the automobile dealership on South US 31 differ as whether the big cat arrived in 1973 or earlier, but it was the only cougar erected in Indiana, and only a few were constructed in other parts of the country, most likely by the California company International Fiberglass. For years the feline perched atop the showroom building but was removed during a major remodeling in the late 1990s and reerected on a platform in the car lot.[146]

A few blocks east is the campus of the University of Indianapolis, which has undergone a major expansion and reconfiguration over the last decade. To commemorate the university's centennial in 2002, Indianapolis artist Beverly Stucker Precious (b. 1952) created a monumental abstract sculpture called *Universal Continuum*. Set in a prominent location in front of the Krannert Memorial Library, the piece is nearly eighteen feet high and fashioned of stainless steel and glass.

In the historic suburb of Irvington, founded in the 1870s (annexed to Indianapolis in 1902), there are two busts of author Washington Irving (1783–1859), for whom the former town was named. The original limestone bust stands in front of the George W. Julian School No. 50 (commonly called the Irvington School) on East Washington Street. William Kriner, a local sculptor who had worked on the Soldiers and Sailors Monument, carved the bust in 1936, and it was erected in Irving Circle at Audubon Road and University Avenue. After being severely damaged by vandals in 1943, the piece was removed, repaired, and donated to the school. Its position on the north side of the building has changed a few times, but it has remained essentially in the same area. Irving Circle was without a portrait bust of the author until 1971 when International Harvester (now Navistar), a nearby factory, cast a reproduction from the limestone bust in iron, coated with copper. Far less vulnerable to

vandalism, the piece was erected in the little park that same year. A short distance away on University Avenue is the Marion County Children's Guardian Home, which greatly expanded its facilities in the 1990s. A bronze statue by local artist Ryan Feeney was erected in front of the building in 1998. *Hope* depicts, in a rough-hewn style, two life-size children, arm in arm.[147]

Well east of Irvington along Washington Street is Washington Park Cemetery. Chief among its artistic treasures is the Sanctuary of Memories, now called Mount Vernon Mausoleum, with reliefs in limestone by Adolph Wolter, completed in 1944. Two large panels flank the entrance door: *Spiritual Victory* depicts an angel, and *Resurrection* portrays a classical female figure reaching toward a cluster of butterflies, which are symbolic of resurrection. Above her head is a dove, no doubt representing the Holy Spirit. On the facade of the mausoleum itself is a smaller panel, *Hand of God*, showing a hand enacting benediction. A life-size bronze statue of George Washington, created in Italy by L. Frizzi, was erected about 1955. *Our Little Lamb*, a charming bronze work by sculptors Florence Gray and Mabel Landrum Torrey, was made in the early 1960s, exhibited in Chicago and Indianapolis, and acquired by the cemetery in 1967. It shows a little girl in overalls and head scarf, crouching down to stare almost nose-to-nose into the face of a little lamb. Another cast of the work is in Muncie. A marble sculpture depicting the Four Chaplains, who during World War II went down with their army transport ship after giving up their life jackets to save others, was placed about 1973. The cemetery also contains numerous marble religious figures, such as a heroic Moses holding aloft the Ten Commandments and a life-size Christ bearing the cross. There is also a large fiberglass figure of Christ.

Celadon Trucking Company on the far east side of Indianapolis began a program with the Herron School of Art in 1998 to sponsor a student competition to create outdoor sculptures. The first five were unveiled at the company's annual anniversary celebration in May 1999, and periodically more are

added. The first year the following pieces were installed: *Mankind*, a steel abstract by Cary Chapman, a junior at the time; senior Kristina Estell's *Wood Grids and Aluminum*, an installation of aluminum and cedar; *inMOTION*, a curving abstract in steel by junior Brent Gann; junior Kevin Huff's steel abstract *Truck on a Steek*; and *Pair*, an abstract of copper, steel, wood, and lead by senior Cory Robinson. The following year three pieces were erected. *Terpsichores Polychromed Towers* by senior Rhonda Kearns is comprised of three separate towers of ceramic, glass, and granite, in which viewers see a mosaic with ceramic figures. Fellow senior Donald Mee's work, *Lines in Negative Space*, is an eight-foot steel abstract. Michael Wilken created *Evolutionary Tree* out of fabricated steel. One piece was unveiled in 2001, *Ordered Column*, a twelve-foot tower of cast and fabricated aluminum by J. Craig Riddle, a junior.[148]

Outside the former agricultural center of Oaklandon in the far northeast corner of the county is Veterans Memorial Park, on the south side of State Road 67. In it is William Arnold's *Battle of the Chosin Reservoir*, which depicts a battlefield scene with three life-size figures, all fashioned of wire. One GI crouches to help his fallen buddy, while the third stands guard, looking away as if in horror. The battle took place in Korea in November 1950. Dedicated in 1995, the memorial honors all Korean War veterans.[149]

Religious Sculpture

Marion County, the state's most populous, has many examples of religious sculpture, but proportionately fewer overall than Saint Joseph County or Allen County. Center Township, which encompasses the oldest neighborhoods of Indianapolis, has several examples of religious statuary, most by unknown artisans. An exception is the modern interpretation of Saint Rita (1959) on the church of the same name on Dr. Andrew J. Brown Drive. It was carved in limestone by Father Anthony J. Lauck (1908–2001) of Notre Dame, who was born and raised on the south side of Indianapolis. Next to the elongated figure of the saint are three relief plaques carved with symbols pertinent to the Crucifixion.

The earliest outdoor religious sculpture is the large limestone relief medallion by Joseph Quarmby, *Saint John Pondering the Scriptures*, above the entrance to Saint John Catholic Church on Capitol Avenue, completed in 1871.

Another downtown Catholic church, Saint Mary, dedicated in 1912, has several carved limestone statues and reliefs. Three reliefs in the Gothic-arched tympanums over the triple-door main entrance depict the Nativity, the Crucifixion, and the Ascension. It is uncertain who did these carvings, possibly Alexander Sangernebo, who created a total of twenty-two gargoyles and grotesques in nooks and crannies and eaves all around the building. In ornate niches high on the church are somewhat larger-than-life figures of the Blessed Mother, Saint Henry of Bavaria, and Saint Boniface of Fulda, attributed to William Kriner. The church's urban location has not been kind to the sculptures. In front of the church are two nearly life-size marble statues of Mary and Saint Joseph that arrived in 1970. They were originally at Saint Agnes Academy, a Catholic girls' school, which opened in 1893 and closed in 1969. The statues were made by Mayer and Company of Munich. Vandals toppled these statues in 2003. Fortunately, they were repaired, and the damage is visible only upon a close look. A marble figure of the Sacred Heart of Jesus, also from Saint Agnes Academy, stands in front of the rectory.

The limestone statue atop Roberts Park Methodist Church on Delaware Street is something of a mystery. It is said to be Mary, the mother of Jesus, but this certainly is atypical for a Methodist church, and the figure holds a cross. In any case, the statue, about ten feet tall, dates to the construction of the church in 1876.

Sacred Heart Church, a magnificent building constructed in 1888 to serve a largely German population on the city's near south side, displays a large collection of outdoor religious sculpture. In a niche of the connecting south wing, built in 1890, is a painted figure of the Sacred Heart. The figures of Our Lady of Lourdes and Saint Bernadette, which date to at least 1942, are displayed in front of the

church. Originally they were in a grotto that was built in 1908 on the northwest corner of the church. When the grotto was demolished in 1961, the statues were moved to the present location. That relocation made it necessary to move a statue of Saint Francis of Assisi. The sandstone figure, dating to before 1920, which originally stood on a fieldstone pedestal, was moved several feet to the south in front of the friary. Between the church and the friary is a marble figure of the Sacred Heart of Jesus that came from the Alverna Retreat House on Spring Mill Road, which had been started by the Franciscans in 1960. The house and its grounds were sold to developers in the 1980s, and the statue, purchased by a parishioner, was donated to Sacred Heart Church and erected in 1992. Farther south on Meridian Street is Saint Roch parish, which recently erected a fiberglass figure of the saint, notable for being the only outdoor sculpture of Saint Roch in Indiana. The church, just east of the school on Sumner Avenue, has a small grotto on its eastside.

Saint Joseph–Holy Cross Catholic Cemetery at 2400 South Meridian Street is a beautiful cemetery, hilly and tree-filled, containing a wonderful collection of funerary sculpture, especially from around the turn of the last century. The little brick Saint Joseph Chapel that had been built in 1874 was demolished in the 1990s to make way for a nondescript mausoleum. The chapel displayed a metal figure of Saint Joseph, dating to the nineteenth century, in a niche above the entrance. When the mausoleum was built, the statue of Saint Joseph was inappropriately erected near the corner of the structure. Since the figure had been designed to be in a niche, it leans forward slightly and thus appears to be crooked. Also, the hook that secured it in its niche is now visible on the statue's exposed back. Another life-size metal statue of Saint Joseph, on a limestone base and sheltered by a vaulted roof, stands on the south side of the cemetery and may also date to the nineteenth century. Near the main entrance drive off Meridian Street is a marble Guardian Angel, originally placed inside the Saints Peter and Paul Cathedral on North Meridian

Street. The statue was donated to the cemetery in 1987 when the cathedral's interior was heavily remodeled. About a mile south on Bluff Road is the more recent Calvary Cemetery, which contains several of the religious figures common to modern cemeteries, but also a ten-foot granite Sacred Heart of Jesus, erected about 1960. Concordia Cemetery, at South Meridian Street and Southern Avenue, is the Protestant equivalent of the Catholic cemetery only two blocks to the north and contains a large number of angel figures and other funerary art from the late nineteenth and early twentieth centuries.

Good Shepherd Catholic Church, located where Saint James Church once stood just off Shelby Street, displays a life-size bronze statue of Jesus, the Good Shepherd. Sculpted by local artist Guy Robert

Guy Robert Grey's interpretation of the Good Shepherd stands next to the church of the same name on the south side of Indianapolis.

Grey, it was erected in 1998.[150]

In the town of Beech Grove on the city's southeast side is Our Lady of Grace Monastery, housing the Sisters of Saint Benedict. A concrete statue of Our Lady dating to 1956 stands before the main building. Behind the monastery is a marble statue of the Sacred Heart of Jesus, and a Crucifixion scene with marble figures is in the cemetery. Farther south, Saint Francis Hospital, opened in 1914, has a life-size limestone statue of the saint over its original entrance on Seventeenth Street (Sherman Drive). In front of the hospital's eastward extension, the Saint Francis Medical Arts

One of twelve castings in Indiana, *Spirit of St. Francis* by Sufi Ahmad stands off the entrance drive to Saint Francis Hospital's south campus.

Building at 1500 Albany Street, is a casting of Fort Wayne artist Sufi Ahmad's (b. 1936) *Spirit of Saint Francis* erected in 2002. The heroic bronze figure depicts a kneeling Francis, surrounded by birds.[151] The hospital had opened another campus in the 1990s at South Emerson Avenue and Stop 11, and the same sculpture was installed there in 1997.

Just across Albany Street from the original hospital is the Church of the Holy Name, which in 2004 installed a wonderful bronze figure, *The Welcoming Christ*, the work of Indianapolis artist Guy Grey.

Still standing at what was originally the Disciples of Christ International Headquarters in Irvington is *Somos Unos* ("Created to Be One"), installed in 1981, the work of Michael Dominguez and the Reverend Wayne Selsor. The fourteen-foot Cor-Ten steel abstract is composed of strips suggesting a cross, with arrows pointing upward and a circle, seeming to suggest something of the church's missionary activities as well as the concept of oneness. The church has vacated the building, which is now senior housing. Built in 1941, Our Lady of Lourdes Catholic Church on East Washington Street has a beautifully carved limestone relief in the Gothic-arched tympanum above the main entrance. A heroic figure of Mary, radiating light, seems to be hovering above stylized flowers and is flanked by two kneeling angels. A life-size statue of the Virgin Mary stands east of the entrance.

Saint Therese of the Infant Jesus (commonly known as the Little Flower) Catholic Church on East Thirteenth Street displays a life-size figure, dating to about 1940, of Saint Therese holding a bronze crucifix. Holy Angels Catholic Church, at Twenty-eighth Street and Martin Luther King Drive, is watched over by a guardian angel that dates to about 1910.

Off Fifty-sixth Street, above the main entrance to Cathedral High School (formerly Ladywood Academy) built in 1963, is a life-size figure of Mary. Just to the east is Our Lady of Fatima Retreat

House, which includes a shrine with slightly larger-than-life marble statues made by the Enrico Pandolfine Group of Pietrasanta, Italy, in 1966. Three young children and two sheep stand before the figure of the Immaculate Heart of Mary.

At Bishop Chatard High School at Kessler Boulevard a few blocks west of Keystone Avenue is a slender, stylized heroic marble figure of Mary, wearing a crown and standing on a crescent. The piece, mounted on the wall beside the entrance to the school, is about eleven feet high. The school was built in 1961. Almost due west at Immaculate Heart of Mary Catholic Church at Fifty-seventh Street and Washington Boulevard is a beautifully rendered limestone relief, depicting Our Lady of Fatima. It was carved by Harry Liva of Bedford and dedicated in 1950. Odon native Ira Correll (1873–1964) carved statues of Matthew, Mark, Luke, and John in niches on the four sides of the cantabile of Saint Joan of Arc Catholic Church at Forty-second Street and Central Avenue. The limestone figures are about eight feet high and were completed in 1929.

Indianapolis sculptor Adolph Wolter worked on two entrances of the huge neo-Gothic Second Presbyterian Church built in 1959 on North Meridian Street. (He also did several projects within the building.) The Gothic-arched Door of the Reformer, the main entrance to the church, features above it the life-size figure of a sixteenth-century man holding a Bible, symbolizing Protestant reformers. The Doorway of the Angels on the southwest side leads into the chapel and is flanked by two twelve-foot angel figures.

At the New Hope Group Home on Payne Road is a marble statue of Saint Louise de Marillac, which was originally erected in front of a cottage across from the former Saint Vincent Hospital on North Capitol Avenue, north of Fall Creek Parkway. Saint Louise, a seventeenth-century Frenchwoman, helped found the Daughters of Charity of Saint Vincent de Paul and is the patron saint of social workers. The cottage, long since demolished, was used by the Ladies of Charity, a lay group of women organized to help the nuns in their service to the poor. The statue was removed when Saint Vincent Hospital relocated to its present site at Eighty-sixth Street and Harcourt Road and was given to New Hope in 1989 when the two facilities merged. A life-size bronze figure of Saint Vincent de Paul, dating to 1940, originally stood in front of the old hospital and was moved to its new location on West Eighty-sixth Street in 1971. The figure depicts the saint reaching to a ragged figure that kneels at his feet. Another life-size statue of the saint, this one in marble, was erected in 1983 along Harcourt Road. In this portrayal, Saint Vincent holds an infant cradled in one arm, while his other rests protectively on the shoulder of a little girl. Nearby at the Saint Augustine Home for the Aged an eight-foot limestone statue of Saint Joseph, holding lilies and a carpenter's square, was erected in 1967. In the facility's front yard, as if blessing busy Eighty-sixth Street, is a life-size stone figure of the Sacred Heart of Jesus, also placed in 1967. Next to the nursing home is a Fatima shrine with slightly larger-than-life marble figures, erected about 1977. A little farther west on Eighty-sixth Street is Brebeuf Jesuit College Preparatory School, which displays a bronze statue of Saint Ignatius Loyola (1491–1556), founder of the Society of Jesus (Jesuits). The figure, completed in 1991, is the work of Jack Kreitzer.

The Carmelite Monastery on Cold Spring Road houses a cloistered order, and the sculptures within its walls are not for public view. In a niche on the outside of the convent, however, is a life-size limestone figure of *Sancta Mater Teresia* (Teresa of Avila), carved in 1932 by Elmer Harland (E. H.) Daniels (1905–1986). The saint holds a quill in her hand, and a cherub hovers at her side, holding an arrow. Marian College, farther north on Cold Spring Road, has a life-size figure of a seated Saint Francis of Assisi, surrounded by birds and animals. Dedicated in 1941, the statue is sited within a semicircular colonnade composed of twelve pairs of columns constructed of limestone slabs and mortar, a remnant from the grounds of the James A. Allison mansion that is now part of the campus.[152]

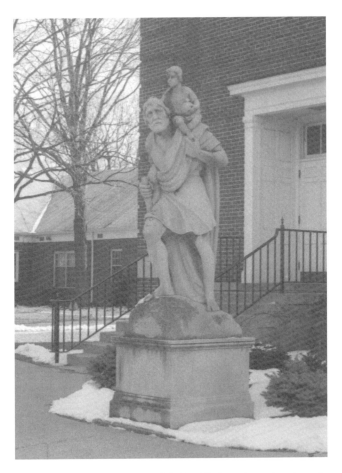

A rare outdoor sculpture of Saint Christopher stands outside the church of the same name in Speedway.

Master stone carver Harry Donato of Bloomington fashioned an eight-foot limestone figure of Saint Christopher, one of only two outdoor statues of the saint in Indiana, in 1941. Erected in front of Saint Christopher Catholic Church in Speedway, the saint is depicted carrying a little boy, traditionally interpreted as the Christ Child, whom he steadies by holding onto the child's foot. In 1983 a parish family commissioned a six-foot limestone statue of Saint Ann (sometimes spelled Anne), the mother of Mary, for the church of the same name on South Holt Road. Henry Morris of the Bybee Stone Company in Ellettsville carved the statue. Much was made of the fact that the saint was portrayed alone, instead of the traditional depiction showing her teaching Mary. However, while such statues are rare, there is another figure of the saint by herself at Saint Mary-of-the-Woods College near Terre Haute, where she is called Saint Anne du Bois.

MARSHALL

Rolling farmland and lakes dominate this region that once belonged to the Potawatomi (alternately, Pottawattomie) Indians before they were forcibly removed by General John Tipton and a company of soldiers. Chief Menominee was the leader of the band of 859 men, women, and children who resisted being taken from their homeland. The tribe's tragic journey to Kansas, on which 150 died, began at Twin Lakes in September 1838 and is immortalized

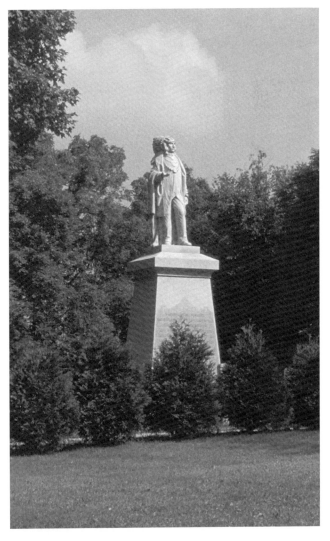

Dedicated in 1909, state funds were allocated to raise this monument near Twin Lakes to Potawatomi Chief Menominee.

as the "Trail of Death." Today a seven-foot granite image of Chief Menominee stands in the vicinity in a small isolated park. The statue was carved by Novelli and Calcagni of Barre, Vermont, with funds appropriated for the purpose by the state, and dedicated on the site in 1909. A local newspaper article claimed in 1936 that this was the "only monument [in the entire country] ever created to a tribe of Indians."[153]

At the courthouse in the county seat of Plymouth is one of six identical replicas of the Statue of Liberty that were part of the "Crusade to Strengthen the Arm of Liberty" in the early 1950s. Purchased through the Boy Scouts, the eight-foot statues were made by a company in Kansas City. Plymouth's little Liberty was erected in 1951. In the town's Oak Hill Cemetery is a World War Memorial with a bronze plaque by Italian-born Pompeo Coppini (1870–1957), dedicated on Decoration Day, May 30, 1925. The plaque depicts the figure of Victory crowning a kneeling warrior with a laurel wreath and is set into a large granite tablet surmounted by a cross. Also in the cemetery is a six-foot figure of the Sacred Heart of Jesus of painted concrete. Dating to the 1930s, it originally stood at the Divine Heart Seminary in Donaldson, which closed in the 1980s.

Still surviving near Donaldson, however, is the Ministry Center of the Poor Handmaids of Jesus Christ, which includes the motherhouse and convent of the order, Ancilla College, the Lindenwood retreat center, a complex of senior housing, and other facilities. There are numerous statues of saints and religious figures throughout the grounds, and on the main convent building is a large marble figure of the Blessed Virgin carved by an unknown Bavarian sculptor in 1921. But the most astounding statue is that of Our Lady of Grace, an eighteen-foot marble representation of the Virgin Mary, standing before an open field behind the Catherine Kasper Home for retired nuns. The statue originally watched over Saint Vincent Villa, an orphanage in Fort Wayne operated by the Poor Handmaids for many decades. After the orphanage closed, the

bishop in Fort Wayne donated the figure to the sisters. It arrived by train at Donaldson and was carefully loaded onto a flatbed truck for the remaining few miles to the convent, where Our Lady was placed in her present location in 1978.

The campus of Culver Military Academy has several fine small sculptures that the institution prefers not to discuss, but which a walk around the lovely grounds will reveal. In front of the main facade of the Eppley Auditorium is a large semicircular fountain flanked by two bronze allegorical figures, likely representing Music and Drama, astride dolphins. Although the design suggests it could be much older, the fountain was created in 1960 by C. L. Schultz.

Now on land belonging to Crane Naval Surface Warfare Center is a small cemetery containing the grave of Civil War veteran John D. Laughlin.

MARTIN

In a land of rugged hills and forests such as Martin County is, it is surprising to find any sculpture at all. Nevertheless, a limestone bust, mounted on an ornate pedestal, can be found at the Crane Naval Surface Warfare Center. The bust is of the man for whom the site was named in 1943, Commodore William Montgomery Crane (1784–1846). Crane began his naval career as a midshipman in 1799, rising to become the first Chief of the Bureau of Ordnance and Hydrography in 1842. The work was carved by Italian sculptor Dominic Mazzullo and completed in 1943. Within the boundaries of the Crane facility, which opened in 1941 as the Naval Ammunition Depot, are a number of family cemeteries. One of them, the Williams Cemetery, contains the grave of Civil War veteran John D. Laughlin, who died in 1900. On his grave is a limestone statue of a Union soldier.[154]

Worth noting in the Goodwill Cemetery at Loogootee is the grave of Henry Hymen, who died in 1898. His grave marker takes the form of two detailed stacked barrels with a cooper's adze resting on top, the whole of which is over four feet high. In life, Hymen was "a cooper by trade," which is inscribed on the bottom barrel.

MIAMI

Stream-filled Miami County seems to have only two outdoor sculptures, both on the south side of the courthouse square in Peru. The first was dedicated on Armistice Day, November 11, 1930, by the American Legion to honor the veterans of World War I. It is one of the famous figures by Indiana native Ernest Moore Viquesney (1876–1946), *The Spirit of the American Doughboy.* The second statue erected at the courthouse is an eight-foot Statue of Liberty replica of sheet copper over base metal. Dedicated in 1951, it is one of six around the state

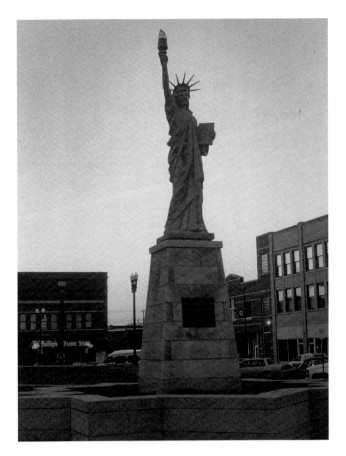

Erected in 1951, Peru's replica of the Statue of Liberty in front of the Miami County Courthouse is one of six in the state.

procured through a program undertaken by the Boy Scouts in that era.[155]

MONROE

An abundance of limestone quarries and a large university combine to make Monroe County, despite its largely rural character, a hotbed of outdoor sculpture. *Light of the World,* a heroic sculptural group by Albert Molnar Sr. surmounts the main (south) entrance of the Monroe County Courthouse built in 1908. Molnar came to America to work on Hungary's exhibition at the 1904 World's Fair in Saint Louis and ultimately settled in Stinesville, touted as the "birthplace of the limestone industry." Molnar sculpted the allegorical work, using his wife as the model for the center figure, which holds a torch.

The figure's hand had broken off decades ago, but in 1976 master carver Harold E. "Dugan" Elgar (1910–1984) replaced it.[156]

The courthouse square is crowded with so many sculptural monuments that there is no room for more. They run the gamut, starting with the Alexander Memorial, named for its chief donor, Captain W. M. Alexander, and designed by architect George W. Bunting. Erected in 1928 at the southeast corner of the square, the limestone monument honors Monroe County soldiers who fought in the Mexican War, Civil War, Spanish-American War, and World War I. Each side of the monument has a relief devoted to a particular war, and the large pedestal is topped with a sentry approximately eight feet high. The statue and the reliefs were carved by Joseph Graf and Albert McIlveen. Unfortunately, time and weather have ravaged the monument to the point

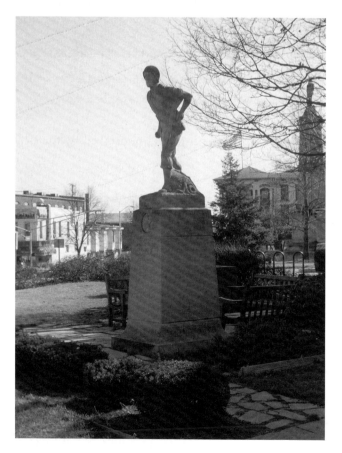

A limestone rendition of E. M. Viquesney's *The Spirit of the Fighting Yank* stands in Bloomington's courthouse square. The Alexander Memorial is in the background.

that some of the reliefs are difficult to identify and the inscriptions are illegible in places. In the northeast corner of the square is Ernest Moore Viquesney's (1876–1946) *The Spirit of the Fighting Yank*, dedicated in 1944. This is the only life-size rendition of this piece in Indiana. Viquesney's World War I doughboy was much more popular for public monuments in its day. Local master stone carver Harry Donato rendered the work in limestone.

A healing memorial to the veterans of the divisive Vietnam War is on the west side of the courthouse, designed by Tony Grub and erected in 1991. As much architecture as sculpture, it includes a sunken wall engraved with names, inspired by the Vietnam monument in Washington, D.C. In 1979 a monument to peace was installed in the southwest corner of the square. Local stonecutter William T. Dahman, who was studying anatomy at Indiana University to further his aspiring career as a sculptor, carved the peace monument with funding from the Comprehensive Employment and Training Act (CETA) program. The statue depicts a woman holding a dove in her left hand. After the hand was broken off sometime in the next decade, stone carver William Galloway of Nashville carved a replacement, and the restored statue was dedicated in June 1991, through the efforts of the group Congregations for Peace.[157]

On the west side of downtown at the Bloomington Showers Common, completed in 1998, are four oversize working weather vanes designed by David Jemerson Young of 2nd Globe. Made of sheet aluminum, each represents an activity that takes place at the site: a large stylized carrot refers to the farmers' market; a Picasso-like interpretation of the masks of drama and comedy, and the finial that is a jester's cap, addresses theater performances; a guitar, topped with a pick, speaks of the musicians that play at the commons; and a hand holding a paintbrush refers to the visual arts. The supports for the awnings that shelter the produce stands are treelike, calling to mind the orchards from which the fruit has come.[158]

The Commons lies immediately south of the renovated Showers Furniture factory complex, into which the city hall relocated in 1995. Two years ear-

lier, Bloomington's Common Council had passed Indiana's first "percent for art" ordinance, which established that one percent of the construction costs of certain capital projects was to be dedicated to the creation and installation of public art. The first project to be funded under this ordinance was an artwork for the new Showers Civic Plaza fronting the entrance to the city hall. The commission was awarded, not without controversy, to a non-Hoosier artist, Brad Goldberg, a sculptor from Dallas, Texas. Erected in 1996, his fountain sculpture centers on a forty-ton carved limestone piece, twelve feet high and shaped like a Native American vessel. From it water spills over into a serpentine channel, reminiscent in pattern of the Great Serpent Mound in Ohio, that meanders through plantings of river birches.

At the southwest corner of Sixth and Madison streets is a painted steel abstract by Michigan-born Jerald Jacquard, a professor emeritus at Indiana University. The piece is a series of connected geometric solids created in 1978 called *Point/Counterpoint*. Near the south entrance to the Monroe County Public Library between downtown and the west side of the university campus are two streamlined bears of polished limestone, carved by Morgan County sculptor C. R. Schiefer in 1989. The bears had stood for several years on the sidewalk in the 100 block of East Sixth Street. Another of Schiefer's works, *Rhinoceros,* is in the yard of the Harmony School on Second Street. He carved the beast about 1975, and it stood in front of an art gallery in town for about twelve years. Schiefer took the piece back to his studio after another of his works was destroyed by vandals. The students at Harmony School wanted to prove that young people could appreciate and care for art, so they began a multifaceted fund-raising campaign to purchase the rhino and install it at their school, where it has been since

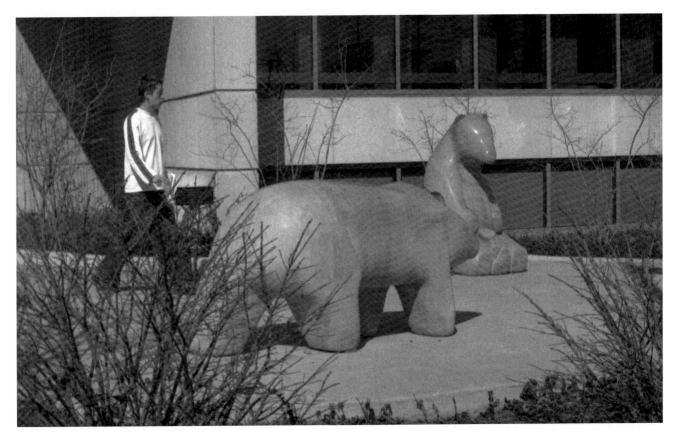

C. R. Schiefer's "touchable" limestone bears prowl outside the Monroe County Library on the west side of downtown Bloomington.

1988. The school's grounds also display a steel abstract piece painted blue, resembling a slightly distorted window, and, in fact, is called *The Window*. Dedicated in 1992, it was designed by student Cymon Paidle when he was thirteen. The fabrication and welding were done by a local company.

Collaborative artist Joe LaMantia has worked with several schools and youth groups in Bloomington to create pieces inside buildings as well as outdoor public art. In 1997 he and the students of Templeton Elementary School assembled *Scrappy*, a colorful stylized tiger made of various pieces of metal. The next year, at Clear Creek Elementary School, he and the students created *School Is Out*, an artistic pun depicting a fanciful seascape with groups of fish. In 1999 the collaborative result at the Early Childhood Development Center was *Makers of Art and Other Things*. One of LaMantia's earliest collaborative public pieces in Bloomington was *Spot, the Firehouse Dog*, for and with WFHB Community Radio, which is located in a former fire station on Fourth Street.[159]

In Miller-Showers Park on the north side of town is the huge and intriguing *Red, Blond, Black, and Olive* by Jean-Paul Darriau (b. 1929), dedicated in 1980. At first glance the piece appears to be two fourteen-foot blocks of limestone that are carved with immense faces gazing into each other's eyes. On closer inspection, one half of each face is different from the other, so there are actually four facial images, each representative of a different race or ethnicity. Among other things, the work speaks to the diversity of the Bloomington community. Also in the park is *Axis*, by Bloomington sculptor Dale Enochs (b. 1952), a piece that was commissioned by Bloomington after winning the All-America City Sculpture contest in 1983. The tall, slender slabs of limestone with linear cuts in an abstract design were erected two years later.

In Rose Hill Cemetery, apart from a fine collection of funerary art, are several sculptural memorials. Among them is the earliest Union sentry figure erected in Indiana, dedicated in 1883 by the Women's Relief Corps of the Grand Army of the

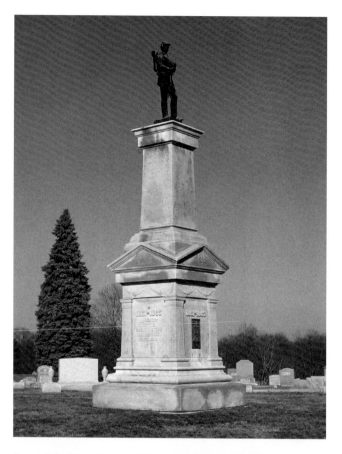

Rose Hill Cemetery's GAR monument is the first use of a sentry figure on a Civil War memorial in Indiana.

Republic. The figure is a larger-than-life bronze, standing on a twenty-foot, multitiered pedestal that incorporates a Greek portico in its design. Commemorating the veterans of World War I is the War Mothers' Monument, erected in 1923. It features a bronze doughboy advancing atop an even more ornate limestone pedestal with Doric columns and a dentilled cornice. There is also a limestone eagle perched on a tall Doric column, the College City Aerie Monument, commemorating deceased members of the Fraternal Order of Eagles (FOE) Number 1085. It was placed in the cemetery about 1910.

The Valhalla Memory Garden contains a limestone monument honoring departed members of the Elks, erected by BPOE 446 about 1980, with the figure of a resting elk in relief. The cemetery, typical of this type, contains a large marble figure of Christ in the Garden of Gethsemane and a giant Praying Hands. In the Clear Creek Christian

Church Cemetery on the far south side of town is the grave of renowned stone carver Harold "Dugan" Elgar. On it is his own interpretation of the *Pietà* in marble, completed in 1968, a poignant statement of his art.

An unusual interpretation of *Jesus Feeding the Multitude* by Marie Zoe Greene is formed of bronze rods shaped in an open pattern, suggesting the figure of Christ. The piece was erected in 1956 at the First Baptist-United Church of Christ at 2420 East Third Street. At Saint John the Apostle Church on West Third Street is a life-size statue of the saint carved in limestone by local carver Henry A. Morris in 1974.

South on Old Highway 37 is the headquarters of the Indiana National Guard, Second Battalion, 150th Field Artillery. Very often these armories have old ordnance on display. In this case, there is a simple field cannon carved in limestone. The piece, erected in 1991, is by local carver Gilbert Payton.

The culture of public sculpture has reached even the sprawl area of Bloomington. The Whitehall Crossing shopping mall boasts an untitled abstract piece by Stephen Powell of San Francisco, who holds a master of fine arts degree from Indiana University. The work, erected in 2001, is hard to miss; it is more than fifty feet high and has several kinetic elements.[160]

The IU campus has a large collection of outdoor sculpture scattered about: commemorative statues, aesthetic and allegorical pieces, numerous abstracts, as well as a great deal of whimsy. The late Chancellor Herman B Wells is captured in bronze twice. When Robert Laurent (1890–1970) was sculptor-in-residence at the university, he created a bronze bust of Wells, wearing his chain of office. It was installed on a pedestal in 1965. French-born Laurent is most famous on campus for the Showalter Fountain, dedicated in 1961. In it is *The Birth of Venus*, portraying a hefty goddess reclining on or floating above a giant clam shell. The figure was actually completed three years earlier and cast in Rome. Venus is surrounded by several bronze fish spouting water. The fountain, in its prominent loca-

tion in the Auditorium Plaza, is the site of many campus pranks and occasional acts of vandalism or theft. Harold R. "Tuck" Langland (b. 1939) was commissioned after Wells's death to create a more informal portrait of him, and the result was a wonderful life-size figure of the rotund gentleman, dedicated in 2000. He sits affably on a park bench, as if inviting students to sit and chat with him, which he often did in life.[161]

Commissioned to honor the retiring President Thomas Ehrlich, who strongly supported the arts, *Indiana Arc* graces the plaza fronting the university's Art Museum. Montana-born Charles O. Perry (b. 1929) sculpted the twenty-foot curvilinear abstract, which was dedicated in 1995. The piece is fashioned of aluminum and painted bright red. An

Alexander Calder's huge stabile *Peau Rouge Indiana* stands near the Musical Arts Center on the Indiana University campus.

even larger work of bright-red steel is *Peau Rouge Indiana,* a stabile by renowned sculptor Alexander Calder (1898–1976), erected in front of the Musical Arts Center twenty-five years earlier. Forty feet high, the piece is composed of curvilinear planes that suggest the motion of a mobile (but are in fact stable, hence the term). Outside the McCalla School is *February* by Jerald Jacquard, a tripod of blue-painted steel geometric forms completed in 1988. On the building itself, atop the flat roof of the addition on the north, was a work of glass and pink neon, spelling out "RELAX" in large block letters by faculty artist Georgia Strange (b. 1949). The work was originally created as an installation at Wabash College in 1992 and was moved to IU the following year.[162] Unfortunately, concerns over the roof resulted in the piece being removed.

Jean-Paul Darriau created nearly life-size bronze figures of Adam and Eve, standing about six feet apart as they discover each other. Dedicated in 1969 in the Well House Woods, they stand on a concrete base divided into segments. In 1971 artist Nan Dietert created a piece consisting of twenty irregularly shaped limestone blocks arranged in a grid pattern, all cut from one large block of stone. The work is outside the east entrance to the Fine Arts Building. In the courtyard off the mezzanine of the Memorial Union is a small bronze work called *Soul,* alternatively known as *Search of Universal Life,* the work of William Snapp Jr. completed in 1987. It depicts a young man standing on a sphere, his hand upraised. Snapp, a peace activist who studied commercial art in Indianapolis as a young man, worked on the piece for more than two decades in his spare time.

Many buildings on the campus, some as late as the 1960s, exhibit sculptured reliefs or full figures of native limestone. At the peak of each gable at the north and south of Maxwell Hall, built in 1890, is a batlike creature holding a shield emblazoned with "IU." Although they are commonly referred to as gargoyles, they are true grotesques—perhaps intended to frighten the students into studying! The entrance on the south of Memorial Hall, originally a

dormitory built in 1925, is rife with curious sculptures. Above the arched portal is the university seal framed by flaming torches and surmounted with what is probably the head of Athena. Flanking the entrance are a seated schoolmaster ringing a bell and a comical student falling asleep over his books. The interior arches are flanked with figures that probably represent Service, Recreation, Scholarship, and Piety. The portico of Myers Hall, formerly the Medical Sciences Building completed in 1936, displays a recessed tripartite relief above the arch depicting three different scientists at work: a biologist, a chemist, and a biochemist. In addition, stylized owls decorate projections along the water table, and there are carved faces separating the windows. On the main facade of the Auditorium, completed in 1941, are two classical figures, one male, one female, atop the pilasters flanking the entrance. Much of the building ornamentation around the campus was the work of fabled master stone carver Albert McIlveen (1885–1965). High above the bookstore entrance on the south side of the Memorial Union Building (this section built in 1932) is a somewhat stylized owl about three feet high, and flanking the arched entrance are waist-up depictions of a scholar and a professor. A whimsical figure strongly resembling Donald Duck wearing a mortarboard stands atop the gable on the west side of Goodbody Hall, built in 1936.

The exterior of Wright Quadrangle, built in 1949, features nine different neoclassical relief figures, ranging from three to six feet high, by Joseph P. Pollia (1893–1954). Themes depicted are football, track, baseball, basketball, philosophy, science, art, justice, and drama. Robert Laurent designed *Veritas, Filia Temporis* ("Truth, Daughter of Time") for the northwest corner of Ballantine Hall, the new humanities building, in 1959. The relief is a personification of the motto, which dates to the Renaissance. The same year Nat Choate (1899–1965) designed a classical scene in high relief for Rabb Hall (part of Teter Quadrangle). Depicting three figures among the heavens, it may be a representation of Zeus, Apollo, and Artemis. On Harper Hall in Fos-

ter Quadrangle, completed in 1963, is an eighteen-foot relief of two classical female figures, one holding an open book, the other a lighted lamp above it. Inscribed nearby is a verse from the Psalms: "Open mine eyes that I may behold wondrous things."

North of Bloomington in front of the Oliver Winery is an untitled environmental sculpture by Mark Wallis, commonly referred to as "Stonehenge." About sixty by ninety feet, the work, erected in 1990, is an abstract arrangement of three hundred tons of limestone blocks. The piece became a regional landmark almost instantly.

In a cemetery where once a country church stood on Anderson Road is the Riddle monument, the grave of two brothers who had fought in World War I, both of whom died of influenza in 1919. On

The Riddle monument in a rural cemetery northeast of Bloomington marks the grave of two brothers who died at the end of World War I.

the grave is a life-size limestone statue of a dough-boy. In Mount Carmel Cemetery near Stinesville is the grave of young Emory Titzel, who was killed in 1905 at the age of twenty-two while working for the Monon Railroad. Atop the grave is a small but very detailed carved replica of Locomotive 215 and its tender.

At the edge of Stinesville, where the limestone industry began, is a new limestone sign with a life-size statue of an early-twentieth-century stone carver. The work was done by carvers Barney Duncan and Tom Dixon in 2002. The sign proclaims the town as the home of the Quarry Lads, the team name of the high school that closed in 1964.[163]

MONTGOMERY

All the outdoor sculpture of Montgomery County seems to be confined to its county seat of Crawfordsville, with an exception that must be noted, a twelve-foot cast-aluminum replica of the Statue of Liberty, located on a farm on State Road 236, east of US 231. It was installed in July 1999 and in a very short time became something of a local landmark.[164]

Crawfordsville's most prominent sculpture is the Soldiers and Sailors Monument at the courthouse, dedicated in 1906, with bronze figures by Austrian-born Rudolf Schwarz (1866–1912), who created numerous monuments around the state. The monument has a figure of Liberty atop a thirty-foot pedestal, and statues representing Cavalry and Infantry flank the base. Additional ornate bronze emblems adorn the base, and plaques placed in remembrance of those who made the supreme sacrifice in subsequent wars are affixed on all sides. Schwarz also did several smaller projects for Wabash College, notably a large, elaborate bronze plaque commemorating those from the college who fought in the Civil War. There is also an outdoor bench that he fashioned, although it is covered with so many coats of paint it is no longer recognizable as bronze.[165]

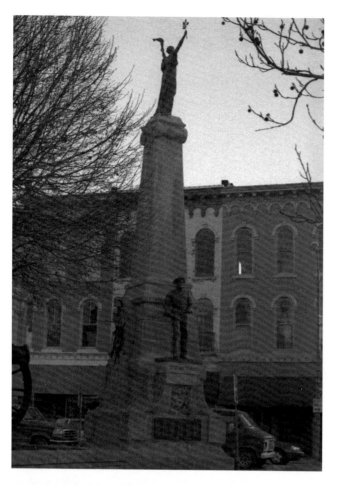

Crowded next to the Montgomery County Courthouse is one of several Soldiers and Sailors monuments around the state featuring sculptures by Austrian-born Rudolf Schwarz.

Crawfordville's most famous personage is surely Lew Wallace (1827–1905), a Civil War general and the author of *Ben-Hur* and several other novels popular in their day. At the General Lew Wallace Study and Museum east of downtown is a life-size bronze statue of Wallace in his military uniform, created by sculptor Andrew O'Connor (1874–1941) in 1910. The study itself, which was constructed in the late 1890s to Wallace's own designs based upon several exotic influences, was built to house his huge collection of books and as a place to write. It features a limestone frieze incorporating carved faces of the characters in his books. The work was by English artist Henry Saunders, who created a somewhat similar design for the sills and entrance of the Blacherne apartment building that Wallace owned in Indianapolis. Also on the General Lew Wallace

Study and Museum property is one of the portrait medallions that once graced the English Hotel and Opera House in downtown Indianapolis. Ironically, Saunders was the sculptor of the many portraits in stone of Indiana governors, one of whom was David Wallace, Lew's father, who served as governor from 1837 to 1840. The piece came to Crawfordsville after the hotel was demolished in 1948.

Wallace is buried in Oak Hill Cemetery, and a thirty-foot draped obelisk of granite marks his grave. There are a number of good examples of high funerary art in the cemetery. The Nathaniel Parker Willis monument features a bronze relief portrait of Willis, who died in 1909, and his young daughter, along with an inscription that only hints of the lurid true tale that rivals any modern soap opera. Suffice it to say that Willis, a successful printer and photographer, was shot while attempting to see his beloved child who was in the custody of his ex-wife and her new husband. His artful grave marker was completed in 1912 by sculptor George Julian Zolnay (1862–1949). In the newer section of the cemetery there is a marble interpretation of Jesus giving the Sermon on the Mount.

At Saint Bernard Catholic Church on East Main Street is a large painted statue of the Virgin Mary that dates to 1876. The statue was made for a niche on the facade of an earlier Saint Bernard's at a different location. When that building was demolished, the statue was saved and moved to its present site at the new church in 1958.

In 1998 the Sisters of Saint Francis acquired the former Culver-Union Hospital on Lafayette Road and renamed it Saint Clare Medical Center. To honor their patron saint, a casting of Sufi Ahmad's lively *Spirit of Saint Francis* was erected on the campus.

MORGAN

The glaciers stopped here, making much of Morgan County hilly and wooded. Its sculpture is mostly found in the county seat of Martinsville, but southeast of town on Low Gap Road is the studio and

C. R. Schiefer's sleek *Seals Courting* in downtown Martinsville demonstrates the artist's "touchable" style.

outdoor gallery of C. R. Schiefer, who started out doing art as a means of relaxing from his work as a speech pathologist. Eventually, in the 1970s, he quit his job and turned to art full time. Schiefer's rural sculpture garden, ever changing, contains over 170 sculptures of limestone and marble that he calls "Touchables"— their smooth finish invites touching and the artist encourages it.[166]

Since about 1977 Schiefer's sleek *Seals Courting* has delighted the patrons of a bank on South Main Street in Martinsville. On North Main is the former New Highland Sanitarium, built in the heyday of the town's mineral springs health resorts in the early twentieth century. Now an apartment building, the structure still displays classically inspired limestone statues from its days as a spa in the 1920s.

In Bradford Woods north of Martinsville is Camp Riley, a facility for physically handicapped children. In 1990 Nashville artist Joe James carved a fourteen-foot totem pole of tulip poplar for the camp, basing the figures on legends of the Haida people who lived off the coast of present-day British Columbia. Artist Mary Ann Whitaker painted the pole.[167]

Commercial designer and sculptor Gary Rittenhouse used himself and his family as models for his depiction of *The Family Doctor*, erected at the Kendrick Family Medical Pavilion (now Saint Francis Medical Pavilion) on State Road 67 outside Mooresville in 1997. The figures are constructed of fiberglass over a steel framework and coated with acrylic. Saint Francis Hospital acquired the medical facility in 2000 and completed a major expansion up the hill on Hadley Drive in 2004, where a casting of *Spirit of Saint Francis* by Sufi Ahmad was erected near the entrance.

To the northeast along State Road 67, in the sprawling development of Heartland Crossing, Rittenhouse has created a number of whimsical fiberglass pieces, including golfers and a large mushroom in the children's recreation area.[168]

NEWTON

The open prairies of Newton County, once mostly wetlands, are sparsely populated. There appears to be no outdoor sculpture in the county.

NOBLE

Amidst the rolling glacial moraine of Noble County are a handful of outdoor sculptures, most of a religious nature. The county seat of Albion has two pieces by Lynn Olson, who works with a

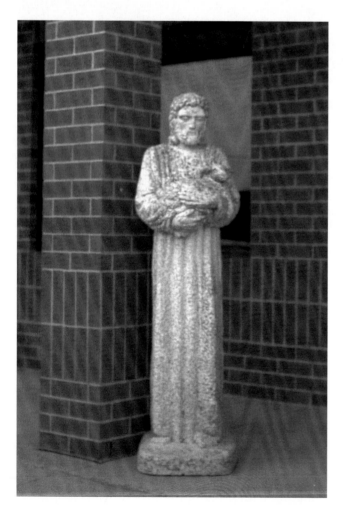

Lynn Olson's *The Good Shepherd* at Blessed Sacrament Church in Albion.

special formula of "fiber-cement" to create his expressive works. Both are outside the Church of the Blessed Sacrament on the south side of town. One is an untitled seven-foot Crucifix; the other, a life-size interpretation of Christ, *The Good Shepherd*.[169]

There are several pieces of religious statuary at Avilla: at the Sacred Heart Home; at the nearby Saint Mary Church, where there is a small replica of a Lourdes grotto created by a local parishioner in the 1960s; and at Saint Mary Cemetery and its chapel.

At Rome City is a marble statue of Saint Gaspar at the church of that name on State Road 9. Two limestone owls top the gateposts flanking the entrance to the Gene Stratton-Porter State Historic Site outside Rome City. The realistic three-foot birds were designed by Stratton-Porter, a gifted naturalist, but who carved them is unknown.

OHIO

The tiny county of Ohio, along the river of the same name, apparently boasted but one sculpture for more than a hundred years. In Union Cemetery at the county seat of Rising Sun, the Soldiers and Sailors Monument was erected in 1891. It features a life-size marble Civil War-era sentry on a granite pedestal.[170]

Rising Sun's fortunes changed in the 1990s with the construction of a riverboat gambling casino and resort, which spurred a Main Street revival and riverfront development. As part of the latter, Batesville artist Chaz Kaiser (b. 1959) was commissioned by the city to fabricate a fanciful fountain of stainless steel, copper, and bronze called *Riparian Arbor*. Based on a design conceived by Andrea Grimsley of Rising Sun, the piece is a willowy tree fourteen feet high with sixteen different copper bowls at the ends of the bronze branches, from which the water bubbles forth. The piece was dedicated downtown in 2005.

This lonely sentry in the cemetery at Rising Sun is one of many in Indiana.

ORANGE

Orange County is largely wooded hills and rocky streams, but like an old matron with a wink, it has had an exciting, even steamy past that may still be revived. The twin historic resort towns of West Baden and French Lick seem to have had the only outdoor sculpture in the county, although much is now gone. At the French Lick Springs Hotel are two identical six-foot copper statues of Pluto that once were exterior ornaments on the building. They date to about 1902. Today, both are displayed inside the hotel for safekeeping. Pluto, in this case depicted as a devil, was the logo for the famous Pluto Water once bottled from the springs here.[171]

The nearby West Baden Springs Hotel was very nearly demolished but now has been partially restored with generous donations from philanthropists William and Gayle Cook and Historic Landmarks Foundation of Indiana. The gardens around the hotel were once full of classically inspired statuary; however, nearly all of the pieces disappeared over the years. As the gardens are restored, the sculpture is gradually being replaced. West Baden had its counterpart to French Lick's Pluto, called Sprudel, a gnomelike figure. A statue of Sprudel survives on private property in West Baden.

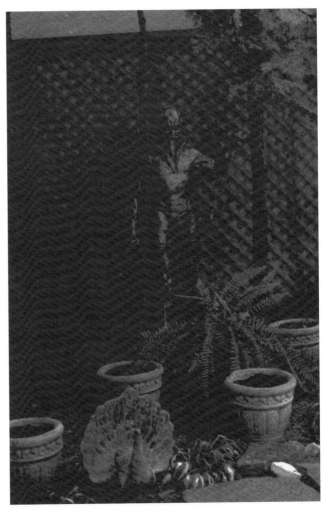

One of two statues of the French Lick Hotel's famous character Pluto that once topped a building housing mineral baths. Today they are both safely displayed inside.

OWEN

A river runs through "Sweet Owen" County, as its residents sometimes call it, and the stony hills and forests kept the population from overcrowding the land until recent years. This was the home of Ernest Moore Viquesney (1876–1946), who created *The Spirit of the American Doughboy* statue and several others. Naturally, one of his bronze doughboys,

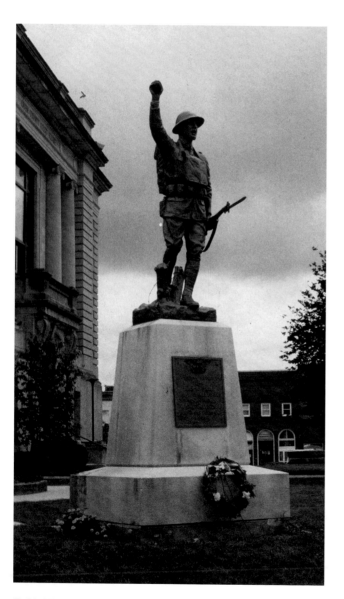

E. M. Viquesney's hometown of Spencer would be remiss if it did not display one of his famous *The Spirit of the American Doughboy* statues on the courthouse square.

erected in 1927, graces the courthouse square in Spencer. Viquesney is buried in Riverside Cemetery. Viquesney placed *The Unveiling*, a statue of a partly shrouded figure of a woman, on the family plot in 1935. On a hill at the cemetery is another Viquesney work, an ornate bronze plaque with a striding Liberty in high relief and the words of "The American's Creed," a patriotic affirmation written by William Tyler Page and adopted by Congress in 1918. The plaque, placed in 1939, is mounted on a tablet within the Soldiers Pavilion, which is largely constructed of geodes. An identical plaque is displayed inside the Owen County Courthouse on the second floor.[172]

East of Spencer at the Cook Urological Plant is an environmental sculpture by Mark A. Wallis, erected in 1986. It is an arrangement of rough limestone blocks, plantings, and paths, evoking the earth and the primitive peoples who constructed the stone circles such as that at Stonehenge.

North of the village of Patricksburg in the Lutheran Cemetery is a limestone statue of a doughboy, placed on the grave of the young soldier Carl H. Kaiser. Sent to France, he died in 1918 of pneumonia at the age of twenty-seven.

At the Gosport Cemetery is the charmingly unpretentious Soldiers Monument erected by the Grand Army of the Republic (GAR) in about 1890. It is simply a carved limestone cannon atop a pedestal. A little farther down State Road 67 in a small roadside park is the *Ten O'Clock Line Monument,* commemorating the signing in 1809 of a treaty with four Indian tribes: the Miami, the Potawatomi, the Delaware, and the Eel River people. The Ten O'Clock Line is the northern boundary of a tract of land that the Native Americans agreed to let the settlers enter and live peacefully. The monument is a large slab of limestone over six feet high, depicting the signing of the treaty carved in relief. There are eight figures in all, but the two principal characters in the center are Chief Little Turtle of the Miami tribe and William Henry Harrison, governor of the Indiana Territory. Sculptor Frederick L. Hollis completed the work in 1957.

PARKE

Best known for the many covered bridges through-
out its creek-filled landscape, Parke County has very
little outdoor sculpture. The county seat of
Rockville has a World War Memorial on the south-
west side of the courthouse square. The limestone
doughboy, standing on a fieldstone pedestal, was
carved by Theodore F. Gaebler and dedicated in
1930. Saint Joseph Church on Ohio Street has two
religious statues dating to about 1932 that were
originally at the Saint Meinrad College Chapel in
Spencer County. The figures of Saint Joseph and the
Blessed Virgin were moved to their present loca-
tions in the early 1980s.[173]

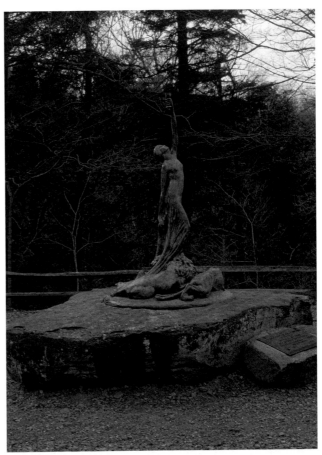

Hidden behind the inn at Turkey Run State Park is this beau-
tiful bronze work by Indianapolis sculptor Myra Reynolds
Richards.

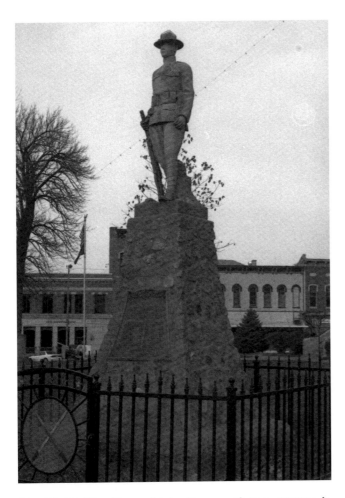

The World War Memorial in the courthouse square in
Rockville.

East of Rockville in Billie Creek Village, an out-
door history museum, is one of the portrait medal-
lions of Indiana governors that once graced the
English Hotel and Opera House in Indianapolis,
which was demolished in 1948. It was carved by the
English sculptor Henry Saunders in 1898. This one
has been identified as Joseph A. Wright (1810–1867),
who had practiced law in Rockville before he became
governor in 1849, serving one three-year term under
the 1816 constitution and reelected to a four-year
term under the 1851 constitution.

There are two significant works at Turkey Run
State Park. One is the portrait bust in bronze of the
"Father of Indiana State Parks," Richard Lieber
(1869–1944), nationally known for his conservation
efforts and expertise in creating park systems. The
memorial was dedicated in 1932 in gratitude for

Lieber's sixteen years as the first director of the Indiana Department of Conservation, under whose aegis the first twelve state parks were established. The sculptor was Elmer Harland (E. H.) Daniels (1905–1986). After Lieber's death at another state park in 1944, he was buried here and the memorial was enlarged.

The other piece seems almost out of place. It was erected in 1922 as a tribute to Juliet V. Strauss (1863–1918), a journalist whose efforts were instrumental in the establishment of Turkey Run as a state park in 1916. The Women's Press Club of Indiana commissioned Myra Reynolds Richards (1882–1934), one of several successful women sculptors working in the early twentieth century, to create the memorial. *Subjugation,* a very sophisticated piece, depicts a female figure holding a chalice aloft and various beasts arrayed at and under her feet. While modern interpreters see the piece as having a feminist message, the artist herself was seeking to convey the theme of the spiritual overcoming the material. The statue is in its third location. It was initially dedicated in a fountain setting (a stream of water originally poured from the chalice) behind the park's inn near Sunset Point. In the 1930s it was relocated into the canyon below, a particularly inappropriate place. In the 1990s the sculpture was removed, refurbished, and ultimately reerected in its present—and unfortunately obscure—site at the rear of the inn.[174]

PERRY

The Ohio River borders Perry County, much of which is hilly and forested. Religious statuary is scattered throughout in rural Catholic parishes, with large bronze, marble, or concrete figures of saints or the deity on display at the churches or their cemeteries at Leopold, Saint Mark's, Siberia, and Troy, as well as at Cannelton, the county seat until the mid-1990s. At Troy, which was the first county seat, is the stunning *Christ of the Ohio,* high atop a bluff overlooking the river. Herbert Jogerst (1912–1993)

created the work out of travertine in 1956. The Christ is more than eleven feet high and is carved in the German sculptor's distinctive style, which can also be seen on several figures that Jogerst created at Saint Meinrad Archabbey, less than fifteen miles to the north. A shrine east of Saint Meinrad across Anderson Creek, just barely in Perry County, shelters a nine-foot statue of Saint Joseph carved of oak by the Benedictine brother Herman Zwerger in 1949.[175]

In Tell City, which is now the county seat, are two bronze statues of William Tell and his son Walter (Walther), virtually identical, except for size. The smaller piece, just two feet high, of the burly peasant and his son striding down a rugged path is displayed on a pedestal outside the Tell City National Bank at 601 Main Street. The sculpture, the work of

The bronze statue of William Tell and his son Walther grace a fountain in front of Tell City's government building.

Swiss artist Richard Kissling, dates to 1895 and was purchased in Altdorf, Switzerland, in the 1970s. The small piece was used as a model for the life-size work in City Hall Park that stands atop a fountain constructed with a donation from the bank. Donald Ingle from Evansville sculpted the large work. He took it to New York for casting and, on his return, Ingle's truck with the statue inside was stolen. Fortunately the abandoned truck with the sculpture intact was found a week later, and the dedication in August 1974 during the town's annual Schweizer Fest took place as planned. On the north side of the city hall is a pair of upright seated lions, carved of limestone by local sculptor John C. Meyenberg in 1907. This is their third location. The lions started out at the railroad depot that once overlooked the steamboat landing on the Ohio River. Later they were moved near the municipal swimming pool. Now they flank the sidewalk that leads to the north entrance of the city hall.

PIKE

For a hundred years, a cast-iron Newfoundland dog, which appears to be straight out of the catalog of J. L. Mott Iron Works of New York, was probably the only sculpture in sparsely populated Pike County. It guards the graves of the Hornaday family in Walnut Hill Cemetery in Petersburg and was likely placed around 1900. The pooch, which had been long neglected, was cleaned and repainted in the 1990s.[176]

Recently, another critter has joined the ranks of Pike County sculptures. A whimsical buffalo dubbed *Trace* stands at the Otwell Elementary School, the work of artist Joe LaMantia in collaboration with the pupils of the school. The work, which is mindful of the fact that Otwell sits on the route of the Buffalo Trace, was dedicated in 2001.[177]

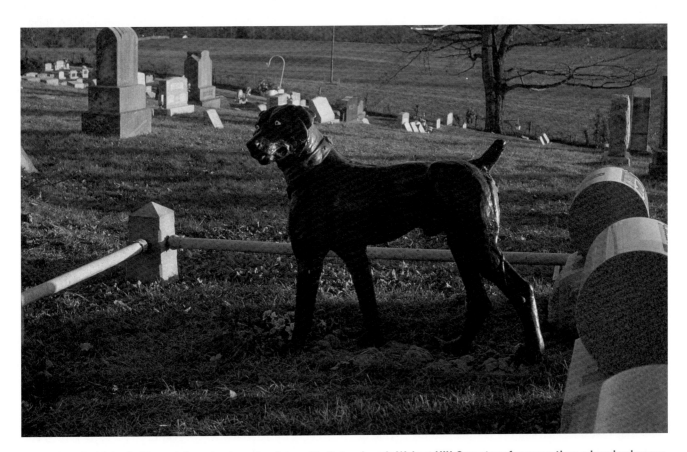

Recently refurbished, this cast-iron dog has stood guard in Petersburg's Walnut Hill Cemetery for more than a hundred years.

PORTER

Suburban sprawl is overtaking much of the northern half of Porter County, except for the areas protected as part of the Indiana Dunes State Park or National Lakeshore. Until the mid-1990s, there was a large collection of religious sculpture at the Shrine of the Seven Dolors, an extended grotto complex northwest of Valparaiso and constructed of what was asserted to be "lake coral." (Although it indeed was coral, it was not from Lake Michigan.) The Franciscan-built shrine opened in the 1930s, and over the years grew to incorporate a large collection of religious sculptures. The shrine was demolished in the late 1990s,

and all that remains is the moundlike grotto some distance behind the Seven Dolors Church and an unusual piece by Hungarian sculptor Eugene Kormendi (1889–1959). Kormendi created a variation on the *Pietà* as a memorial for those who died in World War II. In place of the body of Christ, the figure of Mary holds a dead soldier. At the time he did the evocative sculpture in 1946, Kormendi was sculptor-in-residence at the University of Notre Dame.[178]

With the loss of the Seven Dolors Shrine, sculpture appears to be confined primarily to Valparaiso. At Saint Paul Church on Harrison Boulevard are two pieces installed in 1971 by Spanish sculptor Cesaer Bobis. An eight-foot figure of Saint Paul, fashioned from bronze and scrap metal, stands at the front of the church. According to the artist, it evokes Saint Paul's charge to "be the new man." His image of Our Lady of Paradise, locally known as Our Lady of Valparaiso, stands at the rear of the church in a small garden setting. West of the church, placed at the Tiny Tim Child Development Center, is the *Christian Totem Pole,* created by Canadian carver Ross C. Jobe in 1989. Well over thirty feet high, the totem stacks stylized images of creatures symbolizing aspects of the region's history and the Christian faith.

A monumental weathering steel sculpture resembling a massive butterfly was erected on the courthouse square in 1977, the result of a Bicentennial project. *Caritas* was created by Wisconsin-born Frederick L. Frey (b. 1940), a member of the art department faculty at Valparaiso University. When the courthouse was renovated in 1995, the county gave the sculpture to the university. The piece was moved to the campus, where it was placed near the Chapel of the Resurrection, a site the artist found particularly appropriate as the butterfly symbolizes resurrection.[179] It joined two large contemporary works on campus that had been installed in 1987. Betty Gold's (b. 1935) *Kaikoo XV,* a large welded steel abstract, stands outside the library. *Phoenix II,* a stacked and twisted assemblage of clay and metal objects by Richard Montgomery (b. 1953), is in the courtyard of Mueller Hall.

This haunting reinterpretation of the Pietà is a World War II memorial that once marked the entrance to the Shrine of the Seven Dolors, since demolished, near Valparaiso.

Caritas by Fred Frey originally was erected in front of the Porter County Courthouse but now stands on the Valparaiso University campus.

Two pieces by S. Thomas Scarff (b. 1932) of Michigan City are on long-term loan to the Valparaiso Academic Center on the north side of town. One, called *Indigo Blue,* is a slender work, fourteen feet high, of bronze with cobalt blue neon. The other, called *LightRay,* is about ten feet long and crafted of aluminum and neon.[180]

Both Graceland Cemetery and nearby Saint Paul Cemetery on Sturdy Road off US 30 have many examples of religious figures. Notable in the former is a heroic marble figure of Christ as the Good Shepherd, complete with five different sheep.

Collaborative artist Joe LaMantia has worked with some of the schools in Porter County; however, not all of the resulting pieces can be classified as outdoor sculpture. In 2002 he and the students of

Northview Elementary School on the edge of Valparaiso completed a colorful steel piece that stands outside the school called *Knights Around.*[181] Two years earlier, LaMantia and the community of Porter Lakes Elementary School in Hebron fashioned a work resembling puzzle pieces called *We the People.*

POSEY

Posey County nestles in the southwestern toe of Indiana where the Wabash River meets the Ohio. Though the county is largely rural, the presence of New Harmony makes it a surprising treasure trove of outdoor sculpture. This historic phenomenon, with remnants of early-nineteenth-century religious and

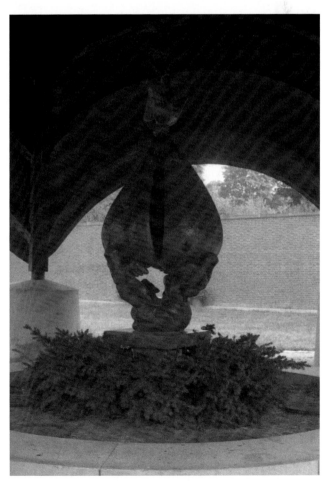

Descent of the Holy Spirit by Jacques Lipchitz was the first piece installed in the Roofless Church in New Harmony.

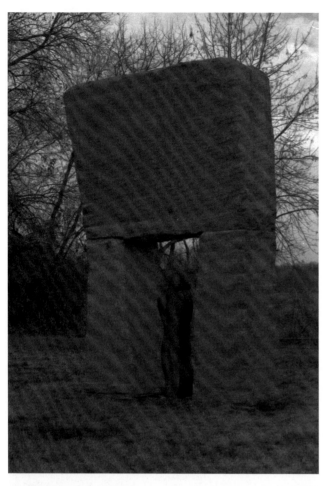

In New Harmony, one cannot avoid encounters with sculpture. Behind the Barn Abbey is the granite and bronze piece *Shalev: Angel of Compassion* by Tobi Kahn.

social experiments and its intact late-nineteenth-century commercial district, has evolved—no doubt with Robert Owen (1771–1858) somewhere smiling in the cosmos—into a center of art and culture. It started in 1960 with architect Philip Johnson's (1906–2005) Roofless Church, the centerpiece of which is the evocative *Descent of the Holy Spirit* (also known as *Virgin*) by New York sculptor (born in Lithuania) Jacques Lipchitz (1891–1973). It is a writhing work in bronze, filled with symbols: a dove flies downward holding a star-studded, billowing cloth in which appears to be a figure. Lipchitz also designed the massive *Suzanne Glemet Memorial Gates* at the main entrance on the east side of the courtyard around the Roofless Church. The twelve-foot-high gates are fashioned of gilded bronze and

structural steel and were installed in 1962. In contrast to these dramatic works, Lipchitz produced *Meditation,* which depicts a woman in an attitude of contemplation. Cast in 1960, the bronze piece is nestled among plantings west of the Red Geranium Inn.[182]

The Roofless Church displays other sculptures within the forecourt and without. Mounted on the wall at the northwest corner is *As the Clay . . .,* completed in 1983 by Ohio ceramicist Gail Russell. On the southwest side, outside the walls, is *Arch* by New York artist Bruno La Verdiere (b. 1937). This interesting piece, eight feet high, is essentially a very large piece of pottery. La Verdiere fashioned the coil-built stoneware piece in 1971. It came to New Harmony in 1988 and was originally installed in the woods behind the New Harmony Inn. It was moved to its present location in 1992. Close by is a bronze abstract by California sculptor Stephen DeStaebler (b. 1933) that was installed in 1997. *Angel of the Annunciation* is an elongated suggestion of an angel figure, more than ten feet high. Inside the Roofless Church is an earlier controversial piece by DeStaebler, an interpretation in bronze of the Pietà. Created in 1988, it is an abstract standing figure with no arms and a second head emerging from the figure's chest. A shapeless form hovers above. Nearby is a more conventional piece based on a fifteenth-century wood carving. The ceramic statue, smaller than life, is that of a king sitting on a throne and holding before him the crucified Christ. Polish artist Eva Sygulska created the piece, commonly called the Polish Memorial, in 1968. Next to it, set into the wall, is the abstract *Breath of God,* two small carved marble pieces mounted in a rusting steel frame, created by New York artist Mark Mennin (b. 1960) in 1994. Close by is *Baptismal Font,* a fountain of black granite designed by William Schickel (b. 1919) and dedicated in 1995 "in celebration of all grandparents." Just outside the Lipchitz gates is *Our Lady, Queen of Peace,* a life-size figure allegedly from the fourteenth or fifteenth century, but its style suggests that it may not be quite that old. Although its ori-

gins are obscure, the Madonna was a gift to Holy Angels Catholic Church from philanthropist Jane Blaffner Owen and was moved to its present location about 1986. The wayside shrine is dedicated to the memory of the Trappist monk and theologian Thomas Merton (1915–1968).[183]

In 2003 noted sculptor Don Gummer, who grew up in Indianapolis, completed a commission for Historic New Harmony. The piece, called *Fountain #3,* is dedicated to the late Kenneth Dale Owen.

Across from the Roofless Church is Carol's Garden, dedicated to Carol Owen Coleman (daughter of Jane Owen and Kenneth Dale Owen) in 1982. Within it is *Fountain of Life,* the sparse limestone work of David Rodgers, formerly of Bloomington, who also created the two limestone benches nearby. Off to the side is *For Carol,* a cast-bronze seat fashioned in 1983 by Texas sculptor Carroll Harris Simms (b. 1924). Also on the south side of North Street is the Cathedral Labyrinth, perhaps not precisely a sculpture, but nonetheless a huge circle of granite, more than forty feet in diameter, marked with a labyrinthian path based on a twelfth-century design discovered at Chartres Cathedral in France. Kent Schuette led the design team, and the layout of the garden is based geometrically on Chartres. Within the Sacred Garden, completed in 1997, is the *Orpheus Fountain,* created of Indiana limestone by British sculptor Simon Verity (b. 1945). The lyre-shaped fountain was installed in 1998.[184]

East of the Roofless Church across the north extension of Main Street is the Red Geranium Inn. On the exterior of the west wall is a colorful relief in the style of a medieval triptych. Carved of wooden boards laid side by side and fastened together, *Charlemagne* depicts the French king, a bishop, and courtiers with what appears to be a cathedral in the background. Artist William Duffy created the work in 1993.

Father Earl Rohleder's *Global Ethic* graces Angels Park in New Harmony.

Rudolf Schwarz's sailor statue on the Soldiers and Sailors Monument in Mount Vernon.

To the north in Paul Tillich Park is a large bronze portrait head of the theologian for whom the park is named. The piece was done by Pennsylvania-born sculptor James Rosati (1912–1988). The work was installed in 1967. Continuing around to the north side of Tillich Lake and past the Chapel of the Little Portion (not a sculpture, but, interestingly, designed by Stephen DeStaebler) is *Saint Francis and the Angel of the Sixth Seal* (1989), a mystical work in bronze by former monk David Kocka (b. 1950), a sculptor working in southern Indiana. Farther on, in the far northeast corner of the New Harmony Inn property near the Barn Abbey, is *Shalev: Angel of*

Compassion, a work of bronze framed by South Dakota granite, dedicated in 1993. The piece was created by Tobi Kahn (b. 1952) of New York. Back on the east side of the Red Geranium Inn is *Sky Dance,* a bright red steel abstract, all swirls like a ribbon blowing in the wind. It was created by Larry Reising with the assistance of local craftsmen Tom and Elmer Helfrich in 1985.[185]

In Angels Park at South and Main streets is *Global Ethic* by Father Earl Rohleder (b. 1937), a six-foot high open sphere comprised of seven crescents. It was the signature piece for Global Ethic Expo '98, an artists' festival dedicated to world peace and interdependence. The work was permanently installed in its present location in November 1998. It was joined a year later by an older piece that had originally stood outside the Atheneum. Evansville native Timothy Fitzgerald (b. 1955) completed *Quest for Harmony,* a Cor-Ten steel abstract work formed of rods, circles, and elongated triangles in 1999. The following year Rohleder created *Angels and a Visitor,* four rusted steel abstract figures that hold the carved wooden sign identifying the park. He also fashioned a painted steel bench, joined by two concrete benches embedded with glass mosaics, made by Jean Burnes.[186]

The county seat of Mount Vernon features a Soldiers and Sailors Monument more than fifty feet high on the west side of a courthouse, designed by F. M. Young and dedicated in 1908. The bronze figures are the work of Rudolf Schwarz (1866–1912). Four heroic military figures surround the base (Navy, Infantry, Cavalry, and Artillery), and the shaft is topped by a twenty-foot figure representing Liberty.

In the Bellefontaine Cemetery north of Mount Vernon is the grave of Alvin P. Hovey (1821–1891), a Posey County native who died while serving as Indiana governor. On his grave is a large bronze portrait in relief by John Walsh of Montgomery, Indiana, which was placed about 1893.

Saint Philip Catholic Church on the north side of State Road 62 displays statuary dating back to the 1910s or older.

PULASKI

In Pulaski County, what is not river and floodplain (much of which is state-owned recreational land) tends to be used for agriculture in this largely rural region. There is, however, a bit of sculpture in the county seat of Winamac. The courthouse, designed by A. W. Rush and completed in 1894, displays a number of odd faces amidst the vinelike ornamentation, all carved of limestone.[187]

With funding from the Pulaski County Community Foundation, the Pulaski County Historical

Society commissioned Pennsylvania sculptor Casey Eskridge to create a bronze piece for the courthouse square. Erected in 2002, *The Teacher* depicts an adult Native American engaged in teaching a child to fish from the Tippecanoe River. Eskridge grew up in Winamac and studied at the Herron School of Art in Indianapolis.[188]

Eskridge's piece is not the first effort to commemorate the Native American presence in Pulaski County. At the main entrance to Winamac's city park is a gateway built in 1934, designed by local sculptor Russell Rearick and constructed of native stones. The work was done as a New Deal project through the Civil Works Administration (CWA). For the summit of each of the two flanking pillars of the gateway, Rearick carved a three-foot-high Indian head of limestone. The one to the east is a defiant young brave wearing a single feather, and the westward one is an older chief in full headdress. Both represent the Potawatomi who once lived in this area along the river.

Saint Joseph Church in the little village of Pulaski on State Road 119 displays a replica of the Lourdes Grotto and shrine, constructed in 1954.

In the small town of Francesville off US 421 is Saint Francis Solano Church, built in 1951. In a niche above the entrance is a nearly life-size statue of Saint Francis that appears to be of concrete.

PUTNAM

Putnam County is a geological dividing line, clearly delineating where the glaciers of the Ice Age stopped. The county is filled with creeks and sandstone outcroppings. All of its sculpture appears to be in the county seat of Greencastle. On the courthouse square is *The Spirit of the American Doughboy* by Owen County native Ernest Moore Viquesney (1876–1946), erected in 1927 on a pedestal of mortared fieldstone. On the campus of DePauw University, near East College, a large bronze owl sits atop a pedestal. A fanciful

Winamac native Casey Eskridge created this tribute to the Potawatomi Indians who once lived in the area.

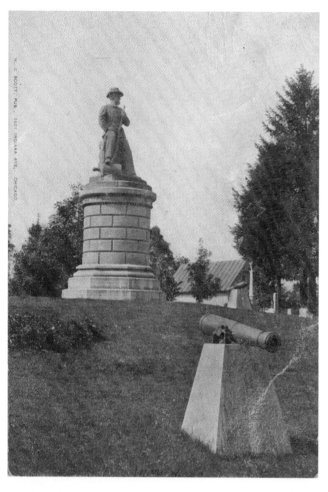

The first Civil War monument in Indiana to display a human figure was erected in 1870 in Forest Hill Cemetery outside Greencastle.

fish and basin indicate that once this piece was a fountain, although it no longer functions as such. The work was erected in 1903 as a memorial to a successful alumnus, Edward Scarritt, who died at the age of thirty-one in Tacoma, Washington, where he had just become president of the State Bank. His brother Winthrop, also a DePauw alumnus, donated the fountain, which today is a frequent target of students' pranks.[189]

Outside town in Forest Hill Cemetery is a Civil War Memorial featuring a seated soldier, an unusual pose and the only one found in Indiana. Dedicated in 1870, it is also one of the earliest Civil War monuments in the state and the first to use a human figure. The sculptor was Thomas D. Jones (1811–1882) of Cincinnati. Among the

many personages giving speeches at the dedication was Indiana governor Conrad Baker.

The pupils and community of Cloverdale Elementary School collaborated with Bloomington artist Joe LaMantia in 1999 to produce *New Horizons for Kids*. The whimsical piece of wood and metal depicts a huge open book, complete with bookmark.

RANDOLPH

Much of the county is what is often considered the quintessential Hoosier landscape of open farmland. (Indeed, there is even a town named Farmland!) All of the public sculpture in Randolph County appears to be of the military memorial variety. Even the small town of Ridgeville has a Soldiers Monument, erected in 1903, in Riverside Cemetery. It features a limestone sentry.[190]

On the northeast corner of the courthouse square in Winchester is one of the largest Civil War monuments in the state, the Randolph County Soldiers and Sailors Monument, dedicated in 1892. In form it follows what was becoming the most popular basic design (if a community had the funds to go the full route): a base surrounded by four military figures—Infantry, Cavalry, Artillery, Navy—with a tall shaft topped by a flag bearer (or other figure). The ornate granite monument itself, with its columns and crenellated battlements, was designed by A. A. McKain of Indianapolis. The life-size bronze statues and reliefs around the base of the monument are the work of the famous Illinois sculptor Lorado Taft (1860–1936). Ironically, the fund drive for the monument was begun with a two thousand-dollar behest from the estate of James Moorman, a Quaker who was opposed to war. The total cost was $25,100, a hefty sum in the 1890s. On the northwest corner of the square is Ernest Moore Viquesney's (1876–1946) *The Spirit of the American Doughboy*, erected in 1928 in honor of the veterans of World War I. It was restored in the 1990s.

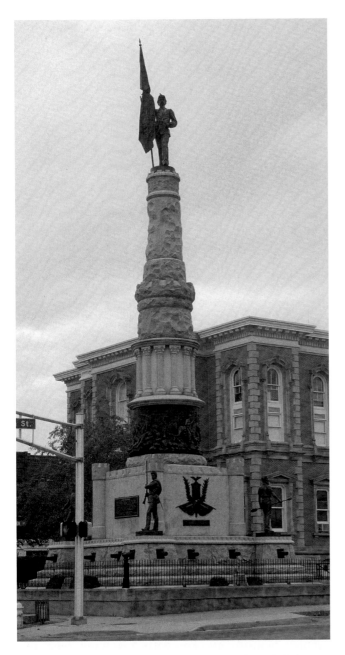

Lorado Taft's bronze sculptures adorn the Randolph County Soldiers and Sailors monument in Winchester.

RIPLEY

Until recently, hilly and stream-laden Ripley County had almost nothing in the way of sculpture apart from a few examples of religious statuary: a Crucifixion tableaux at the Saint Anthony of Padua Church in Morris and in the Saint Louis

Catholic Cemetery at Batesville. But Batesville in the last few years has experienced an explosion of public art, even spilling over the line into Franklin County.[191]

There has been considerable art activity in Batesville's schools, some of which has resulted in permanent outdoor pieces brightening the grounds, as well as several artworks that are exhibited within buildings. The Batesville Community School Corporation has a lively arts-in-education program that involves students, teachers, resident artists, and the community. *Sands of Time,* nicknamed "Voodoo Tower" by the students, was dedicated in front of Batesville High School (just within Franklin County on State Road 46) in October 1997. The piece calls forth images of the distant past with its carved sandstone faces, slab of limestone, and pillars resembling totem poles. Cincinnati artist Michael Jackson, assisted by Batesville artist Chaz Kaiser, Sharon Mulvaney of Sunman, and Rebecca Davies of Dillsboro, worked with the students to create the sculpture. *Waters of Time* (also known fondly as the "Fountain Mountain") is a multimedia fountain piece that took three years to complete, 1998–2001. Located in front of Batesville Primary School on State Road 46, just barely in Franklin County, the piece includes a wall of copper with numerous small copper sculptures affixed to it and a hand-painted fired brick patio. The resident artists were Kaiser and Davies, assisted by Mulvaney, Amy McCabe, and Sheri Focke of Batesville. Among the most recent projects is *Time Travelers,* which involved making castings of students, grades six through twelve, engaged in various school activities. Some of these are hung from the ceilings on the interiors of all four school buildings, but plans are to weatherproof others and place them in appropriate locations around the schools.[192]

In Batesville proper, the Batesville Beautification League, mindful of the town's Sesquicentennial in 2002, successfully worked with members of the community to beautify the center of downtown with a commemorative fountain, surrounded

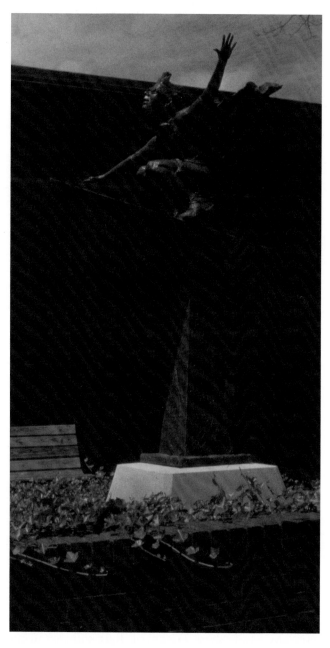

In 2002 this wonderfully appropriate piece was erected in front of the Batesville Memorial Public Library. *Paper Airplanes: Journeys of the Imagination* is the work of Gary Price.

is a message speaking of the hope for peace and harmony among mankind and between mankind and nature. Evidently the Beautification League so liked Price's sculptures that they purchased another, *Flower Girls,* which was erected in front of the fire station at Main and Catherine streets in 2003. In addition, a large work by Price, funded through the library board, was erected in 2002 in front of the Batesville Memorial Public Library on Walnut Street. *Paper Airplanes: Journeys of the Imagination* is a charming piece depicting a little boy atop a flying paper airplane, all clearly the daydream of a boy looking up from his book.[193]

RUSH

Rolling and river-strewn, Rush County remains largely agricultural and is especially noteworthy for its collection of covered bridges distinguished by their Italianate brackets. The little town of Moscow, however, boasted not only a covered bridge, but, until recently, an interesting portrait sculpture in its cemetery. John Owen's grave was marked by a nearly life-size limestone likeness of a handsome young man in the dress clothes of the late nineteenth century. Vandals knocked the statue over, and it is in pieces, awaiting future restoration. In Carthage, above the entrance to the public library that dates to 1902, is a large relief portrait of Henry Henley, almost lionlike with his wavy hair and beard. The face is surrounded by architectural scrolls and garlands, all covered with so many layers of paint that the material is impossible to determine. Henley was a prominent nineteenth-century farmer and mill owner in Carthage. The library sits upon what was once his land.[194]

Most of the county's outdoor sculpture is in Rushville, and almost all of it is commemorative in some fashion. A. W. Rush designed the courthouse built in 1896, and similar to his earlier courthouse in Winamac, this one also has faces carved amidst the architectural ornament. The faces on the north

by trees and flowers, designed by local architect Laura Dunbar. Water flows toward a circular basin, and surrounding bricks tell the history of Batesville. South of the fountain is a small bronze statue, *Children of Peace,* by Utah sculptor Gary Price. It shows a sister and brother back to back, joyfully dancing as they release doves. At the base

The cornerstone of the Rush County Courthouse touts the area's agricultural heritage.

facade are said to be those of the county commissioners. A cornerstone tablet in deep relief depicts a shock of wheat flanked by two cornstalks, indicating the prominence of agriculture in the county. At the Rush County Historical Society on North Perkins Street is a portrait medallion of Governor Samuel Bigger (1802–1846), who was born in Ohio but lived in Rushville for several years. The limestone portrait came from the English Hotel and Opera House in Indianapolis and was one of several governors' images that were removed and sold when the building was demolished in 1948.

Probably Rushville's most famous favorite son was Wendell L. Willkie (1892–1944), who ran for president in 1940 against Franklin D. Roosevelt. Willkie is buried in East Hill Cemetery, where his grave is marked with a simple granite cross on which is carved a crusader's sword. Nearby is a large open book in which are engraved passages from the treatise that he wrote in the 1940s, *One*

World. Before the book is a granite bench. All were the work of New York sculptor Malvina Hoffman, who was a friend of Willkie's widow. Also in East Hill is the marble gravestone of the Reverend James Havens and his wife Anna, both of whom died in 1864. The gravestone displays a very detailed portrait of the minister in high relief. Although allegorical female figures were not uncommon around the turn of the century, the one that guards the grave of Elisha King is unusual both for its size and detail. The sixteen-foot bronze statue representing Agriculture, holding a plow in one hand and a sheaf of wheat in the other, perches atop a twenty-foot granite pedestal. Erected in 1903, the figure is the work of a New York sculptor named Appel. In Calvary Cemetery on the McCoy family plot is a large Crucifixion scene in Italian marble, dating from the mid-1950s. Both cemeteries contain many fine examples of high funerary art.

A huge bronze figure representing Agriculture stands atop the grave of Elisha King in Rushville's East Hill Cemetery.

SAINT JOSEPH

In terms of sheer quantity of outdoor public sculpture, Saint Joseph County is second only to Marion County. The northern half of the county is largely urban, and nearly all the sculpture is concentrated within the South Bend-Mishawaka area. While the University of Notre Dame and its sister institutions are no doubt the largest contributors, a substantial ethnic Catholic population that generated considerable religious statuary, the South Bend campus of Indiana University, the South Bend Regional Museum of Art, and an active community of artists all add to the mix.[195]

There are a few scattered sculptures outside the urban area. The town cemetery of New Carlisle contains a Civil War monument featuring a life-size Union sentry in granite, erected in 1909. On the other side of the county in Osceola are the Chapel

Hill Memory Gardens, which contain several examples of the marble statuary imported from Carrara, Italy, usually found in these sorts of cemeteries, for example, a statue of Christ and a relief of the Last Supper. Less common is a life-size relief of the Four Chaplains, the World War II clergymen who gave their life jackets to others and went down with their torpedoed ship *Dorchester*. There is also a large relief of the Nativity. There are concrete reliefs of the Four Apostles and a statue of Jesus and the Woman at the Well; these are the oldest sculptures in the cemetery, about 1969. The marble pieces date from about 1978 into the early 1990s.

While a good deal smaller than its "twin" city South Bend, Mishawaka offers up a fair amount of public sculpture. In Shiojiriniwa Gardens, a Japanese garden on East Mishawaka Avenue, is a sculpture of four children (two boys and two girls) in bronze, seated on granite benches that form a circle. One pair is Caucasian and the other Japanese. Installed in 1987, it is the work of Japanese artist Hidekazu Yokozawa.

In honor of the five hundredth anniversary of the arrival of Christopher Columbus in the New World, local artist David M. Layman (b. 1959) created a bronze statue of the explorer in Central Park in 1992. A little larger than life, he holds a globe in one hand and maps in the other. To the west in Battell Park is a Civil War monument erected in 1884, with a heroic figure of a sentry in white bronze (a zinc alloy) on a twenty-foot pedestal. The park also contains a fanciful fieldstone creation that today would likely be considered environmental sculpture. Built in 1936–37 by Works Progress Administration labor, a long, terraced rock garden and water feature cascades from the main section of the park along Mishawaka Avenue all the way to the Saint Joseph River, some one hundred fifty feet. Battell Park is listed in the National Register of Historic Places. Across the river at Logan Street and Lincolnway West in a small park called Kate's Garden is a large bronze work by Harold R. "Tuck" Langland (b. 1939), professor emeritus at Indiana University South Bend. The *Educators,* dedicated in 2000 and funded by the Mishawaka Art in Public Places Com-

mission, is comprised of two classically inspired but stylized figures reaching toward each other, forming an arch. The piece speaks of the passages of life as well as that of education.[196]

At Gateway Park at the south end of the Main Street bridge is *The Immigrants,* a painted steel sculpture by California-born Kathryn Field. The fragmented piece consists of two parts in silhouette, approximately thirty feet apart. One group depicts an immigrant family in motion, gesturing upward toward an array of banners whipping in the wind, symbolizing their search for a new beginning. The second group portrays life-size figures of an elderly woman seated on a bench and a young girl standing before her, listening, perhaps, to her tale of coming to America. Erected in 1993, the sculpture is readily visible to the traffic rushing by, but is also accessible (with a little effort) to pedestrians.

In the new Beutter Park on the riverfront, created in the space once occupied by the vast UniRoyal plant (demolished in 2002), is a large abstract of stainless steel polished to a mirror finish. The many-faceted work resembles giant crystals coming out of the water on two tall towers more than twenty feet high. Created by Indianapolis artist Jan Martin (b. 1948), *River Shards* was installed in late 2004.

Not far away, on a peninsula behind the Mishawaka police station, a stainless steel interpretation of a soaring eagle is to be placed in the spring of 2005.

At the city hall on Third Street is a life-size bronze figure of an Indian woman with windblown hair, reaching for an arrow to place in the large bow she holds. This is *Princess Mishawaka,* the legendary figure for whom the city is named, a young woman who appears to combine the attributes of Joan of Arc and Pocahontas and more. Pakistani-born Sufi Ahmad (b. 1936) of Fort Wayne completed the work in 1987.

Tuck Langland's *Educators,* a tribute to teachers, stands in Kate's Garden in Mishawaka.

The Saint Francis Provincialate—home of the Sisters of Saint Francis of Perpetual Adoration—on Dragoon Trail contains several religious sculptures, the most recent a lively depiction in bronze of Saint Francis of Assisi surrounded by birds. *Spirit of Saint Francis* was created by Ahmad in 1997. Two other castings were made at the time, and the Sisters decided to commission more for the several hospitals around the state that they began to acquire in the late 1990s. As of the end of 2004, twelve of Ahmad's renditions were located throughout Indiana. There are two other figures of Saint Francis on the grounds, one dating to 1944, as does a life-size limestone figure of the Sacred Heart of Jesus. Also dating to that time are limestone Stations of the Cross, which flank a Crucifixion scene of cast concrete. The Grotto of Our Lady of Lourdes is constructed of limestone, with a six-foot statue of Mary, placed in 1947, and a stone statue of Saint Bernadette, acquired three years later. *Our Lady of the Poor*, in front of Our Lady of Angels Convent, was a gift in 1972 and is said to have been made in Belgium. A number of smaller religious statues dot the grounds as well.[197]

Saint Joseph Church on South Mill Street displays a life-size marble statue of the saint dating to 1910. Not far away, Saint Joseph Hospital has a life-size statue of Saint Joseph made by the family-run Gast Monument Company in Chicago in 1918. Originally it was placed over the front entrance to the hospital. Then, nearly thirty years later, it was mounted on a pedestal in front of the entrance on Fourth Street. In 1970 the statue was relocated into the lobby of the new hospital, but in 1985 it was moved outside to its present site in the courtyard of the new addition.

South Bend has many statues of a religious nature, most by unknown artisans, although local artists have created several. Not all are at Roman Catholic institutions. In a small meditation garden at Grace United Methodist Church on South Twyckenham Drive is a Guardian Angel by Henry R. "Hank" Mascotte of Notre Dame. The piece, a stylized angel hovering protectively over two chil-

dren, is of cast concrete, installed in 1994. Another cast-concrete angel by Mascotte, this one in relief, marks a forested burial site at Hilltop Lutheran Church of the Ascension on South Ironwood Road. *Angel in Flight* was placed in 2001. Mascotte also created *Cross and Shield* for the local offices of the Diocese of Fort Wayne-South Bend on Wayne Street in 1993. Four cast-concrete panels embedded with glass mosaic and an imprint of the diocesan shield form a negative cross and circle at the second-story level. Just above the entrance is another rendition of the diocesan shield, again of cast concrete embedded with glass mosaic.[198]

On Saint Joseph Church on Hill Street is an eight-foot Saint Joseph the Worker and the Child Jesus by Ohio-born sculptor Theodore Golubic (b. 1928). The slightly stylized limestone figure was installed in 1965 on the newly erected church. In 1951 Hungarian-born Eugene Kormendi (1899–1959), who was a sculptor-in-residence at Notre Dame, created a relief figure of Saint Michael as a war memorial for Our Lady of Hungary Church on Calvert. The church also displays a heroic figure of the Madonna high on its tower, erected in 1960. A block to the east, a limestone Madonna and Child stands high in a niche at the cornice line of the school, dating to its construction in 1927. Saint Patrick Catholic Church on Taylor Street features a life-size bronze figure of the Sacred Heart of Jesus by Father Anthony J. Lauck (1908–2001), who headed the sculpture department at Notre Dame for many years. The statue was dedicated in 1969. The church was completed in 1886, and the gilded figure of Saint Patrick, high in a niche just beneath the gable, dates to that time. Nearby Saint Hedwig Church, built five years earlier on Scott Street to serve the growing Polish population, has three outdoor pieces, the oldest a large painted metal figure of the Sacred Heart of Jesus that probably dates to around the turn of the twentieth century. In 1946 a painted metal Crucifixion scene was erected as a veterans memorial, and a small limestone Grotto of Our Lady of Lourdes with life-size figures of Mary and Saint Bernadette was constructed in 1954. Saint Casimir Church to the southwest, the second Polish parish established in South Bend, displays a painted metal

Father Anthony J. Lauck of Notre Dame created this Sacred Heart of Jesus for Saint Patrick Church in South Bend.

tor on her nest of five baby birds with a sunburst effect in the background. In 1919 a life-size Jesus Christ the Arbiter was erected on the northeast corner of the church property. At the time, the present church had not yet been built and the parish was served with a combination church and school building. The Carrara marble figure was badly vandalized in the 1980s, and to disguise the repairs a local sculptor applied a light coating of concrete mortar. The statue is said to be based on a nineteenth-century work by Danish sculptor Bertel Thorwaldsen (1770–1844). A life-size statue of Saint Michael the Archangel, his foot resting on the devil's head, was erected in 1951 as a parish war memorial. Between the school and the church is a life-size marble figure of the Blessed Mother, her foot treading on a serpent. Saint Stanislaus Church on Brookfield Street displays a life-size metal figure of Christ the King, dedicated in 1950 to celebrate the church's jubilee (fiftieth anniversary). In 1962 stonemason William Buckles constructed a Lourdes Grotto of fieldstone to the design of Chester L. Jankowski. The life-size figures of Mary and Saint Bernadette are joined by a small statue of Saint Joseph nearby.

Saint Anthony of Padua Church on East Jefferson Boulevard features a heroic marble figure of Christ on a steel-reinforced granite cross, a giant crucifix by Andrew Maglia (1905–1974) of Detroit. It was erected when the church was built in 1959. Outside the adjacent school is a marble figure of the Sacred Heart of Jesus, probably dating to 1949, when the school opened. Holy Family Church displays a small, slightly stylized interpretation of the Nativity scene, installed about 1991 near its Mayflower Road entrance. At the southeast corner of the church grounds at Western Avenue (State Road 2) is a version of the Madonna and Child, dedicated in 1988.

In the Hungarian Sacred Heart Cemetery on State Road 2, established in 1928, is a life-size figure of the Sacred Heart of Jesus. Across the road in Saint Joseph Cemetery is a large carved granite crucifix dating to 1904. Flanking the entrance to the chapel, built in 1940, are life-size limestone figures

statue of the saint. On the church itself, completed in 1925, is a stone figure of Saint Casimir in a niche, as well as four angels on the bell tower and a cherub just beneath the north gable. To the north on the former Saint Stephen School on Thomas Street is a heroic limestone figure of the patron saint in a niche above the entrance, dating to the 1920s.[199]

Saint Adalbert Roman Catholic Church, built in 1926 at the corner of Olive and Huron streets, displays the greatest number of outdoor pieces. On the church itself are beautiful limestone reliefs above the triple-arched entrance. The center tympanum features Saint Michael the Archangel atop a conquered demon. One of the reliefs on the side features a lamb resting across a Bible, its foot holding a combination cross and crook. The symbolism of Christ is obvious here. The other relief is carved with a rap-

of Mary and Joseph. There also, Notre Dame art professor Derek Chalfant recently completed a "Life Memorial," commissioned by the Knights of Columbus, as well as a "Children's Memorial." In Riverview Cemetery on Portage Avenue is a six-foot granite statue of Christ standing on a columbarium (a small mausoleum to hold ashes in urns). One of the few examples of classically inspired sculpture in the county is in nearby Highland Cemetery in the limestone pediment of the entrance to the mausoleum, patterned after a Doric temple front. Erected in 1929, the pediment contains seven female figures in high relief. Both Highland and Riverview cemeteries contain many fine examples of funerary sculpture.

The Erskine Manor Home, convent of the Sisters of the Holy Cross, has several pieces of religious statuary on its grounds, including a seven-foot marble figure of Mary from Italy, a life-size statue of the Blessed Mother and Jesus, and a slightly larger-than-life image of the Sacred Heart of Jesus, all dating to the late 1950s.[200] Mishawaka artist David M. Layman sculpted the *Caregivers Diptych* in front of the Saint Joseph Care Center on West Washington Street. One panel shows Joseph with the Child Jesus; the other portrays two nurses with a patient. Saint Joseph High School at Angela Avenue and old US 31 (North Michigan Street) displays a life-size marble statue of Mary.

Christ the King Church is on old US 31 in Roseland, the suburb immediately north of South Bend. Completed in 1961, the facade of the church features a seven-foot bronze figure of Christ the King. A life-size marble figure stands in front of the building, below the name.

In October 2001 the twenty-fifth *Angel of Hope* in the country was dedicated in South Bend in Pinhook Park, part of a nationwide phenomenon that began with the 1995 publication of Richard Evans's book *The Christmas Box*. The author, after repeatedly being asked about the angel statue that plays an important role in the story, decided to commission one, enlisting the father and son sculptors Jared and Ortho Fairbanks of Salt Lake City, Utah. Evans

makes the bronze angel figures available at cost to groups who want to erect one in a community.[201]

Temple Beth-El, near downtown at Lafayette Boulevard and Madison Street, established a small sculpture garden in 1999, with pieces suggestive of, rather than directly conveying, religious themes. The city's second George Rickey (1907–2002) sculpture, *Two Open Triangles, Up Gyratory IV*, originally created in 1986, is installed on the temple's terrace. The interplay of its constantly moving triangles, sensitive to the slightest breeze, suggests to many the Star of David. Janet Berman, the benefactor who made the sculpture garden possible, commissioned Kalamazoo artist Kirk Newman to create *Woman and Child*, a portrayal in bronze of a grandmother and her grandchild seated on a bench, reading a prayer book. A third piece, *Tree of Life*, was installed the following spring. The sculpture, a collaboration of Los Angeles artists Sharron Gale and Marilyn Simon, was inspired by an ancient symbol for the Torah. It is a highly stylized bronze tree, nearly ten feet high.[202]

A painfully poignant Holocaust memorial was dedicated in 2003 at the Jewish Federation of Saint Joseph Valley. Of black granite imported from India, *Broken Lives* was carved by Gary Sassi of Vermont from a design by Steve New, son of the memorial donor. The piece as a whole resembles the Hebrew word for life, "chai," and from it four faces appear to emerge in a wisp of smoke.

The architectural firm of McDonnel and Son from Buffalo, New York, designed the Saint Joseph County Soldiers and Sailors Monument, topped with a ten-foot-high bronze statue of a flag bearer and featuring heroic figures of Infantry, Cavalry, Artillery, and Navy on the base. The bronze pieces are the work of Austrian sculptor Rudolf Schwarz (1866–1912), who came to the United States in 1897 to work on the Soldiers and Sailors Monument in Indianapolis. Schwarz decided to stay in America, and the South Bend monument, dedicated in June 1903, was his next large commission in Indiana. Originally the monument stood on the southeast corner of the courthouse square, which put it in the way of the new County-City Building erected in

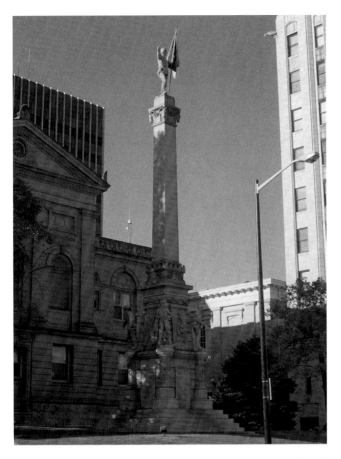

The Soldiers and Sailors monument in downtown South Bend used to stand on the other side of the old courthouse.

1967. The huge monument was carefully dismantled and stored at the county home for the next five years. After much wrangling about a new location, the monument was reerected on Washington Street just west of Main Street and rededicated in 1973. The eight-foot sheet-copper replica of the Statue of Liberty, originally erected by the Boy Scouts in 1951 on the north side of the courthouse, was also relocated at that time to its present site in front of the east entrance on Main Street. There are two other Civil War monuments in South Bend, both in City Cemetery off La Porte Avenue and within sight of each other. The first one was erected in 1911 by the local chapter of the Women's Relief Corps and dedicated to the "unknown soldier and sailor dead." A life-size Union sentry in granite stands atop a pedestal (the statue is now headless). Three years later the same organization erected a similar, but not identical, monument, this one dedicated to all veterans of the Union army.

A plaza at the north end of downtown east of the Morris Center for the Performing Arts is all that remains of an ill-conceived downtown mall experiment in the 1970s. Tuck Langland's *Violin Woman* was originally erected on a fountain base in 1982, but it deteriorated after only a few years, and the surreal sculpture was moved onto a new foundation a few feet to the west. In early 2005 *Violin Woman* was moved to the southwest corner of the plaza, cleaned, and lit for greater visibility. The bronze work is a somewhat abstracted violin that clearly shows its similarity to the female form. Nearby is *Trilithon* by local artist Robert Kuntz (b. 1925), who was inspired by Stonehenge. Installed in 1974, the ten-foot welded-steel work consists of hollow rectangular forms stacked into a hulking monolith.[203] This piece suffers a severe identity crisis. In a recent artist résumé, its name is given as *Megalith,* and in a 2004 article in the *South Bend Tribune,* it is unimaginatively titled *Rectangles in Metal.*

Another piece that had been installed in the downtown mall in the 1970s was moved when Michigan Street was reopened to automobile traffic. The painted metal abstract work by Michigan artist Douglas Gruizenga now stands in front of the main post office, a block south of its original site.

Dedicated in March 2005, a wonderfully warm bronze figure of legendary coach Knute Rockne crafted by Texas artist Jerry McKenna (b. 1937) stands outside the College Football Hall of Fame downtown.

The South Bend Regional Museum of Art, which is part of the Century Center Complex, has a small permanent collection of outdoor pieces, including *Dialogue* by internationally known sculptor George Rickey, who was born in South Bend. Acquired in 1998, the kinetic aluminum piece, consisting of two pairs of joined triangles, is mounted on the front of the museum building. A painted steel piece, *Graffiti,* by Bloomington sculptor Jerald Jacquard, was installed between the entrance drive and the street in 1996. The piece, actually fabricated twenty years earlier, is an abstracted figure about ten feet high and painted blue. *Balanced Trap* by Lee C.

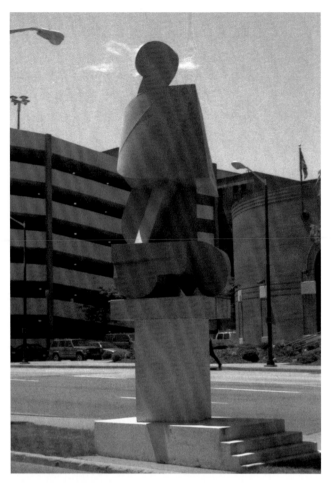

Greeting visitors to the South Bend Regional Museum of Art is Bloomington artist Jerald Jacquard's *Graffiti*.

Smith III was acquired in 1990 and moved from its original site when the museum added a new wing. It now is at the northwest corner of the building and is an assemblage of found objects and sculpted parts, set into a planting.[204] *Lightning Arrow*, created by Goshen artist John Mishler in 1990, stands more than eight feet high and, typical of the artist's work, has a kinetic component. The piece, which has zigzag and arrow elements that suggest the title, is painted black and white. The present piece replaces a smaller version that was placed in front of the museum two years earlier. On a concrete pedestal in the Saint Joseph River is celebrated artist Mark diSuvero's (b. 1933) controversial sculpture, *Keepers of the Fire,* which is the English translation of the tribal name Potawatomi, the native people who once lived in the region. Installed in 1980, the bright

orange abstract made of steel I-beams stands more than thirty feet high, with dangling elements that respond to the wind. Time has eased its acceptance by the community, although it is far from universally loved.

The alumnae of the Memorial Hospital School of Nursing, which closed in 1989 after nearly a hundred years, commissioned David M. Layman to produce *The Spirit of Nursing.* The commemorative statue was dedicated in 2001 in a small plaza near the hospital. It depicts a nurse dressed in the garb of 1894, the year the school originally opened as Epworth Hospital and Training School. At Madison Center, a mental health facility off Niles Avenue across the river east of downtown, is a kinetic abstract work of steel, stone, and water called *Greeting Party,* dedicated in 2000. Designed by Eric

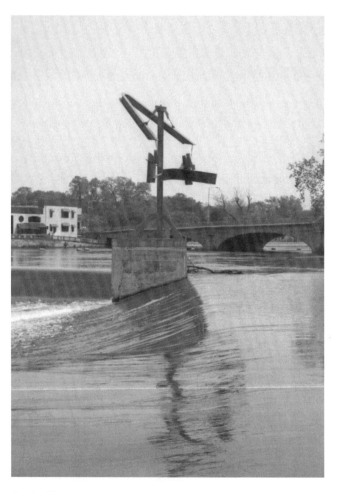

Mark diSuvero's controversial *Keepers of the Fire* stands in the river outside South Bend's Century Center.

Ernstberger of Muncie, the piece consists of dozens of shiny and somewhat flexible upright wings, burnished or etched with various markings and set into two tiers of river stone from which mist sprays. Taken as a whole it is suggestive of a group of people engaged in conversation.[205]

An abstract eagle fashioned from angle iron called *Pride in the Land* was installed in Leeper Park in 1985, the work of Robert Kuntz. Kuntz, who was born and raised in South Bend, was commissioned in 2002 to create *The Freedom Memorial: Standing Tall,* an installation near the Center for Performing Arts in Saint Patrick County Park, commemorating the victims of the terrorist attacks of September 11, 2001. It was dedicated in 2003 on the second anniversary of the attacks. The memorial also symbolizes the planting of new trees, replacing the many that were destroyed in a tornado and a devastating ice storm in subsequent months.[206]

A memorial to fallen firefighters was unveiled in July 2004 in Seitz Park on the East Race. Accompanying a large granite tablet on which the names are carved is an evocative bronze sculpture by Ron Pekar of California. It features two slightly larger-than-life figures of firefighters, one climbing a ladder and the other at the top reaching out to the one coming up.

In Howard Park, east of downtown across the river, is the Vietnam Veterans Memorial designed by Jed Eide and dedicated in 1989. The stark abstract assemblage of long black granite blocks suggests, according to the artist, an exploding shell. Each of the five angled stones represents a branch of the armed services, and the monument sits on a star inside a pentagon.

The campus of Indiana University South Bend displays several outdoor sculptures. The earliest is one of the few abstract works in steel by Tuck Langland, who most often works in bronze and in a representative, albeit stylized, mode. *Ring Ribbons II* was erected in 1973, a gift from the graduating class of that year. In 1987 a work by John Pontius, a student of Langland, was permanently installed on a base left over from an exhibition a few years before.

Reaching is a bronze figure a bit larger than life, stretching and reaching upward toward the sky. Langland's *Memory,* a draped female head and upper torso of bronze, prominently located in the middle of the campus, was dedicated in 1999, a tribute to deceased students, faculty, and staff of the university. Langland's latest work for the campus, dedicated in 2003, his final year of teaching at IUSB, may be his most ambitious. *Crossroads,* clearly inspired by Celtic standing stones, is a curving line of rough-quarried upright limestone running from the Administration Building to the Schurz Library, passing the new Student Services Building, where there is a fountain pool containing two large limestone blocks. Standing atop the stones are a man and a woman in bronze, each holding one end of a scarf, reaching toward each other across the water.[207]

Several blocks west of the campus on Mishawaka Avenue at Beyer Street is another piece by Robert Kuntz, an abstract assemblage of chrome bumpers welded at various angles. More than seven feet high, the work was installed on this busy corner in 1998. On the south side of town at the Erskine Plaza Shopping Mall on Ireland Road is a swooping abstract of Cor-Ten steel about seven feet high, a series of curvilinear pieces forming loops. The artist, William Allen, was living in Saint Joseph County when the piece was installed in 1982, but later moved to Traverse City, Michigan.[208]

In the last decade the line between commerce and art, already blurred, has grown more so. Commercial design companies, either created by artists themselves or who maintain a cadre of artists who create pieces either individually or as a team, are becoming more common. The Exoscope Design and Fabrication Company of Florida created a unique fountain for the Woodwind and Brasswind, a musical instrument distributor located in an industrial park near the airport. In the middle of a pond, surrounded by spouting water, are two perfectly formed, fourteen-foot musical instruments, a trumpet and a saxophone. The pieces were initially carved from foam over a steel framework, then coated with urethane.[209]

The South Bend Regional Airport (formerly Michiana Regional Airport) consistently features a collection of temporary installations of monumental abstract works. Begun in 1998, the *Sculpture at the Airport* program displays nine works of regional artists for a period of two years along the winding drive to the terminal. People encounter art in an unexpected place, and the site functions as a gallery since the pieces are all for sale.[210]

Saint Mary's College is located on a beautiful wooded campus north of South Bend and directly west of its sister institution, the University of Notre Dame. Marble busts of Dante, Socrates, and Plato that once topped the shelves of the old library and probably date at least to the late nineteenth century now decorate the facade of the new library, built in 1982. The grounds display a large number of traditional religious statues, most by unknown artisans. A large marble figure of Our Lady of the Immaculate Conception graces Holy Cross Hall, built in 1904; a life-size Our Lady of Fatima dating to 1948 stands on a little island in Lake Marian; a life-size marble statue of Saint Anthony dates to 1931; a nine-foot Saint Michael was made in 1905; and a concrete figure of Saint Therese of Lisieux (the Little Flower) dates to about the same time. The cemetery on the west side of the campus displays statuary that once was inside the Our Lady of Loreto Church, built in 1885: two beautifully rendered marble angels that once held up the altar and two of limestone in an attitude of prayer. A heroic limestone figure of *Our Lady of the Trinity* is the only work in Indiana of noted New York sculptor Lee Lawrie (1877–1962). Completed in 1926, the statue was installed in a niche above the entrance to Le Mans Hall. In 1954 Sister Monica Gabriel completed a life-size figure *Christ the Teacher,* originally dedicated in front of the old library. She was assisted by Croatian sculptor Ivan Mestrovic (1883–1962), who was in residence at Notre Dame in the 1950s. The work now stands on an island in Lake Marian. The campus has several other smaller religious figures about the grounds.

At the Holy Cross Province Center south of Saint Mary's is a nine-foot limestone statue of Saint Joseph the Educator and the Child Jesus, surrounded by a wall of carved relief panels of liturgical symbols. Croatian sculptor Joseph (Josip) Turkalj (b. 1924), who studied with Mestrovic at Notre Dame, completed the work in 1966. Atop the maintenance garage at the far western edge of the Holy Cross campus are two gargoyles—they are capable of squirting water, but only for fun—based on those on the Cathedral of Notre Dame in Paris; a third sits on the ground nearby. They were fashioned about 1973 by Brother Richard Weber (1936–1999), who was head of the maintenance department.

Across old US 31 is the former Fatima Shrine and Retreat Center, built in the early 1950s. The Retreat Center closed in 2004 and became a retirement facility for Holy Cross priests and brothers. Carved of Italian marble by Luisi of Pietrasanta, Our Lady of Fatima, with the awed children and peaceful sheep before her, was designed by the Carl Froehle Company of Cincinnati and dedicated in 1952. Over a period of a few years, the same artists created a Way of the Cross. The twelfth station is a bronze crucified Christ on a wooden cross, which was installed about 1956. A life-size Orbronze (a sheet metal alloy) statue of Saint Joseph, the patron of the Holy Cross Brothers, was erected in 1955.

Moreau Seminary adjoins the campus of Notre Dame. Its Community Cemetery displays a roughly life-size painted metal Pietà, erected after World War I, a memorial to those who died overseas. A life-size figure of the Sacred Heart of Jesus stands in a niche above the entrance to Saint Joseph Hall, built in 1920. In the woods west of Saint Joseph Hall are the Stations of the Cross. The twelfth station features a Crucifixion scene with a seven-foot figure of Christ and life-size figures of the mourning Mary and Saint John. The statues are painted metal and were erected sometime before World War II.

The south wall of the chapel and library of Moreau Hall is a two-story artwork of stained glass interspersed with forty-three carved limestone panels depicting biblical figures, such as Jonah and the whale, and various symbols, such as carpenter's tools. Some of the panels are duplicated. Indianapolis-born

Father Anthony Lauck, head of the university's art department for many years and the first director of the Snite Museum of Art, designed the stained glass and the limestone panels and executed the work in 1957–58 with the help of his students. In the courtyard of the building are several artworks, including another by Lauck, *Prayer*, which he described as a monument to the act of prayer of all people. Installed in 1959, it is a stepped block of limestone with cryptic, runelike marks on all sides. In 1964 artist-in-residence Waldemar Otto (b. 1929) created a disturbing and highly stylized interpretation of the *Pietà*, an angular work in bronze. On the wall facing the courtyard is a bronze heroic relief of the hand of Christ and the profile of his face. The dramatic piece, installed in 1969, was the work of Montreal sculptor Louis Parent (1908–1982). The most recent sculpture installed at the seminary is the work of Father James Flanigan (b. 1935), a cast-stone piece called *Seat of Wisdom*, installed in 2000.[211]

On the south wall of the seminary is a work by David Hayes (b. 1931), completed in 1961, called *The Descent of the Holy Spirit* or *Tongues of Fire*, which is a good description of the overall effect of the piece. Of copper, it is actually a roughly crescent-shaped formation of abstract doves descending. Hayes graduated from Notre Dame in 1953. Many years later, in conjunction with a one-man show at the Snite, Hayes created *Griffon*, an abstraction of the mythical creature, installed outside the building in 1989. A more recent Hayes piece, *Vertical Motif #3*, stands more than ten feet high in the courtyard of the museum.[212]

Most of the abstract pieces on the Notre Dame campus congregate at or near the Snite Museum, opened in 1980, or amidst the buildings to the south, the most recently developed area of the university. Also in the courtyard is one of George Rickey's kinetic pieces, *Two Conical Segments Gyratory Gyratory II*, created in 1979. Recent sculptures in the new part of campus include Arizona artist Moira Geoffrion's (b. 1944) cast-bronze work *It Is Time to Take a Stand*; *Kanzan*, a welded-steel piece by California artist Michael Todd (b. 1935), com-

pleted in 1974; and a six-foot stone-and-steel work called *Cassopolis Passthrough* by Kansas-born Glenn Zweygardt (b. 1943). Zweygardt has another piece on campus, installed in 1983 east of the Hesburgh Library along Juniper Road. It is a nineteen-foot abstract of black painted Cor-Ten steel called *Upheaval X*. Acquired in 1997, *Hoosier Totem #3* by Bloomington sculptor Dale Enochs (b. 1952) stands near the Hesburgh Peace Center.[213]

Erected in 2004 were four abstract works by Edward McCullough (b. 1934), part of his series inspired by the poem cycle *The Duono Elegies*, written by Rainer Maria Rilke in the early twentieth century. All are approximately four feet tall. Three of the pieces, all of Cor-Ten steel, stand between O'Shaughnessy Hall and Decio Hall. The fourth work, which is stainless steel, is east of the Medoza College of Business.

Sculpture abounds on the Notre Dame campus, and while a majority of the works do have a religious theme, many are contemporary. For decades Notre Dame has had a strong art program and often famous artists-in-residence, among them Hungarian Eugene Kormendi and Croatian Ivan Mestrovic. Mestrovic left a huge body of work at Notre Dame, filling an interior gallery as well as a sculpture garden, the Shaheen-Mestrovic Memorial, which features three of his large bronze pieces that originally had been installed in the courtyard of O'Shaughnessy Hall. The works of Jesus and the Samaritan Woman, Saint Luke, and Saint John have a massive quality that makes them seem more like stone than bronze. They were completed in 1957. Another Mestrovic work, a small Madonna and Child, is in the courtyard of Lewis Hall.

Mestrovic's successor, Polish-born Waldemar Otto, produced several pieces for the campus, many in interior settings. Otto's *Jeremiah*, a highly stylized interpretation of the Old Testament prophet bending beneath a yoke, was originally exhibited inside the art gallery in 1964, but was later installed outside Grace Hall, a dormitory. The campus has two outdoor pieces by Father Austin Collins, a member of the art department faculty, who primarily does

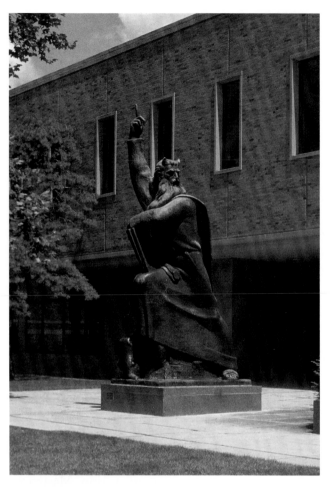

The famous bronze figure of Moses stands outside the Hesburgh Library at Notre Dame.

abstract work. *Firestone Necklace,* a three-piece work of mild steel, was erected in 1989 at Fisher Hall. Installed two years later outside Howard Hall is *Homage to Nevelson,* a seventeen-foot abstract of black-painted Cor-Ten steel.

One of the sculptural landmarks on campus, erected in 1962 on the west side of the Hesburgh Library, is the monumental *Moses,* by Joseph Turkalj. The eighteen-foot bronze statue depicts an authoritative Moses with a flowing beard and his hand in the air, finger pointing to the heavens as he clutches the Ten Commandments to his chest. Fans of the legendary Notre Dame Fighting Irish football team contend that the gesture indicates "Notre Dame Is Number One." A statue that directly relates to football is the heroic bronze figure of famed coach Frank Leahy (1908–1973),

erected on the east side of the stadium along Juniper Road in 1997. Joining him across the road outside the Joyce Center a few years later was Edward "Moose" Krause (1913–1992), who played both football and basketball under Knute Rockne, ultimately becoming Notre Dame's athletic director for more than thirty years. He is depicted sitting on a park bench. Both statues are the work of Texas sculptor Jerry McKenna, a graduate of Notre Dame in 1962.[214]

Eugene Kormendi, a pupil of Rodin, fled wartorn Europe with his wife in the early 1940s and became artist-in-residence at Notre Dame. He left a lasting legacy in the numerous limestone statues that he created for niches on campus buildings as part of a university beautification program. Kormendi's figures of Saint Thomas More and Christ the King grace the Law Building, and Lyons Hall displays his statue of Saint Joseph, who was the patron saint of the man for whom the building was named, Professor Joseph Lyons. The Saint Andrew statue on Morrissey Hall is Kormendi's work, as are the two statues on the student infirmary, Christ the Good Shepherd, holding a lamb, and Saint Camillus, sometimes interpreted as Saint Raphael the Archangel. He carved the Saint Christopher statue on Rockne Memorial Hall. The building, constructed in 1937, also has portrait medallions of explorer Renè Robert Cavelier Sieur de LaSalle and Chief Leopold Pokagon, as well as depictions of twelve different athletes in relief. It is possible that Kormendi also did the figure, sometimes identified as Saint Thomas, on the Cushing-Fitzpatrick School of Engineering. On Alumni Hall is Kormendi's *The Graduate,* sometimes called "Joe College," and he probably did the Madonna and Child on the same building. Father John J. Bednar (1908–1998), who was head of the art department and introduced sculpture into the curriculum, also created statues for the building: Saint Thomas Aquinas and Saint Bonaventure. Unattributed are several limestone panels in high relief, including one of legendary coach Knute Rockne (1888–1931), two Irish terriers, three seated scholars, and three gargoyles extending out from the tops of the decorative

The figure of legendary coach Knute Rockne occupies a niche on Alumni Hall at Notre Dame.

vertical bands of limestone near the corners. Dillon Hall, too, features works by both sculptors. Kormendi carved the statue of Commodore John Barry, and Bednar the figures of Saint Augustine, Saint Jerome, Saint Patrick, and Cardinal John Newman. Some unattributed figures are also on this dormitory: a pair of robed scholars above the main entrance and a number of highly stylized crouched athletes above other entrances and some of the niches.

The Dining Hall, built in 1927, has a relief of a Plains Indian over the west entrance, and two little baseball players flank the entrance. The main north facade of the building features a relief medallion of an eagle. Howard Hall is watched over by the figure of Saint Timothy, which was carved in 1942 by a student, James Kress of Detroit. In 1944 Bednar completed the figures of Saint Michael the Archangel and Saint Joan of Arc, which put the finishing touches on a war memorial created in 1923 at the east entrance of the Sacred Heart Basilica. The Clark Memorial Fountain,

designed by architects John Burgee and Philip Johnson (1906–2005), was dedicated in 1986 to commemorate the Notre Dame alumni who died in World War II, Korea, and Vietnam. Students refer to it as Stonehenge, and its four limestone arches, standing in a rectangular pool constructed of black granite, certainly do suggest the megaliths of the ancient British site. In the center of the pool is a large brown granite sphere.

Greeting visitors at the main entrance to the campus south of the Main Quadrangle is *Our Lady of the University* by Father Anthony Lauck. The piece, while clearly modern, was influenced heavily by medieval art. It originated as a work in limestone, dedicated on the spot in 1954. The limestone did not hold up well through the northern Indiana winters, so ultimately it was removed, and a bronze casting of the piece was made in 1992 and placed on the original pedestal. The original limestone statue was repaired and placed in the foyer of the new DeBartolo classroom building the same year. Lauck's final

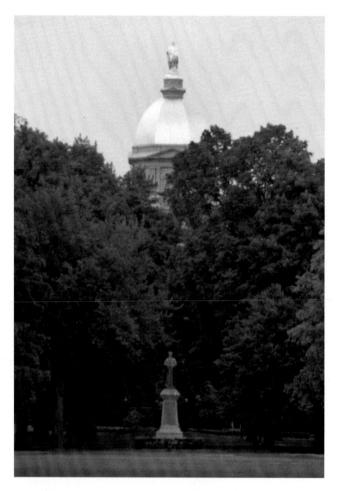

Welcoming visitors to Notre Dame is Our Lady of the University with the glorious Golden Dome topped with a statue of the Immaculate Conception in the background.

outdoor work on campus was an enlargement of a small terra cotta statue he had made in 1953. Called *The Visitation*, it re-creates the event of Mary going to see her cousin Elizabeth just after the Annunciation. The bronze work, depicting the two women embracing each other, was dedicated in 1999 on the south side of the Hammes Bookstore. Nearby, on the Eck Center, is Father James Flanigan's cast-stone statue of Blessed Brother Andre, dedicated the same year. Flanigan also created the bronze work *Christ Teaching*, a very approachable interpretation of a beardless Christ that seems to invite viewers to come sit at his feet. Installed in 2000, the piece sits under a tree north of the bookstore.[215] Another bronze piece with a similar theme was installed south of the Fitzpatrick Engineering Building in 2004. *Christ the Teacher* depicts a life-

size boy and a girl standing in front of a seated Jesus, an expression of love on his countenance. The artist, West Virginia native Burl Jones (b. 1941), turned to sculpture full time after a career in dentistry.

In the main quadrangle stands an eight-foot bronze statue of the founder of Notre Dame, Father Edward (Eduarde) Sorin (1814–1893), the work of Italian sculptor Ernesto Biondi (1855–1917). It was dedicated in 1906. South of the Administration Building and facing it is a life-size bronze statue of the Sacred Heart of Jesus by Robert Cassiani, erected in 1893 on a granite pedestal.

The Golden Dome of the university's Administration Building is surely the best-known landmark of the campus. Atop the dome is a sixteen-foot cast-iron statue, coated with gold leaf, of the Immaculate Conception by Chicago sculptor Giovanni Meli. Completed in 1880, the statue stood on the front porch roof of the building during the two years that the dome was being completed.

A heroic statue of Saint Edward the Confessor, the medieval king of England, stands outside Saint Edward's Hall, built in 1882. The statue, made by the Paris studio of Froc-Robert et fils ("and Sons"), predates the hall by a few years and, next to the Immaculate Conception on the dome, it is the oldest outdoor statue on campus. It is believed to be the first statue of Saint Edward imported to the United States. The heroic figure is made of an imitation stone called *carton-pierre* and originally was richly colored. Today it is covered with a dark bronze-colored coating. Not far away a life-size metal statue of Mary stands between Zahm and Cavanaugh Halls. At Flanner Hall is a piece by local sculptor Tuck Langland, a stylized figure of Jesus called *Christ Teaching*, dedicated in 1979. The slender statue conveys energy and motion, with Christ gesticulating, perhaps in the midst of relating a parable.

Immediately northwest of the Basilica of the Sacred Heart is Corby Hall, built in 1893 with a large niche above the entrance. In it is a seven-foot painted

Father James Flanigan's sculpture *Christ Teaching* (opposite page) shows Jesus as approachable.

metal figure of Mary, Queen of Peace. In front of the building is a statue of Father William Corby (1833–1897), who was the chaplain of the Irish Brigade that fought at Gettysburg. The statue, by sculptor Samuel A. Murray (1869–1941), is a copy of one erected at the battlefield site. Corby became president of Notre Dame after the Civil War.

At the bottom of the slopes leading down to the lakes is a replica Grotto of Our Lady of Lourdes, for which excavation began in 1878, making it the earliest such grotto in Indiana. The grotto was constructed of glacial fieldstone—abundant in this region—from the farm of Peter Kintz, who, with his sons, built the cavern, which included two black stones from Lourdes in France. It was dedicated in 1896, with marble figures of the Virgin Mary and Saint Bernadette. The statue of Mary has been replaced several times, as has the one of Bernadette; the present one is of painted concrete. Additional pieces have been added to the site over the years. Near the opening of the grotto is a three-sided limestone fountain carved by William Schickel in the 1950s. Near the edge of the clearing in which the grotto is set is a bronze statue, dedicated in 1986, of the humanitarian physician Doctor Thomas A. Dooley (1927–1961), who served the poor people of southeast Asia. The work of sculptor Rudolph E. Torrini (b. 1923), it depicts Dooley with two Laotian children. The piece was the model for a nine-foot version eventually erected in Saint Louis in 1997. The reason for the statue and its placement is readily explained by a letter that Dooley wrote to Notre Dame president Theodore Hesburgh, just weeks before the physician's death: "If I could go to the Grotto now, then I think I could sing inside." Each year thousands of people, not only Notre Dame alumni, visit the grotto to seek spiritual comfort.

To the west of the grotto and between Saint Mary's and Saint Joseph's lakes is Columba Hall, built in 1895. A life-size metal statue of Saint Joseph stands in front of the building.

The Founders Monument, which overlooks Saint Mary's Lake, was erected about 1906 to mark the spot where Sorin and six Holy Cross Brothers stood in November 1842, marking the beginnings of the uni-

versity. Originally the twelve-foot tapered base of mortared stone supported an eight-foot figure of Saint Joseph. The statue was removed in 1940 and placed elsewhere. For a time a crucifix stood atop the pedestal, eventually replaced by a small stone figure of Saint Joseph, greatly out of proportion to its huge base.

SCOTT

Much of Scott County is forest and hills and for years had but one sculpture. In the courthouse square at Scottsburg is a bronze likeness of William H. English (1822–1896), created by John H. Mahoney (1855–1919) in the 1890s. The statue was dedicated in 1907 to honor the county's favorite son, born in Lexington, who was an unsuccessful vice presidential candidate in 1880 and the

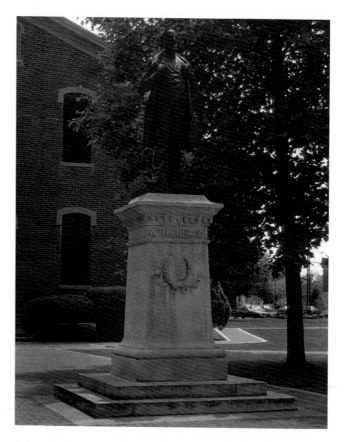

John Mahoney's statue of nineteenth-century politician and businessman William English, who was born in Scott County, stands in front of the courthouse in Scottsburg.

3

builder of the English Hotel and Opera House in Indianapolis. An identical statue, cast at the same time, was erected in the Crawford County town of English, which took its name from the man.[216]

In 2003 Bloomington artist Joe LaMantia collaborated with the students of Scottsburg Elementary School to create *Pillar of Strength*. The piece, fashioned of utility poles, concrete, and mosaic, addresses themes of community unity.

SHELBY

At the Shelby County Courthouse is what is believed to be the last Civil War monument erected in Indiana. Dedicated in 1931, it features a marble sentry. On the square in downtown Shelbyville is a fountain, today crowded by the surrounding parking lot, that once had much more elaborate surroundings, all designed by the Spencer County sculptor George Honig (1874–1962) in 1923. All the approaches and side pieces are gone, the original basin has been replaced, and only the little bronze sculpture in the center remains unscathed. The charming piece portrays three small children looking outward. Also on the square is an interpretation of a scene from the children's novel *The Bears of Blue River,* written by the nineteenth-century Indiana author Charles Major, who hailed from Shelbyville. The bronze piece, depicting a boy in buckskins holding two bear cubs, was the work of Indianapolis sculptor Mary Elizabeth Stout. (Later sources always give her name as Mrs. Norman Hart because she was married not long after completing the piece.) The widow of Charles Major commissioned the statue, which was originally dedicated in front of the Charles Major School in 1929. After the school was demolished, the statue was moved to its present location in 1980.[217]

Saint Joseph Church on East Broadway Street displays an interesting concrete relief of the saint, created in 1982. What is apparently the only sculpture in the county outside of Shelbyville is at

The Bears of Blue River in the town square is a tribute to author and Shelbyville native Charles Major.

Prescott on the old Michigan Road. A life-size statue of Saint Vincent de Paul dating to the 1880s is in a niche on the church of the same name, which was built in 1926 after the original church burned.

SPENCER

Spencer County is a largely rural and rugged county bordering the Ohio River. It has a surprisingly large amount of outdoor sculpture, fully half of which is at Saint Meinrad Archabbey. But the presence of the Lincoln boyhood legacy and also of sculptor George H. Honig (1874–1962) are certainly contributing factors. The strong German Catholic tradition of much of the county has resulted in an abundance of

More than twelve feet high, this figure of Saint Bede is one of several carved by German sculptor Herbert Jogerst on the grounds of Saint Meinrad Archabbey.

most stunning and signature work at Saint Meinrad is that of German sculptor Herbert Jogerst (1912–1993), who carved several pieces for Saint Meinrad and the surrounding communities in the 1950s. Jogerst had been held as a prisoner of war across the river in Kentucky toward the end of World War II. Unable to find work in Germany after the war ended, he accepted a long-term commission from Saint Meinrad, which had several empty niches to fill. On the church's facade are his figures of Saint Benedict, Our Lady, and Saint Scholastica. Saint Bede Hall features a statue of the saint in a niche as well as sandstone reliefs—*Fides, Intellectus, Ecce Lex, Ora, Labora.* Beside the building is Jogerst's heroic interpretation of Christ the King. All of these pieces exhibit his striking linear style. A large medallion

ornately carved stone crosses and crucifixes in parish cemeteries, notably one at Mary, Help of Christians Church in Mariah Hill, dating to 1892. The cemetery at Saint Joseph Church in Dale has some fine work, and there is also a marble statue of Saint Joseph on the church.[218]

For sheer quantity of saints per acre, Saint Meinrad is clearly the winner. There are several figures of unknown authorship, including a statue of Saint Thomas Aquinas on the facade of the seminary that probably dates to about 1889. There are numerous statues of the Virgin Mary, and a large sandstone and metal crucifix from 1946 dominates the cemetery. On the Placidium on the east side of the grounds is a ceramic figure of the Virgin Mary by Timothy Kennedy, created in the 1950s. But the

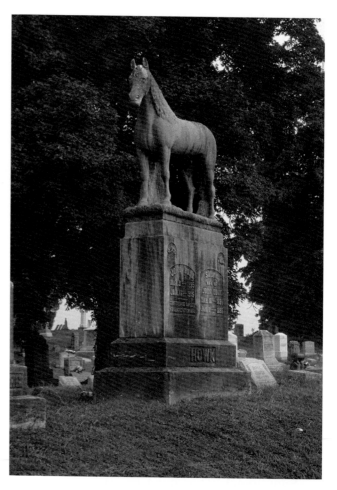

The Howk monument in the cemetery at Rockport displays a nearly full-size horse carved by Ira Correll of Daviess County.

(sometimes called "Our Lady of the Press") on the wall of the building housing the Abbey Press appears also to be Jogerst's work.

Ira Correll (1873–1964), a native of Odon, did several notable cemetery statues in Spencer County. Correll sculpted an almost life-size limestone horse to stand on the grave of Ina Palmer Axton at rural Mount Zion Church in the vicinity of Richland City. Only twenty-four when she died in 1898, the statue is a tribute to Axton's love of horses. In the same cemetery is what appears to be a portrait statue of a woman on the Bauman monument. Another statue of a horse by Correll, very similar to the first, stands on the Howk monument in Sunset Hill Cemetery in Rockport.

Rockport, the county seat, was the birthplace of sculptor George Honig, whose work appears in several places throughout the county. In Rockyside Park is a bronze silhouette of Abraham Lincoln affixed to a boulder at the Ohio River landing where, as a young man, he began his storied trip down to New Orleans on a flatboat. Honig was a serious scholar of Lincoln lore and successfully urged the town to create a replica of an early settlement called Lincoln Pioneer Village, which was erected with the help of New Deal funding in 1935 and 1936. Within the recently restored village is a bronze commemorative relief plaque erected in 1938 by the Southern Indiana McGuffey Club, which had officially organized during the dedication of the village three years earlier. Sculpted by Honig, it honors William Holmes McGuffey (1800–1873), who developed the famous readers bearing his name. Honig's parents are buried in the Rockport Cemetery, and he covered their graves with his fanciful bronze work. In Grandview a double-sided portrait plaque, erected in 1928, stands in front of the public library. It features *Lincoln Triumphant* and *Chief Set-Te-Tah,* who, in 1811, was the last Indian killed in Spencer County. Northeast of Grandview at the New Hope Cemetery is a bronze plaque explaining the barter system used in pioneer days, illustrated with a relief of Taylor Basye's general store that once stood near the site. Another

George H. Honig's striking portrait *Lincoln Triumphant* is displayed on the main street in Grandview.

plaque indicates that Lincoln visited and traded at the store.

The Lincoln Boyhood National Memorial at Lincoln City incorporates land that once belonged to the Lincoln family with a replica of the farmstead. Nearby is an odd sculpture of sorts, the cabin sill (foundation logs) and hearth of a little dwelling rendered in bronze, created by Thomas Hibben and dedicated in 1935 to mark the site where the Lincoln cabin actually stood. A little farther south is the grave of Nancy Hanks Lincoln, and south of that, the memorial itself, with large limestone relief panels depicting Lincoln's life. The panels on the left (east) deal with Lincoln in Kentucky and Indiana; the two on the right address his life in Illinois and Washington, D.C. The center panel speaks to Lincoln's impact on history. Completed about 1943,

The concrete statue of Santa Claus, erected in 1935, is shown in its original unpainted state on a postcard dated 1950.

the sculptured panels were the work of Elmer Harland (E. H.) Daniels (1905–1986), a Michigan native who worked in Indiana for many years.

Finally, there is a Santa Claus—and he is big! The town of Santa Claus began to capitalize on its name in the 1930s. Chicago businessman Carl A. Barrett, who had been born in the little town, donated the huge concrete figure of Santa with a bulging sack of toys for the enjoyment of "the children of the world." Twenty-two feet high, the statue was dedicated Christmas Day 1935 atop a hill that oversaw Santa Claus Park. Later, many other Santa figures of various materials appeared around town. Over time, the park was abandoned and activities moved and evolved—mostly into the theme park of Holiday World—and all the Santas, except for the lonely figure on the hill, disappeared. In

December 2001 a fiberglass replica of the big concrete Santa was unveiled in front of the post office. Yes, Virginia, there are two Santa Clauses.[219]

STARKE

Starke County is largely rural, a blend of lakes, wetlands, and farms. One of the largest natural lakes is Bass Lake, where a Chicago religious order established a branch monastery called Saint Andrew's Missionary Apostolate. Near the entrance to the property is a bronze bust of Archbishop Andrew Sheplytsky, created by cleric-sculptor Monsignor Jaraslav Swyschuk and dedicated in 1979. Nearby is a row of nine plaster busts, modeled by the same

ment went out of business, a similar concern bought the figure and set him outside its sprawling building in the isolated hamlet of Toto, whose claim to fame for the past several years is the presence of several outlet and end-lot stores. The building burned in 2002, but the statue survived, although its future is uncertain.[221]

STEUBEN

Lakes abound in Steuben County, but there is very little sculpture. The soaring shaft of the Soldiers Monument, standing in the middle of the town square, dominates Angola. (The courthouse sits on the southeast corner of the square.) Atop the shaft is a ten-foot statue of Columbia, and around the

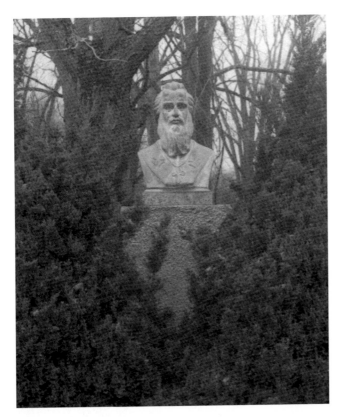

The bust of Archbishop Andrew Sheplytsky is displayed on the grounds of Saint Andrew's Missionary Apostolate in the Bass Lake community.

artist, representing church hierarchy. Each rests on a fluted Corinthian column, and all are sheltered beneath a portico.

Near the village of San Pierre on State Road 421 is the former Little Company of Mary Convent and Health Facility, today Our Lady of Holy Cross Care Center, where there are several examples of religious statuary. Most notable is a twelve-foot marble image of the Virgin Mary on the hospital building. The oldest figure, a limestone statue of Saint John the Apostle, dates to the early 1940s.[220]

The county gained a new sculpture of sorts in recent years, owing to the latest move of a twenty-four-foot statue that had stood in La Porte County at a business outside Michigan City. The huge figure of what is now known as Chief Toto began his career about 1960 in the Enchanted Forest, a small, now-defunct amusement park near Chesterton. In 1992 the figure reappeared at Lakeshore Sales east of Michigan City along US 20. When that establish-

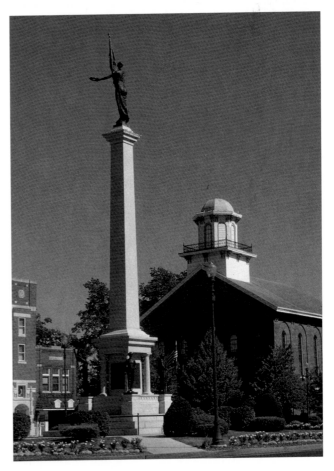

Dedicated in 1917, the Soldiers Monument in downtown Angola is a stunning sight.

base are the four typical military figures of Cavalry, Infantry, Artillery, and Navy—although no one from Steuben County served in the navy during the Civil War. The figures, of sheet bronze over a base metal, are from the W. H. Mullins Company of Salem, Ohio, a major provider of commemorative statuary in the late nineteenth and early twentieth centuries. The monument was dedicated in 1917.[222]

At Saint Anthony of Padua Church on West Maumee Street in Angola are two statues of saints, the patron saint and Saint Francis of Assisi. There is a lovely figure of a young girl, Gloria McNaughton, in an isolated rural cemetery some distance northeast of Fremont. She died in 1936 two months before her tenth birthday.

SULLIVAN

Rugged Sullivan County has been known over the years mostly for its coal, which has largely played out.

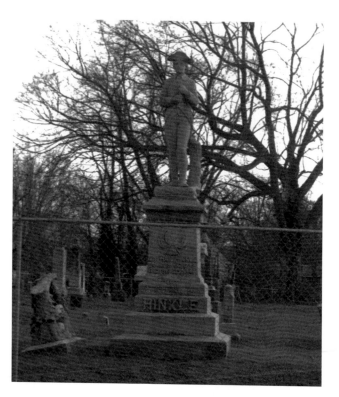

Nathan Hinkle's grave outside tiny Hymera features a statue of a Revolutionary War soldier to honor his service.

There is almost no sculpture, apart from a life-size statue of a Revolutionary War soldier atop the grave of Nathan Hinkle (1749–1848) in a little cemetery on the edge of Hymera. The statue was erected around 1904 to honor the long-lived veteran.[223]

The town of Carlisle had the distinction of erecting the first sculptural World War Memorial in Indiana. It was dedicated only a year after the war's end on Armistice Day, 1919, and it featured a concrete soldier and a sailor atop a substantial base placed in front of the school. Although the base still remains, the figures were removed. There have been efforts afoot to restore the monument.

SWITZERLAND

There appear to be no sculptures in this tiny county on the Ohio River in southeastern Indiana.

TIPPECANOE

Farmland, prairies, and river valleys characterize Tippecanoe County. Most of its outdoor sculpture is in Lafayette or West Lafayette across the Wabash, but there are some surprises.

Probably the most unusual piece is the *Operation Skywatch Memorial,* a tribute to the Civil Defense volunteers who scanned the skies for enemy aircraft in the early 1950s. The first ground observer post to be commissioned was at Cairo, a crossroads hamlet on an open plain, where it scarcely seems that the four-story wooden observation tower would have been necessary. The tower is now listed in the National Register of Historic Places. The limestone statue, erected as a Bicentennial project in 1976, depicts a farmer, his wife, and their young son, all intently looking upward in different directions. Designed by Mary McDonald, it was carved by her with the help of fabled Bedford stone carvers Frank Arena and James Saladee.[224]

At the town of Battle Ground, so named because it grew up at the place where the famous Battle of Tippecanoe was fought in 1811, is a soaring granite monument more than ninety feet high commemorating the battle. A heroic statue of William Henry Harrison (1773–1841) stands on a pedestal at the base of an obelisk. Harrison led an army of a thousand men to Prophet's Town (today, Prophetstown), a Shawnee encampment where the members of various tribes were gathering, and fought a battle with the Native American forces who were urged on by Tenskwatawa (the Prophet), the brother of Tecumseh. By the mid-nineteenth century the battle site had become popular for picnicking and sightseeing, especially after the railroad came through. In 1873 the site was enclosed with an iron fence, which survives. As early as 1835, when Harrison revisited the battlefield, there was talk of building a monument, but it was not until 1908 that it was finally erected.

The new Prophetstown State Park near Battle Ground has within its boundaries a locally run facility called the Museum at Prophetstown, which includes a living history farm as well as works by Bloomington sculptor Dale Enochs (b. 1952). Each piece features his trademark etched limestone. Installed in 1999, there are figure chairs, a "crescent bench," and an "ax bench."

Farther south, in front of the old Commandant's Home on the grounds of the Indiana Veterans Home north of West Lafayette are two life-size, cast-iron Union sentries, dating to the late 1890s. They are painted in blue uniforms.

The Tippecanoe Memory Gardens, located outside of West Lafayette on County Road West 350 N, were begun, like many of its type, in the 1950s. Its various sections are marked with life-size or larger marble sculptures ordered over the years from the Pompeian Studios in Carrara, Italy. Except for a bald eagle and a life-size statue of a Native American, most of the pieces have a religious theme.

At Coyote Crossing Golf Course, which opened in 2000 on County Road 600 N west of State Road 43, are examples of the work of wire sculptor

William Arnold, formerly of Indianapolis. Seven coyotes in various poses are scattered throughout the course.[225]

The ever-changing campus of Purdue University in West Lafayette exhibits a surprising number of outdoor sculptures. The oldest, tucked into the center of the circular drive at Windsor Halls, appears to be a small bronze work by French sculptor Leopoldo Bracony, dating to 1920. *Tired Boy* depicts a dozing mother seated on the ground embracing a sleepy young boy, his head cradled in her lap. The piece was given to Purdue by a benefactor from Michigan City. Another hidden treasure is a charming limestone rendition of three bear cubs rolling and cuddling in play by Jon Magnus Jonson (1893–1947). The piece was originally exhibited at the Chicago World's Fair in 1934 and is presently in the yard of the Child Development and Family Studies Building on State Street. In the 1930s Jonson had a studio outside of Frankfort, at the home where his wife had grown up. He was commissioned by the university to provide a number of sculptures (many of which are inside various buildings on campus). Jonson's most visible work is on the Elliot Hall of Music, which was completed in 1940 with the help of New Deal funding. Placed in large niches on both sides of the building are eight-foot limestone allegorical depictions of the arts. Each side displays three stylized female figures representing Drama, Music, and Oratory. On the Purdue Memorial Union Building are six heroic relief sculptures, three on each side of the piers above the main entrance. Each relief depicts a pair of students engaged in some activity of campus life. Unveiled in November 1939, they are the work of California sculptor Frances Rich (b. 1910).

Mounted on the west wall of Stewart Center is a very large limestone relief by G. J. Busche called *Life*. Completed in 1956, the piece is a composite of several human figures in various life stages, along with a cogwheel and a sheaf of wheat. When the university constructed a new civil engineering building in the early 1960s, Indianapolis artist Adolph Gustav Wolter (1903–1980) designed five cast-aluminum reliefs to be placed above the entrance. Each depicts a structure

that would involve a civil engineer: a dam, a tunnel, a suspension bridge, an airport, and buildings.[226]

Purdue has several fountains scattered about the campus, some old, some recent, and some both. In the Memorial Mall outside University Hall is a cast-metal fountain typical of the turn of the twentieth century, a gift of the class of 1894. Also in the mall near Stanley Coulter Hall is the Stone Lion Fountain, with four felines spewing water, which was originally a gift of the class of 1903. It disappeared for awhile but was replumbed and reinstalled in 2001. Now in Founders Park, the Loeb Fountain, designed by Walter Scholer, was placed in front of Hovde Hall in 1959 but removed in 1987. The fountain was redesigned and enlarged when it was installed in its present location in 1994, becoming an impressive water feature. Another large fountain that tempts students to run through it was designed by Illinois artist Robert Youngman, who taught for a time at Anderson University. Also called the Class of 1939 Fountain, the water sculpture was dedicated in 1989 in the Purdue Mall. Four curvilinear concrete forms with abstract reliefs soar upward nearly forty feet. Among other things, the piece has been compared to the space shuttle. The university's concerns over student and visitor safety have resulted in the large fountains remaining dry much of the time.[227]

Three abstract pieces stood for years outside the old creative arts buildings until they were demolished and a new facility was completed in 2003. In 1973 Minnesota artist Dorothy Berge (b. 1923) created an untitled yin-yang work of two L-shaped pieces of Cor-Ten steel, which did not weather well. The same year John Rietta (1943–1982), who was sculptor-in-residence at the time, created an untitled, somewhat finlike curvilinear abstract piece, also of Cor-Ten steel. Both pieces were sold at auction to a private collector in 2004. In 1986 California artist Betty Gold (b. 1935) presented the university with a monumental steel work, *Kaikoo VI*, one of a series of seventeen that she did while staying in Hawaii. (Another one is located on the campus of Valparaiso University.) The word means "high tide." Typical of her work, the piece features several intersecting

planes, the shapes both positive and negative, bisecting each other. It is more than twelve feet high and painted a brilliant red. The work now stands in Pickett Park, where it is joined by temporary large-scale installations, the winners of the annual "Sculpture on Campus Competition" and other pieces on loan.

In 1999 a sculpture of sorts was erected to demonstrate different connections in steel design. Bright orange, it stands outside the Civil Engineering Building and is simply called *Steel Teaching Sculpture*.[228]

Outside the School of Veterinary Medicine is *Continuum,* a monumental bronze sculpture portraying the long-standing relationship between animals and humans. Nine feet tall at its highest point and more than forty feet long, it makes a dramatic statement, beginning with depictions of cave drawings and ending with a life-size man and animals of today. Sculptor Larry Anderson of Tacoma, Washington, created the piece, his largest to that time, in 2000. That same year the university acquired *Spirit Arch*, a monumental steel piece by Phillip Shore, fresh from its two-year stint at the South Bend Regional Airport. It stands in Centennial Mall.[229]

The new millennium appears to have sparked a new interest in contemporary art on the campus, as several more installations of outdoor sculptures are planned in the next few years. David Jemerson Young and Jeff Laramore of 2nd Globe are creating several pieces for Discovery Park, Purdue's new research complex at the southwest corner of State Street and Intramural Drive. An abstract work by Kentucky sculptor David Caudill (b. 1950) was erected at Schleman Hall in fall 2004. Approximately six feet high of sinuous stainless steel, the piece is called *When Dreams Dance*. Unveiled in April 2002, a huge cast-bronze abstract called *Transformation* stands on Agricultural Mall at Wood and Marsteller streets. Spanish sculptor Faustino Aizkorbe created the work, which symbolizes Purdue's continued evolution and changing nature, supported by the strength of its heritage. Standing

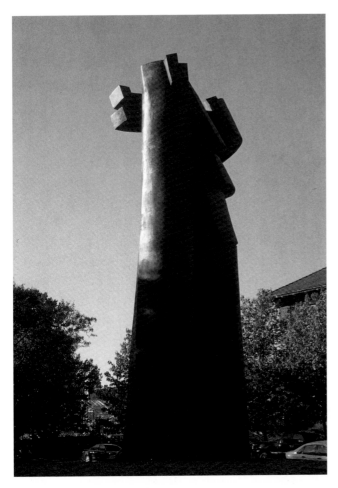

Among Purdue's many new sculptures on campus is Faustino Aizkorbe's huge abstract *Transformation*.

forty feet high, the piece appears almost as if unfolding like a bud.[230] The following year Aizkorbe created a nine-foot sculpture honoring the university's President Emeritus Steven C. Beering. Erected outside the hall named for Purdue's ninth president, the intriguing piece is composed of four iron railroad tracks supporting an abstract bronze torso with a cut-out Maltese Cross.

Commemorative representational sculpture, at least of the outdoor variety, is almost completely lacking on the Purdue campus, with two recent exceptions. Evansville sculptor Don Ingle fashioned a bronze bust of Purdue's first official band director, Paul Spotts Emrick, who served from 1905 to 1954. His accomplishments were many; among the most noticeable was his creation of the world's largest drum that is a trademark of the band. The bust was installed outside Elliot Hall's band office in 2000.[231] Two years later the same artist sculpted a similar bust of Emrick's successor, Al G. Wright, who directed Purdue's bands until 1981. The piece was dedicated in the fall of 2003. Between the two busts is a huge bronze replica of the band "key," which features an image of the Purdue drum.

Across the Wabash River in Lafayette is an eclectic mix of outdoor sculpture, much of it in the immediate downtown area. The Tippecanoe County Courthouse is one of the state's most magnificent, designed by architect James Alexander and constructed in 1882. Its tapered dome is topped with a sheet zinc figure of Justice (often interpreted as Liberty), about fourteen feet high, from the J. L. Mott Iron Works of New York. Beneath each of the four clock faces at the base of the dome is a niche containing one of four allegorical figures representing the seasons. Each classically robed lady, also of zinc from the Mott company, is more than nine feet high. In the east and west pediments are two identical groupings of three limestone allegorical figures, heroically sized, representing Education, Industry, and Agriculture. In the north and south pediments are three historical figures representing William Henry Harrison, the Marquis de Lafayette, and Tecumseh.[232]

At the northeast corner of the courthouse is an octagonal memorial erected in 1887 that appears to honor all and sundry, including the artesian well constructed at the site in 1858. Tippecanoe County's early pioneers, its gallant soldiers, philanthropist John Purdue, and town founder William Digby are all included, as are the courthouses preceding this one, and finally, the Marquis de Lafayette, who provided so much help to the Americans during the Revolutionary War and for whom the city was named. Above the inscriptions are four oval relief plaques of the honorees and atop the memorial is a life-size figure of Lafayette. It is among the earliest commissions (vying with his statue of Schuyler Colfax in Indianapolis) of the renowned Illinois sculptor Lorado Taft (1860–1936).

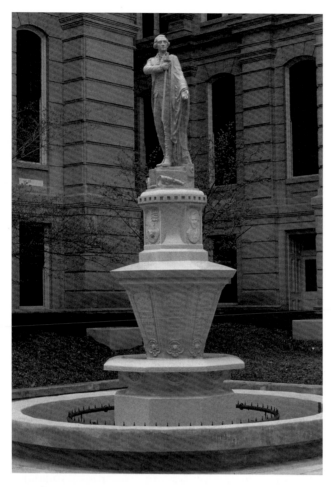

Lorado Taft's fountain sculpture featuring the Marquis de Lafayette, for whom the city was named, stands in the courthouse square.

Facing the courthouse square on the north side are two commercial buildings with notable sculpture on the facades. The former Merchants National Bank at 316 Main Street, completed in 1918, features a three-foot limestone statue of Lafayette on a volute (a scrolled bracket) at the top of the two-story entrance arch. Flanking the marquis, inset but in high relief, are two very large winged Victory figures. At 308 Main Street is the terra cotta–clad Ross Building, also completed in 1918. Flanking the entrance above the Tudor arch are two seated terra cotta robed figures in different poses; each once held a lantern. One more effigy of Lafayette, larger than life in limestone, is affixed to the main facade of the city's Municipal Building, constructed in 1995 at Sixth and South streets.

Richard McNeely's curvy monumental sculpture *Ouabache* originally was erected at Fourth and Columbia streets, in clear view of the courthouse, which created a very interesting visual juxtaposition. The piece was commissioned in celebration not only of the nation's Bicentennial but also the county's sesquicentennial. Sail-like, the piece revolves with the wind and rises in two peaks, the tallest more than thirty feet high. The big aluminum work has been moved from downtown to a new site near the river for which it is named. Although visible off the Harrison Street bridge, its current location does not allow a viewer much opportunity to appreciate the piece.

On what is now a pedestrian bridge that heads west from downtown over the river is a functional as well as aesthetic piece crafted of aluminum called *Millennium Sundial*. Erected in 1999, the work is by David L. Ato.[233]

Terra cotta gnomes perch above the entrance to the Ross Building in downtown Lafayette.

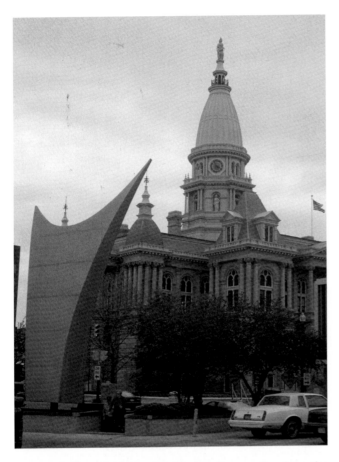

Now located north of downtown Lafayette near the river, the original placement of the aluminum abstract *Ouabache* created an interesting juxtaposition with the nineteenth-century courthouse.

The Greater Lafayette Museum of Art on South Ninth Street displays a colorful swirling piece of painted and unpainted aluminum, with loops of metal rising up a shaft and turning back on themselves in a tribute both to the local aluminum industry and the many astronauts that have studied at Purdue. *Launched Ribbon,* by New York sculptor Dorothy Gillespie (b. 1920), was dedicated outside the museum in 1985.

A whimsical piece by Linda Vanderkolk and Roy Patrick, completed in 1992, sits at Fifth and Main streets, where in the warm weather months the historic Farmers Market gathers thrice weekly. *Family Farm Objects* is actually just what it says, for it is fashioned from all manner of objects, implements, and parts likely to be found on a farm. Three life-size figures are depicted, the farmer, his wife, and a

child. The piece has a serious side as well; it is meant to call attention to the plight of family farms. Patrick, who concentrates on working with discarded metal objects, later created a piece for Columbian Park that incorporates a spiral slide and several other objects of children's play. Aptly called *Playtime in the Park,* the work, erected about 2000, stands near Park Street.[234]

On the corner of Main and South streets is a fire station, outside of which stands a cast-iron Newfoundland dog, dating perhaps to the mid-nineteenth century and probably from a New York foundry. The fire department acquired the dog in 1912, and it originally was accompanied by a small, barefoot African American boy, with rolled-up pants and suspenders. The boy and dog were once used as a hitching post by a local family, who gave the figures to the fire department. The pieces stood in front of the fire station for more than fifty years, until the boy became the object of controversy in the late 1960s. Accusations of racism led to vandalism and theft. Ultimately the damaged figure of the boy was repaired and placed inside the fire station. The dog remains outside, without his companion. Folklore suggests that the statues were cast as a tribute to a young black boy who was killed trying to save his dog in a fire, but that is probably not the case since such figures were once relatively common.

There are a number of fine examples of religious statuary around Lafayette, all but two crafted by unknown artisans. The grounds of both Home Hospital and Saint Elizabeth Hospital, each acquired in recent years by the Sisters of Saint Francis of Perpetual Adoration, display Sufi Ahmad's *Spirit of Saint Francis.* Saint Elizabeth Hospital constructed a replica grotto of Our Lady of Lourdes over a century ago, one of the oldest in the state. It was relocated and reconstructed about 1974, using the original limestone figures. On the grounds are life-size statues of other saints as well, including Saint Francis on the former School of Nursing and a cast-stone interpretation of Saint Joseph planing a two-by-four. Saint Mary Cathedral displays a marble figure of the Blessed Virgin. In Saint Boniface

A whimsical sculpture by Roy Patrick created from playground equipment, toys, and other found objects stands in Lafayette's Columbian Park.

Cemetery is a Crucifixion scene with figures of limestone dating to 1903, as well as a granite figure of Saint Francis, who watches over the graves of Franciscan nuns.

Greenbush Cemetery, established in 1848 at what was then a hillside far from town, is a lovely site. It is dominated by a large cast-iron statue of a classical female figure representing the Resurrection, alternately interpreted as *Hope*. Cast in Philadelphia, the piece dates to the 1880s or earlier and stands on an eight-foot pedestal of granite, limestone, and Italian marble. In Rest Haven Cemetery off Sagamore Parkway is a bronze figure of a little nude boy, clutching a ball in one hand and what appears to be a frog in the other. The piece identifies the section of the cemetery called "Baby Land," set aside

for the graves of children. The model for the statue, created in 1939, was Mack Edward Wooten.

TIPTON

Tipton County appears to be largely bereft of sculpture save for several examples of religious statuary at the convent of the Sisters of Saint Joseph just north of Tipton. An interesting interpretation of Saint Joseph (1957), a seven-foot limestone statue surrounded by relief panels, is on the south facade of the church. A much older and more traditional Saint Joseph (1926), in marble, stands nearby. Also on the grounds are a statue of Saint Therese, the Little Flower (1926), and

A modern interpretation of Saint Joseph holding a lily and a crosscut saw gazes down from the main facade of the convent chapel of the Sisters of Saint Joseph.

a marble rendition of the sighting of Our Lady of Fatima. A Crucifixion tableau with Orbronze (a sheet metal alloy) figures is in the cemetery.[235]

UNION

Union County has no known outdoor public sculpture.

VANDERBURGH

The sprawling city of Evansville along the Ohio River contains a wide variety of outdoor public sculpture, including a collection of pieces at the Evansville Museum of Arts, History and Science. Among the highlights in its sculpture garden overlooking the river are Logansport native Seth Velsey's (1903–1967) *Pink Torso,* a stylized female torso and head of pink marble. *Earth Mother* by Chicago-born Abbott Pattison (1916–1999), also of marble, is influenced by the sculpture of ancient peoples in its blocky, primitive appearance. Nearly eight feet high, the piece portrays a mother and two small children, nude. The museum acquired the work in 1961. Tony Vestuto's (b. 1929) *Button,* purchased in 1967, is mounted on the south wall of the museum building. Vestuto, also born in Chicago, later moved to Brown County. Local artist John McNaughton (b. 1943), who teaches at the University of Southern Indiana, fashioned *Flowing River,* a huge steel squiggle, as a Bicentennial project in 1976. It is meant to evoke the bend in the Ohio River at which Evansville lies.[236]

An architectural artifact, commonly called The Lady of the Grand, is mounted on a pedestal against the wall behind the museum. The heroic bust of Liberty, an early example of the use of terra cotta as building ornamentation in Indiana, originally graced the Grand Opera House, built in 1889. The structure was demolished in 1963, but the lady was saved and placed outside the museum. Another set of historic pieces are the large bronze relief panels setting off the recipients of the Evansville Rotary Club awards. The allegorical reliefs are the work of Rockport native George H. Honig (1874–1962), who lived and worked in Evansville. Cast in 1927, they are two of hundreds of these types of works that he created.

Louisville-born Don Gummer (b. 1946) was raised in Indianapolis and attended the John Herron Art Institute. *The Planes of Nature,* a purely abstract work, was designed specifically for its location on the Kuehn Terrace of the museum, although it was originally planned to be much larger. The piece, dedicated in 1987, mixes granite, marble, and stainless steel and has an architectural quality. *Celestial Quest* by Evansville native Timothy Fitzgerald

Near the Ohio River is this moving memorial to veterans of the Korean War by Kentucky sculptor Steve Shields.

(b. 1955) is an abstract piece of stainless steel suggestive of a celestial navigation device. It was dedicated on the terrace in 1992.[237]

Not far from the museum on Riverside Drive is the Korean War Memorial by Kentucky sculptor Steve Shields (1947–1998), erected in 1992. The heroic bronze work portrays two soldiers helping a wounded buddy. A year later another memorial by Shields was installed on Martin Luther King Jr. Boulevard near the Civic Center to commemorate the veterans of Operation Desert Shield and Desert Storm. Again he fashioned heroic bronze soldiers, each wearing desert battle fatigues and carrying a full complement of gear, but for the first time one of them is a woman. A month later another commemorative sculpture was unveiled, this one honoring the pioneer founders of Evansville, Hugh McGary and Colonel Robert Evans.

The men are depicted in silhouette, cut out of a ten-foot high curved sheet of sandblasted stainless steel. Local artist Amy Musia was commissioned to do the work, titled *The Bend in the River*, in 1989, but funding difficulties, along with some political battles, delayed the completion of the piece for three and a half years. At this writing the work is in storage.

Near the entrance to The Centre, the city's new performing arts facility, lurks another John McNaughton piece, *The World's Largest*, a stainless steel spiral that originally had been placed outside the old Vanderburgh Auditorium in 1975. When the auditorium was demolished to make way for the new structure, McNaughton's piece, almost ten feet high, was moved into a shadowy corner and is often surrounded by trash receptacles. To the east at the Teamsters Local 215 headquarters on Walnut Street

is *Speakers to Heaven,* six gigantic four-sided horns pointing upward, in two staggered rows that flank the entrance to the building. Created by architect Ed Rheem in 1972 as an element of the building, they demonstrate how very blurred the line between architecture and sculpture can be. To the west at the Civic Center is an untitled abstract bronze and granite fountain by George Hall, informally called "Conversation Piece," installed in 1969.[238]

The former Vanderburgh County Courthouse, designed by architect Henry Wolters of Louisville, is perhaps the most sculpture-laden (rivaled only by the Allen County Courthouse in Fort Wayne) seat of county government in the state. The building is festooned with native fruits and flowers, cherubs, and wreaths. Sculptor Franz Engelsmann designed a total of fourteen heroic statues that average about twelve feet in height. A grouping of three statues represents Justice. There are four seated "goddesses" representing Manufacturing and Industry, Agriculture, Commerce and River Trade, and Learning. Another grouping of three figures is titled *The Quest for Knowledge and Truth.* The arts are celebrated by four Muses representing Music, Painting, Sculpture, and Literature. The courthouse was completed in 1891 and served the county until the new Civic Center was built in 1969. Today the exuberant building houses a variety of nonprofit organizations. Inside on the lower level is a nine-foot statue of Vulcan portrayed as an early American blacksmith. The Roman god once graced the exterior of the Vulcan Plow Works on First Street. The company moved to Ohio in 1949, leaving the statue behind. The vacated factory buildings became ware-

Less than ten years after it was erected, the city of Evansville dismantled Amy Musia's *The Bend in the River,* which has languished in storage for several years.

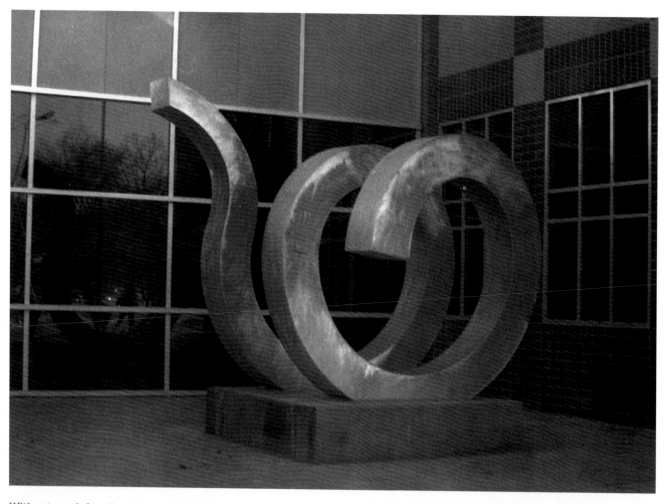

Without much forethought, John McNaughton's *The World's Largest* was placed near the entrance to The Centre.

houses, then were demolished in 1957. A local doctor saved Vulcan from the wrecking ball, and the hulking blacksmith resided in a garden for almost twenty years. The family gave the figure to the Old Courthouse Preservation Society, and Vulcan has had a roof over his head since 1976. William Howard Mullins, the founder of the statuary firm W. H. Mullins Company of Salem, Ohio, was the son-in-law of the founder of the Vulcan Plow Works. Mullins made the Vulcan statue in 1898.

Flanking the entrance to the nearby Evansville Memorial Coliseum (originally, Soldiers and Sailors Memorial Coliseum) are two heroic groupings, *Spirit of 1865* and *Spirit of 1916* by George Honig. These pieces are by far his largest; the bulk of Honig's work is in the form of highly detailed bronze reliefs for outdoor and interior plaques and

panels. *The Spirit of 1865* speaks of war, with an allegorical figure representing valor flanked by a watchful infantryman and a kneeling cavalryman drawing his sword. *The Spirit of 1916* portrays peace—ironically, since the United States would be drawn into World War I the following year. Again there is an allegorical figure, possibly representing Liberty or Peace, standing behind a bench on which sit two elderly veterans, one holding a cane and the other with a book in his lap.

The Spirit of the American Doughboy by Owen County native Ernest Moore Viquesney (1876–1946) was dedicated on Armistice Day, 1928, in Sunset Park along the river. After years of vandalism, the statue was removed in the 1950s and put into storage. In the mid-1960s, with the best of intentions, a local woman who was an air force veteran took it upon herself to

find and then try to repair the badly damaged dough-boy. She painted the figure and replaced the missing left hand (but not the rifle) with one from a mannequin—rather a contrast to Viquesney's finely detailed work. Determined vandals struck the statue again in its new location in front of the Funkhouser American Legion Post 8 on New Harmony Road, leaving the statue in pieces. A body shop repaired it for cost. The statue, more or less whole again, albeit still with a mannequin's hand and a sleeve fashioned from a tin can, is covered with a thick coat of epoxy, giving it an odd plastic look. It stands on a boxlike base inside the American Legion post, where members resist all efforts from outsiders to have the statue restored and placed outdoors once more. The first American serviceman killed in World War I was James

The nine-foot icon of Evansville's Vulcan Plow Works now takes shelter in the lower level of the former Vanderburgh County Courthouse.

Bethel Gresham from Evansville, whose house still stands. Some believe that to be a much more appropriate site for the piece.

In Oak Hill Cemetery, beautiful with its many mature trees and winding roads, is a treasure trove of funerary art, among which is an eleven-foot granite statue of Saint John that marks the Heileman monument, placed in the 1890s. A bronze eagle with a six-foot wingspread guards a lot purchased by the Fraternal Order of Eagles in 1910. The cemetery also contains something of a surprise, the Confederate Monument, erected by the Fitzhugh Lee Chapter of the Daughters of the Confederacy in 1904. A life-size figure of a Confederate sentry guards a large granite tablet listing the names of twenty-four prisoners of war who died in Evansville and are buried here. While not verified, the statue may have come from the W. H. Mullins Company. Its catalog offered a wide range of figures to commemorate those on both sides of the Civil War. Five years later, the Women's Relief Corps erected a statue of a Union sentry from the Mullins catalog and placed it on a seven-foot granite pedestal. Another lovely old cemetery lies across town, sprawled on a hillside. In Locust Hill Cemetery is a life-size limestone statue of a Saint Bernard, guarding the graves of Mayme and Edward Huff. Although not signed, the style of the dog strongly suggests it is the work of Ira Correll (1873–1964), a Daviess County native who carved numerous portrait statues and animal figures for grave markers throughout southwestern Indiana.

At the Hadi Shrine on Walnut Street downtown is a recently erected fiberglass statue that depicts a Shriner in full regalia, cradling a little girl with leg braces in the crook of his arm while holding her crutches in his other hand. About eight feet high, the piece is based on a photograph and is being installed at Shriner hospitals and headquarters all over the country. The work is by Fred Guentart and is called *Silent Messenger*, but is also known as *Editorial without Words*.

Bloomington sculptor Dale Enochs (b. 1952) works with limestone, and his pieces are at once

primitive and modern. His ten-foot high *Memorial,* a limestone piece embellished with steel and black marble, is carved with runelike markings. It was installed in a garden setting at Deaconess Hospital in 1989.[239]

In 2004 the Mesker Park Zoo installed a realistic life-size bronze statue of a baby giraffe, the work of Texas-born sculptor Tom Tischler (b. 1943).

At the Parkside Terrace Apartments on Sunset Avenue, two untitled abstract pieces were installed in 1974. One is a large steel work consisting of five triangular planes set at angles to one another, created by Leonard Titzer. The other, a twelve-foot asymmetrical curvilinear form of stainless steel, is the work of Jim Greer and John McNaughton.

There are several pieces at the University of Southern Indiana (formerly Indiana State University at Evansville) on the far west side. In 1974 McNaughton again collaborated with Greer to produce an untitled work of painted steel that suggests the sun bursting out from behind clouds. McNaughton collaborated with student Gregory Folz in 1977 on a large aluminum piece titled *Sunbird.* About ten feet high, it consists of two upright, slightly twisted curvilinear shapes. Over time McNaughton moved into using more natural materials and in 1994 completed, in collaboration with six students over several years, a work that is part sculpture and part seating arrangement called *Vision.* It is fashioned from Oolitic limestone and redwood. *Processing Component* is a ten-foot-high steel sculpture, weighing more than a ton, created by students Damon Dawson, Peter Fehrenbacher, John Hittner, and Brandon Kight. Dedicated in March 2000, it is a set of rust-colored parallel tubes resting on a giant steel cube.[240]

In 1998 USI students provided three large works of public sculpture for the Pigeon Creek Greenway Passage. A collaboration of Matt Gehring, Joe Hicks, John Hittner, and Bradley Horstman produced *Direction Finder,* a bronze and steel work that calls attention to the environment through its interaction with wind (a wind sock is mounted in the middle) and water (three large fun-

nel-like structures collect rain that drips onto cones beneath). Matt Campbell's *Fish Story* is a wonderful bit of whimsy suggesting "the one that got away." A twelve-foot copper fish, made in ten sections so that it wiggles in the wind, is suspended from a cable that hangs from an angled utility pole. Alena Richards explores the theme of "nature freeing itself" in a series of three giant polystyrene pots containing stylized flowers crafted of painted cedar. The first pot appears normal, the second is tilted, and the third is on its side, with the plant having broken from the pot. *Free Me!* is a wonderful example of contemporary art with a sense of humor. Unfortunately the piece has been irresistible to vandals. After twice repairing the work after it was destroyed, the parks department erected a locked fence around the third edition, adding an element of irony to the piece.[241]

Commerce and art meet at the new Evansville Pavilion retail mall. The developers in an effort to support the local art community opened a competition to university art students for two pieces of outdoor public sculpture, to be fabricated by a local company. Erected in 2002, both are of stainless steel. *The Bench,* a whimsical piece that is both sculpture and resting place, was designed by Beth Hill of the University of Southern Indiana. Danae Fuller of the University of Evansville designed *Populus,* an abstract family group of parents, three children, a dog, and a cat.[242]

The "Christmas Box Angel"—its official name is *Angel of Hope*—was erected at the Vanderburgh County 4-H Center in 1998 to commemorate children who have died. Several of these bronze angel statues have been dedicated around the country, an outgrowth of the response to the book and television movie *The Christmas Box.* After countless queries as to the location of the statue that figured so importantly in the story, the author decided to commission one that he offers to interested groups

This one did not get away, but the remote location of *Fish Story* on the Pigeon Creek Greenway has invited vandalism to this whimsical piece by Matt Campbell.

for cost. Another was erected in Indiana about three years later in South Bend.[243]

Throughout the Evansville area a large number of parish churches and schools display sculpture, most of which is traditional statuary of marble, limestone, metal (often zinc), or concrete. One exception is the stylized rusting steel relief of the Holy Family on the Center for Family Life on Second Street—the former Saint Anthony School. The work of Father Earl Rohleder (b. 1937), it was installed in 1989. In a niche above the entrance to Saint Anthony Church is a marble image of the saint that dates to the 1890s. There is also statuary at Holy Redeemer Church on West Mill Road, Saint Benedict School on South Harlan Avenue, Nativity Church on Pollack Avenue, Holy Rosary on South Green River Road, and Christ the King School on Bayard Park Drive. A large limestone statue of Saint Joseph is high in a niche above the entrance to the nineteenth-century church in Saint Joseph parish north of the city. The much more modern school also displays a statue of the saint.

Corpus Christi Church on the far west side displays a marble statue of Blessed Mary of the Assumption, which once graced the Assumption Cathedral that had been built in 1872. The cathedral was demolished in the 1960s, although its statuary survives in locations all over the city. Another piece from the cathedral, a limestone rendition of the Assumption of the Blessed Virgin, is on the Ziemer family plot in Saint Joseph Catholic Cemetery on Mesker Park Road. The cemetery, established in 1871, is hilly and wooded, with numerous fine examples of religious and funerary art. A marble statue of Saint Joseph that probably dates to the early days of the cemetery stands near the entrance. Immediately south of Saint Joseph Cemetery is Alexander Memorial Park Cemetery, which opened in the 1950s. As sections have been developed over the years, large marble statues with religious themes have been erected to mark the sections, such as a statue of Christ, the Praying Hands, and a relief of the Last Supper. Similar pieces are found in so-called memory gardens all around the state.

VERMILLION

The public sculptures of largely rural and rolling Vermillion County appear to be confined to its largest town, Clinton. Near downtown in a park along the Wabash River is the Quattro Stagioni Fountain, with its four statues representing the seasons, that was installed in 1966. The park is a focal point during the annual Italian Festival held every September in celebration of the town's heritage. In Immigrant Plaza at Clinton and Ninth streets is a bronze statue representing the many young Italians who flocked to the area to work in the coal mines. The life-size figure of an eager young man clutching

The statue commemorates the thousands of Italian immigrants who poured into Clinton to work in the area's coal mines in the early twentieth century.

a shabby suitcase, the work of Italian sculptor Carl Avenatti, was dedicated in 1971. Near the statue is a flowing fountain in the shape of a bull's head, patterned after the corner fountains in Torino, Italy. It was the gift of a local family with roots in the Italian village.[244]

In Riverside Cemetery is a Soldiers Monument, a life-size marble sentry atop a thirty-foot pedestal, erected about 1900. Downtown in little Bogart Park at Third and Mulberry streets is one of the limestone portrait medallions formerly on the facade of the English Hotel and Opera House in Indianapolis, carved by Henry Saunders in 1898. When the building was demolished in 1948, the portraits of the governors and members of the English family were scattered all over the state. This one is of Claude Matthews (1845–1898), who had lived in Vermillion County and served as governor from 1893 to 1897.

VIGO

The Wabash River splits Vigo County in two, but there is sculpture on both sides. West of the river is Saint Mary-of-the-Woods College, a lovely campus alongside a creek, with woods and hollows and beautiful historic structures, all laden with sculpture. Most are religious statues in a wide range of media, and some are quite old, such as the seven-foot metal figure of Saint Joseph the Educator on the north campus, which dates to 1879. A large grotto of Our Lady of Lourdes was dedicated in 1928. The twelve-foot marble figure of Mary that now is known as Our Lady of the Campus dates to the 1880s, as does the limestone figure of Saint Agnes on the north campus. The oldest piece is probably the carved wooden (tulip poplar) image of Saint Cecilia on Saint Agatha Hall. In her present niche since 1879, she was made in Chicago in the 1860s. There are about two dozen examples of religious statuary scattered about the campus. Nearly all were fashioned by unknown artisans, and nearly all are traditional,

although Indianapolis sculptor Adolph Gustav Wolter (1903–1980) created the contemporary relief of Saint Mary-of-the-Woods on the library in the mid-1960s.[245]

Around the main entrance of the campus are three steel abstract works by John David Mooney of Chicago, installed in celebration of the college's sesquicentennial in 1990. The linear *Springflow*, thirty feet at its tallest point and thirty feet long, was originally exhibited in 1975 in Chicago in the Federal Building Plaza and moved from there to the Indianapolis Museum of Art in 1978. *Return to the East* was also first exhibited in Chicago, in the plaza of the Hyatt Regency Hotel in 1976. Later it was

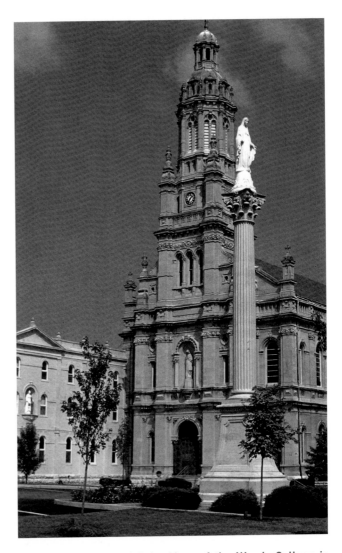

The lovely campus of Saint Mary-of-the-Woods College is filled with religious sculpture.

displayed at the opening of the Snite Museum of Art at the University of Notre Dame in 1980. *High Note,* first installed at Saint Mary-of-the-Woods in 1981, includes neon. Thus, the identity of the sculpture changes at night from a monumental steel work to elements of light. Not far to the west is an installation that blends into its surroundings. *All Human Activities Result from the Conservation of Trees,* by Polish artist Joanna Przybyla, is a fitting theme for a campus that takes its very name from the woods. It was erected in 1992.

In the Darwin Road Cemetery in the vicinity of West Terre Haute is perhaps the largest and among the most unusual of Indiana's two thousand-plus tree stump tombstones. It marks the family plot of John Sheets (1790–1881), who fought in the Battle of Tippecanoe under General William Henry Harri-

son. Fifteen feet high, the gravestone was carved by W. S. Evans of Terre Haute and depicts the trunk of an oak tree upon which is perched an eagle. Carved into the monument are the typical animals Sheets would have hunted, an ax, and a cornstalk, symbolizing pioneer life in the Midwest.

All other sculpture in Vigo County appears to be concentrated in and around Terre Haute, with the exception of the isolated Soldiers Monument erected by the Grand Army of the Republic around 1890 in the little cemetery at Lewis. It features a life-size Union sentry carved of limestone.

In Terre Haute the impressive Soldiers and Sailors Monument, nearly eighty feet high, stands on the northeast corner of the courthouse square. It was dedicated in 1910. The streets adjacent to it have since been widened considerably to accom-

The surroundings of the Vigo County Soldiers and Sailors Monument on the courthouse square are very different today from the time of its dedication in the early twentieth century.

modate the growing snarl of traffic and in the process the original setting of the monument—and the courthouse, for that matter—has been lost. There is little pedestrian traffic, and automobiles speed by too quickly to appreciate the workmanship of Rudolf Schwarz (1866–1912), who did all the bronze work. Typical of the larger monuments of this type, four representative military figures, each on its own individual pedestal, surround the base. A soaring granite shaft supports a flag bearer. The courthouse, designed by Cincinnati architect Samuel Hannaford and completed in 1888, is ornamented with a number of high reliefs in limestone. The most ornate are in the pediments above the entrances on all four sides. The stonework was done by artisans of the Terre Haute Stone Company.

A number of other memorials surround the courthouse. The earliest is a bronze bust of Richard W. Thompson (1809–1900), who moved to Terre Haute in 1843 and was a successful local politician in several posts, serving two discontiguous terms as a United States representative and as secretary of the navy under President Rutherford B. Hayes. The bust by Alexander Doyle (1857–1922) was cast in New York in 1902 and placed at the courthouse in 1906. In 1988 a Vietnam Veterans Memorial was erected, consisting of three limestone panels and a life-size nearly full-round relief of a soldier in full combat gear, carrying an M-16 rifle at the ready. It, too, is placed where it cannot be fully appreciated, along busy US 40, where there is little pedestrian traffic. The monument was designed by Robert Crotty Jr. of Rosedale. The Laborers International School outside Oolitic did the stone carving. The most recent memorial was dedicated in 2001 to the memory of Marine corporal Charles G. Abrell, who died in battle in the early months of the Korean War and was posthumously awarded the Congressional Medal of Honor. Sculptor Bill Wolfe created a life-size bronze portrait of Abrell in full combat gear, standing on a pedestal on the southeast corner of the courthouse.[246] A new Veterans Memorial Plaza

Terre Haute's Medal of Honor winner Corporal Charles G. Abrell is remembered on the courthouse square.

was dedicated in March 2003, incorporating all the existing war memorials. Monuments are to be added as funding permits to commemorate veterans of all American wars.

Although many historic buildings in downtown Terre Haute have been torn down, several with significant sculptural ornamentation survive. The Hippodrome Theater on Ohio Street, built in 1915, displays large and small roundels with roaring lions, along with ornate brackets and other embellishments. The Terminal Arcade in the 800 block of Wabash Avenue, formerly an interurban station, features two flamboyant limestone facades, north and south, carved by J. W. Quayle and Fred Edler. The identical facades are lavish with lions' heads, garlands and wreaths, and a basket of fruit. The exquisite building, built in 1911, was designed by the

famous Chicago architect and city planner Daniel Burnham (1846–1912). A block to the west is the former Fort Harrison Savings Building, constructed in 1926, with its three-foot limestone eagle guarding the entrance. Not far to the west once stood the McKeen Bank Building, atop which perched a nearly life-size running figure of Mercury supported by a face representing the wind. Fashioned of white zinc, it is a copy of a sixteenth-century work by Giovanni da Bologna (1529–1608), installed when the three-story building was constructed in the 1870s. The old bank was demolished in 1958, and for about thirty years the statue was displayed at the Vigo County Historical Society until the effects of earlier damage to the supporting ankle demanded repair. The statue was crated and remains in storage, but plans are underway to restore it.

North of downtown on the former McLean School, constructed in 1917 on Lafayette Avenue, are a pair of gnomelike monk figures of terra cotta. The figures squat on either side above the main entrance, and their extended right hands appear to have once held objects, probably lanterns. The work is unattributed, but very similar figures were done for a library in Indianapolis by sculptor Alexander Sangernebo (1856–1930). A metal eagle that once graced Garfield High School now stands as an independent sculpture, supported by angle iron jutting upward from a concrete base. The eagle, which dates to 1912, has on its chest a crest emblazoned with "GHS." It is erected at the site where the high school once stood in the 1200 block of Maple Avenue. Another sculptural remnant is part of a larger memorial fashioned from architectural salvage as a Works Progress Administration (WPA) project. Two stone eagles and surrounding relief once graced a nineteenth-century post office that had stood at Seventh and Cherry streets until 1932. The reliefs were placed in salvaged pediments supported by Corinthian columns to create the Chauncey Rose Memorial in 1937. The memorial is located in Fairbanks Park. In the same park, as part of a renovation project in the early 1980s, a contemporary fountain was installed. The twenty-foot steel sculpture was

the work of Indiana State University student Thomas Dubois.

On the campus of ISU are several sculptures, although the permanence of the pieces or their locations is subject to change. There are almost no older pieces, apart from some salvaged limestone elfin figures from Reeve Hall, built in 1924 and unfortunately demolished in the 1990s. Erected in 1950, *Dedication to Service*, by Doctor Harry V. Wann, then head of the department of foreign languages, took him eight years to complete during his spare time. The classical heroic female figure was meant to be symbolic of the chief mission of what was then called Indiana State Teachers College: the preparation of teachers to be dedicated to the profession they have chosen. The bronze statue was originally

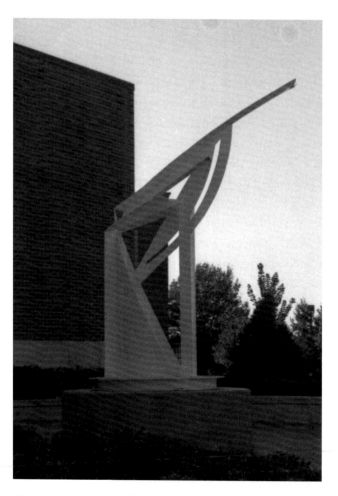

Salute, by Michigan artist Marcia Wood, greets audiences in front of the Center for Performing Arts at Indiana State University.

placed in front of the administration building. It is presently in storage.

Prometheus is a curvilinear abstract piece formed of ferro-cement. Somewhat suggestive of a figure, it holds aloft a disk of welded steel. Prometheus, according to Greek mythology, stole the secret of fire from the gods and gave it to man—a fitting work, then, to be placed at the Science Building. John L. Laska, formerly of the ISU art faculty, created the piece in 1963. It was rededicated in its present location in 1992. Local sculptor Phil Dees completed *In Celebration of the Human Spirit*, which is also known as *Blue Sculpture*, in 1993. The university purchased the piece in 1995 and placed it in front of the old Technology Building. It is a welded steel abstract more than six feet high that, indeed, is painted blue. Michigan artist Marcia Wood (1933–2000), whose work also graces the La Porte Hospital in northern Indiana, completed a painted steel abstract called *Salute* in 1997 that was loaned to ISU the following year. After her death her family's foundation decided that the piece should stay on campus, and the university held a formal dedication ceremony in October 2000 at the new Center for Performing Arts on Seventh Street. Florida native David Wray, a graduate student, completed a contemporary work called *Hook, Line, and Sinker* in 2001, installed farther north on Seventh Street. An assemblage of steel, limestone, and cables, the bright yellow piece is intended to represent "the act of man's desire to remove and relocate nature."[247]

In spring 2003 the university dedicated its first outdoor sculpture gallery—or more accurately, "corridor"—along what had once been Sixth Street before it was closed to traffic and removed. Five student artworks were placed between the science building and Hulman Memorial Student Union, and more will continue to be added to the area. Each piece will be up for two years, on loan to Indiana State, and the artists each receive a merit award. Later that year, a new permanent piece by Edward McCullough (b. 1934) was installed near Dreiser Hall. Nine feet tall of stainless steel, the work, called *Meridian II,* seems to invite the viewer to step

within it. Indeed, the artist encourages such activity, believing that his work is truly "public sculpture" with which people can interact.

At the headquarters of the Laborers International Union of North America on South Fourth Street is a limestone piece of a slinky fish wrapped about an anchor surrounded by open shells that would be at home in the center of a fountain. It was fashioned by students at the union's carving school near Bedford. There are several other carved stone pieces scattered about.

Outside the Vigo County Historical Society at 1411 South Sixth Street is a totem pole of white pine, created in 1938 and originally installed at Rocky Edge, the Chapman Jay Root estate in Allendale. Root founded the Root Glass Company, most famous for its design of the original Coca-Cola bottle. Much of the estate was purchased by the Claretian Fathers, who established the Immaculate Heart Novitiate on the property. The totem pole, however, was not part of the purchased land. Root's grandson created his own estate Rocky Ledge across a hollow from his grandparents' home, and the pole was placed in the hollow. Evidently totem poles were a popular form of garden sculpture in the 1930s, and Mrs. Root hired C. Huston Isaacs, something of an authority on Native American lore, to undertake creating one. Isaacs enlisted the aid of his friend Charles Eggleston, also an amateur Indian scholar, to carve the twenty-foot-high pole they named *Tootooch,* which purports to translate to "Thunderbird"—the top figure of the piece. In 1963 the family donated the totem pole to the historical society, where it dominates the front lawn.

Downtown churches in Terre Haute exhibit religious statuary, two at Saint Benedict on Ninth Street, including a stone image of the patron saint in a niche that dates to the church's construction in 1896, and two at Saint Joseph Catholic Church on Fifth Street. The Saint Joseph Parish Center, the former Saint Joseph Male Academy built in 1888, features a symbolic limestone relief at the third-story level above the entrance. Saint Patrick Catholic Church in the 1800 block of Poplar Street has a

marble figure of its saint. At the Sisters of Carmelite Monastery off South US 41 are two modern traditional figures affixed to the exterior walls: the Madonna and Child is of limestone, but Saint Joseph is of cast aluminum and eight feet high. The First Unitarian-Universalist Congregation on South Fruitridge Avenue erected a piece by retired ISU professor John Laska outside its building in 2003.

Highland Lawn Cemetery on the east side of the city has many exquisite examples of funerary art amidst its wooded and hilly terrain. There is also a large bronze figure of an elk, *Elk's Rest,* erected by the local Elks' lodge in 1904. The figure guards a section of the cemetery that had been set aside for members of the fraternal organization. This figure was cast at the Gorham Company Founders in New York; a similar statue in Logansport was cast at an Ohio firm.

Janet Scudder (1869–1940), one of the most prominent of several women sculptors working in the early twentieth century, was born in Terre Haute. The Swope Art Museum has her famous *Frog Fountain,* although it is displayed inside. The Women's Department Club on South Sixth Street installed Scudder's *Boy with Fish* in a fountain setting in 1941 as the Janet Scudder Memorial. The sculpture, one of four casts made sometime before World War I, was purchased from the Scudder estate. In recent years the piece was restored, and the Swope Museum is seeking to acquire it. Until recently, another of Scudder's works was on the campus of Rose-Hulman Institute of Technology. *Boys at Play* portrayed two small boys vying for possession of a large seashell and was originally intended as a fountain piece. The work first resided at the Rose Orphans Home, which was closed in 1949 and later demolished. It came to the campus in 1989 but disappeared sometime during the next decade; it has since been found and returned to the Vigo County Historical Society.

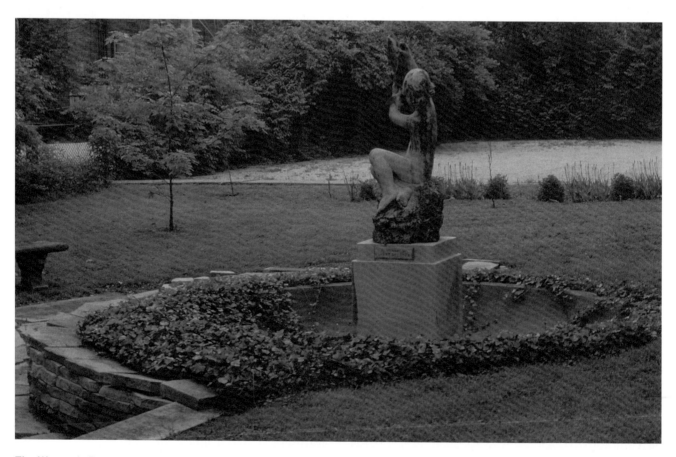

The Women's Department Club purchased *Boy with Fish* to create in 1941 the Janet Scudder Memorial, which stood behind its clubhouse for more than fifty years.

Another prominent woman sculptor of the time, Harriet W. Frishmuth (1880–1980), is represented in the Rose-Hulman collection. The bronze piece *Call of the Sea,* no doubt intended for a fountain, depicts a young girl gleefully riding a fish. It was cast in 1924. Another small bronze piece, *Woman in Prayer,* is the figure of a girl, praying or pleading. Created by nineteenth-century French artist Paul Dubois (1829–1905), the statue may once have been part of a larger group, but its history is lost. The work was cast by the famous French founder Ferdinand Barbedienne.

About 1970 a Cor-Ten steel piece by Mark Parmenter, which resembles a huge gavel hinged to a base, was erected on the campus. C. R. Schiefer of rural Morgan County was enlisted to create a new sundial when an earlier one was broken. Typical of Schiefer's work, two stylized elephants' heads form the pedestal for the sundial, which was installed in 1992. On the facade of the Shook Fieldhouse, built in 1948, are six limestone relief panels, each featuring a different stylized athlete engaged in his sport. Rose-Hulman also has a sort of sculpture created from an assemblage of architectural salvage, a concept which seems to find particular favor in Terre Haute. *The Cairn* was dedicated in 1974 in honor of Chauncey Rose and consists of the chapel bell and fragments of stonework from the demolished Rose Orphans Home. The fragments date to the 1880s.

In 2003 an impressive stainless steel abstract rising from a pond setting was installed next to Hatfield Hall. Standing forty-five feet high, *Flame of the Millennium* by Mexican-born Leonardo Nierman (b. 1932) is clearly visible from US 40.

WABASH

The rolling terrain of Wabash County is still largely rural. Its handful of sculptures in the county seat of Wabash are within easy walking distance of one another. In front of the courthouse is the fine interpretation of Abraham Lincoln by sculptor Charles

Keck (1875–1951). The bronze heroic sculpture of a seated Lincoln in a somber, contemplative pose was a gift from Alexander New in memory of his parents. New grew up in Wabash, studied law, and ultimately built up a large chain of stores whose main offices were in New York. New commissioned Keck, a renowned New York sculptor, to create the statue for his hometown, which was unveiled on Decoration Day, 1932, a year after New's death.[248]

About a block west of the Lincoln is the old Grand Army of the Republic Memorial Hall built in 1899, which today houses the county museum. Flanking the entrance are two figures that remind visitors of the building's original function: a life-size Union soldier and sailor. Although more than a hundred years old, the painted cast-iron figures have survived largely intact.[249]

At the Honeywell Center, built in the 1940s at 275 West Market Street, is a bronze statue by Arizona

Prominently sited on the courthouse square in downtown Wabash is this marvelously wrought figure of Abraham Lincoln.

sculptor John Soderberg (b. 1951) of Mark Honeywell, flanked by two children. The piece was dedicated in 1994 when an addition to the center was completed. Honeywell, cofounder of Honeywell Inc., was a native of Wabash, who gave much back to the community through the foundation he established. Honeywell was childless, and the figures in the sculpture represent the children of the community who are served by the programs the center provides.[250]

The Speiker Cemetery at Urbana has an unusual grave marker widely known in the area, a full bust of Mr. Speiker.

WARREN

One of Indiana's smaller counties, the terrain of Warren County is surprisingly rugged in places and mostly rural. There do not appear to be any outdoor sculptures in the county.

WARRICK

Although Warrick County hugs the north bank of the Ohio River, there are virtually no settlements along it. The county seat of Boonville is in the middle, and what sculpture exists is in the center of town, all around the courthouse square. During the 1930s Rockport native George H. Honig (1874–1962) fashioned several bronze plaques of the county's early movers and shakers, mounted on substantial limestone tablets, each of which included a relief portrait along with a text identifying the person. A portrait plaque commemorating Abraham Lincoln, who, as a youth, frequently walked the seventeen miles to town in order to borrow books, was dedicated on February 12, 1933. The portrait was modeled after the earliest known photograph of Lincoln. On the same day a portrait plaque of William L. Barker, a local historian and Lincoln scholar, was unveiled. In 1938 two more portrait plaques of native sons, each mounted on its own stone tablet, were

Sculptor George H. Honig specialized in commemorative reliefs; this is one of four placed around the Warrick County Courthouse in Boonville.

added to the courthouse square on the north side. William Fortune (1863–1942), present at the dedication, was a newspaper editor and civic leader who made his mark in Indianapolis. Nonetheless, Boonville was proud of the boy who made good. Also dedicated was a portrait plaque of James A. Hemenway (1860–1923), who served in both the U.S. House of Representatives and the Senate.[251]

There was a bit of space left at the southwest corner of the square, so in 1948 when the English Hotel and Opera House in Indianapolis was demolished and its limestone portrait medallions of governors were sold off, Ratliff Boon (1781–1844) came home. Boon was a cousin of the famous pioneer explorer Daniel Boone and the state's first lieutenant governor, serving briefly as governor when Jonathan Jennings resigned. Later he served several terms in Congress. Henry Saunders had sculpted the governors' portraits in the 1890s as part of the facade dec-

oration of the hotel and opera house. Ratliff Boon, refinished and mounted upon a limestone pedestal in the town bearing his name, was dedicated in 1949. In the 1990s he was refurbished once more.

WASHINGTON

Deep in southern Indiana, hilly Washington County for years had only one charming sculpture. Stone carver Collins James Morgan worked on the ornamentation of the courthouse in the center of Salem, then turned his attentions to a bank on the northeast side of the square. In 1884 Morgan carved a limestone lion with a knowing expression in front of

No wonder this lion watching Salem's courthouse has such a knowing expression; he has seen a lot in 120 years!

the bank. The bank behind him has changed, but the lion still sits on the sidewalk, gazing at the courthouse and wondering what all the fuss is about. About 1996 Allen County artist Alison Adams created a lovely limestone piece for the Salem Cemetery, *Mother and Child*.[252]

WAYNE

Most of the sculpture in historic Wayne County, where the National Road crosses the Whitewater River at its gorge, is within the confines of the county seat of Richmond, with a few exceptions. In Riverside Cemetery on the north edge of Cambridge City is a statue of Civil War general Solomon Meredith (1810–1875), which originally had been placed about a mile south at the family home, Oakland Farm, in 1877. The statue was moved to the center of the city cemetery in 1908, where it marks the Meredith family plot. The heroic marble statue is an early work of John H. Mahoney (1855–1919), who later created three large bronze figures for the Soldiers and Sailors Monument in Indianapolis. In the same cemetery is a wonderful stone figure, nearly life-size, of agriculturalist Louis P. Klieber (1865–1941). Dressed in work clothes, he holds a sickle in one hand and a sheaf of wheat in the other. Apparently the statue was carved in the 1930s before Klieber died. The artist is unknown, although Klieber's son-in-law worked for the Repp Monument Company in Cambridge City.[253]

A little farther north at the elementary school in Hagerstown are a pair of stylized limestone owls over three feet high. They once watched over the entrance to the high school building built in 1922 and were saved when it was demolished.

As one might expect on the campus of a Quaker institution, there is no outdoor sculpture at Earlham College except for a statue of seventeenth-century martyr Mary Dyer, who died for her faith in Boston in 1660. The bronze figure is one of three castings of a piece created by Sylvia Shaw Judson

In a small cemetery on the north side of Cambridge City stands this monument to General Solomon Meredith by sculptor John Mahoney.

(1897–1978); the others are at the statehouse in Boston and the Mall in Philadelphia. It was erected at Earlham in 1962.

On the opposite side of town along the old National Road in Glen Miller Park is *The Madonna of the Trail* by August Leimbach (1882–1965) of Saint Louis. Dedicated in 1928, the statue is one of twelve sited along US 40, one in each state through which it passes, erected by the Daughters of the American Revolution to honor pioneer women. The nine-foot figure of a sturdy woman holding an infant while a young child clings to her skirts is made of the cast stone Algonite. In the park's famous rose garden is a much more recent piece,

Hands Holding the Rose, by the husband-and-wife sculptors Bill and Jeanne Magaw. Created in 1993, the thirteen-foot Cor-Ten steel abstract suggests the shape of a rosebud. Within the upward curves is a realistic single rose with stem and leaves.

In 1986 the city of Richmond commissioned the Magaws to create a contemporary piece for the grounds of the Municipal Building downtown. Dedicated the following year, *Justice Being Balanced by the Constitution* suggests a stick figure holding aloft the scales of justice, whose pans hold little figures. The five-foot bronze work is sited on a large rock about twelve feet high. On the nearby Wayne County Courthouse, built 1890–93, is a large limestone medallion, about five feet in diameter, which replicates the seal of the county commissioners. A simple agrarian scene in very high relief shows a tree, a plow, and a bound shock of wheat,

Indiana's *The Madonna of the Trail* by August Leimbach stands in Glen Miller Park in Richmond.

below which is the date in raised numerals "A.D. 1890."

East of the courthouse is a very realistic bronze rendition of a bald eagle, wings spread, talons outstretched ready to grasp a sphere. In 1982 the president of the Wayne Bank commissioned Oregon sculptor Lorenzo E. Ghiglieri (b. 1931) to create the piece. It rests on a pedestal on the grounds of the bank at A and Fifth streets.[254]

Various religious institutions around the city display statuary, much of which dates to the early twentieth century. Saint Andrew Catholic Church on South Fifth Street has a large Guardian Angel, probably marble, that dates to 1912. Nearby, the entrance to the Saint Joseph Chapel displays a beautiful carved limestone Crucifixion tableau (1908), beneath which is an inscription in German. High above the entrance to Saint Mary Catholic Church on North Eighth Street is a large marble statue of the Virgin Mary, dating to 1909. West of the river on West Main Street at Seton Catholic School is a fiberglass statue of Mother Elizabeth Ann Seton (1774–1821) and modern-day children by Sister Margaret Beaudette, a nun of the order of Sisters of Charity. Another casting of the piece, which was made in 1992, is in Fort Wayne.[255]

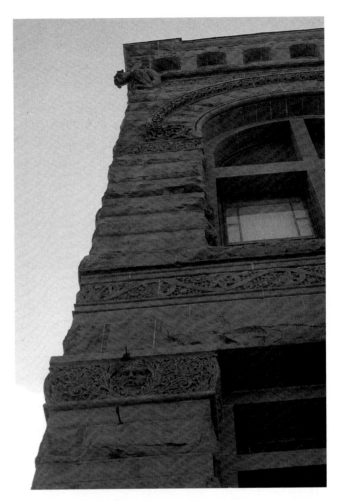

The courthouse in Bluffton is alive with creatures and faces that peer from the stone.

WELLS

The county seat of Bluffton has gathered an odd assortment of sculpture over the years. Built in 1891, the Romanesque Revival courthouse teems with grotesques and a variety of faces peering out of the sandstone ornament from unexpected places. Farther north on Main Street (State Road 1) at its intersection with State Road 124 is a realistic dead tree that sports a bear in its branches, all of concrete. The piece was created about 1936 by a young man named Welker in the town of Petroleum and purchased by the owner of the Moser Oil Company, who hauled it to Bluffton. The tree had no apparent thematic connection to Moser's filling station,

which was built to resemble an airplane. A modern gasoline station has taken its place, but the bear of Bluffton remains.[256]

Farther north on Main Street at Saint Joseph Church is Fort Wayne sculptor Hector Garcia's (b. 1933) interpretation of Saint Joseph the Educator with the Christ Child on his shoulder. Originally installed above the entrance when the church was built in 1964, the fiberglass piece now stands in front of the church, which has since been remodeled. In Elm Grove Cemetery is one of two nearly identical marble recording angels, each about six feet high. Their origin seems to have been lost, but they are said to have come from Italy and are likely by the same carver. About 1960 one was placed at Elm Ridge and the other at Oak Lawn Cemetery in Ossian.

Also in Oak Lawn Cemetery is a Civil War monument erected by the Grand Army of the Republic in 1911, featuring a granite sentry on a tall pedestal. In the Hoverstock Cemetery at Zanesville is a roughly life-size marble statue of William and Margaret Hoverstock, standing atop the family vault. Margaret died in 1890, and William died thirteen years later. The statue was carved in Italy and was most likely based on a photograph.

WHITE

There is virtually no public sculpture in White County, save for religious pieces at various churches,

such as the Sacred Heart at Saint Joseph Catholic Church on the south side of Reynolds. A poignant remnant of the 1894 White County Courthouse in Monticello that was destroyed by a tornado in 1974 is now a bizarrely whimsical freestanding sculpture. Stacked on the cornerstone is the keystone from the main entrance, displaying an unusual face surrounded by tangled vines, a popular decorative motif of the period. It stands near the southeast corner of the block where the courthouse once stood.[257]

Collaborative artist Joe LaMantia of Bloomington worked with the pupils of Woodlawn Elementary School in Monticello to create a colorful garden of flowers constructed of scrap metal. The piece is called *Wild Life*.

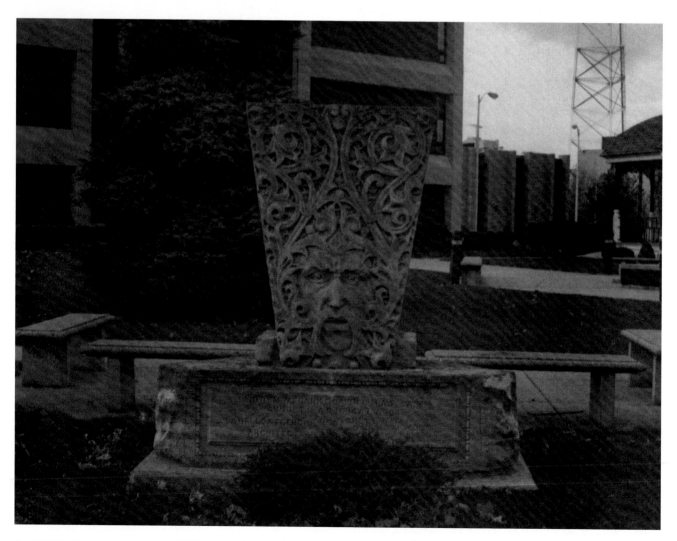

Sculptural fragments of the old White County Courthouse are displayed in downtown Monticello.

WHITLEY

On the north side of the courthouse square in Columbia City stands a Civil War monument, dedicated in 1897, featuring a marble sentry. The 1890 courthouse itself boasts fanciful limestone reliefs, including animals and a Liberty head.[258]

Saint Paul of the Cross Catholic Church at 315 South Line Street features a local cityscape and a relief of Saint Paul in concrete, the work of former priest-sculptor Henry R. "Hank" Mascotte, completed in 1989.

Saint John Bosco Church on Main Street (the old Lincoln Highway) in the town of Churubusco has two life-size marble religious statues, one of Christ and the other of the Virgin Mary. They date to before World War I.

One of many Civil War monuments in Indiana featuring a statue of a sentry stands before the Whitley County Courthouse.

FOREWORD

1. Quoted in "On Site: Contemporary Art in Indiana's Public Places," *Indiana Arts Commission Quarterly* (Summer 1988): 7.

CHAPTER ONE
From Billy Yank to GI Joe
Sculptural Memorials to War and Peace

1. For more information on these monuments see "Indiana Save Outdoor Sculpture!" files (1992–94), Resource Center of Historic Landmarks Foundation of Indiana, Indianapolis. Files are indexed alphabetically by county and town within each county. Specifically, see files 26-007, 29-010, 49-187, 60-002 (hereafter cited as SOS! files).

2. Ibid.

3. Ibid.

4. For an account of the battle see James M. McPherson, *Battle Cry of Freedom: The Civil War Era* (New York: Oxford University Press, 1988), 630. See also SOS! files.

5. SOS! files.

6. Ibid., 49-082.

7. Ibid.

8. Theodore Stempfel Sr., *Ghosts of the Past: Autobiographical Sketches* (Indianapolis: [T. Stempfel Jr.], 1936), 78–94; *Indianapolis News,* Apr. 14, 1912.

9. Stempfel, *Ghosts of the Past,* 84, 92; *Indianapolis News,* Apr. 14, 1912. See also SOS! files.

10. Stempfel, *Ghosts of the Past,* 78–94.

11. SOS! files.

12. W. H. Mullins Company, *Statues in Stamped Copper and Bronze* (Salem, Ohio: The Company, 1913).

13. SOS! files, 47-002.

14. Ibid., 53-008.

15. Ibid., 37-005.

16. The federal government originally took over the Martin County property in 1938 to develop it for recreational use as a state forest.

17. SOS! files, 49-117, 02-011.

18. Information regarding the Bedford sculpture in *Indianapolis News,* Aug. 22, 1932; Larry Corps, telephone interview with the author, Apr. 10, 2002.

19. SOS! files, 60-003, 53-042, 47-012.

20. E. M. Viquesney, *The Spirit of the American Doughboy,* brochure, ca. 1937.

21. *Indianapolis Star,* Oct. 5, 1946.

22. Author's on-site documentation, Mar. 16, 2002; *Indianapolis News,* May 29, 1995; author's on-site documentation, Oct. 16, 1999; William Arnold, interview with the author, May 15, 2002.

23. *Indianapolis Star,* Nov. 15, 1999; *Kokomo Tribune,* Sept. 17, 2000.

24. Don Johnson, telephone interview with the author, Apr. 4, 2002; http://www.communityveteransmemorial.org.

CHAPTER TWO
Movers and Shakers and Monument Makers
Effigies of Heroes and Archetypes

1. "Indiana Save Outdoor Sculpture!" files (1992–94), 85-001, 49-130, Resource Center of Historic Landmarks Foundation of Indiana, Indianapolis. Files are indexed alphabetically by county and town within each county (hereafter cited as SOS! files).

2. Ibid., 49-101.

3. Ibid., 74-004.

4. Duane Chattin, e-mail message to the author, Apr. 5, 2002; on-site documentation by Mark Dollase, Apr. 5, 2002.

5. SOS! files, 49-098, 49-012.

6. Guy Tedesco, telephone interview with the author, May 24, 2002.

7. *Indianapolis Star,* Nov. 26, 1999; *Indianapolis Spotlight,* Apr. 3, 2002.

8. Ralph D. Gray, ed., *Gentlemen from Indiana: National Party Candidates, 1836–1940*, Indiana Historical Collections, vol. 50 (Indianapolis: Indiana Historical Bureau, 1977), 55–82.

9. Ibid., 117–39.

10. Ibid., 83–115.

11. Ibid., 291–315.

12. Greg Perry, letter to the author, Apr. 7, 1995; *Indianapolis Star*, Jan. 15, 1995; *Indianapolis News*, Sept. 27, 1995; *South Bend Tribune*, Oct. 1, 1995.

13. Author's on-site documentation, May 26, 2001.

14. Ibid., Feb. 24, 2002; *Indianapolis Star*, Aug. 17, 1965; Don Caudell Sr., telephone interview with the author, May 31, 2002.

15. SOS! files, 41-003.

16. Tedesco telephone interview.

17. SOS! files, 62-007, 62-008.

18. Ibid., 45-018.

19. Geoff Paddock, telephone interview with the author, May 14, 2002; author's on-site documentation, June 2, 2002.

20. Phil Zimmerman, e-mail messages to the author, Oct. 30, Nov. 1, 2000.

21. SOS! files, 49-115.

22. Ibid., 45-020, 46-014.

23. Ibid., 50-011; Jessie P. Boswell, comp., "Historical Markers and Public Memorials in Indiana," *Indiana History Bulletin* 6, extra no. 1 (Jan. 1929): 40.

24. SOS! files, 05-002.

25. Ibid., 02-015; author's on-site documentation, June 2, 2002.

26. SOS! files, 18-003, 18-016.

27. Rex Allman, e-mail message to the author, Sept. 5, 2001; author's on-site documentation, Dec. 23, 2002.

28. SOS! files, 03-001, 03-020.

29. Ibid., 48-001.

30. Ibid., 26-003, 90-007.

CHAPTER THREE
Saints, Angels, and Graven Images
Religious Sculpture

1. "Indiana Save Outdoor Sculpture!" files (1992–94), 50-001, Resource Center of Historic Landmarks Foundation of Indiana, Indianapolis. Files are indexed alphabetically by county and town within each county (hereafter cited as SOS! files).

2. Ibid., 62-011.

3. Earl Rohleder, e-mail message to the author, June 22, 2002; David Kocka, telephone interview with the author, May 24, 2002; author's on-site documentation, Mar. 15, 1999.

CHAPTER FOUR
Lions and Santas and Bears, Oh My!
Animals, Children, Whimsies, and Oddities

1. "Indiana Save Outdoor Sculpture!" files (1992–94), 25-001, 88-001, 62-009, Resource Center of Historic Landmarks Foundation of Indiana, Indianapolis. Files are indexed alphabet-

ically by county and town within each county (hereafter cited as SOS! files).

2. Ibid., 28-003, 49-088.

3. Ibid., 73-004, 90-002.

4. Ibid., 47-017.

5. Ibid., 74-022; *Christmas in Santa Claus & Spencer County, Indiana*, brochure, 2001; Vevah Harris, e-mail message to the author, Jan. 21, 2002.

6. SOS! files, 43-001.

7. Ibid., 07-002.

CHAPTER FIVE
Scales and Sheaves, Fountains and Flowers
Traditional Allegorical and Aesthetic Public Sculpture

1. "Indiana Save Outdoor Sculpture!" files (1992–94), 82-003, Resource Center of Historic Landmarks Foundation of Indiana, Indianapolis. Files are indexed alphabetically by county and town within each county (hereafter cited as SOS! files).

2. *South Bend Tribune*, June 9, 1996.

3. SOS! files, 45-032.

4. Ibid., 49-165, 49-160, 49-158, 49-083.

5. Ibid., 49-145.

6. Indianapolis is, after all, the city with a mayor that likened the innovative dancer Isadora Duncan to a hoochie-coochie act. SOS! files., 49-127, 73-003, 42-012.

7. SOS! files, 20-011, 17-001.

8. Ibid., 39-004.

9. *Indianapolis Star*, Dec. 11, 1932.

10. Harold R. "Tuck" Langland, interview with the author, June 15, 2000.

CHAPTER SIX
What Is That Supposed to Be?
Public Encounters with Contemporary Sculpture

1. Robert Borns, telephone interview with the author, July 1, 2002; Gary Freeman, telephone interview with the author, July 9, 2002; "Herron Students Install Sculptures at Local Company," IUPUI news release, May 4, 2002; "Sculpture around Town," *Herron Highlights* 3 (Summer 2001): 2; Kathy McKimmie, "Forging Steel Alliances: Celadon Trucking and the Herron School of Art," *Arts Indiana* 21, no. 3 (July–Aug. 1999): 31–32.

2. "Indiana Save Outdoor Sculpture!" files (1992–94), 49-142, Resource Center of Historic Landmarks Foundation of Indiana, Indianapolis. Files are indexed alphabetically by county and town within each county (hereafter cited as SOS! files).

3. Don Gummers's piece was originally designed to be over twelve feet high; the final work is a little over six feet in height. Chip Kalleen, "Sculptor Refutes 'Cornbelt' Story," *Arts Insight* 8, no. 7 (Oct. 1986): 14–15; "On-site: Contemporary Art in Indiana's Public Places," *Indiana Arts Commission Quarterly* (Summer 1988); *Evansville Courier and Press*, May 26, 2002.

4. SOS! files, 49-139; *Indianapolis Star*, Sept. 4, 1999.

5. Wayne Schmidt, quoted in *Indianapolis News,* Sept. 16, 1983; Artist's Statement, dedication program, Sept. 28, 1987; *Evansville Courier and Press,* May 26, 2002.

6. Susan Warren Akers, "Revival of the Fittest: Anderson's Reawakening," *Arts Indiana* 21, no. 3 (July–Aug. 1999): 53; "Breaking the Mold," *Indianapolis Monthly* (Oct. 1982): 56; "On Site," 8–9.

7. Martha Winans, "Public Sculpture Examined," *Arts Insight* 5, no. 7 (Nov. 1983): 14; David Jemerson Young, telephone interview with the author, July 2, 2002; Paul Knapp, telephone interview with the author, June 28, 2002; "92 County Walk Will Spark Conversations about Indiana Counties," *Your Indiana State Museum* (Jan./Feb. 2002); Jessica DiSanto, e-mail messages to the author, Apr. 18, May 17, 2002.

8. Young telephone interview.

9. Julie Pratt McQuiston, "Delicate Stonehenge," *Indianapolis Nuvo,* June 10–17, 1999; artist's statement of Dale Enochs in *Stone Sculpture: Regional Approaches,* program, Louisville Visual Arts Association, 1994.

10. Susan Warren Akers, "Indiana's Millennium 2000: Communities Celebrate through Art," *Arts Indiana* 21, no. 5 (Nov.–Dec. 1999): 75–76; Arlon Bayliss, e-mail message to the author, Apr. 11, 2002.

11. Louis Ortiz, telephone interview with the author, July 18, 2002; *South Bend Tribune,* Aug. 9, 23, 1998, June 15, 2000.

12. Donna Imus, telephone interview with the author, June 19, 2002; *Indianapolis News,* May 26, 1999.

13. Information on the Odyssey exhibition found at http://www.purduenc.edu/cd/odyssey/.

14. "Sculpture around Town," 3; Julie Schaefer, e-mail message to the author, June 30, 2002; Diane Billiard, telephone interview with the author, July 8, 2002.

15. Joe LaMantia, interview with the author, Mar. 29, 2002; *Collaborative Sculpture: A Hands-on Experience for All with Joe LaMantia,* promotional brochure, 1998; "Study Outdoor Sculpture," promotional flyer, n.d. (in use in 2002).

16. Winans, "Public Sculpture Examined," 14.

Outdoor Sculpture around the State

1. Unless otherwise indicated, further information on Adams County's outdoor sculptures erected before 1994 can be found in "Indiana Save Outdoor Sculpture!" files (1992–94), 01-001–01-005, Resource Center of Historic Landmarks Foundation of Indiana, Indianapolis. Files are indexed alphabetically by county and town within each county (hereafter cited as SOS! files).

2. Dale Enochs, telephone interview with the author, Mar. 28, 2002; additional information on the artist's Web site at http://home.bluemarble.net/~denochs/.

3. Unless otherwise indicated, further information on Allen County's outdoor sculptures erected before 1994 can be found in SOS! files, 02-001–02-086.

4. Geoff Paddock, telephone interview with the author, May 14, 2002; author's on-site documentation, June 2, 2002.

5. "Museum Receives Two Sculptures," *Arts Insight* 7, no.

7 (Oct. 1985): 23; J. T. Barone, "World Famous Sculptor Gives 'Phenomenal' Gift of Work," ibid. 9, no. 3 (Apr. 1987): 21.

6. Hector Garcia, telephone interview with the author, June 17, 2002.

7. Saint Jude Catholic School, *Who Put That There? Outdoor Sculptures of Fort Wayne* (Fort Wayne, Ind., 1998); Linda Chapman, reference librarian, Allen County Public Library; author's on-site documentation, May 26, 2001.

8. *Who Put That There?; Fort Wayne Journal-Gazette,* Sept. 9, 1997.

9. Unless otherwise indicated, further information on Bartholomew County's outdoor sculptures erected before 1994 can be found in SOS! files, 03-001–03-026.

10. David L. Lacey, e-mail message to the author, May 22, 2002.

11. Mary Clare Speckner, e-mail messages to the author, June 6, 10, 2002. More information on the Marcheschi work at http://www.kid-at-art.com/htdoc/friends.html.

12. *Columbus Republic,* June 19, 2000.

13. Douglas Wissing, "Outside with Art," *Arts Indiana* 23, no. 3 (Summer 2001): 14.

14. Joe LaMantia, interview with the author, Mar. 21, 2002.

15. See SOS! files, 04-001, 04-002.

16. Further information on Blackford County's outdoor sculptures can be found in ibid., 05-001–05-003.

17. Further information on Boone County's outdoor sculptures can be found in ibid., 06-001–06-007.

18. Further information on Brown County's outdoor sculptures can be found in ibid., 07-001–07-003.

19. Further information on Carroll County's outdoor sculptures can be found in ibid., 08-001, 08-002.

20. Further information on Cass County's outdoor sculptures can be found in ibid., 09-001–09-008.

21. Unless otherwise indicated, further information on Clark County's outdoor sculptures erected before 1994 can be found in ibid., 10-001–10-008.

22. Guy Tedesco, telephone interview with the author, May 24, 2002.

23. David Kocka, telephone interview with the author, May 24, 2002.

24. Tedesco telephone interview.

25. Further information on outdoor sculpture in Clay County can be found in SOS! files, 11-001–11-003.

26. Author's on-site documentation, Oct. 30, 2000; Nancy Hart, letter to the author, Oct. 3, 2000. Further information on Clinton County's outdoor sculptures can be found in SOS! files, 12-001–12-003.

27. Additional information can be found in ibid., 13-001.

28. Information on Daviess County's outdoor sculptures can be found in ibid., 14-001–14-004.

29. Information on Dearborn County's outdoor sculptures can be found in ibid., 15-001–15-005.

30. Information on Decatur County's outdoor sculptures can be found in ibid., 16-001–16-006.

31. Further information on De Kalb County's outdoor sculptures can be found in ibid., 17-001–17-008.

32. Author's on-site documentation, Feb. 24, 2002. Unless otherwise indicated, further information on Delaware County's outdoor sculptures erected before 1994 can be found in SOS! files, 18-001–18-040.

33. Susan M. Smith, e-mail message to the author, June 6, 2002; Sheri S. Beaty, e-mail message to the author, May 30, 2002; Wissing, "Outside with Art," 14–15.

34. Author's on-site documentation, Sept. 26, 1999.

35. Ibid.

36. Ibid.

37. Lynn Ryden, letter to the author, Apr. 8, 2002, and Ryden, e-mail message to the author, May 22, 2002; Program for unveiling and dedication ceremony, Oct. 8, 2001; author's on-site documentation of *Illumination*, June 3, 2001.

38. Unless otherwise indicated, further information on Dubois County's outdoor sculptures can be found in SOS! files, 19-001–19-024.

39. For an account of the battle see James M. McPherson, *Battle Cry of Freedom: The Civil War Era* (New York: Oxford University Press, 1988), 630.

40. Author's on-site documentations, July 13, 1999, Aug. 25, 2002; *South Bend Tribune,* Sept. 6, 1994. Unless otherwise indicated, further information on Elkhart County's outdoor sculptures erected before 1994 can be found in SOS! files, 20-001–20-013.

41. Author's on-site documentation, July 13, 1999; *South Bend Tribune,* July 15, 1994; http://www.johnmishler.com/; *South Bend Tribune,* Aug. 15, 20, 2000, June 16, 2002.

42. Author's on-site documentation, July 13, 1999; *South Bend Tribune,* Dec. 17, 1996.

43. *South Bend Tribune,* Dec. 31, 1993, Apr. 18, 1994.

44. SOS! files, 21-001; Gayle Siebert, e-mail messages to the author, Apr. 11, 15, 2002.

45. Unless otherwise indicated, further information on Floyd County's outdoor sculptures erected before 1994 can be found in SOS! files, 22-001–22-012.

46. *New Albany Ledger-Tribune,* Oct. 14, 1997, Apr. 9, 2000.

47. Kocka telephone interview.

48. SOS! files, 23-001.

49. Unless otherwise indicated, further information on Franklin County's outdoor sculptures erected before 1994 can be found in ibid., 24-001–24-016.

50. Jolene Rockwood, e-mail messages to the author, Apr. 13, May 6, 14, 2002.

51. SOS! files, 25-001.

52. Further information on Gibson County's outdoor sculptures can be found in ibid., 26-001–26-008.

53. Author's on-site documentation, May 26, 2001; Ryden letter. Unless otherwise indicated, further information on Grant County's outdoor sculptures erected before 1994 can be found in SOS! files, 27-001–27-005.

54. Author's on-site documentation, Oct. 28, 1999; *Indianapolis Star,* Oct. 8, 1995; Ryden letter.

55. Randy Ballinger, letter to the author, Dec. 10, 1999; *Marion Chronicle-Tribune,* Aug. 13, 1995.

56. Further information on Greene County's outdoor sculptures can be found in SOS! files, 28-001–28-003.

57. Unless otherwise indicated, further information on Hamilton County's outdoor sculptures erected before 1994 can be found in ibid., 29-001–29-010.

58. "Sculpture around Town," *Herron Highlights* 3 (Summer 2001): 2.

59. David Heighway, e-mail message to the author, Mar. 9, 2002.

60. Arlon Bayliss, e-mail message to the author, May 30, 2002.

61. LaMantia interview, Mar. 29, 2002; *Collaborative Sculpture: A Hands-on Experience for All with Joe LaMantia,* promotional brochure, 1998.

62. William Arnold, e-mail message to the author, Mar. 8, 2002.

63. Author's on-site documentation, Oct. 22, 2000.

64. Further information on outdoor sculptures in Hancock County can be found in SOS! files, 30-001–30-003.

65. *Corydon Democrat,* July 11, 2001.

66. SOS! files, 31-001.

67. Kocka telephone interview.

68. Connie Scott, telephone interview with the author, May 30, 2002. Further information on outdoor sculptures in Hendricks County erected before 1994 can be found in SOS! files, 32-001–32-004.

69. Further information on outdoor sculptures in Henry County can be found in SOS! files, 33-001–33-006.

70. *Indianapolis Star,* Nov. 15, 1999; *Kokomo Tribune,* Sept. 17, 2000. Unless otherwise indicated, further information on outdoor sculptures erected before 1994 in Howard County can be found in SOS! files, 34-001–34-003.

71. Ed Riley, e-mail messages to the author, Sept. 2, 5, 2000; author's on-site documentation, Oct. 22, 2000.

72. Riley e-mails, Sept. 2, 2000, June 23, 2004.

73. LaMantia interview, Mar. 29, 2002.

74. Author's on-site documentation, Oct. 22, 2000; Riley e-mails, Sept. 2, 5, 2000, June 22, 2004.

75. SOS! files, 35-001–35-002; author's on-site documentation, Mar. 13, 1993; *Indianapolis Star,* May 26, 1928.

76. SOS! files, 36-001.

77. *Seymour Jackson County Tribune,* Mar. 13, Apr. 5, 2000; Allen Dale Olson, e-mail message to the author, Mar. 16, 2002.

78. Nathan Montgomery, e-mail message to the author, Mar. 17, 2002.

79. Further information on outdoor sculptures in Jasper County can be found in SOS! files, 37-001–37-005.

80. *Indianapolis Star,* Sept. 24, 1936.

81. Further information on outdoor sculptures in Jay County can be found in SOS! files, 38-001–38-003.

82. Unless otherwise indicated, further information on outdoor sculptures erected before 1994 in Jefferson County can be found in ibid., 39-001–36-005.

83. E. G. Yarnetsky, e-mail messages to the author, May 30, 31, 2002.

84. SOS! files, 40-001, 40-002.

85. Unless otherwise indicated, further information on outdoor sculptures erected before 1994 in Johnson County can be found in ibid., 41-001–41-008.

86. Matthew Berg, e-mail message to the author, July 19, 2002.

87. Author's on-site documentation, Apr. 23, 2000; *Indianapolis News*, Sept. 24, 1996.

88. LaMantia interview, Mar. 29, 2002.

89. Unless otherwise indicated, further information on outdoor sculptures erected before 1994 in Knox County can be found in SOS! files, 42-001–42-012.

90. Duane Chattin, e-mail message to the author, Apr. 5, 2002; on-site documentation by Mike Dollase, Apr. 5, 2002.

91. Unless otherwise indicated, further information on outdoor sculptures erected before 1994 in Kosciusko County can be found in SOS! files, 43-001–43-005.

92. *South Bend Tribune*, June 23, 1999.

93. Unless otherwise indicated, further information on outdoor sculptures erected before 1994 in Lake County can be found in SOS! files, 45-001–45-051.

94. Don Johnson, telephone interview with the author, Apr. 4, 2002; http://communityveternsmemorial.org.

95. Public relations information packet on the town of Munster, provided to the author by Charlene Stout, Dec. 7, 2001.

96. Susan Warren Akers, "Indiana's Millennium 2000: Communities Celebrate through Art," *Arts Indiana* 21, no. 5 (Nov.–Dec. 1999): 74–76.

97. Suzanne Long, e-mail message to the author, May 1, 2002.

98. David Scott, telephone interview with the author, May 30, 2002; Kathleen Pucalik, e-mail message to the author, June 3, 2002.

99. Author's on-site documentation, Nov. 22, 2002.

100. Ibid., Sept. 12, 2000.

101. S. Thomas Scarff, telephone interview with the author, May 23, 2002; "SculpTour Map" of Michigan City, n.d. Unless otherwise indicated, further information on La Porte County's outdoor sculptures erected before 1994 can be found in SOS! files, 46-001–46-040.

102. "SculpTour Map."

103. Information on the Orak Shrine, e-mail message to the author, July 18, 2002.

104. Tammy Steinhagen, letter with enclosure to the author, Apr. 11, 2002.

105. Author's on-site documentation, Apr. 30, 2002; *Indianapolis Star*, Nov. 21, 2000.

106. Unless otherwise indicated, further information on Lawrence County's outdoor sculptures erected before 1994 can be found in SOS! files, 47-001–47-017.

107. Author's on-site documentation, Feb. 24, 2002; *Indianapolis Star*, Aug. 17, 1965; Don Caudell Sr., telephone interview with the author, May 31, 2002.

108. *Indianapolis News*, Aug. 22, 1932; Larry Corps, telephone interview with the author, Apr. 10, 2002.

109. Unless otherwise indicated, further information on Madison County's outdoor sculptures erected before 1994 can be found in SOS! files, 48-001–48-017.

110. Arnold e-mail.

111. Author's on-site documentation, Oct. 16, 1999.

112. Phil Simpson, telephone interview with the author, May 30, 2002; author's on-site documentations, Oct. 16, 1999, June 2, 2002.

113. Ryden letter.

114. Ibid.

115. Bayliss, e-mail, Apr. 11, 2002; Jason Knapp, e-mail message to the author, May 29, 2002.

116. Unless otherwise indicated, further information on Marion County's outdoor sculptures before 1994 can be found in SOS! files, 49-001–49-201.

117. *Indianapolis News*, Apr. 28, 1995. Author's on-site documentation, Apr. 15, 1999.

118. *Indianapolis News*, June 15, Apr. 19, 1999.

119. David Jemerson Young, telephone interview with the author, July 2, 2002; Paul Knapp, telephone interview with the author, June 28, 2002; "92 County Walk Will Spark Conversations about Indiana Counties," *Your Indiana State Museum* (Jan./Feb. 2002); Jessica DiSanto, e-mail messages to the author, Apr. 18, May 17, 2002.

120. Donna Imus, interview with the author, June 19, 2002; *Indianapolis News*, May 26, 1999.

121. *Indianapolis News*, Nov. 22, 1993.

122. Enochs telephone interview; Amy Brier, e-mail message to the author, May 27, 2002; Jan Martin, telephone interview with the author, Apr. 3, 1999; author's on-site documentation, Dec. 30, 1999; *Indianapolis Star*, June 5, 1999; http://home.bluemarble.net/~denochs/.

123. *Indianapolis Star*, Dec. 11, 1932; Julie Schaefer, e-mail to the author, June 30, 2002; Diane Billiard, telephone interview with the author, July 8, 2002; "Sculpture around Town," 3.

124. Author's on-site documentation, June 3, 2000; Enochs telephone interview.

125. Author's on-site documentation, Nov. 1, 1999.

126. Ibid., May 19, 2002.

127. Ibid., Apr. 11, 2002; Shiel Sexton sales booklet (ca. 2001).

128. Author's on-site documentations, June 11, 2001, July 8, 2002; Enochs telephone interview; Jerald Jacquard, letter to Riley Area Development Corporation, Jan. 16, 2000; Murat Shrine information desk, July 16, 2002.

129. *Indianapolis Star*, Nov. 26, 1999; *Indianapolis Spotlight*, Apr. 3, 2002; *Indianapolis Star*, Mar. 4, 1934.

130. Greg Perry, letter to the author, Apr. 7, 1995; *Indianapolis Star*, Jan. 15, 1995; *Indianapolis News*, Sept. 27, 1995; *South Bend Tribune*, Oct. 1, 1995.

131. Nat Pendleton, e-mail message to the author, Mar. 22, 2002.

132. *Indianapolis Star*, Oct. 28, 2000; Guy R. Grey, telephone interview with the author, May 30, 2002.

133. Object Report, June 24, 2002, Art Registration Department, Indianapolis Museum of Art.

134. Ibid.

135. Ibid.; Eric Nordgulen, telephone interview with the author, June 26, 2002.

136. Records are unclear, but very likely it was a program under FERA (Federal Emergency Relief Administration, 1933). The WPA (Works Progress Administration) was not established until 1935.

137. David Thomas, interview with the author, May 31, 2002; Diane Seybert, "Indianapolis Art League: Fifty-four Years of Service," *Arts Insight* 10, no. 2 (Mar. 1988): 28; *Indianapolis News*, Aug. 17, 1996.

138. *Indianapolis Star*, Aug. 8, 1999; C. R. Schiefer, telephone interview with the author, Apr. 25, 2002.

139. Paul Knapp telephone interview.

140. Robert Borns, telephone interview with the author, July 1, 2002; Gary Freeman, telephone interview with the author, July 9, 2002.

141. LaMantia interview, Mar. 29, 2002; *Collaborative Sculpture*.

142. Ibid.

143. David Scott telephone interview.

144. *Indianapolis News*, May 26, 1999; *Indianapolis Star*, Apr. 27, 2000; Berg e-mail, June 21, 2002.

145. *Indianapolis Star*, Nov. 5, 1998.

146. Ibid., Sept. 18, 1999.

147. Ibid., Feb. 5, 2002; author's on-site inspection, June 26, 2002.

148. Julie Schaefer e-mails, Feb. 22, June 30, 2002; "Herron Students Install Sculptures at Local Company," IUPUI news release, May 4, 2000; "Sculpture around Town," 2; Kathy McKimmie, "Forging Steel Alliances: Celadon Trucking and the Herron School of Art," *Arts Indiana* 21, no. 3 (July–Aug. 1999): 31–32.

149. *Indianapolis News*, May 29, 1995; author's on-site documentation, Oct. 16, 1999; Arnold interview.

150. Author's on-site documentation, Feb. 29, 2000; *Indianapolis Spotlight*, Dec. 16, 1998.

151. Author's on-site documentation, May 31, 2000.

152. Ibid., May 30, 2000 (Sancta Mater Teresia).

153. *Plymouth News*, June 13, 1936. Further information on this and other outdoor sculpture in Marshall County can be found in SOS! files, 50-001–50-011.

154. Further information on the outdoor sculptures of Martin County can be found in SOS! files, 51-001–51-003.

155. Information on Miami County sculpture can be found in ibid., 52-001–52-002.

156. Unless otherwise noted, information on Monroe County's outdoor sculptures erected before 1994 can be found in ibid., 53-001-53-043.

157. Howard Canada, "A History of the Peace Statue on the West Lawn of the Monroe County Courthouse," unpublished manuscript, n.d.

158. Paul Knapp, e-mail message to the author, July 8, 2002.

159. LaMantia interview, Mar. 29, 2002; *Collaborative Sculpture*; "Study Outdoor Sculpture," promotional flyer, n.d. (in use in 2002).

160. *Indianapolis Star*, Apr. 20, 2002.

161. Ibid., Dec. 6, 2000; Harold R. "Tuck" Langland, interview with the author, June 16, 1999.

162. Kathleen Adair Foster, letter to the author, Dec. 14, 2001.

163. *Indianapolis Star*, Mar. 25, June 5, 2002.

164. Dian Moore, e-mail message to the author, June 6, 2002.

165. Author's on-site documentation, Dec. 27, 1999. Information on Montgomery County's outdoor sculptures erected before 1994 can be found in SOS! files, 54-001–54-007.

166. Unless otherwise indicated, information on Morgan County's outdoor sculptures erected before 1994 can be found in SOS! files, 55-001–55-003.

167. *Indianapolis News*, Nov. 13, 1990.

168. Gary Rittenhouse, telephone interview with the author, May 3, 2002.

169. Lynn Olson discusses his techniques and formulae in *Sculpting with Cement: Direct Modeling in a Permanent Medium* (Valparaiso, Ind.: Steelstone Press, 1981). Information on Noble County's outdoor sculptures can be found in SOS! files, 57-001–57-007.

170. SOS! files, 58-001.

171. Ibid., 59-001.

172. Information on Owen County's outdoor sculptures can be found in ibid., 60-001–60-007.

173. Information on Parke County's sculptures can be found in ibid., 61-001–61-007.

174. Author's on-site inspection, Dec. 27, 1999.

175. Information on Perry County's outdoor sculptures can be found in SOS! files, 62-001–62-011.

176. Pike County information can be found in ibid., 63-001.

177. LaMantia interview, Mar. 29, 2002.

178. Author's on-site inspection, Nov. 16, 1999. Unless otherwise noted, information on Porter County's outdoor sculptures erected before 1994 can be found in SOS! files, 64-001–64-012.

179. Frederick L. Frey, e-mail message to the author, June 9, 2002.

180. Scarff telephone interview.

181. LaMantia interview, Apr. 28, 2002.

182. Unless otherwise indicated, information on outdoor sculptures in Posey County erected before 1994 can be found in SOS! files, 65-001–65-014.

183. "Artworks in the Collection of Jane Blaffner Owen/The Blaffner Trust/Red Geranium Enterprises on Public Display," unpublished document, n.d.; Mark Mennin, telephone interview with the author, June 10, 2002; author's on-site documentation, Nov. 17, 1999.

184. "Artworks in the Collection of Jane Blaffner Owen"; author's on-site documentation, Nov. 17, 1999.

185. Kocka telephone interview; author's on-site documentation, Mar. 15, 1999.

186. Author's on-site documentations, Mar. 15, Nov. 17, 1999; Earl Rohleder, e-mail message to the author, June 22, 2002.

187. Information on Pulaski County's outdoor sculptures erected before 1994 can be found in SOS! files, 66-001–66-003.

188. Rex Allman, e-mail message to the author, Sept. 5, 2001.

189. Information on Putnam County's outdoor sculptures can be found in SOS! files, 67-001–67-003.

190. Information on Randolph County's outdoor sculptures erected before 1994 can be found in ibid., 68-001–68-003.

191. Information for Ripley County, ibid., 69-001, 69-002.

192. Rockwood e-mails.

193. Dorothy Voegele, telephone interview with the author, May 20, 2002.

194. Rush County native William F. Gulde, chair, Social Studies Department, North Central High School, Indianapolis. Information on the outdoor sculpture of Rush County can be found in SOS! files, 70-001–70-008.

195. Unless otherwise indicated, information on the outdoor sculptures of Saint Joseph County erected before 1994 can be found in SOS! files, 71-001–71-127.

196. Author's on-site documentation, Nov. 7, 2000; *South Bend Tribune*, Oct. 10, 1998, Oct. 17, 2000.

197. Author's on-site documentation, June 16, 1999.

198. Henry R. "Hank" Mascotte, telephone interview with the author, May 25, 2002, and Mascotte, letter and photos to author, June 16, 2002.

199. Author's on-site documentation, Mar. 11, 2003.

200. David M. Layman, e-mail messages to the author, June 14, 19, 2002.

201. *South Bend Tribune*, Oct. 29, Dec. 26, 2001; author's on-site documentation, Apr. 29, 2002.

202. *South Bend Tribune*, Sept. 3, 1999; author's on-site documentation, Oct. 24, 2000.

203. Ann Kuntz, e-mail message to the author, June 25, 2002.

204. *South Bend Tribune*, Dec. 12, 1996; author's on-site documentation, July 18, 2000; Kim Hoffman, letter to the author, Oct. 13, 2000.

205. "News Briefs," *Pulse* (Fall 2001); author's on-site documentation, Apr. 2, 2002; *South Bend Tribune*, June 15, 2000; author's on-site documentation, July 18, 2000.

206. Kuntz e-mail; *The Freedom Memorial: Standing Tall*, fund-raising brochure, Saint Joseph County Parks Foundation, 2001; *South Bend Tribune*, Apr. 27, 2002.

207. Author's on-site documentation, Dec. 14, 1999; *South Bend Tribune*, Apr. 28, 1999; Janice Langland, e-mail messages to the author, June 11, 18, 2002.

208. Kuntz e-mail; author's on-site documentation, Nov. 7, 2000.

209. Michael Levine to Ann Robertson, Sept. 6, 2000; author's on-site documentation, Apr. 2, 2002.

210. *South Bend Tribune*, Aug. 9, 23, 1998, June 15, 2000.

211. James Flanigan, e-mail message to the author, Apr. 17, 2002.

212. *South Bend Tribune*, Sept. 10, 1995; Charles R. Loving, e-mail message to the author, June 28, 2002.

213. *South Bend Tribune*, Sept. 10, 1995, Sept. 14, 1999; author's on-site documentation, Apr. 2, 2002; Michael Dunbar, telephone interview with the author, Apr. 10, 2002; Enochs telephone interview.

214. Author's on-site documentation, Apr. 2, 2002.

215. Flanigan e-mail; author's on-site documentation, Apr. 29, 2002.

216. SOS! files, 72-001.

217. Information on Shelby County's outdoor sculptures can be found in ibid., 73-001–73-005.

218. Information on Spencer County's outdoor sculptures erected before 1994 can be found in ibid., 74-001–74-022.

219. *Christmas in Santa Claus & Spencer County, Indiana*, brochure, 2001; Vevah Harris, e-mail message to the author, Jan. 21, 2002.

220. SOS! files, 75-001–75-005.

221. Ibid., 46-008; author's on-site documentation, Sept. 28, 2001.

222. Information on outdoor sculptures in Steuben County can be found in SOS! files, 76-001–76-004.

223. Information on outdoor sculptures in Sullivan County can be found in ibid., 77-001, 77-002.

224. Unless otherwise noted, information on Tippecanoe County's outdoor sculptures can be found in ibid., 79-001–79-036.

225. Arnold e-mail.

226. *Indianapolis Star*, Feb. 28, 1963.

227. Michael Atwell, e-mail message to the author, May 30, 2002; *Indianapolis Star*, Apr. 23, 2001.

228. Atwell e-mails, May 28, 30, 2002.

229. *Indianapolis Star*, Jan 4, 2000; Linda Vanderkolk, e-mail message to the author, Feb. 23, 2002; Atwell e-mails, May 30, June 28, 2002; *South Bend Tribune*, Aug. 9, 1998.

230. "Class of '52 Sculpture, Arts Building Transform Purdue," *Purdue News* (online) Apr. 20, 2002.

231. Atwell e-mails, May 20, 28, 2002.

232. The Harrison figure is sometimes interpreted as George Rogers Clark, which makes little sense historically. The center figure is sometimes interpreted as George Washington, but it much more closely resembles Lafayette.

233. Author's on-site documentation, Oct. 18, 2002.

234. Linda Vanderkolk, letter with enclosures to the author, Jan. 2, 2002; Roy Patrick, telephone interview with the author, Apr. 25, 2002; author's on-site documentation, Oct. 18, 2002.

235. SOS! files, 80-001–80-005.

236. Unless otherwise indicated, information on Vanderburgh County's outdoor sculptures erected before 1994 can be found in ibid., 82-001–82-043.

237. Chip Kalleen, "Sculptor Refutes 'Cornbelt' Story," *Arts Insight* 8, no. 7 (Oct. 1986): 14–15.

238. *Evansville Courier and Press*, May 26, 2002.

239. Enochs telephone interview; http://home.bluemarble.net/~denochs/.

240. John McNaughton, telephone interview with the author, June 5, 2002.

241. "The Greenway Gallery," *8600 University Boulevard*, 31, no.4 (Summer 1998): 2; McNaughton telephone interview; author's on-site documentation, Nov. 17, 1999.

242. Fred Nance, e-mail message to the author, June 11, 2002; Kim Earlewine, telephone interview with the author, June 7, 2002.

243. Author's on-site documentation, Nov. 17, 1999; *Indianapolis Star*, Dec. 9, 1999.

244. Information on outdoor sculptures in Vermillion County can be found in SOS! files, 83-001–83-004.

245. Unless otherwise indicated, information on outdoor sculptures in Vigo County erected before 1994 can be found in ibid., 84-001–84-065.

246. Author's on-site documentation, Mar. 16, 2002.

247. Author's on-site documentations, Nov. 5, 2000, Mar. 16, 2002; Phil Dees, e-mail message to the author, Feb. 22, 2002; David Wray, e-mail message to the author, Mar. 30, 2002.

248. SOS! files, 85-001.

249. Ibid., 85-002.

250. Phil Zimmerman, e-mail messages to the author Oct. 30, Nov. 1, 2000.

251. Information on Warrick County's outdoor sculptures can be found in SOS! files, 87-001, 87-002.

252. For Washington County see ibid., 88-001; Alison Adams, interview with the author, Oct. 5, 2002.

253. Unless otherwise indicated, information on Wayne County's outdoor sculptures erected before 1994 can be found in SOS! files, 89-001–89-011.

254. Kathleen Glynn, conversation with Hernly Boyd, in e-mail message to the author, July 8, 2002.

255. Author's on-site documentation, Apr. 6, 1991.

256. Information on outdoor sculptures in Wells County can be found in SOS! files, 90-001–90-07.

257. Information on White County sculptures can be found in ibid., 91-001, 91-002.

258. Information on the outdoor sculptures of Whitley County can be found in ibid., 92-001–92-004.

Andersen, Wayne V. *American Sculpture in Process, 1930–1970.* Boston: New York Graphic Society, 1975.

Armstrong, Tom et al. *Two Hundred Years of American Sculpture.* [Boston]: R. D. Godine, 1976.

Artcyclopedia.
http://www.artcyclopedia.com/artists/.

Arts Indiana. 1987–2001.

Arts Insight. 1979–87.

Ashton, Dore. *Modern American Sculpture.* New York: H. N. Abrams, [1968?].

AskART. http://www.askart.com/.

Boswell, Jessie P., comp. "Historical Markers and Public Memorials in Indiana." *Indiana History Bulletin* 6, extra no. 1 (January 1929).

The Bronze Gallery.
http://www.bronze-gallery.com/A.

Burnet, Mary Q. *Art and Artists of Indiana.* New York: Century, 1921.

———, and Mrs. Robert E. Burke, comps. *Art Guide to Indiana: From an Art Survey by the Indiana Federation of Clubs.* [Bloomington, Ind.: s. n., 1931].

Durman, Donald Charles. *He Belongs to the Ages: The Statues of Abraham Lincoln.* Ann Arbor, Mich.: Edwards Bros., 1951.

Falk, Peter Hastings, ed. *Who Was Who in American Art, 1564–1975: Four Hundred Years of Artists in America.* 3 vols. Madison, Conn.: Sound View Press, 1999.

Greiff, Glory-June. *Indiana Save Outdoor Sculpture! Project: List of Sculptures by County.* Indianapolis: Historic Landmarks Foundation of Indiana, 1994.

———, comp. "Indiana Save Outdoor Sculpture! Files." 1992–94. Resource Center of Historic Landmarks Foundation of Indiana, Indianapolis / Smithsonian Institution, Washington, D.C.

Harris, Moira F. *Monumental Minnesota: A Guide to Outdoor Sculpture.* [St. Paul?]: Pogo Press, 1992.

Hartley, W. Douglas. *The Search for Henry Cross: An Adventure in Biography and Americana.* Indiana Historical Society Publications, vol. 23, no. 3. Indianapolis: Indiana Historical Society, 1966.

Historical Markers in Indiana. Rev. ed. Indianapolis: Indiana Historical Commission, 1924.

IAC News. 1977–85.

IAC Quarterly. 1985–94.

Illustrated Catalogue of Statuary, Fountains, Vases, Settees, etc., for Parks, Gardens, and Conservatories Manufactured by the J. L. Mott Iron Works. New York: E. D. Stater, Printer, 1875.

Langland, Tuck. *From Clay to Bronze: A Studio Guide to Figurative Sculpture.* New York: Watson-Guptill Publications, 1999.

Memorials of Art Value for Indiana. Indiana University Extension Division, vol. 16. Bloomington,

Ind.: Public Welfare Service, 1931.

Mullins, W. H., Company. *Statues in Stamped Copper and Bronze.* Salem, Ohio: The Company, 1913.

National Sculpture Society. *Contemporary American Sculpture.* San Francisco, 1929.

Naudé, Virginia Norton, ed. *Sculptural Monuments in an Outdoor Environment: A Conference Held at the Pennsylvania Academy of the Fine Arts, Philadelphia, November 2, 1983.* Philadelphia: The Academy, 1985.

Olson, Lynn. *Sculpting with Cement: Direct Modeling in a Permanent Medium.* Valparaiso, Ind.: Steelstone Press, 1981.

Opitz, Glenn B., ed. *Dictionary of American Sculptors: "18th Century to the Present."* Poughkeepsie N.Y.: Apollo, 1984.

Percoco, James, and Michael Richman. *Commemorative Sculpture in the United States: A Unit of Study for Grades 8–12.* Los Angeles: Organization of American Historians and the National Center for History in the Schools, University of California, 1998.

Reynolds, Donald Martin. *Monuments and Masterpieces: Histories and Views of Public Sculpture in New York City.* New York: Macmillan, 1988.

Roberts, Warren E. *Viewpoints on Folklife: Looking at the Overlooked.* Ann Arbor, Mich.: UMI Research Press, 1988.

Rubins, David K. *The Human Figure: An Anatomy for Artists.* New York: Viking, 1953.

Rubinstein, Charlotte Streifer. *American Women Sculptors: A History of Women Working in Three Dimensions.* Boston: G. K. Hall, 1990.

Scudder, Janet. *Modeling My Life.* New York: Harcourt, Brace and Company, 1925.

Taft, Lorado. *The History of American Sculpture.* New York: Macmillan, 1930.

Volunteer Handbook: Save Outdoor Sculpture! Washington, D.C.: National Institute for the Conservation of Cultural Property, 1992.

Watson-Jones, Virginia. *Contemporary American Women Sculptors.* Phoenix: Oryx, 1986.

Wood, Kathleen Sinclair. *Clues to American Sculpture.* Washington: Starrhill Press, 1990.